The Secret Lives of Colour

Kassia St Clair

First published in Great Britain in 2016 by John Murray (Publishers) An Hachette UK company

1

Copyright © Kassia St Clair 2016

The right of Kassia St Clair to be identified as the Author of the Work has been asserted by her in accordance with the Copyright, Designs and Patents Act 1988.

All rights reserved. No part of this publication may be reproduced, stored in a retrieval system, or transmitted, in any form or by any means without the prior written permission of the publisher, nor be otherwise circulated in any form of binding or cover other than that in which it is published and without a similar condition being imposed on the subsequent purchaser.

Every reasonable effort has been made to trace the copyright holders, but if there are any errors or omissions, John Murray will be pleased to insert the appropriate acknowledgement in any subsequent printings or editions.

A CIP catalogue record for this title is available from the British Library

Hardback ISBN 978 1 473 63081 9 Ebook ISBN 978 1 473 63082 6

Typeset in Kings Caslon by James Edgar Design

Printed and bound in China by C&C Offset

John Murray policy is to use papers that are natural, renewable and recyclable products and made from wood grown in sustainable forests. The logging and manufacturing processes are expected to conform to the environmental regulations of the country of origin.

John Murray (Publishers) Carmelite House 50 Victoria Embankment London EC4Y 0DZ

www.johnmurray.co.uk

The purest and most thoughtful minds are those which love colour the most.

John Ruskin, *The Stones of Venice* (1851–3)

Contents

Preface 1	O Colour vision:	
	How we see	13
	Simple arithmetic:	
	On light	17
	Building the palette:	
	Artists and their pigments	21
	Vintage paint charts:	
	Mapping colour	26
	Chromophilia,	
	chromophobia:	
	Politics of colour	29
	Colourful language:	
	Do words shape the	
	shades we see?	33

	38		62
Lead white	43	Blonde	67
Ivory	47	Lead-tin yellow	69
Silver	49	Indian yellow	71
Whitewash	52	Acid yellow	74
Isabelline	54	Naples yellow	76
Chalk	56	Chrome yellow	78
Beige	58	Gamboge	80
		Orpiment	82
		Imperial yellow	84
		Gold	86
	92		114
Dutch orange	96	Baker-Miller pink	118
Saffron	98	Mountbatten pink	120
Amber	101	Puce	122
Ginger	104	Fuchsia	124
Minium	107	Shocking pink	126
Nude	110	Fluorescent pink	128
		Amaranth	130

236
BESTERNING.

Khaki	240
Buff	242
Fallow	244
Russet	246
Sepia	248
Umber	250
Mummy	253
Taupe	256

Vi de la companya de	
Kohl	264
Payne's grey	266
Obsidian	268
Ink	271
Charcoal	274
Jet	276

Melanin

Pitch black

260

278

280

Glossary of other interesting colours	
Endnotes	285
Bibliography and suggested further reading	306
Acknowledgements	315
Index	316

Preface

I fell in love with colours in the way most people fall in love: while concentrating on something else. Ten years ago, while researching eighteenth-century women's fashions, I would drive down to London to gaze at yellowing copies of *Ackermann's Repository*, one of the world's oldest lifestyle magazines, in the Victoria and Albert Museum's wood-clad archive. To me, the descriptions of the latest fashions of the 1790s were as mouth-watering and bewildering as the tasting menu of a Michelin-starred restaurant. One issue described: 'A Scotch bonnet of garnet-coloured satin, the ends trimmed with a gold

That worst and vilest of all colours, pea-green!

Arbiter Elegantiarum, 1809

fringe'. Another recommended a gown of 'puce-coloured satin' to be worn with a 'Roman mantle of scarlet kerseymere'. At other times, the well-dressed woman would be nothing without a pelisse in hair brown, a bonnet trimmed with cocquelicot-coloured feathers or lemon-coloured sarsenet silk.

Sometimes there were coloured plates accompanying the descriptions to help me decipher what hair brown could possibly look like, but often there were not. It was like listening to a conversation in a language I only half understood. I was hooked.

Years later, I had an idea that would allow me to write about my passion month in, month out, turning it into a regular magazine feature. Each issue I would take a different shade and pull it apart at the seams to discover its hidden mysteries. When was it fashionable? How and when was it made? Is it associated with a particular artist or designer or brand? What is its history? Michelle Ogundehin, the editor of the *British Elle Decoration*, commissioned my column and in the years since I have written about colours as ordinary as orange and as

recherché as heliotrope. These columns provided the germ for this book and I am profoundly grateful.

The Secret Lives of Colour is not intended to be an exhaustive history. This book is broken down into broad colour families and I have included some – black, brown and white – that are not part of the spectrum as defined by Sir Isaac Newton.¹ Within each family I have picked out individual shades with particularly fascinating, important or disturbing histories. What I have tried to do is provide something between a potted history and a character sketch for the 75 shades that have intrigued me the most.

Some are artists' colours, some are dyes and others are almost more akin to ideas or sociocultural creations. I hope you enjoy them. There are many wonderful stories that I didn't have room for here, so I have included a glossary (or colour swatch) of other interesting hues along with suggestions for further reading.

I don't believe there are 'off-putting' colours.

David Hockney defending another shade of green – olive, 2015 Light is therefore colour, and shadow the privation of it.

J. M. W. Turner, 1818

Colour vision

How we see

Colour is fundamental to our experience of the world around us. Think of hi-vis jackets, brand logos, and the hair, eyes and skin of those we love. But how is it, precisely, that we see these things? What we are really seeing when we look at, say, a ripe tomato or green paint. is light being reflected off the surface of that object and into our eyes. The visible spectrum, as you can see from the diagram on page 14, only makes up a small proportion of the entire electromagnetic spectrum. Different things are different colours because they absorb some wavelengths of the visible light spectrum, while others bounce off. So the tomato's skin is soaking up most of the short and medium wavelengths - blues and violets, greens, yellows and oranges. The remainder, the reds, hit our eyes and are processed by our brains. So, in a way, the colour we perceive an object to be is precisely the colour it isn't: that is, the segment of the spectrum that is being reflected away.

When light enters our eyes it passes through the lenses and hits the retinas. These are at the back of our eyeballs and are stuffed with light-sensitive cells, called rods and cones because of their respective shapes. Rods do the heavy lifting of our vision. We have about 120 million in each eye; they are incredibly sensitive and principally distinguish between light and dark. But it is the cones that are most responsive to colour. We have far fewer of these: around six million in each retina, the majority huddled together in a small, central spot called the macula. Most people have three different types of cone,² each tuned to light of different wavelengths: 440 nm, 530 nm and 560 nm. About two-thirds of these cells are sensitive to longer wavelengths, which means we see more of the warm

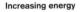

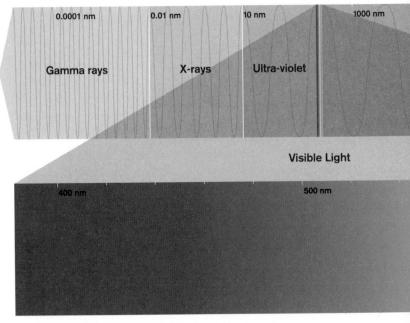

colours – yellows, reds and oranges – than the cooler colours in the spectrum. Around 4.5% of the world's population are colour-blind or deficient because of faults in their cone cells. The phenomenon is not completely understood, but it is usually genetic and is more prevalent in men: around 1 in 12 men are affected compared to 1 in 200 women. For people with 'normal' colour vision, when cone cells are activated by light, they relay the information through the nerve system to the brain, which in turn interprets this as colour.

This sounds straightforward, but the interpretation stage is perhaps the most confounding. A metaphysical debate over whether colours really, physically exist or are only internal manifestations has raged since the seventeenth century. The squall of dismay and confusion on social media over the blue and black (or was it white and gold?) dress in 2015 shows how uncomfortable we

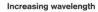

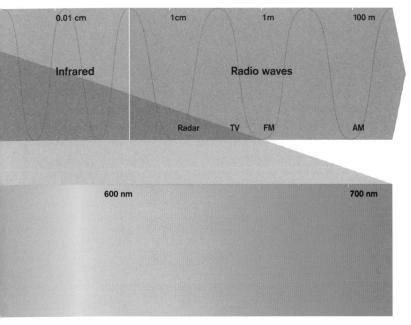

are with the ambiguity. This particular image made us acutely aware of our brain's post-processing: half of us saw one thing, the other half something completely different. This happened because our brains normally collect and apply cues about the ambient light - whether we are in full daylight or under an LED bulb, for example - and texture. We use these cues to adjust our perception, like applying a filter over a stage light. The poor quality and lack of visual clues like skin colour in the dress image meant that our brains had to guess at the quality of the ambient light. Some intuited that the dress was being washed out by strong light and therefore their minds tuned the colours to darken them; others believed the dress to be in shadow, so their minds adjusted what they were seeing to brighten it and remove the shadowy blue cast. That is how an internet full of people looking at the same image saw very different things.

Whiteness and all grey Colours between white and black, may be compounded of Colours, and the whiteness of the Sun's Light is compounded of all the primary Colours mix'd in a due Proportion.

Sir Isaac Newton, 1704

Simple arithmetic

In 1666, the same year that the Great Fire of London consumed the city, a 24-year-old Isaac Newton began experimenting with prisms and beams of sunlight. He used a prism to prise apart a ray of white light to reveal its constituent wavelengths. This was not revolutionary in itself – it was something of a parlour trick that had been done many times before. Newton, however, went a step further, and in doing so changed the way we think about colour forever: he used another prism to put the wavelengths back together again. Until then it had been assumed that the rainbow that pours out of a prism in the path of a beam of light was created by impurities in the glass. Pure white sunlight was considered a gift from God; it was unthinkable that it could be broken down or, worse still, created by mixing coloured lights together. During the Middle Ages mixing colours at all was a taboo, believed to be against the natural order; even during Newton's lifetime, the idea that a mixture of colours could create white light was anathema.

Artists would also have been puzzled by the idea that white is made up of lots of different colours, but for different reasons. As anyone who has ever had access to a paint set knows, the more colours you mix together, the closer you approach to black, not white. It has been suggested that Rembrandt created the complex, dark, chocolaty shadows in his paintings simply by scraping together whatever happened to remain on his palette and blending that directly onto the canvas, because so many different pigments have been found within their depths.³

The explanation for the fact that mixing coloured *light* makes white, while mixing coloured *paint* makes

Additive Colour Mixing
Colours are created by mixing
different coloured lights.
Combining the three primaries
produces white.

black, lies in the science of optics. Essentially, there are two different types of colour mixing: additive and subtractive. With additive mixing, different light wavelengths are combined to create different colours, and when added together the result is white light. This is what Newton demonstrated with his prisms. However, the opposite happens when paints are mixed. Since each pigment only reflects back to the eye a proportion of the available light, when several are mixed together more and more wavelengths are subtracted. Mix enough together and very little of the visible spectrum is reflected, so we will perceive the mixture to be black, or very close to it.

For painters with a limited range of impure pigments at their disposal, this is a problem. If they want to create a pale purple, for example, they have to mix together at least three: a red, a blue and a white, but they might have to add even more to get the precise violet they're after. The more colours they blend, the more likely it is that the end result will be murky. But the same is true even for simple colours like green and orange: it's better to use a single pigment rather than mixtures that will inevitably absorb more of the available light wavelengths, sucking the luminosity from the painting. The search for more and brighter colours is fundamental to the story of art, from prehistory to today.

Without paint in tubes there would have been ... nothing of what the journalists were later to call Impressionists.

Pierre-Auguste Renoir, date unknown

Building the palette

Artists and their pigments

Pliny the Elder, a Roman naturalist writing in the first century AD, claimed that painters in classical Greece used only four colours: black, white, red and yellow. He was almost certainly exaggerating – the Egyptians had discovered a way of manufacturing a bright, clear blue [page 196] at least as early as 2500 BC. But it is true that early artists were restricted, for the most part, to a small range of pigments they could extract from the ground or from plants and insects.

Humanity has been well served with earthy red- and yellow-toned browns from the beginning. The earliest pigment use that we know of is from the lower Palaeolithic period, about 350,000 years ago. Prehistoric peoples could render a deep black from the ashes from fires [page 274]. Some whites could be found in the ground; another was produced by early chemists from around 2300 BC [page 43]. Although pigments had been discovered, traded and synthesised throughout recorded history, the process accelerated dramatically in the nineteenth century due to the burgeoning the Industrial Revolution. More and more chemicals were being produced as by-products of industrial processes and some made excellent pigments and dyes. William Perkin, for example, stumbled across the purple dye Mauveine [page 169] while trying to synthesise a cure for malaria in 1856.

The availability of some pigments and the introduction of others has helped to shape the history of art. The palm prints and bison on the walls of prehistoric caves owed their sombre palette to the pigments that the earliest artists could find in the world around them. Fast-forward several thousand years to illuminated medieval manuscripts, and

Subtractive Colour Mixing
By mixing a limited set of colours,
many others can be created.
A perfect mixture of primaries
will yield black.

the black and white remained unchanged, but flat fields of gold and several brilliant colours like red and blue have been added. Centuries later, the paintings of Renaissance artists or old masters benefited as much from a broader range of pigments as they did from realistic representations of perspective and sophisticated ways of dealing with light and shade. Some works from this time remain unfinished, with a single figure left as a simple sketch, because the artist couldn't afford the expensive pigments needed to complete the canvas. The clear blue ultramarine [page 182], for example, was so dear that the commissioning patrons often had to buy it themselves: the artists couldn't afford it. And customers often felt the need to specify, in written contracts, how much of the expensive paints they expected artists to use in the finished work, and which figures should be clothed in which colours, fearful that hard-up painters would use a cheaper alternative.4

For their part, early artists had a very different relationship with their colours than modern artists. Because some colourants reacted with others, artists had to plan their compositions bearing potentially ruinous combinations in mind, ensuring that none overlapped or appeared next to each other. Most pigments were made by hand, either by the artist themselves or with the help of apprentices in their studios. Depending on the pigment, this could require grinding down rocks to powder, or the handling of technically challenging or poisonous raw ingredients. Pigments could also be obtained from specialists, including alchemists and apothecaries. Later, those who produced and traded in colours were known as colourmen, and procured rare pigments from across the globe.

It was only relatively late in the nineteenth century that artists really benefited from a proliferation of ready-made pigments (and even then these weren't always reliable). Cheap compounds, such as cerulean, chrome orange and cadmium yellow, freed artists from either pestles or unscrupulous colourmen who sold unstable mixes that would discolour within weeks or react with other colours, or the canvas itself. Coupled with the invention of collapsible metal paint tubes in 1841, the new colours allowed artists to work outside and douse their canvases with the brightest pigments anyone had ever seen. It is small wonder critics were initially unsure: this was colour as it had never been seen before, and it was dazzling.

Too often histories of colour – what few there are – are limited to the most recent periods and to artistic matters, which is very reductive. The history of painting is one thing, the history of colours is another – and altogether more vast.

Michel Pastoureau, 2015

Vintage paint charts

Mapping colour

In the dying years of the seventeenth century, a Dutch artist called A. Boogert made a concerted attempt to pin all known colours down. In a volume containing over 800 hand-painted swatches glossed with spidery black labels, Boogert described how to mix an array of watercolour tints, from the palest sea foam to deepest viridian. He is far from the only person to have attempted to catalogue all known tints, shades and hues. Scientists, artists, designers and linguists have all spent time trying to chart courses through colour space, and assign plot points with names, codes or grid references. Pantone's index-card-style chips are the most famous modern solution to the problem of locking precise shades across linguistic and cultural divides, but it is only one in a long line of such efforts.

Because colours exist as much in the cultural realm as they do physically, such attempts are somewhat Sisyphean. Take, for example, the idea that colours can be grouped into two camps, warm and cool. We would unhesitatingly say that red and yellow are warm, and green and blue are cool, but this division can only be traced back to the eighteenth century. There is evidence that in the Middle Ages blue was considered hot, even the hottest of colours.

There are also discrepancies between the name a society gives a colour and the actual colour, and these can shift over time, like tectonic plates. Magenta [page 167], which is now considered a pink but was originally more purple-red, is one example. Others can be found among the wonderfully abstruse definitions in Merriam-Webster's *Third New International Dictionary*, published in 1961. Begonia is 'a deep pink that is bluer, lighter, and stronger than average coral, bluer than fiesta, and bluer and stronger

than sweet William'. Lapis lazuli blue is 'a moderate blue that is redder and duller than average copen and redder and deeper than azurite blue, Dresden blue, or pompadour'. The intention of these descriptions was not to send the reader on a wild definition-chase through the dictionary; they were probably the work of colour expert Isaac H. Godlove, a consultant hired by the editor of Webster's Third and the director of Munsell, a colour mapping company.5 The problem is that, fun as these entries are now, average coral, fiesta and copen have largely lost their cultural currency – they don't get the reader one iota closer to knowing what the colour being defined actually looks like. By the same token, someone reading about avocado green in 100 years' time might be equally mystified: is it the dark colour of the skin that's meant? Or the clay green of the outer flesh? Or the butter tint near the seed? But for people today, avocado green still has meaning.

Over the course of time the margin for error becomes ever greater. Even when the documentary evidence, such as a painting, remains, we are often seeing it in lighting conditions entirely different from the ones it was created in. It's the difference between looking at a house-paint sample on your computer screen, in the tin at your local hardware store, and then on the walls in your home. Also, since many stable dyes and paints are recent innovations the colours themselves may have deteriorated. Colours, therefore, should be understood as subjective cultural creations: you could no more meaningfully secure a precise universal definition for all the known shades than you could plot the coordinates of a dream.

Savage nations, uneducated people, and children have a great predilection for vivid colours.

Johann Wolfgang Goethe, 1810

Chromophilia, chromophobia

Politics of colour

A certain distaste for colour runs through Western culture like a ladder in a stocking. Many classical writers were dismissive. Colour was a distraction from the true glories of art: line and form. It was seen as self-indulgent and, later, sinful: a sign of dissimulation and dishonesty. The bluntest expression of this comes from the nineteenthcentury American writer Herman Melville, who wrote that colours 'are but subtle deceits, not actually inherent in substances, but only laid on from without; so that all deified Nature absolutely paints like a harlot'.6 But arguments like these are very old indeed. The Protestants. for example, expressed their intellectual simplicity, severity and humility in a palette dominated by black and white; bright colours like red, orange, yellow and blue were removed both from the walls of their churches and their wardrobes. The pious Henry Ford steadfastly refused for many years to bow to consumer demand and produce cars in any colour other than black.

In art, the tussle over the respective merits of *disegno* (drawing) versus *colore* (colour) raged on through the Renaissance and, although somewhat muted, into the present day. *Disegno* represented purity and intellect; *colore*, the vulgar and effeminate. In an imperious essay from 1920, tellingly entitled 'Purism', the architect Le Corbusier and his colleague wrote that:

[I] na true and durable plastic work, it is form which comes first, and everything else should be subordinated to it... [Cézanne] accepted without examination the attractive offer of the colour-vendor, in a period marked by a fad for colour-chemistry, a science with no possible effect on great painting. Let us leave to the clothes-dyers the sensory jubilations of the paint tube.

Even among those who accept the value of colour, the ways in which they were conceptualised and ordered had an impact on their relative importance. The ancient Greeks saw colours running along a continuum from white to black: vellow was a little darker than white and blue was a little lighter than black. Red and green were in the middle. Medieval writers had great faith in this light-to-dark schema too. It was only in the seventeenth century that the idea emerged of red, yellow and blue as primary colours, and green, orange and purple as secondary ones. Most iconoclastic of all was Newton and his spectrum, an idea that he wrote about in 1704 in Opticks. This was hugely influential: suddenly white and black were no longer colours; the spectrum no longer ran from light to dark. Newton's colour wheel also imposed order on the relationship between complementary colours. These were colour pairs - for example, green and red, blue and orange - that were found to resonate strongly with each other when placed side by side. The idea of complementary colours would prove to have a profound effect on the art that followed; artists including Vincent van Gogh and Edvard Munch used them to give structure and add drama to their paintings.

As colours came to take on meanings and cultural significance within societies, attempts have been made to restrict their use. The most notorious expression of this phenomenon was through the sumptuary laws. While these were passed in ancient Greece and Rome, and examples can be found in ancient China and Japan, they found their fullest expression in Europe from the mid-twelfth century, before tailing off again in the early modern period. Such laws could touch on anything from diet to dress and furnishings, and sought to enforce social boundaries by encoding the social strata into a clear visual system:

Colourful language

Do words shape the shades we see?

It was a stern-faced British politician who first noticed something awry with the colours in ancient Greek literature. William Ewart Gladstone was a devotee of the poet Homer and it was while he was preparing the definitive tract on his hero in 1858 that he stumbled across some psychedelic oddities. Brows could certainly be black metaphorically - in rage - but was honey really green? Or the sea 'wine-dark', the same colour, bizarrely, as oxen, while sheep were violet? He decided to survey the Greek writer's entire oeuvre for colour references. Melas (black), it turned out, was by far the most frequently used, with around 170 mentions, and there were about 100 mentions of white. Next - a steep drop in frequency - erythros (red), which was only used 13 times, while yellow, green and purple were all referenced fewer than 10 times. Blue was not mentioned once. To Gladstone it seemed there was one possible explanation: that the Greeks were, in effect, colour-blind. Or, as he put it, more sensitive to the 'modes and forms of light, and of its opposite . . . darkness' than they were to colour.

In fact, humans evolved the capacity to see in colour several millennia earlier, so colour blindness is not to blame. And it isn't only the ancient Greeks who seem to talk about colour in ways that feel unfamiliar. A decade later Lazarus Geiger, a German philosopher and philologist, began to examine other ancient languages. He pored over the Quran and the Bible in its original Hebrew; he studied ancient Chinese stories and Icelandic sagas. All exhibited the same muddled references to colour and, as he noted in one much-quoted passage on Vedic chants from India, the same omission.

These hymns, of more than ten thousand lines, are brimming with descriptions of the heavens. Scarcely any subject is evoked more frequently. The sun and reddening of dawn's play of colour, day and night, cloud and lightening, the air and ether, all these are unfolded before us, again and again in splendour and vivid fullness. But there is one thing no one would ever learn from those ancient songs who did not already know it, and that is that the sky is blue.8

When the word did appear, it evolved out of the words that had previously served either for green or, more commonly, black. Geiger believed he could trace humanity's seeming sensitivity to different colours through the evolution of their languages. All started out with words for light and dark (or white and black); next came red, and then yellow, then green, then blue. A wider study conducted in the late 1960s by Brent Berlin and Paul Kay confirmed a similar sequence. This, it was believed, meant two things: the first was that colour categories were innate; the second was that if we didn't possess a word for a colour, it affected our perception of it.

However, a broader survey, conducted in the 1980s, revealed many exceptions: languages that didn't necessarily 'develop' in this way, and some that divide up colour space entirely differently. Koreans, for example, have a word that distinguishes yellow green from regular green; Russians have different words for light and dark blue. A classic example is Himba, a language spoken by a tribe in south-west Africa, which splits the colour spectrum into five slices. Another is Rennell-Bellona, a Polynesian language spoken on an atoll in the Solomon Islands, which roughly divides the spectrum up into white, dark and red, where dark includes blue and green and red includes yellow and orange.9

The subsequent literature on the relationship between language, colour and culture is maddeningly inconclusive. One camp – the relativists – say that language influences or even shapes perception and that without a word for a colour we don't see it as distinct. The universalists, following Berlin and Kay, believe that basic colour categories are universal and rooted, somehow, in our biology. What we can say for sure is that the language of colour is tricky. Children who can discern the difference between a triangle and square with ease may still struggle differentiating pink from red or orange. We also know that not having a separate word for something does not mean we can't distinguish it. The Greeks, of course, could see colours perfectly; perhaps they just found them less interesting than we do.

Lead white Ivory Silver

Isabelline Chalk Beige

White

'For all these accumulated associations, with whatever is sweet, and honourable, and sublime, there yet lurks an elusive something in the innermost idea of this hue, which strikes more of panic to the soul than that redness which affrights in blood.' So wrote Herman Melville in the forty-second chapter of *Moby Dick*. Entitled 'The Whiteness of the Whale', the passage is a veritable homily on the troubling, bisected symbolism of this colour. Because of its link with light, white has laid deep roots in the human psyche and, like anything divine, can simultaneously inspire awe and instil terror in the human heart.

Like the eponymous albino leviathan of Melville's novel, white has an otherness to it. If colours were people, it would be admired, but it probably wouldn't be popular: it is just a little too exclusive, autocratic and neurotic. For a start, it's tricky to make. You can't reach it by mixing together other coloured paints, you have to begin with a special white pigment. And anything you add to that pigment will only take it in one direction: towards black. This is due to the way our brains process light. The more pigments there are in a mixture, the less light is reflected back into our eyes, and the darker and sludgier it becomes. Most children will, at some stage, try mixing all their favourite paints together expecting to make an extra special colour. They will gather fire-engine red, sunny-sky blue and perhaps some Care Bear pastels and begin stirring. That such a mixture results not in something beautiful but in an irretrievably murky dark grey, is one of life's first hard truths.

Fortunately, artists have always had relatively easy access to white thanks to one of the most popular pigments known to man: lead white [page 43]. Pliny the Elder described the process of making it in the first century,

and it continued to be the white of choice in art for centuries, despite being highly toxic. In the eighteenth century Guyton de Morveau, a chemist and politician, was asked to find a safer alternative by the French government. In 1782 he reported that a lab technician by the name of Courtois was synthesising a white called zinc oxide at the Dijon Academy. But although it wasn't toxic and didn't darken when exposed to sulphurous gases, it was less opaque, dried slowly in oils and, most importantly, was about four times the price of lead white. It was also brittle - the fine tracery of cracks in many paintings of the era can be laid at its door. (Winsor & Newton did introduce it as a watercolour pigment in 1834 - under the name Chinese White, to make it sound exotic - but it didn't take off. Of 46 English watercolourists questioned in 1888, only 12 admitted to having used it.)1 A third metal-based white was more successful. Titanium white, first mass-produced in 1916, was both brighter and more opaque than its rivals and by the end of the Second World War it had conquered 80% of the market.2 Now, everything from the markings on tennis courts to pills and toothpaste uses this sparkling pigment, while its older sibling languishes on the sidelines.

White has long been intricately connected with money and power. Fabrics, including wool and cotton, had to be heavily processed in order to appear white. Only the very wealthy, supported by battalions of staff, could afford to keep the fresh lace and linen cuffs, ruffs and cravats worn in the sixteenth, seventeenth and eighteenth centuries pristine. This connection still holds true. Someone wearing a snow-pale winter coat telegraphs a subtle visual message: 'I do not need to take public transport.' In *Chromophobia* David Batchelor describes going to the house of a rich art collector that had been decorated entirely in the shade:

There is a kind of white that is more than white, and this was that kind of white. There is a kind of white that repels everything that is inferior to it, and that is almost everything... This white was aggressively white.³

As he points out later in the book, it is not shades of white that are the problem, but white in the abstract, because it is associated with tyrannical labels like 'pure'. Le Corbusier, for example, proclaimed in his 1925 book *L'Art décorative d'aujourd'hui* the Law of Ripolin: all interior walls should be whitewashed [page 52]. This, he argued, would act as a moral and spiritual cleansing for society.⁴

For many, however, white is seen as positive, or as having a transcendent, religious quality. It is the Chinese colour of death and mourning. In the West and Japan, brides wear it because it is a colour symbolic of sexual purity. The Holy Spirit has often been depicted descending onto benighted humanity as a white dove appearing in a rush of pallid golden light. In the early twentieth century, when Kazimir Malevich was completing his *White on White* series, he wrote:

[T]he blue of the sky has been defeated by the supremacist system, has been broken through and entered white, as the true, real conception of infinity, and thus liberated from the colour background of the sky... Sail forth! The white, free chasm, infinity, is before us.

High-end modernists and minimalists, from Tadao Ando, the famous Japanese architect, to Calvin Klein and Jonathan Ive at Apple, have drawn on white's power and hauteur. (Steve Jobs was initially against the tide of white products that Ive began producing around the turn of the millennium. He eventually agreed to the signature headphones and keyboard in 'Moon Gray' plastic.

We think of them as white; technically, however, they are very pale grey.) And despite, or perhaps because, white so readily shows the dirt, it has also become associated with cleanliness. White goods', tablecloths and lab coats are all defiant in their spotless impracticality, daring users to even think about spilling anything. American dentists complain that in a quest for teeth that appear sparkling clean, customers are now asking for teeth to be bleached so unrealistically white that whole new teeth-whitening palettes have had to be produced.

The foundations of the architectural idolisation of white are built on a mistake. For centuries the bleachedbone colour of classical Greek and Roman ruins provided the keystone for Western aesthetics. The inheritance of Andrea Palladio – the sixteenth-century Venetian architect who repopularised supposedly classical concepts – and his Palladian successors can be seen in every grand building in every major city in the West. It was not until the mid-nineteenth century that researchers discovered that classical statuary and buildings were usually brightly painted. Many Western aesthetes refused to believe it. The sculptor Auguste Rodin is said to have beat his chest in sorrow and said: 'I feel it here that they were never coloured.'8

Lead white

Today the tombs of the rulers of the Goguryeo region lie inconveniently over the border between North Korea and China. They were a tough people: the Goguryeo, one of the Three Kingdoms of Korea, resisted the vast armies of its northern neighbours to rule over the peninsula and some of southern Manchuria from the first century BC until the seventh century. But the occupant of Anak Tomb no. 3. depicted in a giant portrait on the wall, doesn't look very warlike at all. In the fine-lined mural, he sits cross-legged in a litter wearing a dark robe decorated with bright red ribbons, an outfit that precisely matches the litter's drapes. His expression is benign to the point of looking slightly tipsy: his lips curve up under a curlicue moustache and his eyes are bright and a little unfocused. What is really remarkable, though, is how fresh his image remains after sixteen centuries in damp tomb air. The secret to his longevity lies in the paint used by the artist as the base layer to prime the cave wall: lead white.1

Lead white is a basic lead carbonate with a crystalline molecular structure. It is thick, opaque and heavy, and there is strong evidence that it was being manufactured in Anatolia from around 2300 BC.2 It has remained in production the world over ever since, using roughly the same method described by Pliny the Elder 2,000 years ago. Strips of lead were placed in a compartment inside a specially designed clay pot that was divided into two. Vinegar was poured into the other half, then the pots were surrounded with animal dung and placed inside a shed with a tightly fitting door for 30 days. During that time, a relatively simple chemical reaction would take place. Fumes from the vinegar reacted with the lead to form lead acetate; as the dung fermented it let off CO², which, in turn, reacted with the acetate, turning it into carbonate (a similar process is used when making verdigris [page 214]).

Lead white, continued.

After a month some poor soul was sent into the stench to fetch the pieces of lead, by now covered in a puff-pastry-like layer of white lead carbonate, which was ready to be powdered, formed into patties and sold.

The resulting pigment was tremendously versatile. It was used in the enamel on ceramic dishes and bathroom fittings, in house paints and wallpapers well into the twentieth century. Artists liked it because it was so opaque and adhered well to almost any surface, and, later, because it could work in oils (if the proportions of the mixture were right). It was also cheap - a key concern for any self respecting artist. In 1471, when the well-known Florentine muralist Neri di Bicci was buying some pigments in his home town, he paid two and a half times as much for a good azurite as for verde azzurro (probably malachite); giallo tedescho (lead-tin yellow, page 69) was one-tenth of the price of the azurite; while lead white was a mere hundredth of the cost.3 Artists were so generous with their use of lead white that, today, when paintings are X-rayed, its dense outline can form a kind of skeleton within a painting. allowing technicians to see alterations and later additions.

Lead white, however, had a deadly flaw. Writing in the Royal Society's *Philosophical Transactions* journal in the winter of 1678, Sir Philiberto Vernatti described the fate of those involved in the production of white lead:

The Accidents to the Workmen are, Immediate pain in the Stomack, with exceeding Contorsions in the Guts and Costiveness that yields not to Catharticks... It brings them also to acute Fevers, and great Asthma's or Shortness of Breath... Next, a Vertigo, or dizziness in the Head, with continual great pain in the Brows, Blindness, Stupidity; and Paralytick Affections; loss of appetite, Sickness and frequent Vomitings, generally of sincere Phlegm, sometimes mixed with Choler, to the extreamest weakning of the Body.⁴

Lead poisoning was not a newly witnessed phenomenon, either. Nicander, a Greek poet and physician, describing the symptoms in the early second century BC condemned 'the hateful brew . . . whose fresh colour is like milk which foams all over when you milk it rich in the spring-time'.

It wasn't just those grinding and producing the pigment that began showing the effects of lead poisoning. White lead had long been used as a cosmetic to make skin look smooth and pale. Xenophon wrote disapprovingly of women wearing a 'plaster of ceruse (white lead) and minium (red lead)' [page 107] in Greece during the fourth century BC and there is evidence that their contemporaries in China were mixing a similar brew with rice powder to use as a foundation.⁵ Japanese archaeologists and professors are still discussing the role that poisonous make-up may have played in undermining the Shogun regime, which collapsed after nearly 300 years in power in 1868. Some scholars argue that breastfeeding infants were ingesting lead worn by their mothers; bone samples show that the skeletons of children under the age of three contain over 50 times more lead than those of their parents. Yet cosmetic ceruse or 'Spirits of Saturn' essentially a white-lead paste mixed with vinegar – remained alarmingly popular for centuries. While at least one sixteenth-century writer was already warning that it made the skin 'withered and grey', 7 women in Queen Elizabeth's court were painting blue veins over its parchment-pale base layer. In the nineteenth century ladies could still buy any number of lead-based skin brighteners with names like 'Laird's Bloom of Youth', 'Eugenie's Favourite', or 'Ali Ahmed's Treasure of the Desert', even after well-publicised deaths, including that of the British society beauty Maria, the Countess of Coventry. Maria, a rather vain woman, who was known to be rather too

Lead white, continued.

heavy a user of white-lead foundation, died in 1760, aged just 27.8

The irony of generations of women slowly killing themselves in an effort to look their best is of the darkest kind. Lead white may have helped the painted occupant of the Goguryeo tomb remain fresh, but then he was already dead. The pigment has seldom been a friend to the living.

Ivory

In 1831, a farmer on the Isle of Lewis, in the Outer Hebrides, discovered treasure that had been hidden in a small stone chamber in a sandbank for 700 years. The horde consisted of 78 chess pieces from different sets, 14 pieces for a game similar to backgammon, and a belt buckle.¹

The Lewis Chessmen, as they are now known, are mysterious. No one knows who made them, or how they came to be hidden on an obscure island.

Each piece is a unique Romanesque sculpture, oozing expressive charm. One of the queens has a hand resting on her cheek, in dismay or in concentration; several of the rooks are biting their shields, and another looks nervously to the left, as if he's just heard an unexpected sound. Each figure sports a subtly different hairstyle, and their clothes hang in stylised rumpled folds. They look as though they could be conjured to life and this is precisely what happened in their recent star turn as models for the wizards' chess set in the first Harry Potter film. They were probably carved from walrus ivory (called 'fish teeth' in Icelandic sagas), in Trondheim in Norway between 1150 and 1200. And while traces remain of the red some of the pieces were originally painted with, the colour has worn away to reveal the natural colour of the ivory itself.²

Ivory, whether sourced from walruses, narwhals or elephants, has long been prized. And when elephant hunts became a status symbol, ivory only grew in prestige. The colour profited by association. Western wedding dresses were generally colourful until Queen Victoria wore ivory satin trimmed with British lace in 1840. Many brides eagerly followed suit. The September 1889 issue of *Harper's Basaar* recommended 'Ivory white satin and lampas [a type of woven fabric] . . . for autumn weddings'. Now it is more common than ever; the Sarah Burton-designed wedding dress worn by the Duchess of Cambridge was made of ivory duchess satin.

Ivory, continued.

Ivory itself was used for thousands of years to make costly decorative items, like the Lewis Chessmen, combs and brush handles. Later it was used for piano keys, ornaments and pool balls. Chinese craftsmen use it to make impossibly intricate sculptures, complete with trees, temples and figures, which can sell for thousands of dollars. So fierce did demand become that by 1913 America alone was consuming around 200 tonnes of ivory annually. Because of their value, elephant tusks were called 'white gold' and walrus tusks, 'Arctic gold'.³

Demand for ivory took an inevitable toll on the animals supplying it. In 1800 there were an estimated 26 million elephants; before 1914 there were 10 million; by 1979, 1.3 million. A decade later, when the trade was finally banned in the West, 600,000 remained.⁴

Demand remains enormous, particularly in China and Thailand. Illegal poaching is rife, and seems to be accelerating. It has been estimated that in the three years to 2014 around 100,000 elephants were killed for their ivory, and around 25,000 more tusk-less carcasses are found each year. At this rate, the elephant could be extinct in the wild within a decade or so, walruses too are on the endagered spieces list.

A bizarre addition to the trade comes from an animal that became extinct nine thousand years before the Lewis chessmen were carved. As the glaciers and icebergs melt across the Arctic tundra, woolly mammoth carcasses have emerged in their thousands. Exact figures are hard to come by – so much of the trade in ivory is conducted on the black market – but it has been estimated that over half of China's current supply of ivory may have come from woolly mammoth tusks. In 2015 a single carved tusk weighing 90 kg was sold in Hong Kong for \$3.5 million.

Silver

It is not unusual for mountains to attract legends, but few are as rich in lore as Cerro Rico de Potosì, a soaring red peak in Bolivia. It isn't its size that attracts attention – at just under 16,000 feet it is far from the largest mountain in the Andes – but what it contains. From root to summit, Cerro Rico is riddled with silver mines. According to tradition, its secret was discovered by a poor local man. While out searching for a lost llama in January 1545, Diego Huallpa built a fire to keep the chill of the alpine night at bay. As the fire burned, the ground beneath it began to ooze liquid silver, like blood from a wound.

Owing to its value as a precious metal, silver has long held an important position in human culture and we have never stopped seeking it out and finding uses for it. In the twentieth century it was used to evoke the future, space travel and progress. From the shiny, zipped-up suits of the 'Mercury 7', the world's first space crew, to Paco Rabanne's metal minidresses and André Courèges' foil fashion in the 1960s, it seemed that silver was the colour we would all be wearing once we'd become accustomed to zero gravity.

But it has symbolic affiliations with old-fashioned superstitions as well as an imagined future. In Scottish folklore a silver branch, covered with white blossom or bearing silver apples, could act as a kind of passport into the fairy otherworld. The metal was also thought to be able to detect poisons, changing colour if it came into contact with one. This belief became so widespread that silver tableware became fashionable and then the standard. The first recorded appearance of the silver bullet being used to dispatch the forces of evil is from the mid-seventeenth century, when the town of Greifswald in north-eastern Germany became all but overrun with werewolves. As the population dwindled it seemed as if the

Silver, continued.

entire town might have to be abandoned, until a group of students made little musket balls from the precious metal. Silver is now firmly embedded in the semiotics of horror movies, effective against all manner of beings, from werewolves to vampires.²

Perhaps such superstitions stem from silver's link with the night. While its more illustrious sibling gold [page 86] is traditionally twinned with the Sun, silver is equated with the Moon. As a partnership this makes a great deal of sense. Silver also waxes and wanes in alternate cycles of polishing and tarnishing. One minute it is bright and reflective, the next it is eclipsed by a black film of silver sulphide. There is something in this imperfection that makes it more human: it seems to have a life cycle and, just as we die, so its brilliance dies a little too.³

Although the metal occurs naturally – finding a piece glinting in the dirt must seem like finding a gift from the Earth itself – it is more frequently mixed with other elements in subtly sheened ores and alloys, and must be extracted by smelting. In Egypt, silver beads and other small objects have been found that date back to the Neolithic era, and these became more common in the twentieth and nineteenth centuries BC. 4 One Egyptian archaeological hoard contained 153 silver vessels, 9 kg of the metal in all.5 It has been used ever since in jewellery, medals, decorative elements on clothes and coins.

It was silver mined in South and Central America that allowed the Spanish empire to flourish for nearly five hundred years. (The Spanish even named a country after it: Argentina's name is derived from the Latin *argentum*, meaning silvery.) Between the sixteenth and eighteenth centuries the conquistadors exported around 150,000 tonnes of the metal. This accounted for around 80% of the world's supply, and funded a series of wars and further

conquests, both colonial and against European rivals. To extract silver ore from Cerro Rico, one of the two most profitable mines in their empire, the Spanish exploited indigenous labour. Using a version of the *mita* forced-labour system the Inca had used to build temples and roads, the Spanish insisted locals over the age of 18 put in a year's work for subsistence wages. Accidents and mercury poisoning were common. The Spanish boasted that with the silver extracted from Cerro Rico, they could have built a bridge across the Atlantic back to their homeland, and still have had silver to carry across it. For the locals, Cerro Rico had a rather different reputation. To them, it was 'the mountain that eats men'.

Whitewash

In May 1894, fear swept through the narrow streets of Hong Kong. Plague. The disease, in its third and final grand pandemic, had been spreading sporadically through mainland China for forty years before materialising on the island. There was no mistaking the symptoms: first, flu-like chills and fever, then headaches and muscle pain. The tongue would swell and become covered with a pale fur. The appetite would disappear. Vomiting and diarrhoea – often bloody – would swiftly follow and, most tellingly, smooth, painful swellings would develop in the lymph nodes in the groin, neck or armpits. Death was common, and agonising.

With the precise cause and even the means of transmission still unknown, those fighting the disease despaired of staunching its course. Volunteers desperately searched back alleys for bodies, tended the sick in swiftly erected, camp-like isolation hospitals, and began furiously whitewashing the streets and houses in the infected areas.³

Whitewash is the cheapest of paints, made from a mixture of lime (crushed and heated limestone) and calcium chloride or salt, combined with water. In 1848, when Britain was battling waves of influenza and typhus, it was estimated that using it to paint a whole tenement, inside and out, would cost seven pennies, five and a half without labour.4 Whitewash does the job, but not well: it flakes and has to be reapplied each year and, if the proportions of the constituent ingredients are not quite right, it can transfer onto clothes. Its disinfectant qualities mean that it has always been popular with dairy farmers, who coat the interiors of their barns and sheds with it. The saying 'Too proud to whitewash and too poor to paint', a phrase usually associated with poverty-riddled Kentucky, gives a good impression of the medium's social standing. Its literary star turn is as a foil for the cunning

of the eponymous hero of Mark Twain's *The Adventures of Tom Sawyer*, originally published in 1876. After becoming very dirty in a fight, Tom's Aunt Polly orders him to daub 'Thirty yards of board fence nine feet high':

Sighing he dipped his brush and passed it along the topmost plank; repeated the operation; did it again; compared the insignificant whitewashed streak with the far-reaching continent of unwhitewashed fence, and sat down on a tree-box discouraged.⁵

Tom, of course, manages to trick friends into finishing the job, but the symbolism of his punishment is telling.

Aunt Polly was not the first to use whitewash to retaliate against perceived sin. During the English Reformation, churches and parishioners used it to obscure colourful murals and altarpieces that depicted saints in ways they now deemed impious. (Over the years, as the paint wore thin, the faces began peeking through again.) This practice perhaps explains the origin of the phrase 'to whitewash', which means to conceal unpleasant truths, usually political in nature.

For those engaged in fighting epidemics, though, blotting out the pestilence using a pail of milky, disinfectant lime must have been profoundly comforting, even ritualistic. Is it a coincidence that it was around this time that white coats were adopted by doctors, and would become a visual symbol of the medical profession?

Isabelline

Isabella Clara Eugenia was, by the standards of her day, exceedingly beautiful. Like her English near contemporary, Queen Elizabeth I, she was very pale, with fine, marmalade-coloured hair, only the merest suggestion of the Habsburg lip and a high, wide forehead. She was also powerful, ruling a large tract of northern Europe called the Spanish Netherlands. This makes it seem all the more unfair that her namesake in the colour world is a dingy yellow-white. As the author of *A History of Handmade Lace* described it in 1900: 'a greyish coffee colour, or in plain English, the colour of dirt'.²

The story goes that in 1601 Isabella's husband, Archduke Albert VII of Austria, began the siege of Ostend. Isabella, believing the siege would be short-lived, vowed she would not change or wash her underwear until he won. Isabelline is the colour the queen's linens had become when the siege finally ended three years later.³ Luckily for the poor queen, proof that this story is nonsense isn't difficult to find. The tale only appeared in print in the nineteenth century – an aeon in Chinese-whisper years – and two exculpatory dresses in the hue crop up in the wardrobe of Queen Elizabeth I. Inventories, one taken a year before the start of the siege, show she owned both an isabelline kirtell (a long dress or tunic; she had 126 in total) and a 'rounde gowne of Isabella-colour satten . . . set with silver spangles'.⁴

Mud, however, sticks, so despite royal endorsement, the colour's fashionable career was short-lived. But it has managed to carve out another niche in the natural sciences, particularly in descriptions of animals. Pale palomino horses and Himalayan brown bears are isabelline, and there are several species of bird, including the *Oenanthe isabellina* or isabelline wheatear, that owe their names to the colour of their pale dun plumage.

'Isabellinism' is also the name of a genetic mutation that renders feathers that ought to be black, grey or dark brown a pallid yellowish colour instead. A handful of the king penguins on Marion Island in the Antarctic make up one prominent group of sufferers. Among the huddled ranks on the island, the wan mutants are the highly visible odd men out, the weaklings, and anyone who has ever watched natural-history documentaries knows what usually happens to them. A dubious legacy indeed for the poor Archduchess Isabella.

Chalk

If you were to view a minute paint sample from an Old Master painting under a microscope, you would likely see something wholly unexpected and far older than the paint itself: nannofossils, the ancient remains of one-celled sea creatures called coccolithophores. How on earth did they get there? Chalk.

Chalk is formed from marine ooze, largely consisting of single-celled algae, that formed a sediment on the ocean floor and was then compounded over millions of years to create a soft, calcium carbonate rock.¹ There is a vast deposit over the south and east of England – responsible for the white cliffs of Dover – and north-western Europe. It is quarried in great blocks that are left to weather, which helps to separate out any chips of flint. The stone is then ground under water, washed and left to settle in large vats. When drained and dried, the chalk is separated into layers. The top layer, the finest and whitest, is sold as Paris white; the one beneath, slightly less fine, is extra gilder's white. Both are used as artists' pigments. The coarsest grade used in cheaper paints and building materials, is sold as commercial white.²

The chemist and colourist George Field was rather sniffy about chalk. It is 'used by the artist only as a crayon', he wrote in his *Chromatography* of 1835.³ Others were less supercilious. Arnold Houbraken, a Dutch artist and biographer, wrote in 1718: 'It is said that Rembrandt once painted a picture in which the colours were so heavily loaded that you could lift it from the floor by the nose.' This was thanks to the chalk, which the artist used to make his paints go further, to thicken them so that they stood off the canvas, and to make glazing layers more transparent – because it has a low refractive index, chalk is almost completely translucent in oils. It was also frequently used as the base layer either by itself

or as part of a gesso mixture, a kind of plaster of Paris. Although the grounds were hidden underneath the finished product, they helped ensure the artwork, particularly murals, did not degrade so fast the patron could demand their money back. The fifteenth-century writer Cennino Cennini dedicates many pages of his *Il libro dell'arte* to lovingly detailing the preparation of different grades of gesso. One, *gesso sottile*, took over a month of daily stirrings to prepare, but, as he assured his readers, the effort was well worth it: 'it will come out as soft as silk'.

Even without such loving preparation, chalk has a long history of use in art. The Uffington White Horse, for example, is one of the stylised chalk figures created in Europe during the Late Bronze Age. It still prances high on a hillside on the edge of the Berkshire Downs in southern England. Amid fears that it might be used for target practice by the Luftwaffe, the horse was covered up during the Second World War. When the war was over, William Francis Grimes, a Welsh archaeology professor, was charged with disinterring it.8 Grimes had believed, as many still do, that the figure was carved directly into the hillside. Instead he discovered that it had been painstakingly constructed by cutting shallow trenches and filling them with chalk. (This had actually been described in great detail by Daniel Defoe in the seventeenth century, but everyone had ignored him.)9

There is much that is still unknown about the White Horse. Why, for example, did the people who made it go to so much trouble to do so? And why, whilst so much else has changed, has it been 'scoured', or cleaned and rechalked, by the local population at least once every generation in the intervening three millennia?¹⁰ Microscopes may have revealed the preferred fundament of the Old Masters, but chalk still has hidden depths.

Beige

Dulux sells a Brobdingnagian array of paint colours to its non-trade customers. Beige lovers riffling through the thick colour-card wads are in for a treat. If 'Rope Swing', 'Leather Satchel', 'Evening Barley' or 'Ancient Artefact' don't appeal, 'Brushed Fossil', 'Natural Hessian', 'Trench Coat', 'Nordic Sails', or any of several hundred others may well do. Those who are in a rush, however, and who don't want to trawl through lists of evocative names, may find themselves a little stuck: not one of these pale yellow-greys is actually called 'beige'.

Is this because the word, with its glutinous-vowelled centre, is unappealing? (Marketers have an ear for that kind of thing.) The word was loaned in the mid-nineteenth century from French, where it referred to a kind of cloth made from undyed sheep's wool. As has often happened, 'beige' attached itself to the colour too. It rarely seems to have incited strong passions. It was mentioned in *London Society* magazine as being in vogue in the late autumn of 1889, though this was only because it 'combines pleasantly with the fashionable tones of brown and gold'. Nowadays it is rarely mentioned in fashion, having been cast aside by more glamorous synonyms.

It was the favourite tint of Elsie de Wolfe, the 1920s interior designer who is credited with inventing the profession. Upon seeing the Parthenon in Athens for the first time, she was enchanted, exclaiming: 'It's beige! My colour!' But while she was clearly not alone – it crops up in many of the twentieth century's key palettes – beige has chiefly been used as a foil for colours with more character.² When two scientists surveyed over 200,000 galaxies and discovered that the universe, taken as a whole, is a shade of beige, they immediately sought a sexier name. Suggestions included 'big bang buff' and 'skyvory', but in the end they settled on 'cosmic latte'.3

There is the nub of beige's image problem: it is unassuming and safe, but deeply dull. Anyone who has ever spent any time visiting rental properties soon comes to loathe it - a few hours in and all the properties seem to be merging together into a sea of determined inoffensiveness. A recent book about how best to sell your home goes so far as to advise against it completely. The chapter on colour opens with a diatribe against its tyrannical hold over the property market. 'It seems,' the author concludes, 'that somehow beige is interpreted as a neutral - an ambiguous colour that everyone will like.'4 In fact the situation is even worse than that: the hope is not that everyone will *like* it, but that it won't offend anyone. It could be the concept-colour of the bourgeoisie: conventional, sanctimonious and materialistic. It seems strangely apposite, then, that beige has evolved from being sheep-coloured to being the colour adopted by the sheep-like. Is any other hue so redolent of our flock instincts for tasteful, bland consumerism? No wonder Dulux's colour-namers wanted to shun it: beige is boring.

Blonde
Lead-tin yellow
Indian yellow
Acid yellow
Naples yellow
Chrome yellow
Gamboge
Orpiment
Imperial yellow
Gold

Yellow

Oscar Wilde was arrested outside the Cadogan Hotel in London in April 1895. The following day the *Westminster Gazette* ran the headline: 'Arrest of Oscar Wilde, Yellow Book Under his Arm'. Wilde would be found officially guilty of gross indecency in court a little over a month later, by which time the court of public opinion had long since hanged him. What decent man would be seen openly walking the streets with a yellow book?

The sinful implications of such books had come from France where, from the mid-nineteenth century, sensationalist literature had been not-so-chastely pressed between vivid yellow covers. Publishers adopted this as a useful marketing tool, and soon yellow-backed books could be bought cheaply at every railway station. As early as 1846 the American author Edgar Allan Poe was scornfully writing of the 'eternal insignificance of yellowbacked pamphleteering'. For others, the sunny covers were symbols of modernity and the aesthetic and decadent movements.1 Yellow books show up in two of Vincent van Gogh's paintings from the 1880s, Still Life with Bible and, heaped in invitingly dishevelled piles, Parisian Novels. For Van Gogh and many other artists and thinkers of the time, the colour itself came to stand as the symbol of the age and their rejection of repressed Victorian values. 'The Boom in Yellow', an essay published in the late 1890s by Richard Le Gallienne, expends 2,000 words proselytising on its behalf. 'Till one comes to think of it,' he writes, 'one hardly realises how many important and pleasant things in life are yellow.' He was persuasive: the final decade of the nineteenth century later became known as the 'Yellow Nineties'.

Traditionalists were less impressed. These yellow books gave off a strong whiff of transgression, and the avant-garde did little to calm their fears (for them the transgression was

half the point). In Wilde's *The Picture of Dorian Gray*, published in 1890, it is down the moral rabbit hole of such a novel that the eponymous antihero disappears, never to return. Just as the narrator reaches his defining ethical crossroads, a friend gives him a yellow-bound book, which opens his eyes to 'the sins of the world', corrupting and ultimately destroying him. Capitalising on the association, the scandalous, avant-garde periodical The Yellow Book was launched in April 1894.2 Holbrook Jackson, a contemporary journalist, wrote that it 'was newness in excelsis: novelty naked and unashamed . . . vellow became the colour of the hour'. 3 After Wilde's arrest a mob stormed the publishers' offices on Vigo Street, believing they were responsible for the 'yellow book' mentioned by the Gazette.4 In fact, Wilde had been carrying a copy of Aphrodite by Pierre Louys and had never even contributed to the publication. The magazine's art director and illustrator Aubrey Beardsley had barred Wilde after an argument – he responded by calling the periodical 'dull', and 'not vellow at all'.

Wilde's conviction (and the failure soon after of *The Yellow Book*) was not the first time the colour had been associated with contamination, and was far from the last. Artists, for example, had numerous difficulties with it. Two pigments they relied on, orpiment [page 82] and gamboge [page 80], were highly poisonous. It was assumed Naples yellow [page 76] came from Mount Vesuvius's sulphurous orifice well into the mid-twentieth century, and often turned black when used as a paint; gallstone yellow was made from ox gallstones, crushed and ground in gum water; and Indian yellow [page 71] was probably made from urine.⁵

In individuals, the colour betokens illness: think of sallow skin, jaundice or a bilious attack. When applied to

mass phenomena or groups the connotations are worse still. Hitched to 'journalism' it indicates rash sensationalism. The flow of immigrants into Europe and North America from the East and particularly China in the early twentieth century was dubbed the 'yellow peril'. Contemporary accounts and images showed an unsuspecting West engulfed by a subhuman horde – Jack London called them the 'chattering yellow populace'. And while the star the Nazis forced Jews to wear is the most notorious example of yellow as a symbol of stigma, other marginalised groups had been forced to wear yellow clothes or signs from the early Middle Ages.

Perversely, though, yellow has simultaneously been a colour of value and beauty. In the West, for example, blonde hair [page 67] has long been held up as the ideal. Economists have shown that pale-haired prostitutes can demand a premium, and there are far more blondes in advertisements than is representative of their distribution among the population at large. Although in China 'yellow' printed materials like books and images are often pornographic, a particular egg-volk shade [page 84] was the favoured colour of their emperors. A text from the beginning of the Tang dynasty (AD 618–907), expressly forbids 'common people and officials' from wearing 'clothes or accessories in reddish yellow', and royal palaces were marked out by their yellow roofs.7 In India the colour's power is more spiritual than temporal. It is symbolic of peace and knowledge, and is particularly associated with Krishna, who is generally depicted wearing a vivid yellow robe over his smoke-blue skin. The art historian and author B. N. Goswamy has described it as 'the rich luminous colour [that] holds things together, lifts the spirit and raises visions'.8

It is perhaps in its metallic incarnation, however, that

yellow has been most coveted. Alchemists slaved for centuries to transmute other metals into gold, and recipes for counterfeiting the stuff are legion. Places of worship have made use of both its seemingly eternal high sheen and material worth to inspire awe among their congregations. Medieval and early modern craftsmen, known as goldbeaters, were required to hammer golden coins into sheets as fine as cobwebs, which could be used to gild the backgrounds of paintings, a highly specialised and costly business.

Although coinage has lost its link with the gold standard, awards and medals are still usually gold (or gold-plated) and the colour's symbolic value has left its mark on language too: we talk of golden ages, golden boys and girls and, in business, golden handshakes or goodbyes. In India, where gold is often part of dowries and has traditionally been used by the poor instead of a savings account, government attempts to stop people hoarding it have resulted in a healthy black market and an inventive line in smuggling. In November 2013, 24 gleaming bars, worth over \$1 million, were found stuffed into an aeroplane toilet. Le Gallienne noted in his essay that 'yellow leads a roving, versatile life' – it is hard to disagree, even if this is probably not what the writer had in mind.

Blonde

Rosalie Duthé, the first person known as a dumb blonde,

was born in France in the mid-eighteenth century. Famously beautiful, even as a child, she was sent to a convent by her parents to keep her out of trouble. Before long, however, she somehow caught the eye of a rich English financier, the 3rd Earl of Egremont, and fled the convent under his protection. When his money ran out she became a courtesan as notorious for her stupidity as for her willingness to pose for nude portraits. In June 1775 she found herself skewered at the Theatre de l'Ambigu in Paris in a one-act satire called *Les Curiosités de la foire*. After seeing the performance, Rosalie was so mortified she is said to have offered a kiss to anyone who could restore her honour, but no one did.1

Although probably more fact than fiction, the legend of Rosalie illustrates the way that blondes, like most minorities – it has been estimated just two per cent of the world's population is naturally blonde – are both reviled and revered by society. In the mid-twentieth century, Nazis held up the ideal of the blue-eyed, pale-haired Aryan as the apogee of humanity. A chilling exhibit in the Stadtmuseum in Munich contains a hair-colour chart, employed in one of the tests designed to help identify those with the Aryan physical characteristics the Führer wanted to propagate in his master race.

Blondes, particularly women, are often associated with lust. In ancient Greece, high-class prostitutes – *hetairai* – bleached their hair using noxious mixtures like potash water and the juice of yellow flowers.² Roman prostitutes were also said to dye their hair pale or wear blonde wigs.³ More recently, a 2014 survey of the prices that female prostitutes charged per hour worldwide showed that those with natural, or natural-looking, blonde hair, could command far more than those with any other hair colour.⁴

Blonde, continued.

In paintings of the Fall, Eve, the Bible's original sinner, is more often than not depicted with flowing golden locks that conceal nothing; her counterpoint, the Virgin Mary, is usually a brunette, swaddled from throat to toe in rich fabric [page 182]. John Milton drew heavily on this symbolism in *Paradise Lost*, published in 1667. Eve's 'unadornèd golden tresses' lie in 'wanton ringlets', echoing the coils of the serpent lying in wait nearby.

Anita Loos, an American scriptwriter born in 1889, wasn't a fan of blondes either. It was a blonde who had stolen the journalist and intellectual Henry Mencken from under her nose. Her revenge came in the form of a magazine column, which became a novel in 1925, then a stage show, and finally the film starring Marilyn Monroe in 1953. The plot is simple: eye-catching Lorelei Lee, anti-heroine of Gentlemen Prefer Blondes, blunders from one millionaire to the next. Although she is no fool when it comes to financial gain - 'I can be smart when it's important,' she says, eyeing up a diamond tiara - she is decidedly bird-brained when it comes to everything else. On board the boat to Europe, she seems uninformed about the birds and the bees: 'most of the sailors seem to have orphans which they get from going on the ocean when the sea is very rough'.5

Goddesses, fairy-tale heroes and heroines, and models are disproportionately fair-haired. Blonde waitresses have been shown to get bigger tips. And for those not lucky enough to have been born with the requisite A (adenine) in place of a G (guanine) in chromosome 12, there is always hair dye. As the coiffed lady from Clairol's 1960s hair advertisements said, If I have only one life, let me live it as a blonde.

Lead-tin yellow

There are many art world mysteries: the identity of

Vermeer's *Girl with the Pearl Earring*; the whereabouts of Caravaggio's *Nativity with St Francis and St Lawrence* [page 250]; who pulled off the 1990 Isabella Stewart Gardner Museum heist, to name but a few. One that has attracted little popular attention, and has yet to be completely solved, is the curious case of the yellow that vanished.

Peter Paul Rubens and Isabella Brant were married in St Michael's Abbey in Antwerp on 3 October 1609. Isabella was the daughter of Jan Brant, an important citizen; Rubens had just returned from a fruitful eight-year stay in Italy, honing his skill as an artist. He had a large workshop in Antwerp, and had just been appointed as a court painter. The double portrait Rubens painted of himself and his new wife brims with love and confidence. Isabella wears a dashing straw hat, a large ruff and a long stomacher embroidered with yellow flowers; Rubens – his right hand clasping his wife's, his left fingering the hilt of a sword – wears a rich doublet with sleeves of yellow and blue shot silk, and a slightly whimsical pair of grapefruit-coloured hose. The pigment Rubens used for all these symbolic golden-yellow touches was lead-tin yellow.¹

He was far from alone in his reliance on this colour: it was the key yellow from the fifteenth to the mideighteenth century. It first crops up around 1300, later appearing in Florence in paintings ascribed to Giotto, and then in the works of Titian, Tintoretto and Rembrandt.² From around 1750, however, and for no obvious reason, use of the pigment began to peter out and it doesn't appear at all in nineteenth- or twentieth-century works. More intriguing still, before 1941 no one even knew that it existed.³

Part of the reason for this is that the pigment we now

Lead-tin yellow, continued.

call lead-tin yellow wasn't known by any one name. To Italians, it was usually known as *giallorino* or *giallolino*; in Northern European sources it was at times known as massicot, at others *genuli* or *plygal*. Perplexingly, these terms were also sometimes used for other pigments, like Naples yellow [page 76]. To add to the confusion, another lead-based yellow, lead oxide (PbO), was also known as *massicot*. Another reason it slipped beneath art historians' radars for so long is that, until the twentieth century, the tests available to restorers and researchers did not allow them to identify all the ingredients in a paint. If they found lead in a yellow paint they assumed it was Naples yellow.

We owe our knowledge of lead-tin vellow's existence to Richard Jacobi, a researcher in the Doerner-Institute in Munich. While doing some research in around 1940, he repeatedly found tin in yellow samples from various paintings.6 Intrigued, he began experimenting to see if he could create this mysterious yellow pigment himself. He found that by heating three parts of lead monoxide with one part tin dioxide a yellow began to form.7 If the mixture was heated between 650 and 700 °C the compound produced was more ruddy; between 720 and 800 °C it was more lemony. The end product was a heavy yellow powder, very opaque in oils and stable, unaffected by exposure to light. As an added bonus it was, like lead white [page 43], both cheap to produce and accelerated the drying of oil paint.8 When Jacobi published his findings in 1941 the art world was dumbfounded. As with all good riddles, however, many questions remain. How and why was the secret of its manufacture lost? Why did artists begin using Naples yellow instead, which even its admirers admitted had many flaws? Answers remain elusive, but that this was the yellow of the Old Masters is beyond doubt.

Indian yellow

For all its sunny brightness, Indian yellow has an obscure history. Although many Indian painters, particularly from the Rajasthani and Pahari traditions, used this pigment in the seventeenth and eighteenth centuries, no one is quite sure where it came from or why its use died out. For Westerners, this pigment, like gamboge [page 80], which it closely resembled, was a product of trade and empire. It began making its way to Europe from the East in the late 1700s, in the form of powdery balls of a rotten mustard colour, with yolk-bright centres and a distinctive telltale reek of ammonia. So strong was its scent that recipients – colourmen like George Field and Messrs Winsor and Newton – would have been able to guess the contents of the packages the moment they began unwrapping them.

While the French colourman Jean François Léonor Mérimée admitted that the odour was very much like that of urine, he stopped short of making a definitive connection.3 Others were less delicate. The New Pocket Cyclopædia of 1813 ventured that it '[is] said to be an animal secretion'.4 An acquaintance of the English artist Roger Dewhurst told him in the 1780s that Indian yellow was possibly made from animals' piss and strongly advised that the pigment be diligently washed before use.5 George Field was less circumspect: '[It] is produced from the urine of the camel.' But even he wasn't completely sure: 'It has also been ascribed, in like manner, to the buffalo, or Indian cow.'6 In the 1880s Sir Joseph Hooker, the great peppery Victorian explorer and botanist, decided he needed a more definite answer to the riddle of Indian vellow and its peculiar smell. Busily engaged as he was in his role as director of Kew Gardens, Hooker decided to make enquiries.

On 31 January 1883 he dispatched a letter to the India

Indian yellow, continued.

Office. Nine and a half months later, by which time Hooker had no doubt forgotten all about the obscure pigment, he received a reply.7 Half a world away Trailokyanath Mukharji, a 36-year-old civil servant, had seen Hooker's letter and taken decisive action. 'Indian yellow' or piuri, Mr Mukharji informed Hooker, was used in India to paint walls, houses and railings and, very occasionally, to dye clothes (although the smell prevented this latter use from catching on).8 He tracked the mysterious yellow balls to what he said was their sole point of origin: Mirzapur, a tiny suburb of Monghyr, a town in Bengal. There, a small group of gwalas (milkmen) tended a herd of ill-nourished cows they fed only on mango leaves and water. On this diet the cows produced extraordinarily luminous yellow urine - about three quarts per day per cow - which the gwalas collected in small earthen pots. Each night they boiled this down, strained it and rolled the sediment into balls that were gently toasted over a fire and then left to dry out in the sun.9

Hooker forwarded Mr Mukharji's letter to the Royal Society of Arts, who published it in their journal the very same month – but the mystery refused to remain solved. Shortly afterwards, the pigment vanished altogether and, while it was believed that the practice had been outlawed, no record of such laws could be found. Stranger still, contemporary surveys of the region by British officials, detailed enough to note the number of adult cows and the havoc wreaked by syphilis in the nearby town of Shaikpoora, made no mention of these valuable cows or the yellow balls made from the contents of their bladders. Ovictoria Finlay, a British writer, decided to retrace Mr Mukharji's footsteps in 2002 only to draw another blank. None of Mirzapur's modern denizens – including the

local *gwalas* – had the slightest clue what *piuri* was. Perhaps, Finlay mused, Mukharji had been a nationalist, wanting to gently poke fun at the gullible Brits.¹¹

This seems unlikely. Mr Mukharji worked for the Department of Revenue and Agriculture, which, despite its stuffy name, was comparatively progressive in relying on and promoting local Indian professionals. A few months before writing his letter to Hooker he had produced the catalogue for the 1883 Amsterdam Exhibition, and was to do the same for the 1886 Colonial and Indian Exhibition and another held two years later in Glasgow. 12 He also became the assistant curator in the Art and Economics section of London's Indian Museum, and in 1887, donated a collection of nearly one thousand different minerals and botanical samples to the National Museum of Victoria in Australia. He even presented a copy of his book, A Visit to Europe, to Queen Victoria in 1889 - hardly the actions of a hardened nationalist. It may be that even as he wrote up his account of the poor cows and the brilliant vellow pigment made from their urine, he had an inkling that he might not be believed. Perhaps this is why he sent his report off to Sir Joseph with some corroborating evidence: some balls of pigment he had bought from the gwalas, an earthen pot, some mango leaves and a sample of the urine itself, all of which arrived on 22 November 1883. While the urine, pot and leaves have vanished, the pigment, still faintly malodorous, remains in Kew's archive to this day.

Acid yellow

In 2015 the Oxford English Dictionary announced that its word of the year was not, in fact, a word, but an emoji: 'face with tears of joy'. The same year Unicode, an organisation that ensures text (and emojis) are represented consistently across different platforms, announced that people had been using many of these little yellow faces incorrectly for years. The one with a double jet of steam coming out of its nose, for example, commonly used to express fury, was intended to appear triumphant. And Unicode 1F633 ('Flushed Face') was used differently depending on the system: Apple users used it to signal alarm, while the Microsoft version looked 'happy go lucky, but with sheepish eyes'.'

One that seemingly needed no clarification though, was the original smiley. The origins of the crude design a perfect bright yellow circle outlined with black, two small lines for eyes and a semi-circular mouth – are contested. A crude smiley appeared in an American television programme in 1963; two brothers based in Philadelphia printed a similar design on badges, some 50 million of which had been sold by 1972. But during the political upheavals of the 1970s, the childlike smiley was co-opted as a symbol of subversion. By 1988 it was a pop-culture phenomenon, inextricably linked with music and the new club scene. A yellow smiley was used on the UK cover for the Talking Heads' song 'Psycho Killer', on 'Beat Dis' by Bomb the Bass, on an iconic flyer for London's Shroom club and later - with crosses for eyes and a squirming mouth - as an informal logo for the band Nirvana.2 A blood-spattered version was also the primary visual motif of Watchmen, the 1985 dystopian graphic novel by Alan Moore and Dave Gibbons.

Soon the acid yellow of the smiley seeped out to become the signature colour of the dance-happy youth,

euphoric one moment, insidious, chemical and rebellious the next. Rave culture – or rather the drugs that were believed to fuel it – began to cause moral panic. 'Acid' could refer both to the subgenre of house music and LSD, while this bright yellow also evoked the laser light shows of nightclubs.

Although rave culture has come down from its premillennial high, its informal mascot, the seemingly benign acid yellow smiley face, beams on. For a new generation it signals something very different. It is believed that the first emoticon smiley appeared in a bone-dry email about humour from Scott E. Fahlman, a research professor at Carnegie Mellon, sent in 1982: 'I propose . . . the following character sequence for joke markers:-).' From such inauspicious beginnings the emoticon smiley has become intrinsic to modern communication, its subversive traces, for the moment, forgotten.

Naples yellow

Sometime in the early 1970s a collection of 90 small bottles was discovered in an old German pharmacy near Darmstadt. Some were as round and plain as jam jars, others looked like ink wells, and some resembled tiny, stoppered perfume bottles. Each had its own carefully written calligraphy label, but even so it was hard to identify what each contained. The powders, liquids and resins were labelled with words as unfamiliar and outlandish as 'Virid aëris', 'Cudbeard Persia', and 'Gummi gutta'.¹ When examined in a laboratory in Amsterdam, it was discovered that this was in fact a cache of pigments from the nineteenth century. One, bearing the cramped legend 'Neapelgelb Neopolitanische Gelb Verbidung dis Spießglaz, Bleies', was Naples yellow.²

The pigment's owner did not yet know it, but at the time that it had been stashed, Naples yellow's days as an essential part of the artist's palette were numbered. The name properly applies to a synthetic preparation of lead antimonate, which is usually pale yellow with just a suggestion of warm red undertones. The earliest use of the term is thought to be in a Latin fresco treatise written between 1693 and 1700 by Andrea Pozzo, an Italian Jesuit brother and baroque painter. He mentions a yellow pigment, 'luteolum Napolitanum', and either the name stuck or it was already in common use. References to giollolino di Napoli appear more frequently from the beginning of the eighteenth century and the term soon made its way into English.4

Although beloved for its colour, and better behaved than chrome yellow [page 78], Naples yellow was far from being the most stable pigment. George Field approvingly mentioned its 'considerable reputation', opacity and 'pleasing, light, warm, yellow tint', but was forced to admit that it had major drawbacks. Not only was it 'liable

to change even to blackness by damp and impure air' if incorrectly glazed, care also needed to be taken to ensure that no iron or steel implements came into contact with it. Field suggested using a spatula of ivory or horn instead.⁵

Part of the pigment's appeal was that, like the bottles discovered in the German pharmacy, no one was quite sure where it came from. Many - including Field, writing in 1835 and Salvador Dalí, writing in 1948 - suggested that it was mined from Mount Vesuvius. In fact lead antimonate is one of the oldest synthetic pigments. (The ancient Egyptians manufactured it, a process that required a good deal of skill and specialised knowledge since the principal ingredients - lead oxide and antimony oxide - also had to be chemically produced.) Another more practical reason for its popularity was that, with the exception of the yellow iron ochres, which even at their best tended to be a little dull and brownish, there were no yellow pigments that were completely reliable until the twentieth century. Naples yellow was one of the best of a bad bunch and, notwithstanding its drawbacks, remained indispensable for many artists. In 1904 the post-Impressionist Paul Cézanne, upon seeing a fellow artist's palette bereft of this pigment, was thunderstruck. 'You paint with just these?' he cried. 'Where is your Naples yellow?'7

Chrome yellow

The baking late summer of 1888 was the happiest of

Vincent van Gogh's life. He was in the 'Yellow House' in Arles in the south of France, eagerly awaiting the arrival of his hero, Paul Gauguin. Van Gogh hoped that together they would found an artists' commune in Arles and he was, for once, optimistic about the future.¹

He wrote to his brother Theo on Tuesday, 21 August to say that he had received a note from Gauguin to the effect that he was 'ready to come to the south as soon as chance permits', and Van Gogh wanted everything to be perfect. He began working on a series of sunflower paintings, with which he planned to cover his whole studio. He told Theo he was painting them 'with the gusto of a Marseillaise eating bouillabaisse', and he hoped they would be a symphony of 'harsh or broken yellows' and blues, 'from the palest Veronese to royal blue, framed with thin lathes painted in orange lead'. The only thing slowing him down, it seemed, was nature itself. He found he could only work in the early morning, 'Because the flowers wilt quickly and it's a matter of doing the whole thing in one go'.²

While the avant-garde artists of the day had access to wonderfully saturated reds and blues, they were lacking an equivalent for the third primary: yellow. Without this, they believed, they would be unable to create balanced compositions, or create sufficiently bright pairings of complementary colours, which Impressionist art relied upon for its drama. Chrome yellow arrived none too soon and Van Gogh was one of many to fall hard for it. It owed its genesis to the discovery in 1762 of a scarlet-orange crystal in the Beresof gold mine in deepest Siberia. The mineral, called crocoite (from the Greek word for saffron, *krokos* [page 98]) by the scientists who discovered it and *plomb rouge de Sibérie* (Siberian red lead) by the French,

wasn't much use as a pigment – the supply was too irregular and the price too high. However, the French chemist Nicolas Louis Vauquelin began working on crocoite and soon discovered that the orange stone contained a new element. It was a metal, which he named chrome or chromium, after another Greek word meaning 'colour', because its salts seemed to come in an extraordinary variety of hues. Basic lead chromate, for example, could range from lemon yellow to 'a yellowish-red or sometimes a beautiful deep red', depending on the method used to make it. In 1804 Vauquelin suggested that these might make useful pigments; by 1809 they were already on artists' palettes.

Sadly for artists and art-lovers alike, chrome yellow has a nasty habit of browning as it ages. Research carried out on Van Gogh's paintings in Amsterdam over the past few years has shown that some of the chrome yellow in the flowers' petals has darkened significantly, due to the reaction of chrome yellow with other pigments in sunlight. Van Gogh's sunflowers, it seems, are wilting, just as their real-life counterparts did.

Gamboge

When William Winsor and Henry C. Newton first started selling artists' pigments from a small shop at 38 Rathbone Place in London in 1832, gamboge, one of their principal pigments, would have arrived in regular packages from the offices of the East India Company. Each package contained a few thin cylinders, about the circumference of a ten pence coin and the colour of old earwax, wrapped in leaves. Winsor & Newton's workers would have broken up these pipe-like lumps using a metal anvil and a hammer. Once crushed, the pigment would be made up into small, brownish cakes. Experienced artists, though, would have been in on the secret: when touched with a drop of water, these toffee-brown blocks yielded a yellow paint so bright and luminous it almost seemed fluorescent.

Although by this time gamboge had been a fixture on palettes for two centuries - the East India Company first imported it in 1615 - little was known of its origins.2 In his 1835 treatise on pigments, George Field waxed evasive: '[It] is brought principally, it is said from Cambaja in India, and is, we are told, the produce of several trees.'3 He was right about the trees. Gamboge is the solidified sap of Garcinia trees, and comes principally from Cambodia or Camboja, as it was once known, which is how Gamboge got its name.4 Milking the trees requires patience. When they are at least a decade old, deep gouges can be cut into their trunks. Hollow lengths of bamboo are used to catch the sap as it trickles out. It takes over a year for the bamboo to fill up and the sap to harden. When some unprocessed resinous clots were broken open during the rule of the Khmer Rouge, it was discovered that they contained stray bullets, trapped like ancient insects in amber.

Artists in Japan, China and India had long used it on scroll paintings, illustrated capitals and ancient miniatures for centuries, but when the pigment first made its way into Europe – in the hull of a Dutch trading galley in 1603 – colour-starved Western painters fell hungrily on the new sun-bright yellow.⁵ Rembrandt favoured it in oils, where it took on the golden hue that often haloes the figures in his paintings.⁶ It has also been found in the work and palettes of J. M. W. Turner and Sir Joshua Reynolds.⁷ William Hooker, the Royal Horticultural Society's botanical artist, mixed it with a little Prussian blue to produce Hooker's Green: the perfect colour for painting leaves.⁸

Like many early pigments, gamboge was as at home on the shelves of the apothecary as an artist's palette. In a lecture given on 7 March 1836, Dr Robert Christison MD, described it as 'an excellent and powerful purgative'. Just a small amount could produce 'profuse watery discharges'; larger doses could be fatal.9 Workers who crushed gamboge at Winsor & Newton would have to rush to the toilet once an hour while working with it. It is hardly an illustrious side-effect for a pigment, yet perhaps it was the scientific community's familiarity with gamboge that led French physicist Jean Perrin to use it in 1908 in his experiments to prove the theory of Brownian motion,10 an idea Einstein posited three years earlier. Using tiny puddles of gamboge solution, just 0.12 mm deep, Perrin showed that, even days after being left untouched, the little yellow particles still jiggled around as if they were alive. He was awarded the Nobel Physics Prize in 1926.11 By this time gamboge had mostly been replaced in artists palettes by aureolin, an artificial yellow that, though slightly less bright and translucent, was less prone to fading. Winsor & Newton continued to receive packages of raw gamboge until 2005, when the company finally stopped selling it: a great relief, no doubt, for the workers, if not for the artists.

Orpiment

In his *II Libro dell'Arte*, Cennino Cennini writes that orpiment is 'made by alchemy'.' It is true that by the early Renaissance most of the pigment that artists were using was manufactured, but orpiment is actually a naturally occurring mineral: a canary-yellow sulphide of arsenic (As₂S₃) that is around 60% arsenic.²

In its glittering natural form, which was thought to resemble gold, it was one of the mineral pigments (like azurite and the green copper ore malachite) and one of two yellows, along with ochre, used in ancient Egyptian art. It appears on papyri scrolls and decorates the walls of Tutankhamun's tomb, where a small bag of it was discovered on the floor.3 The intense yellow can also be found illuminating the ninth-century Book of Kells, the walls of the Taj Mahal and the medieval text the Mappae clavicula. The Romans, who called it auripigmentum, 'golden', were much enamoured with it too. As well as using orpiment as a pigment, they believed gold could be extracted from it using a mysterious method. Pliny recounts a story about the emperor Caligula who, greedy for riches, smelted a vast quantity of raw orpiment, with little success. Not only were such experiments futile orpiment does not really contain any trace of the precious metal - it could also prove fatal for the slaves who mined it.

Cennini warned his readers: 'Beware of soiling your mouth with it, lest you suffer personal injury.' In fact, orpiment is deadly. Although it was occasionally taken in minute amounts as a purgative in Java, Bali and China, where it occurs naturally and was popular as a pigment until the nineteenth century, the risks of abusing it were well known. A delightfully named German merchant called George Everhard Rumphius recalled seeing a woman who had taken too much in Batavia (now Jakarta), in 1660, in his book *The Ambonese Curiosity Cabinet*.

She had become mad, 'and climbed up the walls like a cat'.6

Even as a paint orpiment was not without its drawbacks. It dried badly in oils and could not be used in frescoes. It also reacted with a host of other pigments, particularly those that contained copper or lead. Prudent artists could make use of it, as the Venice-based Renaissance colourist Paolo Veronese did in his *The Dream of Saint Helena* (c. 1570), only if they made sure it was carefully removed from other pigments it might discolour. Orpiment really had only one thing going for it: its colour. It was, in the words of Cennini, 'a handsome yellow more closely resembling gold than any other colour'. And that, it seems, was enough.

Imperial yellow

Katharine Augusta Carl probably thought of herself as imperturbable: born in New Orleans two months before the end of the Civil War, unrest had seasoned her childhood. Thereafter she had been a wanderer, first leaving America to study art in Paris and later travelling through Europe and the Middle East. It was on a visit to China, though, that a life-defining opportunity presented itself when she was asked to paint the portrait of the Empress Dowager Cixi, the feared former concubine who had ruled China for over 40 years. This was how Katharine found herself, just before 11 o'clock on 5 August 1903, standing in the throne room in the heart of the Forbidden City, contemplating the world's most powerful woman.¹

Heightening the sense of intimidation was the liberal use of the red-gold yellow fiercely reserved for royalty. While most Chinese roof tiles, for example, were grey, those of the royal palaces were golden. Cixi's gown was of imperial yellow silk. Stiffly brocaded with wisteria and decorated with strings of pear-shaped pearls and tassels. It seemed more to encase than clothe her. Her right hand, with its claw-like two-inch nail protectors, lay in her lap. At precisely 11 a.m., the time the royal augurs had prescribed as the most auspicious for portrait painting, each of the 85 clocks in the throne room began to chime simultaneously; shakily, Katharine reached forward and began to sketch the empress's likeness.

In China even regular yellow had been special for over a thousand years. Together with red, blue-green, black and white, it was one of the five colours of the Five Element theory. Each colour corresponded with a season, direction, element, planet and animal. Yellow was allied with the element of earth – an ancient Chinese saying is that 'The sky is blackish blue and the earth is yellow' – the centre, Saturn, late or long summer, and the dragon.

The Chur Qiu Fan Lu (Rich Dew of the Spring and Autumn Annals), written sometime in the second century BC, describes yellow as 'the colour of rulers'. They soon began to jealously guard its use, particularly this one shade: the first law that mentions it was passed in AD 618 at the very beginning of the Tang dynasty. 'Common people and officials,' it read, 'are forbidden to wear clothes or accessories in reddish yellow.'4

Even by ancient standards, the dyeing method was labour-intensive. The key ingredient was the *Rehmannia glutinosa*, or Chinese foxglove, a plant with trumpet-shaped flowers and roots that look like elongated golden beetroot. To achieve the precise colour desired, the tubers were harvested at the end of the eighth lunar month, and then pounded by hand into a smooth paste. It took around 1.2 litres of root paste to dye a 4.6 m² piece of silk. The mordant, a substance that helps a colour bite into a fabric so it doesn't wash away, had to be made from the ashes of oak, mulberry or beach wormwood; the cauldron had to be rustproof; each piece of silk went through two, slightly different dyeing vats.

Although neither woman in the throne room knew it, imperial yellow's days were numbered. Its prestige had begun to wane during the previous decades. Initially reserved for royals, it was first granted to household bodyguards and, in a few instances, as an honour to commoners. In one scandalous instance, the empress herself had rewarded a humble train driver with an imperial yellow jacket. Just a few short years after Katharine painted China's last empress, the Xinhai Revolution would topple the Qing dynasty, China's last. With the fall of imperial power, the talismanic colour was shorn of the symbolic significance it had possessed for a millennium.

Gold

Anyone who requires proof that gold is the colour of desire need only see the portrait of Adele Bloch-Bauer, immortalised by Gustav Klimt in 1907. It is so ardent and adoring that when it first arrived at the Belvedere Palace gallery in Vienna, people speculated that subject and painter were having an affair. While proof of a liaison has never emerged, there is no doubt that the painting is an expression of reverence. In the work, the last of Klimt's 'Golden Phase', Adele sits in a field of the precious metal, some of it plain and flat, some worked into a pattern of symbols and tessellations. Her dress is also a complex swirl of gold. Only the hands, hair and face – lips slightly parted, eyes intense – portray a living, breathing woman; the setting and clothing are those of a goddess.

Gold has always been both the colour of reverence and revered itself. Part of its allure lies in the mineral's scarcity and uneven distribution. Although mines have been discovered all over the world, gold rushes mean that they are quickly exhausted and abandoned in favour of those that have been newly uncovered. Europe has relatively few gold deposits and has historically relied on gold traded from Africa and the East. The Carthaginians, whose empire ringed the Mediterranean in the millennia before the birth of Christ, were for many years the principal conduit for African gold into Europe, a right that they defended vigorously. (Even their supplies, though, were limited. After a serious military defeat in 202 Bc they were unable to pay reparations in gold. Instead they paid in silver – a little under 360 tonnes over the next 50 years.)

Gold has also been used to inspire awe. When the pious Mansa Musa, the Emperor of Mali, travelled through Cairo on his pilgrimage to Mecca in 1324, European and Arabic traders saw for themselves the glittering wealth of the African continent. The emperor travelled with a caravan of

60,000 men; 500 slaves walked before him, each carrying a gold staff weighing four pounds; his baggage train of 80 camels carried another 300 pounds of gold. His legendary journey and generosity left the price of gold in the region artificially low for over a decade.⁴

Cloth of gold – fabric woven from threads with a core of silk or linen wrapped in gold – had been around since Roman times and was beloved by European royalty. The famous meeting in 1520 of Europe's two youngest, lustiest and most glittering monarchs, Kings Henry VIII of England and Francis I of France, is known as the Field of the Cloth of Gold, after the pair vied to outdo each other with the splendour of their retinues. Henry arguably won: his marquee was made entirely from golden cloth.

Like its sister metals iron, copper and silver, gold has a structure that contains mobile electrons that strongly reflect light. It is this that gives these metals their distinctive sheen.⁵ Gold's rich glimmer, coupled with its resistance to tarnishing, makes it an easy emblem for divinity. The medieval Christian Church binged on the metal. The Uffizi gallery in Florence, for example, has a room dedicated to three vast altarpieces, all depicting the Virgin and child. The last of the three, created by Giotto around 1310, was painted for the Ognissanti chapel, a few blocks upriver from the gallery. Just as in the other altarpieces, Giotto's figures are not shown in a room or landscape but lie on a smooth golden ground. The frame too is gold, as are the saints' haloes (the haloes of the saints in front obscure the faces of those behind them, a great scandal at the time because it was thought to be impious) and the decorative border on the Virgin's deep blue robe.

Gilding such panels was painstaking work. The gold came in gossamer-thin sheets, each about 8.5 cm square, which had been hammered from coins; a good goldbeater

Gold, continued.

could pound as many as a hundred leaves from a single ducat. Each leaf would be taken up with tweezers and pressed onto the panel, moulding or frame. The sheets were so thin that almost any glue could be used – honey, gum Arabic and glair, made from egg white, were all popular. At this point the gold would still be a bit dull, its sheen unfocused by imperfections underneath; to really shine it had to be burnished. Cennini recommends using either hematite [page 150] (probably because of the medieval association between red and gold), a precious stone like a sapphire or emerald ('the choicer the stone, the better it is'), or the tooth of a lion, wolf, dog, or 'of any animal which feeds decently upon flesh'.6

Objects, when rendered in flat gold leaf, do not look real; the light falls across them evenly rather than glinting white off the highlights and falling blackly into the shadowed areas as it would do naturally. Artists used gold not for realistic effect, but because of its intrinsic value, and even once Renaissance artists began placing their figures in more natural settings and mastering perspective, they still liked to make use of rich gold paint. It could indicate wealth if used to pick out decorative trimmings in rich fabrics, or it could represent divinity. In *The Birth of Venus* (*c.* 1484–6), Botticelli wove it through Venus's hair.

The natural counterpoint to our desire for and devotion to gold is its tendency to bring out our baser instincts: greed, envy and avarice. This ambivalence is evident in the myth of King Midas, who is granted his foolish wish of being able to turn anything into solid gold just by touching it, only to find that this means he kills anything he touches and cannot eat. Disgust at the human preoccupation with gold can be found in Pliny's *Natural History*: 'We probe her [Mother Earth's] entrails, digging

into veins of gold and silver . . . we drag out her entrails . . . to be worn upon a finger.'8 Today, those who binge on gold are looked down upon as tacky and tasteless. Klimt's golden painting was seized by the Nazis during the annexation of Austria and later spent half a century in a gallery there, despite the wishes expressed in the will of its last owner that it should pass to his heirs. After a prolonged legal battle with the Austrian government it was returned to Adele's niece. Bloch-Bauer now gazes out from her precious golden shroud at visitors to the Neue Galerie in Manhattan.

Dutch orange Saffron Amber Ginger Minium Nude

Orange

Those who have ever wondered which orange referred

to first, the colour or the fruit, need wonder no longer. The fruit was probably first cultivated in China, and then gradually spread west, leaving its name scattered in its wake like a carelessly discarded whorl of peel: from nārang in Persian to nāranj in Arabic; then nāranga (Sanscrit), naranja (Spanish), orenge (French) and finally orange in English. Orange as a name for a colour only emerged during the sixteenth century; before that English speakers had used the cumbersome portmanteau giolureade or yellow-red.¹ One of the word's first-recorded adjectival outings was in 1502, when Elizabeth of York bought 'slevys of orenge colour sarsenet' for Margaret Tudor.²

In his book *Concerning the Spiritual in Art* (1912), Wassily Kandinsky, the Russian abstract artist, wrote that 'Orange is like a man, convinced of his own powers.' There is no doubt that orange has a confidence to it. If blue is a stand-in for the hazy unknown, its colour-wheel opposite has urgency. It's used to draw attention to potential danger. It is the colour of Guantanamo Bay jumpsuits, Agent Orange and, since 9/11, the second highest terror-threat level in the United States. Orange is used in traffic signage and warning symbols on roads, in part because it forms a high contrast against the blue-grey asphalt, even in low light. And the black boxes on aircraft, which record flight information, are, in fact, orange, in the hope this will make them easier to find in the event of a crash.

Thanks to the influence of the House of Orange on early modern Europe, its heraldic colour [page 96] has had a wide geographical reach. Its most obvious association is with the Netherlands: Dutch teams play in *oranje* and a Boer-controlled region in South Africa was known as the Orange Free State – with a flag to match, naturally.

The colour is also linked with Protestantism and protest, particularly in Ireland, where Protestants are known as Orangemen.⁶

When the architect Irving Morrow was deciding in 1935 what colour to paint the Golden Gate Bridge that spans from San Francisco to Marin County, he settled on a rusty shade, now called GGB International Orange, which would blend in with the hills but pop against the sea and sky. Occasionally, orange also pops in fashion too. The wonderfully flamboyant Art Deco cover illustrations for Vogue by Helen Dryden show orange as a permanent fixture of 1920s fashion, and it also had a moment in the late 1960s and 70s.8 It was expedience, though, that helped it become the signature colour of one of the world's most successful luxury brands, Hermès. Prior to the Second World War the company's packaging was cream; it was wartime shortages that forced them to switch to mustard until, finally, they had no choice but to use the last paperboard colour available: orange.9

Kandinsky also described orange as 'red brought nearer to humanity by yellow'. ¹⁰ And indeed it does seem to be forever in danger of sliding into another colour category: red and yellow on either side, brown below. This was even true of the shades featured in this book. Several destined for orange – chrome and ochre to take just two – ended up elsewhere upon further research. In part this is because orange wasn't seen as a separate colour in its own right until relatively recently and so even colours that now seem obviously orange – minium [page 107] is a good example – were once thought of as red or yellow.

It was the Impressionists who convincingly illustrated orange's power. The painting that gave the movement its name, Claude Monet's *Impression*, *Sunrise*, has, at its centre, a bright orange sun. This new school of artists, fired

up on new optical theories of colour contrasts, made extensive use of orange. Paired with blues (its opposite on the colour wheel) the super-bright chrome and cadmium pigments produced zinging contrasts that were deployed again and again by artists including Toulouse-Lautrec, Munch, Gauguin and Van Gogh.

Whatever the medium, there is no denying orange's air of braggadocio. Godey's Lady's Book pronounced it 'too brilliant to be elegant' in 1855.11 Anthony Burgess might have been thinking the same thing when he named his dystopian novel A Clockwork Orange in 1962. (He gave several different explanations for the title during his lifetime: once saying he had overheard the phrase 'as queer as a clockwork orange' in an East End pub; on another occasion implying it was a metaphor of his own making.) Neon-lit signs, invented in 1912 and originally orange, are still perhaps the loudest and brightest form of advertising, and the colout remains popular for billboards and shopfronts. Many brands, including Nickelodeon, Easyjet and Hooters, have made use of its vibrancy and visibility. With apologies to Kandinsky, perhaps a better summation of the colour would be: 'Orange is like a man, desperately seeking to convince others of his powers.'

Dutch orange

Balthasar Gérard was the Lee Harvey Oswald of his day.

On 10 July 1584 he entered the Prinsenhof, the royal residence of the Dutch rulers, and fired his pistol three times into the chest of William I, Prince of Orange, who prayed for mercy for the Dutch people and then died.

To the Dutch, William I (William the Silent) is the father of their nation – and it was an exceedingly tricky birth. In the middle of the sixteenth century the northern Low Countries were not independent, but a largely Protestant region under the rule of the fanatically Catholic King Philip II of Spain. William I, a Catholic himself but a strong believer in religious freedom, led the rebellion against Spain. The House of Orange continued to exert huge influence on European politics for several centuries and William's descendents remain the Dutch royal family to this day.¹ Centuries of turbulence have left their mark, however: the Dutch have fierce pride in their history, their nation and the signature colour of their ruling family.

The House of Orange are proof that personal branding isn't new. In portrait after portrait, its members are gilded in shades of orange. It begins subtly enough: in a study by Adriaen Thomasz Key painted in 1579, William I wears a fine brocade suit in a fashionable shade of black, trimmed with fine embroidery in orange and gold.² A portrait of King William III of England and Dutch Stadtholder (the honorific the Oranges were given in the Low Countries), attributed to Thomas Murray, is less subtle. Here, backed by a swathe of rust brocade, the king wears a voluminous cloak in flame-coloured velvet trimmed with ermine and secured at the front with two vast silk tassels in an eye-catching shade of pumpkin.

The Dutch, in gratitude to William I, took to the colour with gusto. (The exact shade favoured by the Dutch has shifted over the years. In contemporary paintings, the

orange worn by the members of the House of Orange is almost a burnt amber shade; the one favoured today is a sunny mandarin.) Take the humble carrot, for example. Originally a tough and rather bitter tuber from South America, prior to the seventeenth century it was usually purple or yellow. Over the next 100 years, however, Dutch famers selectively bred carrots to produce orange varieties.³ The Dutch flag – today blue, white and red – was originally striped in blue, white and orange to match the livery of William I, but, try as they might, no one could find a dye sufficiently colourfast: the orange stripe would either fade to yellow or deepen to red. By the 1660s the Dutch gave up and began using red instead.⁴

Perhaps the best, if most short-lived instance of the Netherlanders' affinity with this fiery hue occurred on 20 July 1673. On that day Dutch soldiers captured the city of New York, marching up Broadway to take it back from the British.⁵ In triumph they immediately rechristened the city New Orange, a name it bore for less than 12 months. The Dutch, who were fighting several wars simultaneously, had neither the cash nor the stomach to begin another one on yet another front. In 1674 a treaty was signed ceding the city – and its name – to the British.⁶ (The New York flag, unlike that of the Netherlands, still bears an orange stripe, betraying its Dutch origins.)

The legacy of William I may not have given the Dutch a permanent foothold in the New World, but it has given them the gift of visibility. At sporting events, they are unmistakeable: a heaving block of joyous orange. And each April they gather like a flock of exotic birds to celebrate Koningsdag (King's Day), many dressed from head to heels in luminous tangerine, and singing *Oranje boven! Orange boven!* ('Orange on top! Orange on top!') at the top of their lungs.

Saffron

Imagine a field in the pre-dawn blue haze of an autumn morning. The field is small, and probably in Iran, although it could also be in Spain, Macedonia, Kashmir, France or Morocco. As the sun rises it shows that the field, which had been bare earth the night before, is carpeted with small, violet blooms: thousands of *Crocus sativus*. At the centre of each, lasciviously prominent against the purple of the petals, are three crimson stigmas, part of the flower's female sex organs, better known (once removed and dried) as the spice saffron. Before becoming saffron, however, the crocuses need to be harvested, and there isn't much time: by the heat of the day the blooms will have begun to wilt; by the evening they will have withered completely.

No one knows quite when or where C. sativus was first cultivated - the flowers are actually sterile and so can't grow in the wild – but there are a few tantalising hints. Some cave paintings in Iraq made 50,000 years ago were found to contain traces of saffron. The ancient Greeks used it to dve their clothes, and we know it was traded across the Red Sea, from Egypt to southern Arabia, during the first century AD.1 It was being grown in Spain from at least AD 961² and was even grown in England for centuries. Tradition has it is that a pilgrim returned from the Levant during the reign of Edward III (1312-77) smuggling a single bulb hidden either in the brim of his hat or in a hollow in his staff - the legends differ. This bulb must have been peculiarly fecund, because several British towns soon became saffron-producing powerhouses. The most famous of these changed its name during the sixteenth century to Saffron Walden, in celebration of its star produce. (The town changed its coat of arms too, adopting a rather charming visual pun: three crocuses surrounded by a stout set of walls, or 'saffron walled-in'.)3 The plant, though, had a rather stormy relationship with its civic namesake.

In 1540 and 1681 demand plummeted and in 1571 the soil became overworked and the crop sickly. Even in the good years – such as the bumper harvest of 1556 when the saffron farmers, or 'crokers', crowed that 'God did shite saffron' – *C. sativus* wasn't an unalloyed boon. In 1575 a royal decree stipulated that the crockers could no longer throw discarded flowers in the river, on pain of two days and nights in the stocks.⁴

Saffron is, measure for measure, the most expensive spice in the world. In 2013 one ounce of saffron cost \$364, while the same quantity of vanilla cost \$8 and cardamom a paltry \$3.75.5 This is partly because the flowers are so demanding: according to one sixteenth-century account, C. sativus prefers 'warme nights, sweete dewes, fat grounde, and misty mornings'. As well as the brief flowering of the individual blooms, the entire crop comes and goes in a fortnight.6 The blooms need to be picked and the stigmas removed entirely by hand; all attempts to mechanise the process have failed, the flowers are too delicate. It takes between 70.000 and 100,000 flowers to produce one kilo of the spice.7 For those prepared to bear with saffron's peccadilloes, however, the rewards are great. It has been used as an aphrodisiac and a cure for everything from toothache to plague. In food it lends a beautiful colour, and is also prized for its aroma and flavour, which is unlike anything else: simultaneously sweet, bitter and pungent, with a wisp of a taste that at one moment might be reminiscent of hay, and the next something rather more bosky, like mushroom.

At the noon of his power, wealth and influence, Cardinal Wolsey scattered rushes impregnated with the spice on the floor of his rooms at Hampton Court to scent the air.⁸ Cleopatra, who has over the centuries been accused of any number of extravagant follies, was said Saffron, continued.

to bathe in it. It was so costly that there have been many reports of forgery and other crimes. In 1374 the hijacking of 800 pounds of saffron en route to Basel resulted in the 14-month Saffron War. While in Nuremberg in 1444 a man called Jobst Finderlers was burned alive for the crime of adulterating his saffron with marigold.9

As a colour, teetering between vellow and orange. saffron is similarly in demand. Its most famous use is for Buddhist robes. Buddha himself stipulated that the robes could only be dyed using vegetable dye, but of course saffron itself was much too expensive, and either turmeric or jackfruit are used as a substitute (although now many are dyed synthetically). 10 When used as a dye, the spice imparts an intense colour to clothes (although it is not particularly colourfast) and hair - Alexander the Great reputedly used it to make his locks look like gold.11 Zoroastrian priests used saffron to make a sunny ink, with which they wrote special prayers to ward off evil. Later it was used by monastic book illuminators as a cheaper (and presumably unconvincing) alternative to gold. According to one early seventeenth-century recipe, it was made into a pigment by being mixed with glaire, an egg-white concoction, and left for a day and a half.12

The colour saffron is also present in the national flag of India. Today it is said to stand for 'courage, sacrifice and the spirit of renunciation'. When the flag was adopted in 1947, however, the meaning was a little different. As Dr S. Radhakrishnan explained at the time, 'the saffron colour denotes renunciation of disinterestedness. Our leaders must be indifferent to material gains and dedicate themselves to their work.' Sadly for the idealists of 1947, corruption scandals continue to plague India. Perhaps, though, that is not entirely surprising: saffron has seldom brought out the best in people.

Amber

In June 1941 Hitler's Germany and Stalin's Soviet Union had been grimly making peace for two years. War, though, was coming. Operation Barbarossa, the Nazi invasion, began on 22 June, when around 3 million German soldiers poured into Soviet territory. As ever, the invading army were keen to seize valuable treasures as they went. One of the things that the Nazis were keenest to find was holed up in the palace at Tsarskoye Selo, the Russians having plastered over it with thin wallpaper in a desperate attempt to prevent it from being looted. This was the Amber Room, also known as the 'Eighth Wonder of the World'.

The room was, properly speaking, a series of intricately carved panels and mosaics made of glowing honeved amber, studded with semi-precious stones and backed by gold leaf. It had been designed by a German, the seventeenth-century baroque sculptor Andreas Schlüter, and made in 1701 by a Danish craftsman, Gottfried Wolfram, In 1716 Frederick I of Prussia gave the room to Peter the Great in celebration of the alliance between Prussia and Russia against Sweden. The panels - carefully packed into 18 large boxes – were promptly shipped from Frederick I's seat at the Charlottenburg Palace in Berlin to St Petersburg. They were moved again 40 years later, just a few miles south to Tsarskoye Selo, where they were reconfigured and expanded to fit a new, larger space. The panels – now measuring over 180 square feet, weighing around 6 tonnes and costing, it has been estimated, \$142 million in today's money – became the pride of Russia's royalty. Czarina Elizabeth used the Amber Room as a meditation space; Catherine the Great entertained guests there: Alexander II used it as a backdrop for his trophies.² In 1941, however, wallpaper proved insufficient cover for such a famous treasure, and the Amber Room was packed up in a bare 36 hours and shipped to Königsberg.

Amber, continued.

One of the few organic gemstones, true amber is extremely old. It is made of fossilised tree resin that once oozed from species of cedar and other conifers long since extinct.3 (Young amber, not yet fully fossilised, is known as copal.) For many, amber conjures up the scene from the film Jurassic Park, where a scientist extracts DNA from an insect that has been trapped and preserved in a sticky drop of resin. Insect occlusions in amber aren't all that rare, probably because amber is a wonderful natural preservative. (The ancient Egyptians, noticing this quality, used it in their embalming rituals.) In 2012 researchers discovered a spider entombed in the act of attacking its prey, a miniature dramatic tableau that has remained frozen at the moment of crisis for 100 million years. Earlier the same year scientists photographed the oldest parasitic mite ever discovered, trapped in an amber droplet from northern Italy 230 million years ago.4

Amber is most commonly found around the Baltic, where vast forests of conifers once grew; it still washes up on beaches there after storms. Elsewhere, though, amber is rare and consequently treasured. It can be set on fire and used to scent the air with an aroma like burning pinewood. And its clarity and colours – most often palest honey to smouldering ember, but occasionally black, red or even blue – have made it valuable for jewellery and decoration.

The Etruscans and Romans loved it, despite the belief of one Roman historian that amber, which he called *lyncurius*, was made from dried lynx urine. Pieces of amber, intricately carved to resemble the heads of rams, monkeys or bees, have been found at many ancient burial sites. A dark hunk that was sculpted in the first century AD to resemble the head of Medusa is now part of the J. Paul Getty Collection. The Greeks called the gemstone *elektron*, associating it with light from the Sun.

(This is the origin of the English words 'electric' and 'electron'.) In a famous myth, Phaeton, the bastard son of Helios, god of the Sun, borrows the chariot his father uses to pull the Sun across the sky and, desperate to prove himself, sets off to do his father's duty for a single day. Phaeton – young, vain, rash and ambitious – fatally lacks his father's strength and horsemanship. The horses sense his weakness and begin to plunge closer and closer to the Earth, scorching it, laying waste to fertile land. Seeing the plumes of black smoke, Zeus strikes down Phaeton with a thunderbolt, and Helios resumes control. Less well known is the fate of Phaeton's sisters, the Heliades, whose grief over the death of their brother is so fierce that they are turned into poplar trees, their cascading tears transfigured into droplets of golden amber.6

Some believe that amber, like opal, brings bad luck, and the ultimate fate of the Amber Room remains fittingly murky. The trail goes cold in 1943, when panels were still installed in Königsberg; a year later, the city was bombed by Allied troops and the museum where the room had been held was decimated. Some believe that the panels were moved before the bombing. Optimists argue the room is still hidden somewhere in the city. In a book published in 2004 Adrian Levy and Cathy Scott-Clark claimed that it was the Red Army itself that wrecked the treasured Russian artwork, either through ill-discipline or ignorance, and that the Soviets hushed the matter up out of shame. In the late 1970s the Russians began working on a reconstruction; 25 years and \$11 million later, the replica can now be seen at the restored Catherine Palace in St Petersburg, freezing history in place.

Ginger

The Zingiberaceae plant family is an industrious one.

Among its members are *Curcuma longa* (tumeric), *Elettaria cardamomum* (cardamom) and *Zingiber officinale*, a perennial with long narrow leaves, yellow flowers and, hidden from view beneath the soil, a pale dun rhizome known, simply, as ginger. Originating in the tropical forests of south Asia, ginger was among the first spices traded to the West (from around the first century AD) and our appetite for it has yet to wane. It is used to enliven all manner of foods from stir-fries to sticky loaves of gingerbread. To taste, it is hot and pungent, insistent and exotic. And, somewhere along the way, it was these qualities that led to its association with a particular group of people: redheads.

Like blondes, redheads are in the minority (which probably explains the string of evocative if unflattering names that have been bestowed on them: carrot-top, copperknob, piss-brindle, ginger and red). They make up less than 2% of the global population, although there are a few more – around 6% – in northern and western Europe, and up to 13% of the population of Scotland have red hair. Those with red hair are stereotyped as fiery and intense – just like the ginger root. Jacky Colliss Harvey, the author of *Red*, and a redhead herself, remembers being told by her grandmother that God gave women red hair for the same reason he gave wasps stripes.

This myth certainly seems to have found expression in some famous British royals. Dio Cassius described Boudicca, the ruler who for a short time terrorised the Roman invaders, as having a flowing mass of red hair. (Although, as he was writing nearly a hundred years after her death, he may have been saying this purely to make her sound even more fearsome and exotic to his dark-haired Greek and Roman readers.)

King Henry VIII, however, rarely noted for his sweetness of temper, was definitely redheaded. In 1515, when the king was 24 years old, the Venetian ambassador wrote that 'His majesty is the handsomest potentate I ever set eyes on; above the usual height, with an extremely fine calf to his leg, his complexion very fair and bright, with auburn hair combed straight and short, in the French fashion.'2 (Even this, though, is confusing: 'auburn' started out referring to a pale yellow or brown, a kind of off-white. but during the sixteenth and seventeenth centuries, its meaning shifted to a deeper ruddy brown.) Henry's daughter by Anne Boleyn – whose hair colour was possibly also reddish (descriptions vary) - was Queen Elizabeth I, the redheaded ruler par excellence. The precise shade of her hair, though, is elusive: strawberry blonde in one portrait, red-gold in another, coppery auburn in a third.

Away from the British throne, redheads, particularly women, punch well above their weight in terms of cultural visibility. Many fictional female characters, including Annie, Jessica Rabbit and Wilma Flintstone, are imagined with red hair. Then there are redheads in art. While Titian favoured rosy caramel tresses, and Modigliani preferred auburns, Rossetti and his fellow Pre-Raphaelite brotherhood were not fussy, just so long as their models' hair was red. Elizabeth Siddal, a copper-headed poet, was the muse for several of the Pre-Raphaelites: she is Sir John Everett Millais' 'Ophelia', and Rossetti's 'Beata Beatrix'. She was also Rossetti's lover and, later, wife. When she died of a laudanum overdose, Rossetti buried a book of his poetry with her, but years later he disinterred her to retrieve it. A witness said that Siddal's flaming hair had continued to grow, so that it filled the coffin when they prised it open. Rossetti never quite recovered.

Although the origin and whereabouts of the ur-redhead

Ginger, continued.

is still a mystery, some tantalising evidence of its history came to light in 1994. Two jawbones were unearthed in the El Sidrón cave in northern Spain. At first, because the bones were in such good condition, it was assumed they were relatively recent, perhaps dating back to the Spanish Civil War. As more bones began to surface, showing marks where knives had sliced muscle from bone, the scene began to take on the grim character of a cannibalistic massacre. Police and forensic scientists were called in. They discovered that a crime had indeed taken place, but that they were about 50,000 years too late to catch the culprits.³

The cave contained the remains of a family of Neanderthals: three men, three women, three teenage boys, two children and a baby. Enough evidence remained to show that two of the individuals had bright red hair.⁴ They were the victims, rather than the aggressors.

Minium

In the opening pages of the Gladzor Gospels the text is pressed beneath a heavily gilded pediment decorated with a portrait of a tonsured saint. Surrounding him is an explosion of colourful, curlicued foliage filled with fantastical creatures. A pair of blue crane-like creatures with red and green wings face each other, beaks open in silent screeches. Over the page is a startled peacock and four birds that resemble lilac partridges, each with a heart-shaped red leaf clasped in its beak. Some pages are so choked with gilded greenery and bizarre, peeping figures that it seems as if the words were an afterthought.

Prior to Johannes Gutenberg's invention of printing with moveable type sometime around 1440, books were restricted to noblemen, clergy and a few others, such as clerks, who needed to be literate in order to do their jobs. They were also expensive. Manuscripts were created by hand – in Latin *manu* means hand while *scriptus* means written – and were usually commissioned by a powerful patron to reflect his or her piety and status. Each book represented hundreds of hours of labour and was wholly unique, from the animal skins that made up the leaves of parchment and to the pigments used for the illuminations, to the fists of the scribes.

The Gladzor Gospels were created during the fourteenth century, in a small region in central Armenia, halfway between the Black and Caspian seas. Then, as now, Armenia was caught both politically and culturally between the East and the West, the Muslim world and the Christian one. Under the aptly named Gregory the Illuminator, it had been the first country in the world to convert to Christianity in AD 301.¹ Perhaps it was pride in this fact, coupled with anxiety over the Mongol occupation, that led those who worked on the Gladzor Gospels to pour so much frenzied creativity into the

Minium, continued.

manuscript and its illustrations. As in most monastic endeavours, the production of this manuscript required a precise division of labour. First, scribes would have copied the text, carefully leaving space for the paintings, and then a team of artists would have begun their work.² If the team that worked on the volume was large enough, it would have been the sole responsibility of one person to add the capitals, headings and pilcrows (¶) in a particular shade of orange-red so bright that they leapt off the page.

The pigment used was minium. The person who worked with it was called a miniator, and their work, an eye-catching symbol or heading in a manuscript, was called a *miniatura*. (This is the origin of the word 'miniature', which in its original sense did not mean small at all.)³ Minium was used extensively in manuscript illumination during the Middle Ages, and use of it only gradually died out as vermilion [page 144] became more readily available from the eleventh century.⁴

Although minium, or lead tetroxide, can be found in naturally occurring deposits, this is rare and it has more commonly been manufactured. The process is essentially a continuation of the one used to make lead white [page 43] and was described, in a pleasingly magical way, in the eleventh-century *Mappae clavicula*:

... take a pot that has never been used, and put sheets of lead in it.

Fill the pot with very strong vinegar, cover and seal it. Put the pot in a warm place and leave it for a month. Next... shake out the deposits around the sheets of lead into a ceramic pot, and then place [it] on the fire. Stir the pigment constantly, and when you see it turn white as snow use as much of it as you like; this pigment is called basic lead white, or ceruse. Then take whatever is left on the fire, and stir it constantly until it becomes red.⁵

Minium was often used as a cheap alternative to vermilion and cinnabar; in fact, the three pigments were often confused, even though minium is generally much vellower than either (Pliny the Elder described it as 'flame coloured'). Perhaps the confusion was in part due to wishful thinking: although it is cheap, bright and easy to make, minium is far from an ideal pigment. Even though, like its near relation lead white, it was used as a cosmetic in ancient Greece and China, it is just as poisonous.7 Another major problem is that it does not mix well with others, including the near-ubiquitous lead white, and has, George Field reported in 1835, a tendency to turn black in impure air.8 Luckily for historians, the Armenian air proved equal to the challenge. While the stone walls of the Gladzor monastery have long since disappeared, the minium in this particular manuscript is as illuminating as ever.

Nude

The wardrobe choices of women in politics often cause a stir, but in May 2010 the column inches surrounding one particular outfit spooled out further than usual. At a state dinner given at the White House in honour of the President of India, the First Lady (and the first African American First Lady), Michelle Obama, chose a warm cream and silver gown designed by Naeem Khan. This was a subtle act of sartorial diplomacy: Mr Khan was born in Mumbai. The problem arose, however, when the story was reported. Associated Press called the dress 'flesh-coloured'; others used Khan's own description: 'sterling-silver sequin, abstract floral, nude strapless gown'. The response was immediate. As Dodai Stewart, a journalist for *Jesebel*, put it: 'Nude? For whom?'

The terms for this particular pale shade - 'nude' and 'flesh', and even the less common 'suntan' and 'bare' - presuppose a Caucasian skin tone and are therefore problematic. Despite being painfully out of step with a global fashion market, they are curiously obdurate. Nude heels are wardrobe staples; nude lipsticks are daubed on millions of pouts every day. In reference to clothing the terms persist despite the existence of a plethora of alternatives: sand, champagne, biscuit, peach and beige [page 58]. The colour first became popular for women's underthings - corsets, girdles, pantyhose and bralettes in the 1920s and 30s. Soon the association between naked flesh and these silky undergarments invested the colour with an erotic charge. Designers have drawn on it again and again, particularly in the 1990s and early 2000s with the rise of the 'underwear-as-outerwear' trend.3

The idea behind such 'nude' undergarments was presumably that they would be less visible through diaphanous fabrics. Of course, just like their modern equivalents, they only really matched the skin colour of a very select few, even among Caucasian women. One person who understands this better than most is the Brazilian photographer Angélica Dass. Since 2012 Angélica has been working on a 'chromatic inventory' of human skin tone. The ongoing 'Humanæ' project is now composed of over 2.500 portraits of different people from around the world. The subject of each portrait – seemingly naked although only their head and shoulders are visible – is shot with the same clean, bright light. What makes the portraits special are the backgrounds. Each is dved to match the subject's complexion (a sample is taken from their faces), and the matching alphanumeric Pantone code is printed at the bottom. Angélica is a Pantone 7522 C.4 The portraits' power lies in being viewed as a group, and looking at them makes clear immediately how feeble and inadequate the labels 'white' and 'black' really are. The variety in skin tone is both staggering and oddly moving.

It could be argued that 'nude' as a colour term is sufficiently divorced from any actual skin colour to be harmless. The problem, though, is not with the colour, or even the word itself, but with the ethnocentrism behind it. 'Those of us with skin darker than "nude",' wrote Ms Stewart in 2010, 'have realised how noninclusive the colour is – from Band-aids to pantyhose to bras – for years.' There have been advances of course: fewer make-up companies pretend that one shade of sandy pale foundation will 'suit all skin tones', and in 2013 Christian Louboutin launched a range of pumps in five different skin colours, from pale to dark. We all know that 'nude' is a spectrum and not a shade; it is high time the world around us reflected that too.

Baker-Miller pink
Mountbatten pink
Puce
Fuchsia
Shocking pink
Fluorescent pink
Amaranth

Pink

Pink is for girls and blue is for boys; the evidence is everywhere. In the 'Pink & Blue Project', which began in 2005, the Korean photographer JeongMee Yoon captures images of children surrounded by their possessions. All the little girls sit marooned in identikit pink seas.

Amazingly enough, the strict girl-pink boy-blue divide only dates from the mid-twentieth century. Just a few scant generations ago the situation was completely different. In an article on baby clothes in the New York Times in 1893 the rule stated was that you should 'always give pink to a boy and blue to a girl'. Neither the author nor the woman in the shop who she was interviewing were quite sure why, but the author hazarded a tonguein-cheek guess. '[T]he boy's outlook is so much more roseate than the girl's,' she wrote, 'that it is enough to make a girl baby blue to think of living a woman's life in the world." In 1918 a trade publication affirmed that this was the 'generally accepted rule' because pink was the 'more decided and stronger colour', while blue was 'more delicate and dainty'.2 This is probably closer to the real explanation. Pink is, after all, just faded red, which in the era of scarlet-jacketed soldiers and red-robed cardinals was the most masculine colour, while blue was the signature hue of the Virgin Mary. At the turn of the century even the idea of different clothes for children of different sexes was a little odd. The mortality and birth rates were so high that all children under the age of two wore easy-to-bleach white linen dresses.

The word *pink* itself is relatively young too. The first reference in the *Oxford English Dictionary* of the word being used to describe pale reds is the late seventeenth century. Before then *pink* usually referred to a kind of pigment. Pink pigments were made by binding an organic

colourant, such as buckthorn berries or an extract of the broom shrub, to an inorganic substance like chalk, which gave it body. They came in several colours – you could have green pinks, rose pinks or brown pinks – but were, more often than not, yellow.³ It is an odd quirk that while light reds acquired a name of their own, pale greens and yellows did not for the most part (although several languages, including Russian, do have different words for pale and deep blues). Most romance languages made do with a variation of the word *rose*, from the flower. Although it is not certain, it is likely that the English derived their word for the colour from another flower, the *Dianthus plumarius*, also known as the pink.

Pink, however, is far more than the colour of flowers and princess dresses. Dressed (or not) in salmon-coloured silks, the women depicted by the eighteenth-century Rococo artists, such as François Boucher and Jean-Honoré Fragonard, while hardly feminist pin-ups, were certainly shown as being in full control of their allure. Their figurehead was Madame de Pompadour, the mistress of King Louis XV of France and a consummate consumer who helped popularise bright pink Sèvres porcelain. Daring, full-blooded pinks were a hit with strong, characterful women. It was a favourite of magazine editor Diana Vreeland, who liked to call it 'the navy blue of India'. Elsa Schiaparelli, an Italian fashion designer, Daisy Fellowes, an heiress and magazine editor, and Marilyn Monroe, who needs no introduction, all made shocking pink [page 126] the colour of choice for twentieth-century women who wanted to be both seen and heard.

Pink's current image problem is partly due to the feminist backlash against old-fashioned sexism. It is seen as simultaneously infantilising and, ever since artists first

put mixtures of cochineal, ochre and white to canvas to depict naked female flesh, sexualising. Nudes are still, overwhelmingly, female. In 1989, while 85% of the Metropolitan Museum's nudes were women, only 5% of the artists represented were. In a recent article, the Guerrilla Girls, a group pressuring the art world for greater diversity, said that since then the figures have become worse still.⁵ The case against pink as the colour of female objectification was only helped in the 1970s by a surprising discovery made about a particular shade [page 118].

Recently it was revealed that products for women, from clothes to bike helmets to incontinence pads, routinely cost more than products for men and boys that are practically identical. In November 2014 French secretary of state for women's rights, Pascale Boistard, demanded to know '*Le rose est-il une couleur de luxe?*' ('Is pink a luxury colour?') when it was discovered Monoprix were selling a packets of five disposable pink razors at €1.80. A ten-pack of blue disposable razors, meanwhile, cost €1.72.6 The phenomenon has come to be known as the 'pink tax'. Colour preferences may have reversed over the past century, but it seems in many ways the boy's outlook remains more roseate.

Baker-Miller pink

In the late 1970s American cities were scourged by wave after wave of drug epidemics and spiking violent crime rates. So when in late 1979 a professor announced that he had found a way of making people less aggressive, the nation pricked up its ears. The secret, Alexander G. Schauss announced in the pages of *Orthomolecular Psychiatry*, was a sickly shade of bright pink.

Over the course of the past year Schauss had conducted numerous tests. First, he had measured the physical strength of 153 young men, half of whom had stared at a deep-blue piece of cardboard for one minute, the other half at a pink piece of cardboard.1 All but two of the men shown pink were weaker than average. Intrigued, he used a more accurate measure of strength, a dynamometer, to test 38 men: pink did for every one of them what a haircut had done for Sampson. Away from the lab the hue seemed just as effective. On 1 March 1979 two commanding officers at the US Naval Correctional Centre in Seattle, Washington, Gene Baker and Ron Miller, turned one of their holding cells pink to see if it would have an effect on their prisoners. They carefully added one pint of semi-gloss red trim paint to a gallon of pure white latex paint to obtain the perfect Pepto-Bismol shade, and set to work coating the walls, ceiling and ironwork of the cell.2 Before this, violence had been a 'whale of a problem', said Baker, but over the next 156 days there wasn't a single incident.3 Similar results were reported at the Kuiper Youth Centre in San Bernardino; in fact, reported Dr Paul Boccumini, happily, 'it has worked so well that the staff must limit their [delinquents'] exposure because the youngsters become too weak'.4

Schauss began making public appearances to demonstrate how the newly christened Baker-Miller pink (named after the two officers in Seattle) could sap the strength of even the toughest man. During one memorable

television appearance he tried it out on the reigning Mr California; the poor man could barely complete a single bicep curl. It soon became something of a pop-culture phenomenon in America. It crept over the seats of bus companies, the walls of housing estates, small-town drunk tanks (hence its other nickname, 'drunk-tank pink') and, finally, the visitors' locker rooms at college football stadiums.⁵ (This last use led to a ruling that football teams could paint visitors' locker rooms any colour they chose, just as long as the home team's locker room was painted to match.)

There was, naturally, an academic backlash. Over the next decade scientists probed the efficacy of Baker-Miller pink on everything from anxiety levels to appetite to coding ability. Results were contradictory. A 1988 study could not find a link between the shade and blood pressure or strength, but did see significant effects on the speed and accuracy of participants in a standard digit-symbol test. A 1991 study found that there were reductions in the systolic and diastolic blood pressures of emotionally disturbed participants who were put in a room painted pink. Another study, carried out on prisoners and male university students pretending to be prisoners, found that both Baker-Miller-painted walls and pink-filtered light could reduce the time it took for those exposed to become calm.

Today, however, Baker-Miller pink is pretty rare, even in prisons. It seems that as crime rates in the United States – the country where the overwhelming majority of the testing had been done – began to fall, priorities shifted. It is also a rather sickly colour, so it may be that the guards, nurses and wardens had no more desire to be surrounded by it than those under their care. For the moment, the world's interest in Baker-Miller pink lies dormant and hundreds of questions remain unanswered – until the next crime wave perhaps.

Mountbatten pink

For the first six decades of the twentieth century, at precisely 4 p.m. each Thursday, the horn of a large cruise liner would sound across Southampton Water and a Union-Castle ship would slip from its berth and steal south, bound for Cape Town. Even if the timing hadn't been as regimented, it would still have been difficult to mistake these ships for any other: they had scarlet funnels trimmed at the top with a stripe of black; their upper decks were gleaming white while their hulls were an indeterminate dull lavender-grey-pink shade. It was a feature their poster advertisements made much of: those proud pinkish hulls slicing through blue waves, with sunlit landscapes visible in the background.

It was probably not such jaunty images, though, that preoccupied the mind of Lord Mountbatten, the British statesman, while he was aboard his ship, the HMS Kelly, in 1940.1 In the first year of the Second World War the Royal Navy had suffered tremendous losses: the Luftwaffe sighted convoys from above while packs of German U-boats closed in from below. The sheer loss of life was terrible enough, but during the war Britain was utterly dependent on the supplies being brought in from abroad. It was all too clear that something needed to be done. Captains began testing different kinds of camouflage in the hope of evading their hunters. Some elaborated on the strident dazzle designs that had been used during the Great War, the aim of which was not to hide the ships but, like the bold stripes on a zebra, to confuse attackers, making it difficult for enemies to estimate the dazzlepainted ships' bearing, speed and distance. Others tried two-tone greys – dark on the hull, pale on the superstructures - so that the ships' colouring echoed the difference between sea and sky.2

Perhaps it was these efforts that were in Mountbatten's

mind when he noticed that a requisitioned Union-Castle liner, still bearing its civilian livery, disappeared into the gloaming well before the other ships in the convoy. He became convinced that the Union-Castle's distinctive hull colour might be the very thing that the Navy had been looking for. While it stood out during the day, at dawn and dusk – two of the most treacherous times for attacks on ships – the dull, pucey colour seemed to disappear. Before long all the destroyers in his flotilla were painted medium grey with a dash of Venetian red, a tone that quickly became known as Mountbatten pink.

Other captains followed Mountbatten's lead, and the colour might have spread across the entire Navy had it not been for the official camouflage section of the Admiralty, which began putting different paints and patterns through their paces. Ships were soon being painted official camouflage colours: a subdued grey-and-blue version of the dazzle design.

It is not known whether the Admiralty included Mountbatten pink in their tests; nor has it been recorded how sailors felt about the ever-shifting colours of their ships. We do know, though, that just at the time Mountbatten pink was being phased out in 1942, many had become convinced of its effectiveness. One story in particular is still remembered in favour of Mountbatten pink's miraculous powers of concealment. In the final months of 1941 HMS *Kenya* – nicknamed 'The Pink Lady' after her paint job – came under heavy fire just off Vaagso Island near the Norwegian coast. Although strafed by two large guns for minutes on end, she escaped with only cosmetic damage and no casualties. Proof, or so it seemed to some, that this particular shade of pink was the very thing the Navy had been searching for.

Puce

Pre-revolutionary France was awash with evocative colour nomenclature. Apple green and white stripes, for example, were called 'the lively shepherdess'. Other favoured individual shades included 'indiscreet complaints', 'great reputation', 'stifled sigh', and 'the vapours'. Then, as now, indulging in the latest fashions signalled status, wealth and a sense of tribal belonging in the jewelled echo chamber of the French royal court. It was in this stultifying environment that puce became the colour of a season.

In the summer of 1775, 20-year-old Marie Antoinette had been the Oueen of France for one year, and her reign was not going well. In the spring, a wave of riots over the price of grain - known as the Flour Wars - had convulsed the country and the foreign-born queen was rapidly becoming an object of loathing. Rumour-mongers told tales of her wild gambling, her faux-milkmaid exploits at le Petit Trianon on the grounds of Versailles, and her wardrobes stuffed with expensive clothes and hats. To her starving subjects, such profligacy was galling. Alarmed at the reports from France, her mother, the redoubtable Empress Maria Theresa, wrote to scold her daughter for her 'extravagances of fashion', telling her that she was 'hurtling toward an abyss'. '[A] queen', she wrote, 'only degrades herself . . . through unthrifty expenditure, especially in such difficult time.'2 But the young queen would not listen.

Her husband, King Louis XVI, sensing his wife's sartorial indulgences were dangerously unseemly, was less than thrilled when he found her trying on a new lutestring (glossy silk taffeta) gown in a peculiar shade somewhere between brown, pink and grey. Had he been feeling more chivalrous he might have called it 'faded rose' but instead he observed that it resembled the *couleur de puce* – the colour of fleas.³ If it had been the king's intention to shame

his wife, though, his words backfired. 'The next day,' recalled Baronne d'Oberkirch, 'every lady at court wore a puce-coloured gown, old puce, young puce, *ventre de puce* [flea's belly], *dos de puce* [flea's back].'4 Writing to her daughter from the French court that summer, Lady Spencer described puce as 'the uniform at Fontainebleau and the only colour that can be worn'.5

A few days after the fall of the monarchy 17 years later on 10 August 1792, the Bourbon royal family found themselves in drastically different circumstances. Their new, post-Revolution apartments consisted of a cramped and dirty cell-like suite in the Little Tower at the Temple. Here the royal couple were kept under guard until their executions the following year. Naturally, Marie Antoinette was not allowed many clothes, and those she did have had to suit her new life. They needed to survive the squalor of her new rooms and repeated washings, and to signify her status as a prisoner and 'assassin of the people'. Her trousseau consisted of several simple white shifts, an embroidered muslin skirt, two capelets and three dresses: a printed brown toile de Joüy; a simple chemise with an equestrian-style collar, in a colour known as 'Paris mud'; and a taffeta gown the colour of fleas.6

Fuchsia

Fuchsia is one of the many colours that owes its name to a flower, ¹ and although the fuchsia's distinctive, double-skirted flowers actually come in a variety of ballerina hues – including whites, reds, pinks and purples – it is an achingly bright blue-based pink that adopted the name. Today that might not be considered much of an honour; fuchsia was voted one of the three least popular colours in Britain in 1998, and the word has been the bane of spelling-bee entrants for years. ² However, the story behind the flower's name is, at its heart, about love: the love of botany.

Hippocrates, born some time around 460 BC on the island of Kos, is perhaps the earliest known person to have shown a considered interest in plant life. His study was related to the practice of medicine: many plants were used to treat ailments, or to cause them, and a good doctor needed to know which was which. Later came another Greek, Theophrastus (c. 371–c. 287 BC), who published the first treatise on the subject; then Pliny the Elder (AD 23–79), who mentioned over 800 species of flora in his *Natural History*; and Avicenna, the Persian philosopher, scientist and prodigious author – some 240 of his titles still survive – who was born around AD 980.³ Nearly 700 years later, however, when Leonhard Fuchs, who was studying to become a physician in Bavaria, began his own researches into plants, the field had barely advanced at all.

To rectify the situation, Fuchs began creating a garden that he filled with every kind of plant he could lay his hands on. (All the likenesses of him from that time show a man with a plant grasped in one hand and a singularly focused expression.) He applied to friends all over Europe and those setting off to explore the New World, beseeching them to send him samples or descriptions of plants that they came across. The fruit of all his hard work, the finely

illustrated *De historia stirpium commentarii insignes* (*Notable Commentaries of the History of Plants*), was finally published in 1542.

'We have devoted the greatest diligence,' Fuchs proudly wrote, 'so that every plant should be depicted with its own roots, stalks, leaves, flowers, seeds and fruits.'4 Three artists worked on the book's 512 images. Altogether it described some 400 wild and 100 cultivated plants, including descriptions of species from the New World that few Europeans had ever seen before, such as the chilli pepper – the name he gave it meant 'big pod' in Latin. He also gave evocative names to plants that people must have seen hundreds of times, like the beautiful *Digitalis purpurea* (which means purple fingers) to the common foxglove.⁵

Strangely, though, Leonhard Fuchs never saw the plant that now bears his name. Though now common across much of the world, the first specimen known to Europeans wasn't found until 1703 – some 40 years after Fuchs's death – growing wild on the island of Hispaniola in the Caribbean. The man who found it, Père Charles Plumier, was a botanist and, wanting to honour his hero, named it in Fuchs's honour.

Shocking pink

Known to Winston and Clementine Churchill as 'the

Imbroglio', Daisy Fellowes was a very shocking woman indeed.¹ Born in Paris in the dog days of the nineteenth century, she was the only daughter of a French aristocrat and Isabelle-Blanche Singer, the sewing machine heiress. In the 1920s and 30s she was a notorious, transatlantic bad girl: dosing her ballet teacher with cocaine, editing the French *Harper's Bazaar*, carrying on a succession of high-profile affairs, and throwing parties to which she only invited pairs of mortal enemies. She was, according to an artist acquaintance, 'the beautiful Madame de Pompadour of the period, dangerous as an albatross'; to Mitchell Owens, a writer for the *New York Times*, she was 'a Molotov cocktail in a Mainbocher suit'.²

One of her numerous vices was shopping, and it was one of her purchases from Cartier that unleashed this scandalous shade of pink onto the world. The bright pink Tête de Bélier ('Ram's Head'), a 17.47-carat diamond, had once belonged to Russian royalty.3 Fellowes wore it one day when meeting one of her favourite designers, the inventive, surrealist couturier Elsa Schiaparelli (Fellowes was one of the only two women brave enough to wear the infamous high-heel hat designed in collaboration with Salvador Dalí. Schiaparelli herself was the other.) It was love at first sight. 'The colour flashed in front of my eyes,' Schiaparelli later wrote. 'Bright, impossible, impudent, becoming, life giving, like all the lights and the birds and the fish in the world together, a colour of China and Peru but not of the West – a shocking colour, pure and undiluted.'4 She immediately incorporated it into the packaging for her first perfume, released in 1937.5 The bottle, designed by the surrealist painter Leonor Fini, was modelled after the voluptuous torso of the actress Mae West, and came in a distinctive hot-pink case.

Its name, of course, was 'Shocking'. The colour became something of a touchstone for the designer, cropping up again and again in her collections and even in her own interior decoration: her granddaughter, the model and actress Marisa Berenson, remembers Schiaparelli's bed being covered with heart-shaped, shocking pink pillows.

Age has not dimmed the colour's appeal. In the brash 1980s Christian Lacroix often paired it with bright red: most, however, use it only sparingly. A notable exception can be found in the film Gentlemen Prefer Blondes. In 1953 the costume designer William Travilla was urgently called to the set. The filmmakers were panicking about its star. Marilyn Monroe, as a nude calendar featuring the actress had just been released and the press were in a slavering uproar. The studio decided her assets needed to be more jealously guarded. 'I made a very covered dress,' Travilla later wrote, 'a very famous pink dress with a big bow in the back.'7 It is this outfit Monroe wears when singing the tune that helped seal her place in Hollywood's firmament. 'Diamonds are a Girl's Best Friend'. No doubt Daisy Fellowes, by then a determinedly soignée 63-year-old, wholeheartedly agreed.

Fluorescent pink

On 21 April 1978 the British punk band X-Ray Spex released 15,000 limited-edition copies of their new single, 'The Day the World Turned Day-Glo', on pumpkin-orange 7-inch vinyl. On the cover a globe, roughly coloured in a mixture of yellow, red and poison-bright pink, stands against a lime background. The song's lyrics – almost incomprehensible in lead singer Poly Styrene's screeching yowl – bemoan the world's seeping artificiality.

Fluorescent colours were a hot new thing in the 1970s, amped-up versions of the bright colours beloved by advertisers and pop artists in the 1960s. In 1972 Crayola introduced a special-edition box of eight fluorescent crayons, including the ultra pink and hot magenta colours, all of which glowed brightly under a black light. The strident brashness of super-bright colours perfectly suited the aesthetic of the emerging punk movement too. Highly saturated fluorescent-style pinks were used to paint Mohicans and the lettering of many classic punk albums of the era, like the pink and yellow design on the Sex Pistols' *Never Mind the Bollocks* album designed by Jamie Reid in 1977.

Most of the colours we think of as fluorescent are actually just very high-intensity hues. True fluorescents are so bright not only because the colours are very saturated but also because the chemical structure of the dye or material absorbs the very short-wave light in the ultraviolet portion of the spectrum, which humans can't see, and re-emits them as longer wavelengths, which we can. This is what gives them that particular glowing brightness in daylight, and is also why they shine under black lights.

A favourite use of this technology worldwide is in the humble highlighter pen. Created in the 1960s, highlighters were originally just felt tips with thin, water-based inks that allowed the original text to show through. A decade later fluorescent dyes were added to highlighters to make the portions of text they were brushed over seem even more attention-grabbing. Stabilo have sold over 2 billion highlighters to date, and although they are available in an ever proliferating array of colours, two stand head and shoulders above the rest: 85% of sales go to yellow and pink.²

Amaranth

'A rose and an amaranth blossomed side by side in a garden,' begins Aesop's fable. The amaranth, a leggy plant with fresh green leaves and dense, catkin-like blooms, speaks to her neighbour. 'How I envy your beauty and your sweet scent! No wonder you are such a universal favourite.' But the rose replies, a little sadly: 'I bloom but for a time: my petals soon wither and fall, and then I die. But your flowers never fade . . . they are everlasting.'

Aesop's audience would have known exactly what he meant. Although many of the 50 or so species that make up the genus have some rather unpleasant monikers — 'careless weed', 'prostrate pigweed', 'love-lies-bleeding' — amaranth has long been revered. Its name is homonymic, referring to the plant and also meaning 'everlasting' Garlands of amaranth were used to honour heroes like Achilles because they hinted, with their long-lasting blooms, at immortality.² This symbolism made it irresistible for writers: in *Paradise Lost* John Milton gave the angelic host crowns woven from amaranth and gold [page 86].

The people with the richest relationship with amaranth, however, were the Aztecs, who called it *huautli*. The earliest archaeological evidence for amaranth comes from what is now Mexico and dates from 4000 BC. The plant was an important foodstuff: the leaves can be cooked like spinach and the pin-head-sized seeds can be toasted or milled or popped like corn.³ Some amaranth was grown on special floating gardens, boats filled with soil and set adrift on lakes; the water helped regulate the temperature of the soil and stopped animals getting at the crop.⁴ Farmers delivered some 20,000 tonnes of seed to Montezuma (1466–1520), the last Aztec ruler, each year.⁵

The Spanish conquerors were highly suspicious of amaranth. The problem was not the role it played in the Aztecs' diet, but in their religion. They considered the plant

sacred and it played a key role in many rituals. The Catholic Spaniards were particularly disturbed by the practice of mixing a little blood from human sacrifices into amaranth dough, baking it into cakes which were then broken up and eaten by the faithful. It was all a little too close to a parody of Holy Communion for them to stomach. Growing, eating and even possessing amaranth was outlawed.

What saved the amaranth was its toughness and fecundity. A single seed head can contain 500,000 seeds, and it will grow anywhere. Try as they might, the Spaniards could neither stamp the amaranth out completely, nor erase its association with the divine. In 1629 a priest complained that the locals were supplementing their Christian devotions with little edible figures of Christ baked from amaranth dough. In the nineteenth century there were reports of rosaries being made out of the stuff, and popped amaranth, mixed with honey, is still used to make a sweet called *alegria* ('happiness') in Mexico.⁷

As a colour, too, amaranth has gone into a decline. It was well enough known in the eighteenth and nineteenth centuries to make it into both dictionaries and fashion reports. In May 1890, for example, *Harper's Bazaar* recommended it for both silks and woollens, along with aubergine, prune and lees-of-wine. It was also the name given to an artificial raspberry-hued azo dye first created in the 1880s. This is still used as a food additive – under the name E123 – in Europe, where it gives maraschino cherries their distinctive colour, but has been banned in America because it is thought to be carcinogenic.

Although the name is still occasionally used, there is now no consensus on whether it refers to a cherry red, a dusty grape or a rich plum. Time, sadly, has given the lie to Aesop: the rose's beauty is as beloved as ever, while amaranth's fortunes have withered.

Scarlet
Cochineal
Vermilion
Rosso corsa
Hematite
Madder
Dragon's blood

Red

In 2012 a study was published in the Journal of Hospitality & Tourism Research, advising waitresses to wear red. Why? The research found that if they wore this colour, the tips they were given by male patrons would be increased by up to 26%. (It had no effect whatsoever on female diners, who were stingier tippers overall anyway.)

Psychologists have long been fascinated by red's influence on the human psyche. A 2007 study, for example, tested the effect of colour on intellectual performance. The test subjects were required to solve anagrams. Those whose tests had red covers performed worse than those with green or black; they also chose easier options when given the choice.2 At the 2004 Olympic Games in Athens, combat-sport competitors who wore red won 55% of the time. And in a study of games played since the Second World War, English football teams who wear this colour are more likely to be champions and on average finish higher in the leagues than teams in any other.3 Nor are we the only species to be susceptible. Monkeys such as rhesus macaques and mandrills have cherry-coloured areas on their rumps, faces and genitalia that indicate their testosterone levels and aggression.4 (Although the animal most famously irked by red, the bull, is colour-blind. It is the flutter and swish of the matadors' small muleta cape that the bulls react to – tests have shown that they charge at the *capote*, which is magenta [page 167] on one side and blue on the other, with equal fury.)

It is believed that people first began dyeing cloth sometime between the sixth and fourth millennia BC. Most of the scraps of dyed cloth that date from this time until the Roman era, were coloured a shade of red.⁵ (So special was this colour that for the Romans the words coloured (coloratus) and red (ruber) were synonyms.)

Ancient Egyptians wrapped mummies in linens dyed with hematite [page 150]; Osiris, god of the afterlife and underworld, was also known as the 'lord of the red cloth'.6 It is, along with black, one of the colours the ancient Chinese associated with death, and the contrasting pair appear frequently in tombs and graves. Later it formed part of the influential five-element system, associated with fire, summer and the planet Mars.7 Now, in addition to its link with the Party, the Chinese see it as the colour of joy and good luck: gifts of money, called *hongbao*, are given in lacquer-red envelopes at special occasions like weddings.

As the colour of blood, red is also strongly associated with power. The Inca deity Mama Huaco was said to have emerged from the Cave of Origin wearing a red dress.8 Pliny mentioned that the red dye cochineal was reserved for Roman generals, and the colour, however conspicuous and impractical, has often been used by warriors since, including the British redcoats. The Aztecs painstakingly deposited cochineal [page 141] insect eggs onto cactus leaves with fox-hair brushes so that their rulers would have a ready supply of red-fringed headdresses and their priests could attract the attention of the gods during rituals.9 On the other side of the Atlantic, both kings and cardinals were inordinately fond of luxurious red clothes. In 1999 it appeared in around 74% of the world's flags, making it by far the most popular colour to exemplify a nation's identity.

As well as power, red has baser associations with lust and aggression. The devil is traditionally depicted in red. The association of red and sex in the West dates back at least until the Middle Ages. It was frequently the colour assigned to prostitutes in the many sumptuary laws passed over the course of the period. ¹⁰ Small wonder that it has had a stormy relationship with women. Hester Prynne,

the heroine of *The Scarlet Letter*, has so fascinated readers since the novel's publication in 1850 because she defies easy categorisation. On the one hand, she flouts the conventional sexual purity of her age and sex, but on the other, she accepts the condemnation of her Puritan neighbours and meekly wears a scarlet 'A' as punishment. The ambivalent relationship between women and red can be seen in other works of fiction, including *The Bride Wore Red*, 'Little Red Riding Hood' and *Gone with the Wind*.

This potent brew of power and sexuality make the colour a bold but tricky choice for brands. Virgin is perhaps the best example of a company that has successfully harnessed red's innate power, but only by positioning itself as a bold outsider. Coca Cola owes its livery to the red and white flag of Peru, which is where the company sourced the coca leaves and cocaine its drinks contained until the 1920s. 11 Artists of all stripes have relied heavily on the shades between oxblood and persimmon to add drama, eroticism and depth to their work. For the Pre-Raphaelites reds - and redheads [page 104] - were almost talismanic. Rothko, who wrote that his art's principle concern was 'the human element', layered tone upon tone of red on his giant canvases. He identified it, as the art critic Diane Waldman put it 'with fire and with blood'. Anish Kapoor, an avid user of colour, spent the 1980s rendering his pyramidic, phallic and vulva-like sculptures in a red so bright it almost vibrates. His Svayambh (2007) was a slow, crimson train of pigment and wax that squeezed itself back and forth through the triumphal doorways of the Royal Academy in 2009, looking, absurdly, like a voluptuously overweight lipstick. This mobile artwork, just like the red light on the traffic light, stopped people in their tracks.

Scarlet

On 8 February 1587 Mary Queen of Scots was executed after eighteen years' imprisonment. Contemporary accounts of her death at Fotheringhay Castle are gruesome: several report that it took two blows to sever her neck, others say that when her head was held aloft her wig came off to reveal the near-bald scalp of a sick old woman. What many agree on, however, is that before the execution, Mary carefully removed her sombre outer clothes to reveal a bright scarlet undergown. Sympathetic onlookers would have had no difficulty unravelling her intended message: scarlet was closely associated in the Catholic Church with martyrdom. For those hostile to the Scottish queen and her faith, however, her bright red dress was a clear link to the archetypal scarlet woman, the biblical Whore of Babylon.

This binary reading is typical of scarlet. Although it has long been prized as a colour for the prestigious and powerful, it has, from the beginning, always been a victim of unintended meanings. The very name, for example, did not initially refer to a colour at all, but to a kind of particularly admired woollen cloth. From the fourteenth century, because fine cloth was so often coloured with kermes, the brightest and most resilient dyestuff then known, the word came to denote the colour instead.

Like cochineal [page 141], kermes dye was made from the bodies of insects so small that they were often mistaken for seeds or grains.¹(Pliny, writing in the first century AD, described it as 'a berry that becomes a worm'.) Making a single gram of this precious red required the bodies of up to 80 female kermes beetles imported from southern Europe, making it very expensive, and getting precisely the right tone took skill. The finished product, though, was a dye so bright and colourfast that cloth dyed with it became the epitome of luxury.

An account book from the reign of King Henry VI, who ruled England during the fifteenth century, shows that it took a master mason a month to earn enough to buy a single yard of the cheapest scarlet cloth; the dearest cost twice as much.²

Charlemagne, the Frankish king who ruled during the early Middle Ages, is said to have worn scarlet leather shoes when he was crowned Holy Roman Emperor in AD 800. Richard II of England followed sartorial suit 500 years later. Sumptuary laws passed in León and Castile in the thirteenth century restricted use of the colour to kings.³ Red-haired Elizabeth I, who knew a thing or two about the power of appearances, enjoyed wearing scarlet as a princess. It would not do, though, as a colour for the virgin queen, and so after her coronation in 1558 she took to wearing neutral or broken tones like tawny, gold and ash. However, this emblem of majesty was too useful to cast aside completely: Elizabeth hit upon the ruse of dressing her ladies-in-waiting and retainers in scarlet instead, presumably so that they could act as a dramatically symbolic backdrop. William Shakespeare, in his role as a royal actor, was given four and a half yards of cloth with which to fashion himself scarlet livery to wear at the coronation of Elizabeth's successor, James I.4And where wealth goes, power soon follows. Pope Paul II decreed in 1464 that his cardinals were to wear robes of rich scarlet instead of purple; the poor Tyrian-purple molluscs [page 162] being all but extinct by this time.5 The habit stuck and scarlet became inextricably linked with insignia, particularly in the Church and academia, a heritage Mary was drawing on at her execution.

Although many associate the British with the idea of red military uniforms, scarlet's dalliance with men in uniform dates back much further. The highest orders

Scarlet, continued.

of Roman generals wore bright red *paludamenta* – cloaks signalling leadership, which fastened over one shoulder.⁶ It was taken up by the English under Oliver Cromwell, who specified that officers' coats should be dyed scarlet in Gloucestershire using a newly discovered recipe.⁷

In 1606 Cornelis Drebbel, a Dutch scientist and the first man to build a working submarine, was making a thermometer in his lab in London. As the (likely apocryphal) story goes, he boiled up a solution of purplered cochineal and left it under his windowsill to cool. Somehow a phial of *acqua regia*, a strong acid mixture, broke and spilled across the tin window frame, splashing into the cooling cochineal and instantly turning the liquid bright scarlet. One dyer's manual called the result 'Flame-coloured scarlet'. 'The finest and brightest colour,' the author wrote, 'on the orange, full of fire, and of a brightness which dazzles the eye.'

Naturally, this brilliant red has had plenty of detractors too. It was a favourite of the Wife of Bath, Chaucer's morally ambivalent character in 'The Canterbury Tales'. Shakespeare used it in conjunction with hypocrites, indignation and 'sinne.'10 A purple passage from the Book of Revelations in the King James Bible - 'I saw a woman sit upon a scarlet coloured beast' - led Puritans to argue that the entire Catholic Church, now known for its red-robed cardinals, was evil. It was this heritage that Aleister Crowley, the twentieth-century occultist, drew on when he created the Scarlet Woman, the Thelemic deity of female desire and sexuality. And while the hue has been almost continually in fashion since the fourteenth century, not everyone has approved. Scarlet 'is a charming colour', Arthur's magazine conceded in February 1885, 'in spite of its being a favourite with Indians and barbarians generally'.11

Cochineal

Viewed with the naked eye, the female *Dactylopius coccus* could be mistaken for a seed or a piece of grit; scarcely bigger than a pinhead, it is a grey, slightly ridged oval. It was only when one was examined under a microscope at the very end of the seventeenth century that lingering doubts were put to rest: *Dactylopius coccus* is, in fact, an insect. And, while it may look inconsequential, this insect has made and felled kings and empires, and helped shape history.

Today the coccus is most likely to be encountered in Mexico or South America, huddled in a snowy white cluster on the sunny side of a prickly pear cactus leaf, on which they feed exclusively and voraciously.1 If you were to pluck one off and squeeze hard enough to crush it, your guilty fingers would be stained bright crimson. Turning this bright red bug juice into a dye, often called carmine, is relatively easy. One needs only the insects and a mordant, usually alum, to help the colour adhere to the cloth; by using other additives, such as acids or metals like tin, the colour of the dye can be shifted from pale pink to a red so dark it is almost black.2 It requires a lot of insects - around 70,000 dried bugs for a pound of raw cochineal - but the end result is one of the strongest and brightest the world has ever known. The colourant (mostly carminic acid), from a pound of 'domesticated' or farmed coccus, is said to be equivalent to around 10 or 12 pounds of kermes [page 138].3

Civilisations have been aware of cochineal's colourful secret for quite some time. It was used as a dye in Central and South America from at least the second century BC and became intrinsic to the Aztec and Inca empires. A list written around 1520 recorded a list of the tributes the Aztecs required from their subjects: the Mixtec people were to give 40 sacks of cochineal per year; the Zapotecs,

Cochineal, continued.

20 bags every 80 days. It was also used to signal personal power in the region. Captain Baltasar de Ocampo, who in 1572 witnessed the execution of Túpac Amaru, the last of the royal Inca line, carefully described the king's outfit in a moving eyewitness account of his death.

[Dressed in a] mantle and doublet of crimson velvet. His shoes were made of the wool of the country, of several colours. The crown or headdress, called mascapaychu, was on his head, with fringe over his forehead, this being the royal insignia of the Inca.⁵

When his head fell, the Inca ruler was clothed in a symphony of cochineal.

It was in part for the sake of cochineal that this Inca king – and many other South American rulers – died. Spain was desperate to exploit the region's natural resources, and they were not slow to capitalise on them once they gained control. Along with gold [page 86] and silver [page 49], cochineal provided the financial sinew on which the Spanish empire depended. One observer wrote that in the year 1587 alone, around 144,000 pounds or 72 tons of cochineal were shipped from Lima to Spain.⁶ (That is roughly 10,080,000,000 insects.)

Once the shipments arrived in Spain – they were legally required to land in Seville or Cádiz until the eighteenth century – cochineal was exported to paint the towns and people of the world red. It dyed the famous Venetian velvets from the mid-sixteenth century, funded the Dutch dye industry, clothed Roman Catholic cardinals, gave women's cheeks a rosy flush and was also used as medicine. King Philip II of Spain was dosed with a revolting mixture of crushed bugs and vinegar when he felt under the weather. Later it was traded to Cambodia and Siam, and by 1700 the Chinese Kangxi emperor

referred to a foreign dyestuff called *ko-tcha-ni-la*, later renamed *yang hong*, or 'foreign red'.⁸ Americans, desperate for the bright dyestuff but furious that, because it could only be traded to them via Spain, it cost so much, would pore over the contents of shipwrecks in case they contained cochineal. The *Nuevo Constante*, which sank off the coast of Louisiana in 1766, was found to contain over 10,000 pounds of the dye in leather sacks.⁹ It was deemed so valuable that there were several attempts to bug-nap cochineal in order to break the Spanish monopoly. A foolhardy attempt in 1777 by Nicolas-Joseph Thierry de Menonville, a botanist from Lorraine, was covertly financed by the French government.¹⁰

Beetles are still being harvested today to produce the cochineal used by the cosmetics and food industries. It is found in everything from M&Ms to sausages, red velvet cupcakes to cherry coke (to soothe the squeamish it is usually hidden under the far more innocuous label E120). There are signs, however, that humanity's appetite for cochineal may finally be waning: in 2012 Starbucks abandoned it as the principal red food colouring in strawberry Frappuccinos and cake pops after an outcry from vegetarians and Muslims. Excellent news for *Dactylopius coccus*, but perhaps less so for the world's prickly pears.

Vermilion

By the beginning of the twentieth century, Pompeii had been the site of an archaeological dig for over 150 years. What had begun as a scramble to strip away ancient trophies for the private collection of the Bourbon king Charles III, had evolved into an effort to preserve the wonders of the city that had been simultaneously destroyed and preserved by the eruption of Vesuvius in AD 79. In April 1909, when it seemed as if Pompeii might have disgorged most of its secrets, archaeologists discovered a luxurious home with large windows, overlooking the sea. Within a week of the first excavation, a red mural was uncovered that was so well conserved, elaborate and unfathomable that ever since the site has been known as the *Villa dei Misteri* – 'Villa of Mysteries'.

The walls of the room are covered with expressive images of people on an intense ground of deep red vermilion. In one corner a winged figure raises a whip to strike the back of a naked woman kneeling with her face buried in the lap of another. Near the entrance a small boy is lost in the contents of scroll he is reading; at the centre a drunken man lolls against the skirts of a seated figure. Guesses as to what it all means are boundless, but the extravagant use of vermilion tells us that whatever its purpose, this room was intended to induce awe: vermilion was the most coveted red pigment available at the time.

A natural supply of vermilion (mercury sulphide) comes from the mineral cinnabar. This wine-red stone is the principal ore of the metal mercury – the Roman architect Vitruvius picturesquely described the dark red rocks sweating droplets of quicksilver. To become a useful pigment it need only be finely ground. The Romans adored it. A jar of ready-ground cinnabar of the kind used in the villa was unearthed in a pigment shop in the town

below the *Villa dei Misteri*. Pliny wrote that it was used during the religious holidays, smeared on the face of statues of Jupiter, and on the bodies of worshippers. Vermilion, though, was scarce. Much of the Roman supply came, under guard, from Sisapu in Spain, and cost 70 sesterces a pound, ten times the price of red ochre. ²

It was when people discovered how to manufacture vermilion artificially, however, using a reaction that resembled magic, that desire for the pigment really intensified. No one is quite sure who made the discovery, or when: alchemists were fond of using elaborate codes for ingredients and hinting that they possessed special knowledge, without revealing precisely what this knowledge might be. The Greek alchemist Zosimus of Panopolis insinuated that he knew the secret sometime around AD 300, but the first clear description is in *Compositiones ad tingenda* ('Recipes for Colouring'), a Latin manuscript from the eighth century.³

The reason for all this subterfuge lies in alchemists' obsession with creating gold [page 86], which to them was red, rather than yellow, and which they therefore linked with this new red pigment. Even more significant was the fact that making vermilion required the combination and transformation of two key alchemical ingredients: mercury and sulphur. The alchemists forging vermilion were convinced the secret to producing unlimited supplies of gold could not be far away.

The most evocative description of what became known as dry-method vermilion was written by the twelfth-century Benedictine monk Theophilus. He described mixing one part ground sulphur with two parts mercury, which was then carefully sealed in a jar:

Vermilion, continued.

Then bury [the jar] in blazing coals and as soon as it begins to get hot, you will hear a crashing inside, as the mercury unites with the blazing sulphur.

If conducted carelessly, the reaction could be even more dramatic than intended. The mercury fumes released if the jars weren't sealed properly were so poisonous that the process was banned in Venice in 1294.4

Vermilion was once as costly and precious as gold.⁵ It reigned supreme as medieval artists' red and was used, reverently, alongside gold leaf and ultramarine for manuscript capitals and on tempera panels. It was glazed with a revolting mixture of egg yolk and earwax.⁶

But this prince of reds was too profitable for recipes and manufacturers to remain scarce. In 1760 Amsterdam, the principal source of Dutch dry-method vermilion during the seventeenth and eighteenth centuries, exported just under 32.000 pounds to England.7 A wet method of manufacture, discovered by the German chemist Gottfried Schulz in 1687, made it more common still. Even as early as the fifteenth century artists had been all but profligate with its use: Leonardo da Vinci occasionally used it as a grounding layer for his paintings.8 Not only was vermilion becoming more common, it was also adversely affected by the rise of oils as the painting medium of choice in the West from the fifteenth century onwards: vermilion was less opaque in oils, and so worked better either as a base layer on which to apply other red glazes, or as a glazing laver itself.

In tempera and lacquerwork, though, its colour is breathtaking, and it has seduced artists the world over. A Chinese handscroll painting, *Tribute Horse and Groom* by Chao Yung, shows a man wearing a fire-red coat with an indigo collar, and a strange, rust-coloured pointy hat,

leading a beautiful dappled grey horse. Although it was painted in 1347, the vermilion-painted coat still strikes the eye like a hammer. The same effect was used three centuries later by Peter Paul Rubens in the central panel of his triptych *The Descent from the Cross* (1612–14), although its use declined thereafter. In 1912, just a few years after the Villa of Mysteries was uncovered, Wassily Kandinsky described vermilion's colour as 'a feeling of sharpness, like glowing steel which can be cooled by water'. In 1912, in the same part of the sa

Rosso corsa

In September 1907 a neatly built man with a deep widow's peak and a large nose sat at his desk in his neo-Gothic palace on the Isola del Garda. Although a month had elapsed since his return to the island, he was still sunburnt and travel sore and, although he knew it was unbecoming to show it, rather pleased with himself. 'There are people who say that our journey has proved one thing above all others,' wrote the man the society pages knew as Prince Scipione Luigi Marcantonio Francesco Rodolfo Borghese. 'Namely, that it is impossible to go by motorcar from Peking to Paris.' He was being facetious, of course, because that is precisely what he had just done.

It had all begun some months earlier, when the French newspaper *le Matin* had printed a challenge on the front page of the 31 January 1907 edition: 'Will anyone agree to go, this summer, from Peking to Paris by motorcar?' Prince Borghese, who had already travelled through Persia and had acquired a taste for adventure, promptly accepted, along with four other teams, three of them French and one Dutch. The only prize was a case of Mumm champagne – and national honour. Naturally Borghese, as a proud Italian aristocrat, insisted that his vehicle be a product of his native country. The technology was still in its infancy – the first car ever built was only then celebrating its twenty-first year – and choices were few. Borghese chose a 'powerful but heavy' 40-HP Itala model from Turin, which was painted a strident poppy red.³

The race took the contestants some 12,000 miles, past the Great Wall of China and through the Gobi Desert and Ural Mountains. So confident was Borghese of winning that he strayed several hundred miles from the route so that he and his passengers could attend a banquet held in their honour in St Petersburg. As they suffered on the long journey, so the car suffered too. Before its departure Luigi

Barzini, a journalist and one of Borghese's companions, wrote of the Itala: 'it conveyed an immediate impression of purpose and go.' At Irkutsk, a city in south-east Russia, it was looking rather more forlorn. Even after a 'careful external toilette' by Ettore, Borghese's mechanic, 'It was weather-beaten and, like ourselves, had taken on a darker shade.' By the time they reached Moscow it was 'the colour of the earth'.'

None of this mattered, however – either to the contestants or their adoring Italian fans – when the team roared victorious through the Parisian boulevards. In honour of their victory their car's original hue became Italy's national racing colour and later the one adopted by Enzo Ferrari for his cars: rosso corsa, racing red.⁵

Hematite

When Wah, an ancient Egyptian storehouse manager, was mummified in around 1975 BC, he was first wrapped with undyed linen. Amulets and trinkets were secreted between the layers and then, as the finishing touch, he was swathed in a hematite-red cloth that had the words 'Temple linen to protect' along one edge. Osiris, the ancient Egyptian god of the afterlife, was, after all, referred to as 'lord of the red cloth' in the Book of the Dead, and it never hurts to show up to a big event appropriately dressed.¹

The use of hematite in Wah's preparation for the afterlife is just one example of the central role it has played in a whole host of spiritual duties. For the sake of simplicity, *hematite*, which is, strictly speaking, the mineral form of iron oxide, here also includes other kinds of red iron oxides and ochres. All owe their colouring to the same compound: Fe₂O₃, anhydrous iron oxide, or, more simply, rust.² This incestuous family of pigments occurs naturally and widely across the Earth's crust. They come in many different shades of red, from pink through to cayenne; when heated, yellow ochre can even be turned red.

Objects stained deep red have accompanied human habitation since the Upper Paleolithic era, some 50,000 years ago.³ Although not ubiquitous, hematite's use is so widespread that in an article from 1980, the anthropologist Ernst E. Wreschner went so far as to call its collection and use one of the 'two meaningful regularities in human evolution'; the other being tool-making.⁴ Tools, shells, bones and other small objects stained with hematite have been found at Paleolithic sites in Gönnersdorf in Germany, North Africa, Mesoamerica and China.⁵ Perhaps because it resembles blood, it was also widely used in ancient burial rituals. Sometimes it seems as if it has just been sprinkled over or on the body, but in other cases its use is more elaborate. In China it is often found paired with black.⁶

In Egypt, linens stained with hematite, such as those used to wrap Wah's body, have been found dating back to the second millennium BC.

Natural sources of hematite were much prized. In the fourth century BC a law was passed granting Athenians a monopoly over a particularly rich variety on the island of Kea, which they used in everything from shipbuilding to medicine to ink.7 (The ink was so popular for titles and subtitles that the word 'rubric' – from the Latin *rubrica* or *red ochre* – evolved from this practice.)

So why all the prehistoric fuss? The answer seems to lie in the human affinity for the colour red. Most anthropologists and archaeologists believe that, as the colour of blood, red is associated with life – celebration, sex, joy – danger and death. As a conduit to so many useful symbolic meanings, hematite was prized. The fate of the mineral as a pigment provides compelling proof for two theories: if the first is that the colour red holds a special place in the human psyche, the second is surely that people are shamelessly attracted to bright colours. Hematite – which, though red, is not bright – was demoted the moment a more vivid alternative became available. It seems that humanity or, at least its taste in reds, has rather ungratefully evolved past it.

Madder

'The flower is very small, and of a greenish yellow colour,' the man said. 'The root is cylindrical and fleshy, and of a reddish yellow colour." The audience did not know it yet, but the lecture being delivered to the Royal Society of the Arts in London on the evening of 8 May 1879 was going to be a long one. Though the speaker was distinguished, with an imposingly full set of whiskers. he was neither naturally entertaining, nor brief. Over several hours William Henry Perkin, the scientist and businessman who had discovered mauve [page 169] and revolutionised the dye industry, told the assembled listeners, in rich, exact detail, about another breakthrough: the synthesis of alizarin. By the end, only the most determined of his listeners would have grasped the significance of his achievement. Alizarin was the red colourant in the roots of Rubia tinctorum, Rubia peregrina and Rubia cordifolia, better known as madder. Perkin had been able to create in a lab something hitherto only produced by nature.

As he went on to explain to his increasingly inattentive listeners, madder is an ancient dyestuff. Although madder plants are unprepossessing, their pinkish roots, when dried and crushed, pounded and sifted, relinquish a fluffy, orange-brown powdery pigment that has been a long-serving source of red. It was used in Egypt from about 1500 BC, and fabric stained with the plant's root was found in Tutankhamun's tomb.² Pliny wrote of its importance in the classical world, and it was discovered among the wares of a paint-maker's shop in the fossilised city of Pompeii.³ Once the use of mordents that made madder more colourfast spread, its influence grew still further. India's chintz fabrics were printed with it; it dyed medieval wedding clothes an appropriately celebratory shade; and it was used as a cheaper alternative to cochineal [page 141]

for British redcoats. It could also be used to make rose madder paint, a bright pinky-red artists' pigment, which George Field waxed passionate about in *Chromatography* in 1835. 5

It was as a dye, however, that the big money could be made from madder. For a long time the Turkish had a monopoly on a special method of using madder to obtain a red so bright it could almost trump its more expensive rivals. In the eighteenth century, first the Dutch, then the French and finally the British uncovered the malodorous secret of Turkey Red - it was a tortuous process involving rancid castor oil, ox blood and dung.6 The trade must have seemed unassailable. By 1860 imports to Britain were worth over £1 million annually but were often of poor quality. The French were accused of adulterating their madder with everything from brick dust to oats.7 The cost soared too: by 1868 a 100-weight cost 30 shillings, a week's wages for a labourer. A year later the same amount would cost just 8 shillings.8 This, of course, was due to the simultaneous discovery by Mr Perkin in Britain, and three German scientists in Berlin, of the process for synthesising alizarin. For the first time in history, clothes could be dyed madder red without a single Rubia tinctorum being uprooted.

Dragon's blood

On the morning of 27 May 1668, a gentleman was riding through a remote corner of Essex in south-east England when he stumbled across a dragon. It had been sunning itself at the edge of a birch wood but suddenly reared up at his approach. It was vast: nine feet from hissing tongue to tail, about as thick as a man's thigh, with a pair of leathery wings that appeared far too small to get its enormous bulk airborne. The man spurred his horse and 'with winged speed hafted away, glad that they had escaped such an eminent danger'.

But the tale of the beast was not quite over yet. Men from the nearby village of Saffron Walden, perhaps worried that the dragon might become peckish and begin making inroads into their cattle herds, or perhaps bored and sceptical, set out in pursuit. To their surprise they found it in almost exactly the same place. Again it lifted the front of its body into the air and, hissing loudly, disappeared into the underbrush. The villagers saw it again and again over the next few months, until one day, without explanation, they found the birch wood to be dragon-free once more. The whole saga was written down in a pamphlet, 'The Flying Serpent or Strange News out of Essex', a copy of which is still on view at the local library.'

It is odd to think that, at the same moment villagers were scouring the local countryside trying to see off a dragon, some forty miles away in London Isaac Newton was beginning to foment the scientific revolution. Perhaps the dragon's appearance was a last-gasp display from a creature that was on the cusp of being driven forever into the realm of myth by the advance of the enlightenment. And with the dragon, of course, went its blood, which had been an exclusive pigment since before the birth of Christ. When Pliny, deploring an ever-expanding palette distracting artists from the serious business of art, wrote

that 'India contributes the ooze of her rivers and the blood of dragons and elephants', he was referring to dragon's blood.² The belief was that elephants had cooling blood and dragons, during the dry season, craved something cool to slake their thirst. The dragons would hide in trees, waiting to ambush any elephants who might wander underneath, and then pounce. Sometimes they killed the elephants outright and drank their blood, but sometimes the elephant would crush the dragon and they would die together, their two bloods mixing to form a red resinous substance called dragon's blood.³

As with most myths, this one contains a nub of truth overlaid with a great deal of embellishment. For a start, no animals of any kind, even mythological, are harmed in the production of dragon's blood. But this pigment does exist, it does come from the East and trees do play a part in its production. It is in fact a wound-red resin, drawn often, though not exclusively, from the *Dracaena* genus of trees. George Field, writing in 1835, wasn't enthusiastic. Not only was the pigment 'deepened by impure air, and darkened by light', but it also reacted with the ubiquitous white lead and took forever to dry in oils. 'It does not,' Mr Field concluded sternly, 'merit the attention of the artist.'

He was, by this time, preaching to a choir of disenchanted artists: they had little use for yet another red, particularly one with such obvious limitations. Without widespread belief in dragons to sustain it, dragon's blood followed Saffron Walden's winged serpent into obscurity.

Tyrian purple Orchil Magenta Mauve Heliotrope Violet

Purple

In The Colour Purple, the Pulitzer-Prize-winning novel by

Alice Walker, the character Shug Avery seems at first like a superficial siren. She is, we are told, 'so stylish it like the trees all round the house draw themself up tall for a better look'. Later, though, she reveals unexpected insightfulness, and it is Shug that supplies the novel's title. 'I think it pisses God off,' Shug says, 'if you walk by the colour purple in a field somewhere and don't notice it.' For Shug purple is evidence of God's glory and generosity.

The belief that purple is special, and signifies power, is surprisingly widespread. Now it is seen as a secondary colour, sandwiched in artists' colour wheels between the primaries red and blue. Linguistically, too, it has often been subordinate to larger colour categories – red, blue or even black. Nor is purple, per se, part of the visible colour spectrum (although violet, the very shortest spectral wavelength humans can see, is).

The story of purple is bookended by two great dyes. The first of these, Tyrian [page 162], a symbol of the wealthy and the elite, helped to establish the link with the divine. The second, mauve [page 169], a man-made chemical wonder, ushered in the democratisation of colour in the nineteenth century. The precise shade of the ancient world's wonder-dye remains something of a mystery. In fact 'purple' itself was a somewhat fluid term. The ancient Greek and Latin words for the colour, *porphyra* and *purpura* respectively, were also used to refer to deep crimson shades, like the colour of blood. Ulpian, a third-century Roman jurist, defined *pupura* as anything red other than things dyed with *coccus* or carmine dyes. Pliny the Elder (AD 23–79) wrote that the best Tyrian cloth was tinged with black.

Even if no one is quite sure precisely what Tyrian purple looked like, though, the sources all agree it was the

colour of power. While he griped about its odour, which hovered somewhere between rotting shellfish and garlic, Pliny had no doubt about its authority:

This is the purple for which the Roman fasces and axes clear a way. It is the badge of noble youth; it distinguishes the senator from the knight; it is called in to appease the gods. It brightens every garment, and shares with gold the glory of the triumph. For these reasons we must pardon the mad desire for purple.³

Because of this mad desire, and the expense of creating Tyrian, purple became the symbolic colour of opulence, excess and rulers. To be born into the purple was to be born into royalty, after the Byzantine custom of bedecking the royal birthing chambers with porphyry and Tyrian cloth so that it would be the first thing the new princelings saw. The Roman poet Horace, in his *The Art of Poetry* written in 18 BC, minted the phrase 'purple prose': 'Your opening shows great promise, / And yet flashy purple patches; as when / Describing a sacred grove, or the altar of Diana.'4

Purple's special status wasn't confined to the West. In Japan a deep purple, *murasaki*, was *kin-jiki*, or a forbidden colour, off-limits to ordinary people.⁵ In the 1980s the Mexican government allowed a Japanese company, Purpura Imperial, to collect the local caracol sea-snail for kimono dyeing. (Unsurprisingly, a similar Japanese species, *Rapana bezoar*, is vanishingly rare.) While the local Mixtec people, who had been using the *caracol* for centuries, milked the snails of their purple, leaving them alive, Purpura Imperial's method was rather more fatal for the snails and the population went into freefall. After years of lobbying the contract was revoked.⁶

Like many special things, purple has always been

a greedy consumer of resources. Not only have billions of shellfish paid dearly to clothe the wealthy, sources of slow-growing lichens like *Roccella tinctoria*, used to make orchil [page 165], have been over-exploited, forcing people to look further afield or do without. Even mauve required vast quantities of raw produce: in the early stages it was so demanding of scarce raw material that its creator, William Perkin, later admitted that the whole enterprise was close to being abandoned.⁷

Luckily for Perkin, his new dye became immensely fashionable, and the prospect of the fortunes to be made meant that an explosion of other aniline colours followed swiftly on mauve's heels. Whether this was also good for purple is another matter. Suddenly everyone had access to purple at a reasonable price, but they also had access to thousands of other colours too. Familiarity bred contempt, and purple became a colour much like any other.

Tyrian purple

One of the most notorious seductions in history took place in late 48 BC. Shortly before, on 9 August, Julius Caesar had defeated the far larger army of his rival and son-in-law Pompey at the Battle of Pharsalus. Now he was in Egypt and the most famous woman in the world, less than half his age, had smuggled herself past his guards and into his apartment rolled in a rug. When, nine months later, Cleopatra gave birth to a son called Caesarion, 'Little Caesar', the proud father returned to Rome and promptly introduced a new toga, which only he was allowed to wear, in his paramour's favourite colour: Tyrian purple.¹

This rich tone – ideally the colour of clotted blood, according to Pliny - was the product of two varieties of shellfish native to the Mediterranean, Thais haemastoma and *Murex brandaris*. Were one to crack open the shell of one of these spiky, carnivorous gastropods, they would see a pale hypobranchial gland or 'bloom' transecting its body. If this were squeezed, a single drop of clear liquid, smelling of garlic, would be released. Within moments, the sunlight would turn the liquid first pale yellow, then sea green, then blue and finally a dark purple-red. The best colour, so deep it was tinged with blackness, was obtained by mixing the fluids from both kinds of shellfish.2 Getting the colour to adhere and permeate cloth involved a long and foul-smelling process. The liquid harvested from the shellfish glands was placed in a vat of stale urine (for the ammonia) and allowed to ferment for 10 days before the cloth was added; some accounts recommended treating cloth to two separate baths.3

The earliest evidence of Tyrian dyeing comes from the fifteenth century BC. The odour of rotting sea snails, aging urine and the fermenting mixture must have been overpowering – archaeologists have tended to find ancient dyeworks relegated to the outskirts of towns and cities.

The dye was particularly associated with the Phoenicians, from Tyre, who gave it fame and made a fortune trading it across the region. Tyrian-dyed cloth is mentioned in Homer's *Iliad* (c. 1260–1180 BC) and Virgil's *Aeneid* (c. 29–19 BC) and depictions of it have also been found in ancient Egypt.

The colour's popularity was terrible news for the *Murex* and *Thais*. Since each specimen contained a single drop, it took around 250,000 to make an ounce of dye.⁵ The piles of shells discarded millennia ago are so large they have become geographical features littered along the eastern coast of the Mediterranean. The huge labour involved – each snail, for example, had to be caught by hand – had two, interrelated effects. The first was to make Tyrian purple eye-wateringly expensive. In the mid-fourth century BC it cost as much as silver; soon enough, Tyrian-dipped cloth was literally worth its weight in gold. By the third century, one Roman emperor told his wife he could not afford to buy her a Tyrian dress.⁶

The second was to associate the colour with power and royalty. In Republican Rome it was a tightly constrained badge of status. Triumphant generals could wear a purple and gold robe; those in the field, plain purple. Senators, consuls and praetors (a kind of magistrate) wore a broad Tyrian band on their togas; knights a narrow band. This visual hierarchy changed upon Caesar's return to Rome, when the rules became even more draconian. By the fourth century AD only the emperor was allowed to wear Tyrian purple; anyone else caught wearing it could face death. Once, the emperor Nero saw a woman in mollusc-mauve at a recital. He had her dragged from the room, stripped naked and relieved of her property, so seriously did he equate the colour with imperial power. Diocletian, a Roman ruler who was more pragmatic (or perhaps just

Tyrian purple, continued.

greedier) than the others, said that anyone could wear the colour, just so long as they could afford the exorbitant fee and all the profit went to him. Further east, Byzantine queens gave birth in wine-dark rooms so that the royal offspring were said to be born 'in the purple', thus cementing their right to rule.

Fortunately for the poor snails, international politics and fate granted them a reprieve before they could be wiped out completely. In 1453 Constantinople, the capital of the Roman and Byzantine empire, fell to the Turks and with it was lost the secret of the manufacture of the world's finest purple. It was another four centuries before an obscure French marine biologist called Henri de Lacaze-Duthiers stumbled across the *Murex* and their purple. ¹⁰ The year, though, was 1856: the very same year in which another shade of purple, mauve [page 169], went into production.

Orchil

Colour can be found in the most unpromising of places.

Orchil (alias: archil, orchell, tournesol, orcein and cudbear) is a dark red-purple dye, made from lichens. Most people know lichen when they see it growing flatly on bricks or the bark of trees, but few take much notice. On closer inspection, lichen proves more intriguing. It is not a single organism but usually two, typically a fungus and an alga, living in a symbiotic relationship so close that it takes a microscope to distinguish one from the other.¹

Several lichens can be used to make dye. Early modern Dutch dyers produced one called Lac or Litmus, which they sold in the form of small, dark blue cakes. (Lichens are very sensitive to differing pH levels and doctors could grind up various species and use them to test the acidity of a patient's urine, hence 'litmus test'.) The one principally used for orchil is called *Roccella tinctoria*. Seen clinging to a rock, it does not look very promising at all. Like most of the orchil-producing lichens, it is a nasty buff-grey colour, and it grows in small clumps that resemble pallid seaweed. Lichens such as this grow in many places, including the Canary and Cape Verde Islands, Scotland, and various small sites in Africa, the Levant and South America.²

The secret of orchil production seems to have been lost to the West until the fourteenth century, when an Italian merchant called Federigo travelled to the Levant and discovered the tinting properties of the local lichens.³ On his return to Florence, he began using the lichens to dye wools and silks the much loved, rich purple colour, that had previously been associated only with the (much more expensive) *Murex* pigments. Federigo's enterprise made him rich. His family, sensing a branding opportunity, changed their name to Ruccellis.⁴ Gradually knowledge of the dye spread, first to other Italian dyers – a fifteenth-

Orchil, continued.

century Venetian dyers' manual devotes four chapters to it – and then to other European countries.

Making orchil was arduous. First a source had to be discovered and, because lichen populations proved so fragile, each site was quickly exhausted. To feed the market, lichens were imported at great expense from increasingly far-flung locations as trade routes and empires blossomed.6 The lichens had to be carefully harvested by hand - in May and June for some varieties, August for others - and ground to a fine powder. The following stages were even more finicky. The two essential ingredients are ammonia and time. For much of the period that orchil was produced, the most readily available source of ammonia was putrid human urine. A Venetian recipe from 1540 calls for 100 pounds of powdered orchil and 10 pounds of an alum such as potash to be mixed with urine until it was the consistency of dough. This had to be kneaded frequently, up to three times a day – adding wine when it got too dry - and kept in a warm place for up to 70 days. After which time, 'it will have become so thick that it will be good to use'.7 Even modern recipes, require up to 28 days to produce the right colour.8

Some lichens were said to smell wonderful – like violets – as they developed into a dye, but even so it must often have been unpleasant, stinky and labour-intensive work. The rewards, though, were the colours produced at the end. One was a full-blooded purple fit for royalty; another was much redder. In one telling story, when the Napoleonic army landed in Fishguard, Pembrokeshire, in February 1797, the invading army were spooked by the sight of a group of Welsh women wearing rosy lichen-dyed cloaks. Mistaking them for a crack troop of redcoats, the invaders scattered without having fired so much as a single shot.

Magenta

During the latter half of the nineteenth century, while waves of settlers were busy colonising one frontier in America, another Wild West-style struggle was surreptitiously being waged across Europe. The spoils at stake in this European contest, though, were not territories, but colours.

The colours in question were the aniline dyes, a family of synthetic colourants produced from sticky, black coal tar. The name *aniline* came from *anil*, Spanish for indigo [page 189], coined in 1826 by Otto Unverdorben, a German chemist who had been working on isolating the indigo plant's colourant in his lab. The first synthetic aniline to be created was the startlingly purple mauve [page 169], which was accidentally discovered by a London teenager in 1853. This, though, was only the beginning. It was immediately obvious that aniline had a good deal more to offer the world of colour. Across the world, scientists began feverishly testing the new compound with anything and everything they could get their hands on.

One of the first to strike it lucky was François-Emmanuel Verguin. He had been the director of a factory that produced yellow from picric acid, but in 1858 he joined a rival firm, Renard Frères & Franc, and, almost immediately, created a rich colour on the cusp between red and purple by mixing aniline with tin chloride.¹ He called his new creation fuchsine, after the flower [page 124]. Almost simultaneously, the British firm Simpson, Maule & Nicholson hit upon aniline red. This eye-searing colour was an immediate success. The first customers, intriguingly, were several European armies, who it used to dye their uniforms. The names though – 'fuchsia' in France and 'roseine' in Britain – would not do for so dashing and assertive a hue. Instead it became known as 'magenta', in honour of the small

Magenta, continued.

Italian town near Milan where, on 4 June 1859, the Franco-Piedmontese army had won a decisive victory against the Austrians.

Soon magenta was pouring out of rival factories in Mulhouse, Basle, London, Coventry and Glasgow, and onto the backs of a public hungering for bright, affordable new clothing. Within the space of a few years a slew of other anilines – a yellow, two shades of violet, aldehyde green, bleu de Lyon, bleu de Paris, Nicholson's blue, dahlia (somewhere between mauve and magenta) and a black – had flooded the market. Regulars at the Black Horse pub, an establishment a stone's throw from Perkin's dyeworks at Greenford Green, were fond of saying that their stretch of the Grand Junction Canal turned a different colour each week.²

All this experimentation, sadly, contained the seeds for magenta's decline in fashion. For the next decade the industry was paralysed by a succession of lawsuits, as firms began trying to enforce their patents and guard their intellectual property. Verguin himself profited little from his creation: his contract at Renard Frères & Franc had signed over the rights to any colour he created in return for one-fifth of the profits.³ In the early twentieth century it was discovered that a number of these miraculous new colours contained dangerous levels of arsenic, up to 6.5% in some samples of magenta. More subtly, so much choice led to consumer neophilia; magenta was now one option among thousands. Its survival is largely thanks to colour printing. The colour is associated almost exclusively with the (decidedly pink) process ink used in CMYK colour printing.

Mauve

Malaria was rife in Europe during the eighteenth and nineteenth centuries. In the 1740s Horace Walpole wrote, with the preoccupation typical of a beleaguered tourist, of 'a horrid thing called the *mal'aria* that comes to Rome every summer and kills one'. (The word *malaria* is a corruption of the Italian for 'bad air', as it was believed the disease was airborne; the connection with mosquitoes wasn't established until later.) Half of all the patients admitted to St Thomas's Hospital in London in 1853 were diagnosed with ague, or malarial fevers.¹

Quinine, the only known treatment, was extracted from the bark of a particular South American tree and cost a fortune: the East India Company spent around £100,000 on it annually.² The financial incentives for synthesising quinine were obvious. It was partly these, and partly a love of chemistry for its own sake, that drove an 18-year-old scientist to spend his holidays holed up in a makeshift laboratory in his father's East London attic, trying to synthesise quinine from coal tar. Today, William Perkin is celebrated as one of the heroes of modern science. It is not because of quinine, which he never did manage to produce, but because of a rich seam of chemistry that opened up when he accidentally happened upon a particular shade of purple: mauve.

In the first few months of 1856 Perkin's experiments with coal tar, the abundant, oily black by-product of gas lighting, resulted in a reddish powder, which, when further experimented on, produced not colourless quinine, but a bright purple liquid.³ Most chemists would have thrown this errant slop away. Perkin, who had once dreamed of being an artist, dipped a piece of silk into his beaker, and realised that he had made a light- and wash-proof dye. Sensing its commercial possibilities, he initially named his creation after the exclusive colour that had been extracted

Mauve, continued.

from molluscs by the ancient Greeks and Byzantines [page 162]. Soon after, however, he adopted instead the French name for the mallow plant, *mauve*, whose blooms are a similar hue.⁴

It was not an immediate success. Dyers, used to working with plant and animal extracts, were dubious of the newfangled chemical. It was also expensive to make. It took 100 pounds of coal to produce just 10 ounces of coal tar, which in turn yielded only a quarter-ounce of mauve.5 Thankfully for Perkin and for us (without his perseverance, it is possible that coal tar might have been abandoned before the discovery of modern commonplaces, including hair dyes, chemotherapy, saccharin and artificial musk), the spoilt, extravagant wife of Napoleon III, Empress Eugénie, decided that the colour mauve precisely matched her eves. The Illustrated London News notified their readers of the world's most fashionable woman's preference for Perkin's purple in 1857. Queen Victoria took note, and chose to wear 'a rich mauve velvet [dress], trimmed with three rows of lace' with a matching petticoat - 'mauve and silver moiré antique, trimmed with a deep flounce of Honiton lace' - to her daughter's marriage to Prince Frederick William in January 1858.6 By August 1859 Punch declared that London was 'in the grip of the Mauve Measles' and 21-year-old Perkin had become a rich and well-respected man.7

Soon enough, however, mauve went into that most Victorian of things: a decline. Over-consumption, as well as the continuing loyalty of an older generation, meant that the colour soon became shorthand for a particular kind of aging lady. 'Never trust a woman who wears mauve,' Oscar Wilde declared in *The Portrait of Dorian Gray*, published in 1891. 'It always means they have a history.'

Our current queen, perhaps bearing this stigma in mind, vetoed blooms of this colour in palace flower arrangements. More carefree characters, though, have refused to be put off. Neil Munro Roger, the dandy couturier, who invented Capri pants and was known to everyone by his childhood nickname of Bunny, was partial to what he liked to call 'menopausal mauve'. It had become such a signature that at the Amethyst ball he threw to celebrate his 70th birthday, he wore it from egret-feathered top to glimmering cat-suited toe.

Heliotrope

Some colours loom larger in the popular imagination than in real life. Take heliotrope: a plant whose name was forged from two Greek components, *helios*, 'sun' and *tropaios*, 'to turn', because its purple flowers were supposed to turn and follow the sun as it moved across the sky. The colour, in turn, takes its name from the plant's blooms. Really, however, this shrub doesn't follow the light much more than any other, and the most distinctive thing about *Heliotropium* is its sweet, cherry-pie scent. An early ancestor of the plant was used as a perfume ingredient in ancient Egypt and traded with Greece and Rome.

The colour's apogee came towards the end of the nineteenth century, the boom time for many shades of purple. Part of the colour's appeal was novelty. Before William Perkin's mauve [page 169], purple had been difficult to produce, and still retained the imperial glamour of its ancient status, so perhaps the Victorians should be forgiven for the increasingly lurid combinations heliotrope appeared in over the next decade. In 1880 it was paired with light green or apricot; later it was partnered with canary yellow, eucalyptus green, art bronze and peacock blue. 'No colours seem too bright,' as one commentator put it. 'The combinations of them are sometimes quite startling.'²

In the Victorian language of flowers, heliotrope often signified devotion, which is partly why it was one of the few colours women were allowed to wear after the death of a loved one. The cult of mourning reached its zenith during the nineteenth century, with ever more elaborate social rules governing what people, particularly women, could wear in the months and years following the death of a relative or monarch. Heliotrope, and other soft shades of purple, were required wearing during half-mourning. For widows, who endured the most serious degree of grief,

half-mourning was only reached after two years of wearing plain, matt black dresses; for remoter relations, mourning was less severe and subdued colours were allowed from the beginning. A serious outbreak of influenza over the winter of 1890 resulted in a rash of black, grey and heliotrope being worn the following year.³

While this hue's fortunes have suffered something of a collapse in the real world, it has had a distinguished literary afterlife. Badly behaved characters are often described as wearing the colour. The deliciously immoral anti-heroine of Oscar Wilde's *An Ideal Husband*, Mrs Cheveley, makes her entrance in heliotrope and diamonds, before swashbuckling her way through the remainder of the play and commandeering all the best lines. Allusions to heliotrope also crop up in the works of J. K. Rowling, D. H. Lawrence, P. G. Wodehouse, James Joyce and Joseph Conrad. The word is pleasurable to say, filling the mouth like a rich, buttery sauce. Added to which, the colour itself is intriguing: antiquated, unusual and just a little bit brassy.

Violet

In Paris in 1874 a group of artists founded the Anonymous Society of Painters, Sculptors, Printmakers, &c. and began organising their first show. They wanted the exhibition to act as mission statement, rallying call and, most importantly, a snub to the Académie des Beaux-Arts, which had just rejected their work for the prestigious annual Salon. The founder-members of the new group, Edgar Degas, Claude Monet, Paul Cézanne, Camille Pissarro and others, thought the old, academic style of art was too dull, too staid, and too coated in a unifying layer of honey-coloured varnish to capture the world as it really was and, therefore, to have any value at all. The establishment was equally scathing about the Impressionists. In a biting review for le Charivari newspaper, Louis Leroy accused Monet's Impression, Sunrise, of not being a finished painting at all but a mere preparatory sketch. Many more such criticisms were aimed at the fledgling movement over the following years, but one constant theme concerned their preoccupation with a single colour: violet.

Edmond Duranty, an early admirer of the Impressionists, wrote that their works 'procédent presque toujours d'une gamme violette et bleuâtre' ('almost always proceed from a violet and bluish range').¹ For others, this violet tinting was more troubling. Many concluded that the artists were, to a man, completely mad, or at the very least suffering from a hitherto unknown disease, which they dubbed 'violettomania'. It would be as difficult to persuade Pissarro that the trees were not violet, joked one, as to persuade the inmate of a lunatic asylum that he wasn't the Pope in the Vatican. Another wondered if the artists' fascination with the colour was a result of the Impressionists spending too much time en plein air: the violet tint could be the result of a permanent negative

after-image caused by looking at sunny yellow landscapes for too long. Alfred de Lostalot, in a review of one of Monet's solo shows, hypothesised that the artist might be among that rare number of people who could see into the ultraviolet part of the spectrum. 'He and his friends see purple,' wrote Lostalot. '[T]he crowd sees otherwise; hence the disagreement.'2

Their preference for violet was the result of two new-minted theories. One was the Impressionists' conviction that shadows were never really black or grey, but coloured; the second concerned complimentary colours. Since the complimentary colour to the yellow of sunlight was violet, it made sense that this would be the colour of the shade. Soon enough, though, this shade had transcended its role in the shadows. In 1881 Édouard Manet announced to his friends that he had finally discovered the true colour of the atmosphere. 'It is violet,' he said. 'Fresh air is violet. Three years from now, the whole world will work in violet.'

Ultramarine
Cobalt
Indigo
Prussian blue
Egyptian blue
Woad
Electric blue
Cerulean

Blue

During the 1920s the Catalan artist Joan Miró produced

a group of paintings that were radically different from anything he had done before. One of his 'peinture-poésie', a large canvas created in 1925, remains almost completely blank. In the top left-hand corner the word 'Photo' is rendered in elegant, swirling calligraphy; over on the right there is a popcorn-shaped daub of forget-me-not-coloured paint and underneath, the words, in neat, unassuming letters, 'ceci est la coleur de mes rêves' ('this is the colour of my dreams').

Just two years previously, Clyde Keeler, an American geneticist studying the eyes of blind mice, had made discoveries that indicated Miró might be on to something. Inexplicably, although the mice completely lacked the photoreceptors that enable mammals to perceive light, their pupils still contracted in response to it. It would be three-quarters of a century before the link was definitively proven: everyone, even the non-sighted, possesses a special receptor that senses blue light. This is crucial because it is our response to this portion of the spectrum, naturally present in the highest concentrations in early daylight. which sets our circadian rhythm, the inner clock that helps us sleep at night and remain alert during the day.1 One problem is our modern world, filled as it is with spot-lit rooms and back-lit smartphones, overloads us with blue light at odd hours of the day, which has negative effects on our sleep patterns. In 2015 American adults reported getting an average 6.9 hours of sleep on a work night; 150 years ago it was between 8 and 9 hours.2

Westerners have a history of undervaluing all things blue. During the Paleolithic and Neolithic periods, reds, blacks and browns reigned supreme; the ancient Greeks and Romans admired the simple triumvirate of black, white and red. For the Romans, in particular, blue was associated with barbarism: writers from the period mentioned that Celtic soldiers dyed their bodies blue, and Pliny accused women of doing the same before participating in orgies. In Rome wearing blue was associated with mourning and misfortune.³ (Exceptions to this ancient aversion to blue are more common outside Europe; the ancient Egyptians, for example, were evidently very fond of it [page 196].) It was largely absent too from early Christian writings. A nineteenth-century survey of colour terms used by Christian authors before the thirteenth century reveals that blue was the least used, at a mere 1% of the total.⁴

It was during the twelfth century that a sea change occurred. Abbot Suger, a prominent figure in the French court and an early champion of Gothic architecture, fervently believed colours – particularly blues – to be divine. He oversaw the reconstruction of Saint-Denis Abbey in Paris in the 1130s and 40s. It was here that craftsmen perfected the technique of colouring glass with cobalt [page 187] to create the famous ink-blue windows that they took with them to the cathedrals at Chartres and Le Mans.5 At around the same time, the Virgin was increasingly depicted wearing bright blue robes previously she had usually been shown in dark colours that conveyed her mourning for the death of her son. As the status of Mary- and Marian-centred devotion waxed in the Middle Ages, so too did the fortunes of her adopted colour.

From the Middle Ages the pigment most commonly associated with Mary was the precious pigment ultramarine [page 182], which remained the most coveted, bar none, for centuries. This was not the only substance to have a huge impact of the history of blue, however: indigo [page 189] was also decisive. Although the first is a pigment made from a stone and the second a dye wrung

from fermented plant leaves, they share far more than you might imagine. Both required care, patience and even reverence, in their extraction and creation. While colourmen and painters were laboriously grinding and kneading the one, dyers would be stripped to the waist beating air into nauseating vats of the other. The pigments' expense helped stoke desire and demand in a dizzying cycle that ended only with the creation of synthetic alternatives in the nineteenth century.

Although traditionally the colour of sadness, many cultures, including the ancient Egyptians, Hindus and the North African Tuareg tribe, have included a special place for blue and blue things in their lives. A large number of businesses and organisations use a dark shade for its anonymous trustworthiness in their logos and uniforms, perhaps little considering that its history of brisk respectability began with the armed forces, particularly the navies (hence navy blue), who needed to dye their clothes with a colour that would best resist the action of sun and sea.

At the end of the twelfth century the French royal family adopted a new coat of arms – a gold fleur-de-lis on an azure ground – as a tribute to the Virgin, and Europe's nobility fell gauntlet over greaves in their rush to follow suit. In 1200 only 5% of European coats of arms contained azure; by 1250 this had risen to 15%; in 1300, one quarter; and by 1400 it was just under one third. A recent survey conducted across 10 different countries in four continents found that blue was peoples' favourite colour by a considerable margin. Similar surveys conducted since the First World War returned similar results. It seems blue, once considered the colour of degenerates and barbarians, has conquered the world.

Ultramarine

In April AD 630, Xuanzang, a Buddhist monk on a journey to India, made a 1,000-mile detour into Afghanistan. He had been lured far out of his way by two immense carvings of the Buddha hewn just over a century earlier directly into the side of a mountain in the Bamiyan Valley. Both were decorated with precious ornaments. The larger one – 53 metres from heel to crown – was painted with carmine; the smaller, older one was draped in robes painted with the region's most famous export: ultramarine. In March 2001, nearly 1,400 years after Xuanzang's pilgrimage, the Bamiyan statues were declared false idols by the Taliban government, surrounded with dynamite and destroyed.

Although now so remote, the site of the Bamiyan buddhas was once on one of the busiest and most influential trade routes ever known. The Silk Road. which runs through the mountains of the Hindu Kush, was used by the caravans that shuttled goods between East and West. Ultramarine was first bumped along the Silk Road by donkey and camel in the form of lumps of lapis lazuli. When these reached the Mediterranean coast in Syria they were loaded onto ships bound for Venice, and thence traded throughout Europe. Even the word ultramarine, from the Latin for 'beyond' – ultra – and 'sea' – mare - indicates that this was a colour worth going the extra mile for. Cennino Cennini, the Renaissance Italian painter and author of Il libro dell'arte, called it 'illustrious, beautiful and most perfect, beyond all other colours; one could not say anything about it, or do anything with it, that its quality would not surpass'.2

The story of this blue begins deep in the ground. Lapis lazuli ('the blue stone' in Latin) is now mined from countries including China and Chile, but the overwhelming majority of the intense, night-coloured rock that was used for ultramarine pigment in the West prior to the eighteenth century came from a single source: the Sar-e-Sang mines, tucked in the mountainous folds of Afghanistan, some 400 miles north-east of Bamiyan. Like the Buddha statues, the mines were famous; Marco Polo, who visited in 1271, wrote of a 'high mountain, out of which the best and finest blue is mined'.³

Although lapis lazuli is thought of as a semi-precious stone, it is really a mixture of minerals. Its deep blue colour is thanks to lazurite, while the delicate traceries of white and gold are silicates (including calcite) and fool's gold (iron pyrite) respectively. Nuggets of the stone were used for decorative purposes in ancient Egypt and Sumeria, but no one seems to have used it as a pigment until much later. Not only is it difficult to grind, but because lapis contains so many impurities, the result can be disappointingly grevish. Turning it into a useable pigment is an exercise in extracting the blue lazurite. To do this, the finely milled stone is mixed with pitch, mastic, turpentine and linseed oil or wax, and then heated together to form a paste. This is then kneaded in an alkaline lye solution - 'just as', wrote Cennini, 'you would work over bread dough'.4 The blue would gradually wash out into the lve and sink to the bottom. It would take a few successive kneadings, each drawing out progressively grever solutions, to remove all the colour; the final extraction would produce only a pallid colour known as ultramarine ashes.

The oldest examples of lapis being used as a pigment are found in a small number of fifth-century wall paintings in Chinese Turkmenistan and some seventh-century images from a cave temple at Bamiyan. The earliest known European use is in the San Saba church in Rome, dating from the first half on the eighth century, where ultramarine was mixed with Egyptian blue [page 196]. (At this time Egyptian blue was the ancient world's preeminent blue,

Ultramarine, continued.

though it was soon to be superseded by ultramarine.)5

Not only did the long journey from the mines increase the pigment's price, it also affected how – and even if – ultramarine was used. Italian artists, particularly Venetians, who were first in the European supply chain and could procure the pigment at its cheapest, were relatively profligate with this precious pigment. This is evident, for example, in the vast swathe of star-strewn sky in Titian's Bacchus and Ariadne, painted with ultramarine in the early 1520s. Northern European artists had to be thriftier. Albrecht Dürer, the foremost printmaker and painter of the German Renaissance, used it occasionally, but never without complaining bitterly of the cost. When buying pigments in Antwerp in 1521 he paid almost one hundred times for ultramarine what he paid for some earth pigments. The difference in price and quality meant it made more sense for artists to buy pigments from Venice if they were working on prestigious commissions. Filippino Lippi's 1487 contract for the frescoes in the Strozzi Chapel at Santa Maria Novella in Florence included a provision that a portion of the fee be set aside for when 'he wants to go to Venice'. There was a similar clause in Pinturicchio's 1502 contract for the frescoes in the Piccolomini Library in Siena: 200 ducats were reserved for a Venetian pigment expedition.7

The reasons for all this fuss were both practical and emotional. While many other blue pigments are tinged with green, ultramarine is a true blue, occasionally bordering on violet, and is extraordinarily long-lasting. It was also prized because of the esteem in which the raw lapis lazuli was held. The colour's rise in the West also coincided with the Renaissance's increasing preoccupation with the Virgin Mary. From around 1400, artists increasingly depicted the Madonna wearing ultramarine-

blue cloaks or gowns, a material sign of their esteem and her divinity. Giovanni Battista Salvi Sassoferrato's *The Virgin at Prayer* (1640–50) seems as much a tribute to ultramarine in all its intensely midnight beauty, as to Mary. While she sits, head modestly bent so her eyes find the floor, it is the thick, creamy folds of her blue cloak that capture the viewer's gaze.

The precise use of this pigment was a key point in many surviving contracts drawn up between artists and their patrons. The 1515 contract for Andrea del Sarto's Madonna of the Harpies stipulated that the Virgin's robe be painted with ultramarine 'at least five broad florins the ounce'. Some patrons purchased the pigment themselves to control its use; a 1459 document suggests that while Sano di Pietro was working on a fresco on a gateway in Siena, the town authorities kept hold of his supplies of gold and ultramarine. They weren't always wrong to be suspicious. Almost four centuries later, when Dante Gabriel Rossetti, William Morris and Edward Burne-Jones were painting a set of murals in the library of the Oxford Union in 1857, a potful of ultramarine was upset amid the 'jollity, noise, cork-popping, paint-sloshing, and general larking about'. Their patrons were horrified.9

To add salt to the wound, there was, by this time, a good alternative. In 1824 the Société d'Encouragement pour l'Industrie Nationale in France offered 6,000 francs to anyone who could create an affordable synthetic ultramarine. Four years later the prize was awarded to Jean-Baptiste Guimet, a French chemist. (Although Christian Gmelin, a German rival, announced he had happened on a similar recipe the previous year, the prize money remained with Monsieur Guimet, and the new formula was known thereafter as French ultramarine.) To create the synthetic, china clay, soda, charcoal, quartz

Ultramarine, continued.

and sulphur are heated together; the result, a green, glassy substance, is pulverised, washed and reheated once more to create a rich blue powder.

French ultramarine was exponentially cheaper. In some instances the real thing could, ounce for ounce, sell for 2,500 times more than the synthetic. In the early 1830s the original cost 8 guineas an ounce, while French ultramarine between 1 and 25 shillings per pound; by the 1870s French ultramarine had become the standard. Despite this, the interloper still faced initial resistance. Artists complained that it was too one-dimensional. Because the particles were all the same size and reflected light in the same way, it lacked the depth, variety and visual interest of the real thing.

The French post-war artist Yves Klein agreed. He patented International Klein Blue in 1960 and used it to create his hallmark: the lustrous, textured blue canvases known as the 'IKB series' after the colour. (It was these seemingly simple monochromes that Klein later proudly called his 'pure idea'.) While he loved the intensity of the raw powdered ultramarine, he was disappointed with the dullness of the paint made from it. He worked with a chemist for over a year to develop a special resin medium. This, when mixed with the synthetic to form IKB, allowed the pigment to approach the clarity and lustre of the original.

Cobalt

On 29 May 1945, shortly after the liberation of Holland, Han van Meegeren, an artist and art dealer, was arrested for collaborating. Not only had he amassed a suspicious fortune during the Nazi occupation, he had sold *Christ and the Adulteress*, an early work by Vermeer, to Hermann Göring. If found guilty, he could be hanged.¹

Van Meegeren not only vigorously denied the accusation, but countered with a claim of his own. The 'Vermeer', he said, wasn't really a Vermeer at all: he had painted it himself. At worst, he said, he was guilty only of forgery, and, since he had completely fooled the Reichsmarschall, should he not in fact be celebrated as a Dutch hero? Some of the paintings that he alleged to have passed off during his career as a forger – several more Vermeers and a couple of Pieter de Hoochs, among others – were on display in museums and had been hailed by critics as long-lost masterpieces. Van Meegeren claimed to have made 8 million guilders (around \$33 million today). When prominent museum directors and critics refused to believe him, Van Meegeren found himself in the unusual position of having to persuade people of his guilt.

He had, he told the court, specialised in Vermeers because of the huge gap in that artist's oeuvre – most of his known paintings are from when he was an older man – and the dissonance between his style as a young man and that of his later years. Van Meegeren had used a composition from a Caravaggio for one forgery – *Christ and the Pilgrims at Emmaus* – knowing that art historians were desperately looking for proof of the theory that Vermeer's style had an Italian origin. He had also paid attention to the technical details. Rather than using the traditional linseed oil as his paint medium he had used Bakelite, a plastic that sets solid when heated. This let him fool the standard X-ray and solvent tests used to determine the age of oil paintings,

Cobalt, continued.

which take much longer to harden. He had painted on old canvases that had authentic craquelure (the network of tiny fissures that develop in old paintings) and had only used pigments that would have been available in the seventeenth century ² – in every case, that is, except one. The giveaway was a particular shade that was found, upon closer examination, to contain a pigment that wasn't created until 130 years after Vermeer's death: cobalt blue.³

It is not surprising that Van Meegeren had missed the switch. Cobalt blue was, after all, one of the blues created specifically as a synthetic substitute for ultramarine.4 A French chemist, Louis-Jacques Thénard, decided the key would lie in cobalt, the element Sèvres potters used in their blue glazes, just as it had been used to make the sky-coloured tiles on the roofs of Persian mosques. It was also present in the famous medieval iris-blue glass at Chartres and Saint Denis in Paris, and in the cheap, artists' pigment smalt. In 1802 Thénard made his breakthrough: a mixture of cobalt arsenate or cobalt phosphate and alumina, roasted at high temperatures, produced a fine, deep blue.5 The chemist and author George Field, writing in 1835, described it as 'the modern improved blue . . . neither tending to green nor purple, and approaching in brilliancy the finest ultramarine'.6

The presence of cobalt blue in Van Meegeren's work, though, had unmasked him, and his works were quietly taken down from museum walls and discreetly stashed away. In November 1947, two years after his arrest, he was finally found guilty. Not of collaboration with the Nazi regime – although a book of his drawings had been found in Hitler's personal library, bearing the inscription 'To my beloved Führer in grateful tribute' – but of forgery. He was sentenced to a year in prison, but he died – some said of a broken heart – the following month.

Indigo

In 1882 the British Museum acquired an object it would take

11 decades to understand. The artefact is a tiny clay tablet, around 7 cm square and 2 cm thick, covered in minute text written in Babylon some time between 600 and 500 BC. In the early 1990s, when academics finally cracked the translation, they discovered that what had been inscribed in the still-damp clay thousands of years before was a set of instructions for dyeing wool dark blue. Although it isn't mentioned, the description of the process – with all its repeated dipping – indicates that the dye was indigo.

For a long time it was presumed that both the seeds for the indigo-bearing plants and the knowledge of how to turn them into a dye the colour of the night sky had blown west with the winds of trade; from India to the Middle East and Africa. (An imprint of this assumption survives in the word itself. Its etymological root is the Greek *indikon*, which means 'a substance from India'.) Now, though, this seems unlikely. Instead, people seem to have discovered the process independently, and at different times, across the world. There are many different species of plant that produce indigo – woad [page 198] is one – but the one most coveted for its colourant is *Indigofera tinctoria*.¹ For a dye-producing workhorse it is a pretty shrub, with small, slightly dusty green leaves, pink blooms that look like miniature sweetpeas, and dangling seedpods.²

Although, unlike woad, *I. tinctoria* is a 'nitrogen fixer' and therefore good for the soil, it is still temperamental and prone to mishap.³ Farmers in Central and South America, for example, not only had to deal with the usual risks – fluctuating prices and rainfall, sinking trade ships – but also with a host of others of biblical proportions, including earthquakes, and plagues of caterpillars and locusts.⁴ Even once the crop was harvested the poor, nerve-shredded farmers couldn't sleep easy.

Indigo, continued.

Even today, with more chemicals and equipment at our disposal, the process for extracting the dye from the leaves is cumbersome; the traditional process, done entirely by hand, was far worse. First, the greenery was fermented in an alkaline solution. The liquid was then drawn off and vigorously beaten to aerate it. This caused a blue sediment to form, which was then dried into cakes or blocks to be sent off to market.⁵

The result is worth the effort. In addition to the vivid colour, indigo ages beautifully, as any denim aficionado worth their Japanese selvedge will confirm. It is also the most colourfast of the natural dyes. Where it has been used in combination with others to create colours like green or black, it is often only the indigo that remains. The phenomenon is so common that the now sky-coloured foliage in Renaissance tapestries is said to suffer from 'blue disease'. 6 Unlike most dyes, indigo doesn't need a mordant to fix it to fabric. While the relatively weak indigo content in woad could colour absorbent fibres like wool, the dye from other indigo bearing plants could be up to ten times stronger, more than powerful enough to saturate less accommodating vegetable fibres like silk, cotton, flax and linen.7 Fabric dipped into the chartreuse-hued dye vat changes colour upon coming into contact with the air, turning from vellowish green to sea green before settling on a deep, stolid blue.

Indigo is woven into the burial customs of many different cultures globally, from Peru to Indonesia, Mali to Palestine. Ancient Egyptian dyers began threading thin lines of blue fabric into the edges of their linen mummy cloths from around 2400 BC; a state robe found in the extensive funerary wardrobe of Tutankhamun, who reigned around 1333–23 BC, was almost entirely indigo.8 The dye has made inroads into other cultural spheres too.

Males of the Tuareg tribe in northern Africa are given *tagelmusts*, or headscarves, at a special ceremony that marks their transition from boy to man. The most prestigious in a community wear the glossiest indigo *tagelmusts*, whose gloriously resonant hue is developed through multiple rounds of dyeing and beating.9

Because it has always been so highly prized, indigo has, from as far back as records and educated guesswork allow, been a bedrock of global trade. The wealthiest Romans could import indigo at 20 denarii a pound, around 15 times the average daily wage (prices were so high that some merchants apparently tried their luck selling a counterfeit made from pigeon dung). 10 Adding to the expense were the restricted trade routes. Before Vasco da Gama nosed his ship around the Cape of Good Hope and opened up another passage to the East, goods travelling westwards had to make their way over land through the Middle East or around the Arabian Peninsula. This route was unpredictable and difficult to navigate, prone to civil unrest and heavy duties were levied by the various rulers along the way, ratcheting up prices for those at the end of the journey. Obstacles were endless. In 1583 there was a dearth of camels following an extreme dry spell and caravans ground to a halt. After nearly causing a diplomatic incident in Bayana, India, by outbidding the emperor's mother for 'twelve carts loaded with nil [indigo]', a British merchant lost both his precious cargo and his life in Baghdad on the journey home.11

Despite Europe's slow adoption of imported indigo – chiefly due to the resistance from local woad farmers – the rise of colonialism in the sixteenth and seventeenth centuries, and the prospect of the fortunes to be made, overcame lingering resistance; trade became almost frenzied. In just one year, 1631, seven Dutch ships carried

Indigo, continued.

a total of 333,545 pounds of indigo back to Europe, a cargo worth five tons of gold [page 86]. Over in the New World, the Spanish began producing indigo on a commercial scale almost immediately after conquering Guatemala in 1524; it soon became the region's principal export.¹²

New trade routes, combined with ample use of slave and forced labour in the New World and India, drove prices downwards. Armies began using indigo for their uniforms. Napoleon's Grande Armée, for example, consumed around 150 tons per year. (French infantrymen still wore madder or alizarin red [page 152] trousers until the First World War; this was replaced with indigo when they realised that it was making them too easy a target.) Naturally, after William Perkin unlocked the secret to aniline dyes in 1856, a manmade version of indigo was only a matter of time. After an initial breakthrough in 1865, it would be another 30 years before the German chemist Adolf von Baeyer, with financial backing from the German pharmaceutical giant BASF to the tune of 20 million gold marks, finally got 'Pure Indigo' to market.

From being a luxury on a par with imperial purple [page 162], indigo has become the colour of the 'blue-collar' workforces, not only in Europe but also in Japan and China, where the dusty blue Mao suit became ubiquitous in the twentieth century. If it is, strangely enough, this workwear association that has proved this pigment's most enduring legacy, in the form of blue jeans. If Although it peaked around 2006, the global denim industry, which is dominated by the classic indigo blue, was worth \$54 billion in 2011. If Jeans have been a wardrobe staple since the 1960s, and, as Giorgio Armani is often quoted as saying, they 'represent democracy in fashion'. In them one can be at home, and understood, everywhere.

Prussian blue

Some time between 1704 and 1706, in a dingy room in Berlin, a paint manufacturer and alchemist called Johann Jacob Diesbach was making up a batch of his signature cochineal red lake (a kind of paint made using an organic colourant and an inert binder or mordant) [page 141]. The chemical process was a relatively simple one using iron sulphate and potash. On this day, though, when it came to the crucial stage, Diesbach realised he had run out of potash. He bought some more from the nearest supplier and carried on, but something wasn't right. When he added the potash, the mixture did not turn a strong red, as it ought to; instead it was pale and pinkish. Perplexed, he began trying to concentrate it. His 'red lake' solution turned first purple, then a deep blue.

Diesbach found the man who had sold him the potash, a disreputable fellow alchemist and pharmacist called Johann Konrad Dippel, and demanded an explanation. Dippel deduced that the iron sulphate had reacted strangely with potash because the latter was adulterated with animal oil. The reaction had created potassium ferrocyanide (a compound still known in German as *Blutlaugensals*, literally 'blood alkali salts'), which had combined with the iron sulphate to produce iron ferrocyanide, a compound we now know as Prussian blue.¹

This was a very auspicious time for a new blue. Ultramarine [page 182] remained the ideal, but it was still fiendishly expensive and supply was inconstant. There was also smalt, blue verditer, azurite and even indigo [page 189], but these were all slightly greenish, with poor coverage and not particularly reliable once on the canvas.² Prussian blue was a revelation. A deep, rather cool colour with tremendous tinting strength and the ability to create subtle tones, it also behaved well with lead white [page 43] and combined with yellow pigments like orpiment

Prussian blue, continued.

[page 82] and gamboge [page 80] to make stable greens. In his pigment compendium of 1835, George Field called this 'rather modern pigment', 'deep and powerful . . . of vast body and considerable transparency'.

Dippel, who may have been dishonest but clearly did not lack business acumen, began selling it around 1710. The formula remained a secret until 1724, when an English chemist called John Woodwood published the method for making Prussian blue in the *Philosophical Transactions of the Royal Society.* By 1750 it was being manufactured across Europe. Unlike many other pigments of the time (and despite the 'cyanide' in its chemical name), it isn't toxic; it was also a tenth of the price of ultramarine. It did have drawbacks, though, becoming discoloured by strong light and alkalis. W. Linton, author of *Ancient and Modern Colours* (1852), while conceding that it was 'a rich and fascinating pigment to the colourist', said it was 'not to be depended upon'; and yet fretted it was difficult to avoid.

The colour is seen in the works of artists as diverse as William Hogarth, John Constable, Van Gogh and Monet. Japanese painters and woodblock craftsmen were delighted with it. It was also the blue Picasso favoured during his blue period in the first years of the twentieth century after the death of a friend, its transparency giving cool depths to his melancholic settings. It is still very much in use: Anish Kapoor's flattened topographical sculpture *A Wing at the Heart of Things*, created in 1990, is made from slate coated in Prussian blue.

The pigment has been busy colonising other industries too: it has long been used in wallpapers, house paints and textile dyes. John Herschel, a nineteenth-century British chemist, astrologer and photographer, worked out how to use it in combination with photosensitive paper to make a kind of proto-photocopy. The results, which

showed up as white marks on a blue ground, became known as 'blueprints', a word that has come to denote any technical drawing.⁶ It is also used to treat people with thallium and radioactive caesium poisoning, as it prevents the body absorbing them. The only side effect is alarmingly blue faeces.⁷

Remarkably, for most of its history no one was quite sure exactly what Prussian blue was; they knew the steps to take to make it, but were unclear on exactly what was reacting with what. Perhaps, though, that isn't so remarkable: iron ferrocyanide, a crystalline blue solid, is a complicated compound with a dizzying lattice structure at a molecular level. That such a thing was created by happy accident seems almost miraculous. As the French chemist Jean Hellot remarked in 1762:

Nothing is perhaps more peculiar than the process by which one obtains Prussian blue, and it must be owned that, if chance had not taken a hand, a profound theory would be necessary to invent it.8

Egyptian blue

William, a small ceramic statuette of a hippopotamus, can now be found in the Metropolitan Museum of Art, around 6,000 miles and some 3,500 years away from his point of origin: the banks of the Nile in Egypt. Although to our eyes he cuts rather a beautiful figure, with his blue-green glazed skin decorated with flowers, to his creators he would have seemed far less benevolent. Hippos were dangerous creatures, both in real life and in mythology, where they might upset your journey to the underworld. Figurines like this had their legs broken (William's have subsequently been repaired) and were placed in tombs as talismans to protect their occupants on their onward journeys.

The Egyptians were uncommon in valuing blue: most Western cultures didn't even possess a separate word for the slice of spectrum between green and violet. For the ancient Egyptians, though, the colour represented the sky, the river Nile, creation and divinity. Amun-Ra, the empire's principal deity, was often depicted with blue skin or hair, a trait that other gods borrowed from time to time too. The colour was thought to dispel evil and bring prosperity, and was much sought after in the form of beads, which in themselves were believed to possess magical protective qualities. Although the Egyptians also used and valued other blues, including turquoise and azurite, both had their disadvantages: the former because it was rare and expensive, the latter because it was hard to carve. So from the time Egyptian blue was first manufactured, sometime around 2500 BC, it was put to frequent use. Scribes wrote with it on papyri and it has also been found making up hieroglyphics on walls, used as a glaze on funerary objects, and decorating coffins.2

It was the Romans who first referred to the pigment as 'Egyptian blue'; the originators themselves called it,

simply, iryt (artificial) hsbd (lapis lazuli).3 Its chemical name is calcium copper silicate, and the raw ingredients used in its manufacture were chalk or limestone; a coppercontaining mineral, such as malachite, which gives it the blue colour; and sand. These were likely fired together between 950 and 1000 °C, to create a brittle, glassy solid that was ground down and then refired at between 850 and 950 °C to produce an intense blue that was long-lasting and versatile.4 Not only was it resistant to alkalis and acids but it also lasted well in strong light. Depending on how finely it was ground, it could be as dark as lapis lazuli or as pale as turquoise; if it was applied over a dark base layer it could be almost electric. Producing it was an extraordinary technical challenge. Not only did the ingredients need to be fired together at precise temperatures, the oxygen levels needed to be regulated too.

Mysteriously, given the existence of texts describing it, the manufacture of Egyptian blue petered out. Examples from the thirteenth century have been found in Italy, but it is believed this was due to reuse of old pigment stock – small balls of Egyptian blue are often found in Roman excavations. Elsewhere, artists began to favour ultramarine [page 182] from around the ninth century. One explanation is that a decreasing demand for blue (before the twelfth-century revival) meant that people stopped bothering to pass the secret down and the technical skills were lost. Alternatively, perhaps a shift in the idea of preciousness is to blame. While modern chemists marvel at the skill needed to make Egyptian blue, Western artists and patrons seem to have preferred raw materials with intrinsic value, like ultramarine.

Woad

Merton Abbey Mills, in Surrey in the south of England, had been the site of a textile works for over a century when William Morris purchased it in June 1881. Morris spent his young adulthood picking up and then discarding several careers - priest, artist, furniture maker - before hitting on the one that would make his name and fortune: reviving Gothic designs for fabric and wallpapers. He shunned many of the new synthetic dyes available, preferring vegetable and mineral-based ones. These acquired interesting patinas as they aged and were truer to the intricate medieval patterns he was partial to. One of his favourite tricks was showing visitors to Merton Abbey skeins of wool being dipped into the deep vats of woad. They would emerge an almost grassy colour, and then, before the astonished eyes of his visitors, they would turn first deep sea-green and then a resonant blue.1

The plant behind this miraculous transformation was *Isatis tinctoria* (often also called pastel), a member of the mustard family native to clay-rich soils in Europe. It is one of the 30 or so plant species that produce the colourant indigo [page 189]. Extracting indigo from woad plants is long, complicated and expensive. Once harvested the leaves are ground to a paste, formed into balls and left to cure. After 10 weeks, when the balls have lost three-quarters of their size and nine-tenths of their weight, water is added and the mixture is left to ferment again. After a further two weeks the woad will be very dark and granular, resembling tar. This mixture contains around 20 times as much indigo as the same weight of fresh leaves, but must still undergo a further round of fermentation, this time with wood ash, before it can be used to dye cloth.

This process was noxious, requiring lots of fresh water, producing waste that was often emptied directly into the nearest river, and draining the soil of nutrients, leaving

those in woad-growing areas at risk of starvation. Prior to the thirteenth century, woad production was very small-scale. There is evidence that ancient people were familiar with the process: leaves and seed pods have been found at a Viking site called Coppergate in the north of England, and it was purposefully cultivated at various sites from at least the tenth century.² Classical writers described the Celts making themselves blue, either daubing it on before battle or tattooing it directly into the skin. (Tattooed Celtic remains have been found, both in Russia and in Britain, although it is impossible to say if woad was the dye used.) It has even been suggested that the word *Briton* derives from a Celtic one meaning 'painted people'.

It was some time around the end of the twelfth century, though, that woad's fortunes began to change. Innovation in the production process resulted in a brighter, stronger colour, which attracted the notice of a more luxurious market.³ It also helped that blue, a previously overlooked colour, was not part of the sumptuary system that governed which colours people were allowed to wear, so it could be worn openly by anyone. Over the next century, demand for blue clothes began gaining ascendency over the pre-eminent red ones. It was also used as an under- or over-dye to add to the longevity and to mix other colours, including the famous British Lincoln green and even some scarlets [page 138]. One Elizabethan wrote: 'No colour in broadcloth or kersey [woven fabrics, usually woollen] will well be made to endure without woad.'4

From around 1230 woad was grown, like madder [page 152], in near industrial quantities. This created fierce rivalries between woad and madder merchants. In Magdeburg, the centre of Germany's madder trade, religious frescoes began to depict hell as blue; and in Thuringia, the madder merchants persuaded the stained-

Woad, continued.

glass craftsmen to make the devils in the new church windows blue, rather than the traditional red or black, all in an effort to discredit the upstart hue.⁶

Such tactics proved futile. Areas that grew the 'blue gold' – like Thuringia, Alsace, Normandy – became rich. Woad, wrote one contemporary in Languedoc, 'hath made that country the happiest and richest in Europe'. When Emperor Charles V captured the French king at the Battle of Pavia in 1525, it was an enormously wealthy woad merchant from Toulouse, Pierre de Berny, who was the guarantor for the eye-watering ransom. §

Woad's demise was by this time in sight, as other indigo-producing plants were discovered, first in India and then in the New World. On 25 April 1577 representatives of the merchants and dyers of the City of London sent a memorandum to the Privy Council, requesting permission to use indigo imported from India to make a cheaper, 'oryent' blue. '[F]ortie shillings bestowed in the same, yeldeth as much colour as fiftie shillings in woade'.'

Just as the madder farmers had done before them, those involved in the woad trade tried to stave off the inevitable. Protectionist laws were passed year after year. Emperor Ferdinand III of Germany declared that indigo was the devil's colour in 1654; French dyers could not touch it, on pain of death, until 1737; while in Nuremberg, dyers were still swearing an annual oath not to use it until the end of the eighteenth century. There was even a smear campaign against imported indigo: in 1650 officials in Dresden announced that, the newcomer 'readily loses its colour' and 'corrodes cloths'.¹º It was all in vain. Often produced using slave labour, indigo could undercut woad on price every time, and had far better tinting strength. The European woad trade collapsed, leaving only empty fields and ruined merchants in its wake.

Electric blue

The sound that Alexander (Sasha) Yuvchenko, a 24-year-old nuclear engineer, heard at 1:23 a.m. on 26 April 1986 was not an explosion but a thud, a shaking. It was only two or three seconds later, as radiation from the nuclear core of reactor 4 ripped through the nuclear complex in Chernobyl where he worked, that he heard the almighty boom of the greatest man-made disaster ever known.¹

Yuvchenko had taken the position because Chernobyl was one of the best nuclear stations in the Soviet Union. the money was good and the job was interesting. On that night, though, it was all supposed to be routine: he was overseeing the cooling of the reactor, which had been manually powered down earlier for a planned safety test. He was in his office, chatting to a colleague, as the nuclear rods were lowered into water to cool them. This inadvertently caused a power surge so powerful that the 1,000-ton plate covering the nuclear core blew off. triggering a series of other detonations and spewing radioactive uranium, burning graphite and bits of building into the sky.² Speaking to New Scientist in 2004, he remembered steam, shaking, the lights being extinguished, concrete walls buckling as if they were made of rubber, and things falling around him; his first thought was that a war had begun. He stumbled through the ruined building, scrabbling past blackened bodies, before stumbling out into the hole where the reactor building had been moments before. It was only then that he noticed the glow:

I could see a huge beam of projected light flooding up into infinity from the reactor. It was like a laser light, caused by ionisation of the air. It was light bluish, and it was very beautiful.⁴

Electric blue, continued.

It is not that surprising that a pale, bright blue has come to be the shade of electricity in the popular imagination. After all, the eerie aureole seen haloing very radioactive material after nuclear tests, and at Chernobyl, is blue. Other electrical discharge phenomena observed and puzzled over from the earliest days, such as sparks and lightning, produce similar effects – St Elmo's fire, for example, which dances on ships' masts and across the windows in aeroplanes during storms, is bright blue, sometimes tinted with violet [page 174]. The effect is caused by the air becoming ionised: nitrogen and oxygen molecules become violently excited, releasing photons visible to the naked eye.

The colour blue and electricity came together rather earlier than might be imagined, though. A dusty periwinkle shade named 'electric blue' came into vogue in the late nineteenth century, just as Joseph Swan and Thomas Edison were groping towards harnessing electricity for producing light. A British drapers' association trade publication mentions 'dark electric blue faille and velvet' in its January 1874 issue; while the *Young Ladies' Journal* notes the fashion for a walking dress 'of electric blue double nun's cloth' in November 1883.5

The idea of electric blue has always been shorthand for modernity. For the Victorians, witnessing the latest electrical innovations creep from the lab and factories into smart hotels and then individual homes, it must have seemed as if the future and the present were coalescing. This shade has – apart from a brief spell in the 1980s and 1990s – dominated our imaginings of a technologically controlled destiny. While the film *The Matrix*, released in 1999, is suffused with the ghostly greenish light emitted from monochrome computer screens (which in reality were mostly phased out in the 1980s, but are still portrayed

as futuristic), the technology in *Minority Report*, released just three years later, is powered by electric blue. Similar light can be seen in both the 1982 and 2010 *Tron* films, in publicity stills for *Inception* (2010), and the disturbing dystopian fate humanity suffers in *WALL-E* (2008). Although we see it as the colour of the future, we are clearly more than a little unnerved by electric blue; perhaps we don't trust ourselves with the forces at our disposal. As Sasha Yuvchenko knows all too well, the cost of mistakes can be devastating.

Cerulean

On 17 February 1901 Carlos Casagemas, a Spanish poet and artist, was having drinks with friends in the smart new Parisian cafe l'Hippodrome, near Montmartre, when he pulled out a gun and shot himself in the right temple. His friends were distraught, none more so than Pablo Picasso, who had never quite recovered from watching his sister die of diphtheria, six years previously. His grief cast a pall over his works for several years. He abandoned almost the entire palette, except for the one colour that could adequately express his grief and loss: blue.

Blues have form in helping people to express matters of the spirit. When, at the end of the Second World War, the UN was formed to maintain global peace, they chose for their symbol a map of the world cupped by a pair of olive branches on a slightly greyish cerulean ground. Oliver Lundquist, the architect and designer who created the insignia, chose this shade because it is 'the opposite of red, the war colour'.1

It is spiritual as well as peaceful. Many Hindu gods, including Krishna, Shiva and Rama, are depicted with skin the colour of the sky, symbolising their affinity with the infinite. The French call it *bleu céleste*, heavenly blue. It is also, confusingly, the colour many of the buildings at the Church of Scientology's Gold Base in California – including the mansion awaiting the reincarnation of the religion's founder, L. Ron Hubbard. (The man himself, when founding Scientology, is reported to have told a colleague, 'Let's sell these people a piece of sky blue.') Pantone named its paler, forget-me-not shade as the colour of the millennium, guessing that consumers would 'be seeking inner peace and spiritual fulfilment in the new millennium'.²

A true cerulean pigment – one of the cobalt family [page 187] – was not available to artists until the 1860s,

and then only as a watercolour.3 Made from a mixture of cobalt and tin oxides known as cobalt stannate, it did not make much headway until the 1870s, when it was finally released as an oil paint; in this medium it lost the slight chalkiness it had in watercolours and seduced a generation of painters. While Van Gogh preferred to create his own approximation of the tint using a subtle mixture of cobalt blue, a little cadmium vellow and white. others were less cautious. Paul Signac, known for his airy pointillism, squeezed countless tubes dry, as did many of his fellows, including Monet.4 When the photographer and writer Brassaï ran into Picasso's Parisian paint supplier in November 1943, the man handed him a piece of white paper filled with Picasso's handwriting, 'At first glance it looks like a poem,' wrote Brassaï, but, he realised, it was actually Picasso's last paint order. Third on the list, just below 'White, permanent —' and 'White, silver —', is 'Blue, cerulean'.5

Verdigris
Absinthe
Emerald
Kelly green
Scheele's green
Terre verte
Avocado
Celadon

Green

There is a Buddhist fable about the colour green. In the tale a deity appears to a small boy in a dream one night and tells him that to obtain everything he could ever desire all he need do is close his eyes and not picture sea green. The story has two possible endings. In one the boy eventually succeeds and finds enlightenment; in the other he is so consumed by his continued failure that life and sanity gradually slip away.¹

Today green tends to conjure up comforting images of countryside and environmentally friendly politics. Despite its association with envy, it is generally seen as a peaceful colour and is often associated with luxury and style. A glaucous shade was the darling of the Art Deco movement; emerald was Pantone's 'Color of the Year' in 2013.

The ancient Egyptian hieroglyph for the colour was the papyrus stalk, a plant that the Egyptians held in high regard. In Latin the word for green is viridis, which is related to a large group of words that suggest growth and even life itself: virere, to be green or vigorous; vis, strength; vir, man; and so on.2 Many cultures associate the colour positively with gardens and spring. For Muslims, for whom 'paradise' is almost synonymous with 'garden', green became prominent from the twelfth century. It was the favourite colour, along with white, of the Prophet Muhammad. In the Quran, the robes worn in paradise and silk couches scattered amidst the trees are both the colour of leaves. And in medieval Islamic poetry Mount Oaf, the celestial Mountain; the sky above it; and the water at its feet are all depicted in shades of green. This is why the colour appears in the flags of many predominantly Islamic countries including Iran, Bangladesh, Pakistan, Saudi Arabia and Pakistan.3

In the West green was particularly linked with the courtly rituals of spring. On 1 May, for example, many

courts required members to *s'esmayer* or 'wear the May', which in practice meant wearing a leafy crown or garland, or a prominent item of green clothing. Those who were *pris sans verd*, or showed themselves without this colour, would be loudly mocked.⁴ Possibly because of such rituals, and the inevitable flirtation and trouble they could cause, green also became the badge of youth and young love. The expression 'to be green', meaning inexperienced, was already being used by the Middle Ages. Minne, a Germanic goddess who, like Cupid, was fond of shooting people with mischievous arrows of love, habitually wore a green dress, as did fertile young women – this is one interpretation, for example, of Jan Van Eyck's *Arnolfini wedding portrait* (c. 1435) [page 214].

Despite such positive associations green had, in the West at least, something of an image problem. This was partially due to an early misunderstanding surrounding colour mixing. Plato, the ancient Greek mathematician born in the mid-fifth century BC, stoutly maintained that prasinon (leek colour) was made by mixing purron (flame colour) and melas (black). Democritus, father of atomic theory, believed pale green was a product of red and white.5 For the ancients green was, like red, one of the middle colours between white and black, and in fact red and green were often confused linguistically: the medieval Latin sinople could refer to either until the fifteenth century.6 In 1195 the future Pope Innocent III reinterpreted green's role in the divine order in an influential treatise. It must, he wrote, 'be chosen for holidays and the days when neither white nor red nor black are suitable, because it is a middle colour between white, red, and black'.7 This, theoretically, gave it far greater prominence in the West, but materially it was still rare: it never appeared in more than 5% of heraldic arms.

One reason for this is the long-standing taboo against creating green dyes and pigments by mixing blue and yellow. Not only was this poorly understood for many centuries – see Plato's assertions above – but there was also a deep aversion to mixing different substances together, in a way that is difficult to understand today. Alchemists, who routinely mixed elements together, were mistrusted, and in medieval art colours usually appeared in unmixed blocks with no attempt to show perspective by shading. In the clothing industry this was complicated by guild restrictions and the high degree of specialisation: in many countries blue/black dyers were forbidden to work with red and yellow dye substances. In some countries anyone caught dyeing cloth green by dipping it in first woad [page 198] and then weld, a yellow dye, could face severe repercussions, including large fines and exile. Although there were some plants, including foxglove and nettle, that produced a green colour without the need for any mixing, these did not produce the kind of rich. saturated colour that people of taste and influence wanted to buy. The effect this had is plain from an offhand comment made by the scholar Henri Estienne in 1566: 'In France, if one sees a man of quality dressed in green, one might think that his brain was a little off.'8

Artists had to deal with inferior green pigments. The Dutch artist Samuel van Hoogstraten wrote in the 1670s: 'I wish that we had a green pigment as good as a red or yellow. Green earth [page 227] is too weak, Spanish green [page 214] too crude and ashes [verditer] not sufficiently durable.'9 From the early Renaissance, when the taboo against mixing began to fade, until the late eighteenth century, when new copper greens were discovered by a Swedish chemist called Carl Wilhelm Scheele [page 224], artists had to blend their own green paints.

Even this was tricky. Verdigris was prone to reacting with other pigments and even blackening on its own, and terre verte had poor tinting strength and luminosity. Paolo Veronese, who worked in Venice for most of his career during the sixteenth century and was, like Titian before him, an extremely skilled and resourceful colourist, was famous for being able to coax bright viridescent colours out of recalcitrant pigments. His trick was to apply a precise mixture of three different pigments in two layers and to protect green areas with layers of varnish to stop them reacting. Even he, though, had the occasional green mishap, and as late as the nineteenth century artists were struggling to produce reliable green. The grass in the foreground of Georges Seurat's Sunday Afternoon on the Island of La Grande Jatte, for example, appears withered in patches because of misbehaving pigments. This painting, one of the best-known examples of the pointillist technique and the work that launched the neo-Impressionist movement, was created in the mid-1880s, which demonstrates just how recently painters were struggling against their materials.

The particular difficulties craftsmen and consumers had with green perhaps contributed to the colour's symbolic link with capriciousness, poison and even evil. The association with poison, at least, had some merit after the development and explosive popularity of the new copper arsenite pigments in the nineteenth century. Scheele's green and its close cousin – variously called vert *Paul Véronèse*, emerald green, Schweinfurt green and Brunswick green – were responsible for many deaths, as unsuspecting consumers papered their homes, clothed their offspring and wrapped their baked goods in an exciting new shade that contained lethal doses of arsenic.

The other charges levied against green, however, were the result of petty prejudice. In the West green started becoming visually associated with the devil and demonic creatures from the twelfth century, possibly as a result of the Crusades and the increasing antagonism between Christians and Muslims, for whom the colour was sacred. In Shakespeare's day green costumes were considered bad luck on stage, a belief that persisted into the nineteenth century. In 1847, for example, a French author threatened to withdraw one of his works from the Comédie-Française because an actress was refusing to wear the green dress that the author had specified for the character she was to play. 10 Perhaps the final word on the irrational dislike of green should go to Wassily Kandinsky. 'Absolute green,' he wrote, 'is the most anesthetising colour possible . . . similar to a fat cow, full of good health, lying down, rooted, capable only of ruminating and contemplating the world through its stupid, inexpressive eyes.'11

Verdigris

signature – *Johannes de eyck fuit hic*, 'Jan van Eyck was here' – in 1434, the *Arnolfini Portrait* has intrigued and infuriated art lovers in equal measure.¹ In the painting a couple stand, bodies tilted towards the viewer. She wears a bottle-green gown with preposterously long

Ever since the oil dried on the playfully elaborate artist's

wears a bottle-green gown with preposterously long sleeves; he has fishy eyes and looks a little like Vladimir Putin. Is the woman's left hand, loosely clasping her full skirts over the curve of her belly, the protective gesture of an expectant mother or simply an indication of fashionable indolence? Is this a newly married couple or an allegory of abuse? What is the meaning of the little dog? The gargoyles? The discarded clogs?

One thing is for sure: the dress is incontrovertible evidence of the couple's wealth. The trailing bag-sleeves were so decadent that Scottish peasants were expressly forbidden to wear them in the 1430s: the woollen cloth was further lined with the creamy fur of up to 2,000 squirrels.2 The sap-green colour too indicated money. A deep-dyed and even green was a difficult colour to achieve. Generally it required two dye baths, first in woad and then in weld, a practice that was actually illegal for much of this period because of the medieval taboo on mixing colours. In January 1386 Hans Töllner, a thirdgeneration dyer from Nuremberg, was denounced for doing precisely this; he was fined, banned from the dyeing profession, and exiled to Augsburg.³ Van Eyck, using the finest of his brushes to paint the appliquéd Maltese cross decoration on the woman's trailing sleeves, would have felt equally frustrated. Like the dyers striving for the perfect green, artists too struggled to coax this fresh and beautiful colour out of lousy raw materials; in this case, verdigris.

Verdigris is a naturally occurring carbonate that forms on copper and its alloy bronze when they are exposed to

oxygen, water, carbon dioxide or sulphur.4 It is this green pating that forms on old copper pipes and roofs, and which gives the Statue of Liberty the blue-green colour of the misty sea she often faces. It took the elements 30 years to turn Gustave Eiffel's second most famous structure from rosy copper to full green, far too long a time for an artist to wait for their pigment. It is not known exactly when the technique for speeding the process along was discovered, but it is thought to have travelled westwards with Arabic alchemy. Traces of this route can be discerned in the pigment's various names. Verdigris is French for 'green from Greece', while its German name is Grünspan, or 'Spanish green' - Georgius Agricola, a sixteenthcentury scholar, wrote that it was brought up from Spain.6 Similar to the manufacture of lead white [page 43], leaves of copper were placed in a pot with lye and vinegar or sour wine. The pots were then sealed and left for two weeks, after which the sheets were dried, and the green patina scraped off, powdered, formed into cakes with more sour wine, ready to be sold.7

As the green dress in the *Arnolfini Portrait* proves, verdigris could be used to spectacular effect, but it was fickle. The acids used to make it often attacked the surface on which it was used, nibbling through medieval illuminations of paper and parchment like a caterpillar munching through leaves. It also had a tendency to discolour and to react with other pigments. As Cennino Cennini lamented: 'it is beautiful to the eye, but it does not last.' The truth of his words is evident in the works of everyone from Raphael to Tintoretto, where the greenery has withered to a shade approaching coffee. Even Paolo Veronese, a renowned master of the colour green, was not immune. (Perhaps such incidents were why he dreamed of 'green pigments as good in quality as the reds'. (10)

Verdigris, continued.

The problem was exacerbated by the rise of oil paint in the fifteenth century. While verdigris is perfectly opaque in the egg-tempera medium, it becomes glassily transparent in oils, which often led to its being mixed with turpentine resin from pine trees to restore its opacity. This made verdigris even more temperamental, and some began to worry that it should not be used with lead white, rendering it all but useless. Because there were so few alternatives, artists had little choice but to persevere, sandwiching their troublesome green between layers of varnish as a precaution and hoping for the best. For Van Eyck and his wealthy clients, however, it was clearly worth the risk.

Absinthe

In the waning decades of the nineteenth century a green menace harried Europe's citizens. Absinthe was made from a combination of plants and aromatics, including wormwood, aniseed, fennel and wild marjoram, which were first bruised and then soaked in alcohol and distilled. creating a bitter, pear-coloured liqueur. It was not an entirely new concoction: ancient Greeks and Romans had used similar recipes as an insect repellent and antiseptic. The modern version was also intended for medicinal use. Pierre Ordinaire, a well-known French physician living in Switzerland just after the French Revolution, created a take on the ancient recipe as a tonic for his patients.¹ It became commercially available at the turn of the century, but was still largely considered medicinal: French soldiers serving in Africa were given it to help ward off malaria.

Soon enough, though, people began to acquire a taste for it. At first, it was not so very different from any other aperitif, a small alcoholic drink taken before dinner, of which the French were inordinately fond. A measure would be placed in a glass, and was then diluted with ice-cold water poured through a sugar cube, turning the whole thing milky pale.² The difference was in absinthe's visibility and, from the 1860s when producers began using cheaper grain alcohol, its explosive popularity. While at first it was associated with dissolute bohemians and artists like Vincent van Gogh, Paul Gauguin, Oscar Wilde and Edgar Allan Poe, its appeal soon spread. By the 1870s a glass cost no more than 10 centimes, considerably less than wine, and absinthe accounted for 90% of aperitif consumption. In the latter half of the nineteenth century whole districts of Paris were said to smell faintly herbal between 5 and 6 p.m., a time that became known as l'heure verte ('the green hour'). In France consumption

Absinthe, continued.

increased from an average of 0.04 litres per person in 1875, to 0.6 litres in 1913.³

By this stage, absinthe had become a serious cause for concern, and not only in France, but also in Switzerland, where many people drank it, and Britain, where it was feared many soon would. This strange green drink, authorities felt, was poisoning the body-social and a moral panic swiftly ensued. On 4 May 1868 The Times warned its readers that absinthe was threatening to 'become as widespread in France and as injurious there as opiumeating is in China'. This 'emerald-tinted poison' was making 'drivelling idiots' out of those who were lucky enough to drink it and survive addiction and death. Worse still, more and more respectable people were dallying with it. 'Literary men, professors, artists, actors, musicians, financiers, speculators, shopkeepers, even' - here one imagines readers' hands convulsively clutching their throats - women were becoming absinthe's 'ardent lovers'.4

In France doctors began to suspect that it was really a poisonous drug. 'Absinthomania' was increasingly seen as a medical complaint quite distinct from mere alcoholism. People were reporting hallucinations and permanent insanity. To prove it, two scientists doused an unfortunate guinea pig with wormwood fumes (wormwood had quickly become the chief suspect of all absinthe's botanicals), whereupon he 'became heavy and dull, and at last fell on his side, agitating his limbs convulsively, foaming at the mouth'. 5 Dr Valentine Magnan, an authority on insanity and the director of a Parisian asylum, theorised that madness brought on by absinthe - his experiments had been conducted on a dog – was responsible for a collapse in French culture.6 In Switzerland the final straw came in 1905, when a man called Jean Lanfray killed his pregnant wife and two young daughters, Rose and

Blanche, after he had been drinking absinthe. The case was dubbed 'the absinthe murder' and the drink was outlawed completely in Switzerland three years later. France followed suit at the outbreak of the First World War in August 1914, in a groundswell of popular patriotic fervour.

Subsequent tests have shown that much of the supposed proof of absinthe's inherently deleterious effects were nonsense. Wormwood does not cause hallucinations and madness. Although the spirit does contain thujone, which is poisonous in large quantities, the doses a person would need to consume mean that they would die of alcohol poisoning long before thujone overdose became a possibility. The real problem with absinthe is that it is very alcoholic, varying between 55% and 75%, and in the late nineteenth and early twentieth centuries Europe was experiencing widespread social upheaval of the kind that led many to become alcoholics. Jean Lanfray was typical. While it is true that he had started the day on which he murdered his family with two shots of absinthe, he had gone on to drink wine, brandy and then more wine - he could not even remember committing his crime.⁷ But this didn't matter. Absinthe, with its drug-like pouring ritual, working-class and counterculture devotees, and suspicious, poison-green colour, was the perfect scapegoat.

Emerald

It was Shakespeare who cemented the relationship

between green and envy. With *The Merchant of Venice*, written in the late 1590s, he gave us 'green-eyed jealousy'; in *Othello* (1603), he has Iago mention 'the green-ey'd monster, which doth mock / The meat it feeds on'. Prior to this, during the Middle Ages, when each deadly sin had a corresponding colour, green had been twinned with avarice and yellow with envy.¹ Both human failings were the guiding principles in a recent saga concerning a vast green stone, the Bahia emerald.

Emeralds are a rare and fragile member of the beryl family, stained green with small deposits of the elements chromium or vanadium. The best-known sources are in Pakistan, India, Zambia and parts of South America. Ancient Egyptians mined the gemstones from 1500 BC, setting them in amulets and talismans, and they have been coveted ever since.

The Romans, believing green to be restful to the eyes because of its prominence in nature, pulverised emeralds to make expensive eye balms. The emperor Nero was particularly enamoured with the gem. Not only did he have an extensive collection, he was also said to use a particularly large example as proto-sunglasses, watching gladiator fights through it so that he wouldn't be bothered by the glare of the sun.² When L. Frank Baum wrote *The Wonderful Wisard of Os* in 1900, he used the precious stone both as the name and building material for the city his heroine and her band of misfit friends are trying to reach. The Emerald City, at least at the beginning of the book, is a metaphor for the magical fulfilment of dreams: it lures the characters in because they all want something from it.

The Bahia was heaved from the beryllium-rich earth of north-eastern Brazil by a prospector in 2001.

Stones from this area are generally not worth much; they tend to be cloudy and occluded and sell for, on average, less than \$10. This one, however, was gargantuan. The whole lump weighed 840 pounds (roughly the same as a male polar bear) and was thought to contain a Kryptonite-green gem of 180,000 carats. In the years since its discovery the gemstone's vast size and value have done little to secure it a stable home. Housed in a warehouse in New Orleans in 2005, the Bahia narrowly escaped the flooding caused by Hurricane Katrina. It has allegedly been used in any number of fraudulent business dealings – a judge called one such scheme 'despicable and reprehensible'. It was listed on eBay in 2007 for a starting price of \$18.9 million and a 'buy-it-now' price of \$75 million. Gullible potential buyers were regaled with a back-story that involved a journey through the jungle on a stretcher woven from vines and a double panther mauling.

At the time of writing the Bahia emerald is valued at around \$400 million and is at the centre of a Californian lawsuit. Around a dozen people claim to have bought the stone fair and square in the 15 years since it was discovered, including a dapper Mormon businessman; a man who says he purchased it for \$60,000, only to be tricked into believing it was stolen; and several of the people who brought it over to California in the first place. An international row has been brewing too: Brazil claims that the stone should be repatriated.³ The story of the Bahia emerald is, in short, a parable of avarice worthy of the Bard himself.

Kelly green

It is well known that the only people more proud of their Irish heritage than the Irish are the Americans of Irish descent. New York's St Patrick's Day Parade, for example, proudly traces its lineage all the way back to 17 March 1762, 14 years before the Declaration of Independence. Every year, while the White House dyes the waters of its fountain the colour of mulched leaves, hundreds of thousands gather to celebrate Ireland by drinking Guinness, wearing green and trying out their rusty Irish accents. By contrast, Kelly green, one name given to the spring-grass colour so many wear on St Patrick's Day, is a rather recent invention, emerging only at the beginning of the twentieth century.

Most people would, if asked, say the connection between the Irish and Kelly green has to do with St Patrick. Everything known about the saint comes from the man himself: during his lifetime in the fifth century he wrote his *Confessio*, an account of his life in Latin, the first text written in Ireland to have survived. It begins simply: 'My name is Patrick. I am a sinner, a simple country person, and the least of all believers.'2 His first acquaintance with the country of which he is now patron saint was not a happy one. He was born to a relatively wealthy Christian family in a place named Bannavem Taburniae – which was probably in England, although no one is quite sure – and was brought to Ireland as a slave after being captured by Irish raiders. In all he spent six years as a captive tending sheep, after which he escaped, returned home and became a priest. Clearly he did not bear Ireland any ill will, because he soon returned as a missionary, converting much of the population, most famously using a shamrock to explain the idea of the trinity. He died some time in the late fifth century. and was being celebrated as a saint by the seventh.

Strangely, though, the colour he was most associated with until the middle of the eighteenth century, was a shade of blue.³

The shift in Irish loyalty from St Patrick's blue to green is convoluted. Responding to what they perceived as the anti-Catholic bias of William of Orange and the orangewearing Protestants [page 96], Catholics wanted a symbolic colour of their own. By this time the saint's lesson of the shamrock had become increasingly central to Irish Catholic identity. At the same time green had become associated with revolution when, on 12 July 1789, a young lawyer called Camille Desmoulins picked up a linden leaf in the middle of haranguing a Parisian crowd, stuck it in his hat and invited patriots to do the same. Soon enough, the linden leaf had become a green cockade, and it might have been adopted as the symbol of the French Revolution had it not been remembered at the last minute that it was the colour of the livery of the detested Count d'Artois. Louis XVI's younger brother. By 14 July, the green cockade had been eclipsed by the tricolour.4 Nevertheless a green flag, sometimes bearing a golden harp, became the symbol of the fiery Irish Home Rule movement, which sought independence from Britain. In a deliberate snub, when the Prince of Wales visited Ireland in the spring of 1885, a green flag vied for space with the Union Jack.⁵ In the end, the Irish decided to follow the French once more in the adoption of a tricolour flag. The green symbolised the Catholic nationalists, orange the Protestants, and white the peace it was hoped would reign between them.

Scheele's green

The island of Saint Helena lies like a lost seed in the middle of the Atlantic, 2,000 kilometres west of Africa and 4,000 kilometres east of South America. It is so remote that it has, for the majority of its history, been uninhabited, serving only as a stop-off for ships to collect fresh water and repair their hulls. It was here that the British decreed that Napoleon should be sent in October 1815 after his defeat at Waterloo. And it was here too that he died. six years later. Although his physician had initially suspected stomach cancer, when Napoleon's body was exhumed in 1840 it was found to be curiously well preserved, a symptom of arsenic poisoning. A sample of his hair, tested in the twentieth century, was also found to contain abnormally high levels of the poison. Once it was discovered in the 1980s that the walls of his damp little room in Saint Helena were papered with a verdant design containing Scheele's green, the rumour spread that the British had poisoned their difficult prisoner.

In 1775 Carl Wilhelm Scheele, a Swedish scientist, was studying the element arsenic when he came across the compound copper arsenite, a green that, though a slightly grubby pea shade, he immediately recognised as having commercial potential in an industry starved of green pigments and dyes.1 It went into production almost immediately and the world fell in love with it. It was used to print fabrics and wallpapers; to colour artificial flowers, paper and dress fabrics; as an artists' pigment; and even for tinting confectionery. J. M. W. Turner, ever willing to try out the latest innovations, used it in an oil sketch of Guildford in 1805.2 After a trip to Italy in 1845, Charles Dickens returned home seized with a passion to redecorate his whole house in the newly fashionable shade. (He was, luckily, dissuaded by his wife.)3 By 1858 it was estimated that there were around

100 square miles of wallpaper dyed with copper arsenite greens in British homes, hotels, hospitals and railway waiting rooms. And by 1863 *The Times* estimated that between 500 and 700 tons of Scheele's green were being made each year in Britain alone to satisfy the ballooning demand.

However, just as it seemed as if the appetite for greens could not be satiated, disturbing rumours and a string of suspicious deaths began to dull consumers' hunger. Over 18 months working as an artificial-flower maker a 19-year-old called Matilda Scheurer rapidly sickened – her likely symptoms included nausea, vomiting, diarrhoea, rashes and listlessness – and finally died in November 1861. In another case, a little girl had died after sucking the green powder from a bunch of artificial grapes.⁴

As more and more people succumbed after experiencing similar symptoms, doctors and scientists began conducting tests on all green consumables. An article in the British Medical Journal in 1871 noted that green wallpaper could be found in all manner of houses, 'from the palace down to the navvy's hut'; a six-inch-square sample of such a paper was found to contain enough arsenic to poison two adults.⁵ G. Owen Rees, a doctor at Guy's Hospital in London became suspicious after a patient was apparently poisoned by some calico bed curtains. He did further tests in 1877 and found to his horror that 'some muslin of a very beautiful pale green' used for dressmaking contained over 60 grains of an arsenic compound in every square yard. 'Imagine, Sir,' he wrote to *The Times*, 'what the atmosphere of a ball room must be where the agitation of skirts consequent on dancing must be constantly discharging arsenical poison.'6

Scheele had known from the beginning that his eponymous pigment was poisonous: he said so in a letter

Scheele's green, continued.

to a friend in 1777, adding that his other principal concern was that someone else might get the credit for his discovery.7 The head of the Zuber & Cie factory in Mulhouse wrote to a professor in 1870 to say that the pigment, 'so beautiful and so brilliant', was now only being supplied in small quantities. 'To want to prohibit all trace of arsenic in papers is to go too far', he continued, 'and to hurt business unjustly and needlessly'.8 The public, it seemed, largely agreed, and no laws were ever passed banning its use. If this seems strange, it should be remembered that this was a world where arsenic and its dangers were accepted with more equanimity. Even after a mass-poisoning in 1858, when a packet of powdered white arsenic was mistaken for icing sugar and added to a batch of peppermints in Bradford, it took a long time for people to come around to the idea of regulations and warning symbols.9

This more laissez-faire attitude to the poisonous substance was given some accidental backing by researchers at Italy's National Institute of Nuclear Physics in 2008. In order to finally settle the question of Napoleon's death, they tested other samples of hair from different stages of his life, and found that the levels of arsenic had remained relatively stable. They were, yes, very high by today's standards, but not at all unusual for his.¹⁰

Terre verte

Reading treatises and manuals by early artists, it is hard not to think that they often faced a Sisyphean struggle to create works of lasting beauty. Pigments were often mercurial, reacting badly with other pigments or changing colour over time, like verdigris [page 214]; they were downright lethal, like orpiment [page 82] and lead white [page 43]; or they were ludicrously expensive and difficult to acquire, like ultramarine [page 182]. It could be assumed, then, that if a pigment were found that was inexpensive, relatively plentiful, completely stable and in a colour where there were very few other options, that this pigment would be in high demand. The case of terre verte shows this is not the case.

Also known as green earth or Verona green, terre verte is a rather mongrel collection of naturally occurring pigmented earths of varying hues and mineral make-ups. The green colouring agents are usually glauconite and celadonite, but can also include many other minerals.1 The pigments crop up in great quantities in various locations throughout Europe, most famously Cyprus and Verona, and come in a range of colours, from deep forest. to an almost crocodilian shade, and even a rather beautiful sea mist. The drawback is their low tinting strength, but they are all very permanent and stable, rather transparent, work perfectly in all mediums, give a peculiar almost buttery texture to oils and, crucially, were some of the few green pigments readily available. And yet, when artists write about terre verte, their words have the air of a school report about a child who means well but is totally devoid of charm. George Field, in his book Chromatography, published in the mid-nineteenth century, is typical in his indifference:

Terre verte, continued.

[I]t is a very durable pigment, being unaffected by strong light and impure air, and combining with other colours without injury. It has not much body, is semi-transparent, and dries well in oil.²

Curiously, prehistoric man seems to have been equally apathetic when it comes to the green earths. In the Lascaux caves in France, where images date back to 15000 BC, the pigments that dominate are red and yellow ochres, manganese oxide browns and blacks, and calcite white. At Altamira in Spain, where paintings date from 10000 BC, much of the work uses hematite [page 150]. In fact cave art is dominated by browns, whites, blacks and reds; the use of blues and greens is almost unheard of. With blue, which is very rare in mineral form, this is not. surprising, but the absence of green certainly is: terre verte was widely available and easy to process and use.3 It did get used a lot later on. It can be seen, for instance, in a wonderful naturalistic mural of a tree in Stabiae. a town near Pompeii that was also destroyed by the eruption of Vesuvius in AD 79. Terre verte really came into its own, however, when artists discovered that it was perfect for shading the pale pinky-red of European skin. In some European manuscripts, where the top layers have faded, the green underlayer shows through, giving the saints an unsuitably demonic air.

Cennino Cennini, an artist pupil of the Tuscan master Giotto, was undoubtedly a pragmatist. He loved art and also enjoyed showing others how they could replicate it themselves. His *Il libro dell'arte* spent several centuries consigned to oblivion on a dusty Vatican shelf before being rediscovered and republished in the early nineteenth century, and it has remained in print ever since. In this book he explains all manner of processes, from gilding a panel to making glue with the 'muzzles, feet, sinews, and

... skin' of goats (a practice that should only be attempted in March or January).4 Terre verte and its uses occur again and again. Cennini notes enthusiastically that the pigment is good for everything from faces to draperies, and works just as well in fresco as it does in secco (dry). To produce good flesh tones in tempera, for example, he tells his readers to lay two coats, mixed with white lead, 'over the face, over the hands, over the feet, and over the nudes'. He recommends using tempera made with the 'yolk of a town hen's egg' for young faces, because their flesh is cooler, while the yolk of a 'country or farm' hen is better suited 'for tempering flesh colours for aged and swarthy persons'. For the flesh of corpses he suggests omitting the pink that was usually layered over the top: 'a dead person has no colour'.5 It is difficult to know what it was that made him look more favourably upon this rather unlovable pigment. Perhaps the secret lies in his first encounter with it. When he was a boy, Cennino's father, Andrea Cennini, took him to the workings at Colle di Val d'Elsa. '[U]pon reaching a little valley,' he wrote, 'a very wild steep place, scraping the steep with a spade, I beheld seas of many kinds of colour'.6

Avocado

In February 1969 the beaches of Santa Barbara, California, turned black. Several days earlier, on the morning of 28 January, an oil well 10 kilometres off the coast had ruptured. In all it is estimated that 200,000 gallons of crude oil escaped, and for 11 days it spewed out from the sea floor, coating a 35-mile stretch of Californian coastline and any marine wildlife in its path. The Santa Barbara spill marked a turning point in the way the world, and particularly the United States, perceived the globe and its fragility.1 The inaugural Earth Day was celebrated on 22 April the following year. (It was founded by Senator Gaylord Nelson, who had seen for himself the damage at Santa Barbara.) Over the next few years, in response to popular protests, legal progress against pollution gained traction in America: the Clean Air, Clean Water and National Environmental Policy Acts were passed.

Over the next decade the environmental health of the world loomed increasingly large in the public consciousness. A picture of the globe taken on 7 December 1972 by the crew of the Apollo 17, who were bound for the Moon, made the world look, for the first time, vulnerable. The 'Blue Marble' photo became one of the most iconic and widely shared images of all time. Artists like Robert Smithson and James Turrell used the land as a raw material, creating works that frankly commented on the Earth's fragility and challenged perceptions of the planet as immutable and inexhaustible.2 It was during this period that the colour green became the shorthand for nature. The two had always been linked, of course - the ancient Egyptian hieroglyph for 'green' was a papyrus stalk - but during the 1970s the link became ubiquitous.3 A small organisation called the Don't Make Waves Committee changed its name to Greenpeace in 1972. PEOPLE, the forerunner to the British Green Party, was founded in 1973; Germany's equivalent, Die Grünen, in 1979; and France's Les Verts were consolidated in the 1980s.

These grand ideas and a burgeoning concern for the natural world were translated into a back-to-nature palette of earthy colours: burnt orange, harvest gold and, above all, avocado. This shade, which appears so dated now, dominated palettes throughout the 1970s. As shoppers strove to appear sincerely concerned for the welfare of the world, the furthest reaches of consumer goods – clothing, kitchen appliances, baths, even cars – were colonised by this smoky yellow-green tint.

These attempts at environmental redemption through consumption may well seem hopelessly naïve, but similar consumer impulses prevail today. And avocado has stealthily been reprising its role since the millennium. Those who doubt this need only check their Instagram feeds. While few advocate for avocado-coloured macramé and shag pile, the Persea americana has become the poster-fruit (technically it's a single-seed berry) for a new kind of luxury consumption underpinned by the concept of natural healthfulness. Lovingly slathered on pieces of toast everywhere from southern California to Slough. they have become the centrepiece of the eat-clean brand of aspirational lifestyle. And as one of the few hearthealthy, 'good' fats that nutritionists consistently agree on, avocado imports have skyrocketed. In 2014, four billion avocados were consumed in America, around four times the number eaten a scant 15 years before. In 2011 alone sales were \$2.9 billion, an 11% increase on the year before. As Mike Brown, a marketing executive for the Mexican Hass Avocado Importers' Association, told a reporter for the Wall Street Journal in 2012: 'the stars have aligned.'4

Celadon

Honoré d'Urfé led a dramatic life. He was imprisoned for his political beliefs, lived much of his life as an exile in Savoy, and married his brother's beautiful widow in order to keep her fortune in the d'Urfé family. It was perhaps this surfeit of intrigue that led him to write the nostalgic, meandering *L'Astrée*. Published between 1607 and 1627, the 5,399-page and 60-book pastoral comedy recounts the futile quest of Céladon, a lovelorn shepherd, to win back his lover Astrée after a misunderstanding. Despite its prodigious length and unwieldy cast of characters, it was a hit with his contemporaries. It was widely translated, circulated throughout Europe and spawned a stage play and even a fashion for dressing in sylvan green à la Céladon.²

So firmly linked was Céladon with this particular woodland-fog colour that the word 'celadon' was soon used to refer to a kind of similarly hued type of ceramics imported from the East. The Chinese had been making celadon objects for centuries before d'Urfé's hero sprang into being. Usually greyish green - although the colours can vary enormously, from blues to greys to ochres and even blacks - these ceramics are characterised by the presence of iron in the clay and iron oxide, manganese oxide and quartz in the glaze.3 Pieces are usually fired at just under 1150 degrees and oxygen levels are dramatically reduced mid-way through. Many have thin networks of fissures in the glazes, as fine as the network of veins in a leaf, which are produced intentionally to made the surface resemble jade.4 Although the method originated in China, similar ceramics were produced by the Goryeo dynasty on the Korean peninsula between AD 918 and 1392. Even within China, there was a great variance in the style, colour and aesthetic of celadon pieces produced in different regions and eras.5

Song-dynasty celadon has been found as far afield as Japan and Cairo and there is evidence of a healthy trade in celadon with the Middle East, Turkish rulers, who believed celadon was a natural antidote to poison, amassed a vast collection that can still be seen at the Topkapi Palace in Istanbul.6 A variant, called mise or 'mysterious colour', was long the most costly and exclusive ceramic made in China, reserved for royal households. Nor was mise a misnomer: few contemporaries outside the courts had ever seen a single piece and could only guess at what it looked like. Xu Yin, a tenth-century poet, described the colour as 'carving light from the moon to dye the mountain stream', which certainly sounds like an artful guess.7 The true colour of mise celadon was only rediscovered by archaeologists in the late 1980s, when a precious cache was discovered in a secret chamber underneath a collapsed temple tower. The mysteriously coloured celadon China's rulers had guarded so jealously turned out to be a rather drab olive.8

Although 'oriental' books and *objets d'art* had been dribbling west for centuries, Europeans, at the far end of a series of tortuous trade routes, were too distant from the source to understand celadon's myriad classifications. Patterns and colours that, to a trained observer, would have communicated purpose, place and time of origin, meant nothing to seventeenth-century Europeans. For them, the beautiful, sea-mist ceramics that had travelled so far conjured up only the hapless Céladon in his shabby coat of green.

Khaki
Buff
Fallow
Russet
Sepia
Umber
Mummy
Taupe

Brown

The creation of man from clay is a motif that appears across

many cultures and religions, from Babylonian to Islam. As the Bible has it: 'In the sweat of thy face shalt thou eat bread, til thou return unto the ground; for out of it wast thou taken: for dust thou art, and unto dust shalt thou return.' It may be symbolic of the rich soil from which we get our food, but we will never show brown our gratitude. After all, it is not only the colour of the earth to which we will one day return, but also mud, filth, refuse and shit.

Brown suffers in part because it is not a hue, but a shade. It is not found in a rainbow or on a simple colour wheel: making it requires darkening and greving down vellows, oranges and some impure reds, or mixing together the three artists' primaries - red, yellow and blue. That there is no bright, or luminous brown led to its being despised by both medieval artists and modernists. For medieval artists, who disliked mixing on principle and saw the glory of God reflected in the use of pure precious materials like ultramarine [page 182] and gold [page 86], brown was inherently corrupt. Centuries later Camille Pissarro boasted that he had expunged all the earth pigments from his own palette (although in actual fact they do crop up occasionally).2 Where browns were necessary - inevitably, since the Impressionists and many who came after them enjoyed painting landscapes en plein air - they were made using mixtures of the saturated new synthetics.

This was wilfulness on the part of the artists, because iron oxides, known as ochres, are some of the most common compounds on the earth's surface. They were also one of the first pigments used by humankind. The cattle, deer, lions and hand prints found on the walls of prehistoric caves were lent their warm browns and maroons by earth pigments. The ancient Egyptians,

Greeks and Romans also used ochres. To add to their utility, they were not only plentiful but also found in many different varieties.

Like some blacks, browns have long been used by artists for under-drawings and sketches. Bistre, a dark but not particularly colourfast material, usually prepared from the tarry remains of burned beech wood, was popular.³ Other notable examples include the yellowy sienna from Italy and umber [page 250], which is darker and cooler. A blood-brown earth known as sinopia, after the port it came from, was beloved too. Pedanius Dioscorides, a Greek physician who lived around AD 40-90, described it as heavy and dense and the colour of liver.4 In July 1944 an Allied bullet grazed the roof of a building beside the leaning tower in Pisa's famous Piazza dei Miracoli and set it aflame, seriously damaging the Renaissance frescoes within. According to Giuseppe Ramalli, a local lawver who saw the whole thing, they were left 'swollen, dilated, coming off or stained by thick. wide streaks, drawn by the lead dripping down from the molten roof . . . Words fail to convey that ruin'.5 When what remained was ripped off the walls to be repaired, a host of spirited sinopia preparatory drawings were revealed. These can still be seen, in all their fresh and expressive glory, today.

The artistic period most associated with browns, and which valued them most for their own sake, came after the first flush of the Renaissance. The principal figures in the works of artists like Correggio, Caravaggio and Rembrandt stand out like bright islands in spaces full of capacious shadow. So much shadow demanded an extraordinary array of brown pigments – some translucent, others opaque; some warm, others cool – to prevent the works from looking featureless and flat. Anthony van Dyck,

a Dutch artist active in the first half of the seventeenth century, was so skilled with one pigment – cassel earth, a kind of peat – that it later became known as 'Vandyke brown'.6

In an echo of what happened in art, bright, colourfast dyes for cloth, such as scarlet [page 138], were difficult and expensive to come by, and therefore remained the preserve of the wealthy and powerful. This left brown for the poor. Fourteenth-century sumptuary laws reserved russet [page 246] - back then a duller brown-grey shade for those in the meanest occupations like carters and ox-herds. Over time, though, probably in reaction to conspicuous displays of wealth, humbler cloth in humbler colours gained favour. This was helped by both an increased interest among the wealthy in sporting pursuits and soldiers' uniforms. Buff [page 242] leather coats, for example, were worn by cavalry in the sixteenth and seventeenth centuries, and by the mid-1700s buff breeches were an essential part of the well-dressed European gentleman's wardrobe.

Although light tans continued to be a part of military uniform through the nineteenth century, it was usually only as a facing to bolder colours like emerald greens and Prussian blues [page 193]. These helped comrades find each other in battle, and also served to intimidate the enemy. As the nineteenth century drew to a close,however, the limitation of these uniforms began taking its toll. After a series of humiliating military setbacks in its colonies, the British Army slowly became more responsive to innovation. One example of this shift was the adoption of khaki [page 240] and, later, camouflage, which helped fighters disappear into their surroundings. By clothing soldiers in brown, thousands were saved from a premature return to the earth.

Khaki

On 5 August 1914, Lord Kitchener became Britain's

Secretary of State for War. It must have been a daunting prospect. The day before, Britain had declared war on Germany, a country far larger and better equipped;¹ at the time, Britain's Expeditionary Force consisted of just six infantry divisions and four cavalry brigades. Over the next four years much of the government's time and energy was expended persuading, cajoling and finally making millions of British men swap their civvies for khakis in the effort to provide men for the front.

At the outbreak of the First World War, though, khaki was only a relatively recent recruit itself. It is said that when the two sides encountered each other on the field at the Battle of Mons, some Germans expected their enemy to be wearing red coats and bearskins; they were very taken aback to see the new khaki uniforms, which they thought looked rather like golfing tweeds.2 The word is borrowed from Urdu - khaki means 'dusty' - and was used to refer to cloth, usually for military clothing, that was dust-coloured. It is thought to have been invented by Sir Harry Lumsden, who raised a Corps of Guides at Peshawar, in what is now Pakistan, in 1846. Wanting to give them a suitable uniform, he bought up metres of white cotton cloth at a bazaar in Lahore and ordered it to be soaked and rubbed with mud from the local river. before being cut into loose tunics and trousers.³ This would, he hoped 'make them invisible in a land of dust'.4 It was revolutionary: for the first time in organised military history, an official uniform had been devised that, rather than calling attention to itself, blended into the landscape.

It soon caught on, helped in large part by the Indian Mutiny of 1857, which broke out during the summer, making the usual kit even more impractical than usual. Dusty brown uniforms – dyed, when muddy riverbeds

weren't to hand, with coffee, teas, soil and curry powders - spread in fits and starts through the Indian Army between 1860 and 1870, and then to the rest of the British Army and on to the armed forces of other countries.5 Changes in warfare, military tactics and technology meant that camouflaged troops had an advantage. For thousands of years prior to this, warriors had decked themselves out in eye-catching styles to intimidate opponents. Bright colours, such as the red cloaks of Roman legions and the emerald and silver jackets of the Russian Imperial Guard. could make individuals and forces look larger than they really were, and served as easy identification of friend or foe on smoke-filled battlefields. At the turn of the twenty-first century, however, increasingly sophisticated use of planes for reconnaissance, coupled with the invention of the smokeless gun, meant that the risks of being visible seriously outweighed the advantages.6

By the end of the First World War, four blood-andmud-stained years later, khaki had become synonymous with soldiery. Men who had enlisted, or had been rejected from military service, were given khaki brassards or armbands with small red crowns sewn onto them. And when, in the excitement of the first few months of the war, young, working-class women were deemed too aggressively susceptible to the soldiers' charms, they were accused of 'khaki fever'.7 From posters demanding 'WHY AREN'T YOU IN KHAKI?', to music hall songs and uniforms,8 this determinedly inconspicuous colour was continuously pressed into service. On 11 November 1918, four years after Lord Kitchener's first day on the job. the war ended. At 9.30 a.m., 90 minutes before the silence of peace rang out at 11 o'clock, private George Edwin Ellison was shot just outside Mons in Belgium, the Great War's final, khaki-clad victim.

Buff

To do something 'in the buff', as everyone knows, is to do it naked, but this idiom has an unlikely origin. The word buff is itself slang: a shortened form of buffalo. In the sixteenth and early seventeenth centuries the word was generally used for a kind of buttery tanned ox leather a thicker and more robust form of the kind now known as chamois 1 While the material was sometimes used to make fashionable and decorative jerkins and doublets, it was most commonly associated with fighting.2 Long heavy coats of buff were part of European soldiers' standard kit during this era, often worn in place of proper metal armour (although the material was sometimes worn underneath chain mail for added protection and padding).3 Even after fashions and military technology had moved on, the colour – by this time also known as buff - remained a staple of men's wardrobes and military uniforms.

Its most memorable turn was during the American Revolutionary War in the late eighteenth century when the colonies of North America fought against Britain and King George III for their independence. George Washington, later to become the first president of the United States of America, came to the cause as a veteran of the Seven Years War, in which he'd fought for the British in their traditional scarlet. As a savvy politician, he knew a change of political allegiance necessitated a change of colours. When representatives from the fledging United States met at the Second Continental Congress in the summer of 1775. Washington was wearing a new uniform: the buff and blue of the home-grown Fairfax Independent Company of Volunteers. It had the desired effect. John Adams, a Founding Father who later became the second president of the United States, wrote to his wife Abigail that: 'Coll. Washington appears at Congress

in his Uniform, and by his great Experience and Abilities in military Matters, is of much service to Us. Oh that I was a Soldier!' Washington was commissioned there and then as the commander-in-chief of the Continental Army and thereafter, where possible, clothed his soldiers in buff and blue. In a letter dated 22 April 1777, Washington wrote to Captain Caleb Gibbs to specify the uniform he desired for his personal guard:

Provide for four sergeants, four corporals, a drum and fife, and fifty rank and file. If blue and buff can be had I should prefer that uniform, as it is the one I wear myself. If it can not, Mr Mease and you may fix on any other colour, red excepted.6

From its appointment as one of the colours of the new United States of America, buff graduated to a symbol of liberty. On the other side of the Atlantic, the Whig Party, under the influence of Edmund Burke and Charles James Fox, adopted Washington's colours to show their support for American independence. Georgiana, the Duchess of Devonshire and a prominent Foxite, campaigned for the Whigs wearing buff and blue, and chose the combination for the livery of her footmen at Chatsworth. Two centuries later, when Prime Minister Harold Macmillan met John F. Kennedy at a summit in Bermuda in 1961, Macmillan presented Kennedy with a set of silver buttons taken from the Devonshire livery as a token of Britain's enduring friendship with the United States.⁷

Fallow

Some time in the tenth century, a collection of around 90 handwritten Anglo-Saxon riddles were collected into the back of a book known as the *Codex exoniensis*. Its origins are murky: we only know for certain that it was owned by Leofric, the first bishop of Exeter who died in 1072, and who donated the manuscript to his cathedral library. It is also a mystery why the riddles – which range from the whimsical to the filthy² – are there at all. They are huddled at the back after pages of serious, Christian content more befitting reading matter for a man of the cloth. While most of the riddles have been solved, with answers ranging from an iceberg to a one-eyed garlic seller, a definitive answer to the fifteenth still proves elusive.³ It begins:

Hals is min hwit – heafod fealo
Sidan swa some – swift ic eom on fepe...
beadowæpen bere – me on bæce standað...
[My neck is white, my head is fallow
And so are my sides. I am swift in my stride...
I bear weapons of battle. On my back there is hair...]⁴

Fallow is a faded, caramel-tawny colour, the tint of withered leaves or grass, and one of the oldest colour names in the English language.⁵ From the 1300s the word has been applied to farmland resting between seasons of use to replenish the soil – we still speak of fields lying fallow – but it has also been used to describe animals with coats that help them melt into their surroundings. An early debut was in 'Beowulf', where it's used to describe horses; Shakespeare mentions a 'fallow Greyhound' in The *Merry Wives of Windsor*. The best example, however, is the coquettishly white-rumped, dappled-bodied fallow deer, the forebears of which have been common over Europe and the Middle East for millennia.

Hunting them was a favourite pastime of the Norman nobility after the conquest of England in 1066, and special parks were created to close the deer off from wolves and Britons alike. So seriously did the hunters take their sport that under William the Conqueror the punishment for killing such deer was equal to that for killing a man – even centuries later, if you were caught poaching one you might find yourself being deported.

A deer, however, is not the answer to riddle 15 – that would be too easy. This animal, the riddler tells us, walks on her toes on the grass but also burrows, 'with both hands and feet . . . through the high hill' to escape the 'hateful foe' that means to kill her and her children. Guesses as to the mystery creature's identity have included badger, porcupine, hedgehog, fox and weasel, with no one animal quite fitting exactly. The answer, it seems, may remain hidden forever, while the hunters keep on hunting.

Russet

Russet is a reminder that a colour lives more in the

imagination of a generation than bound into a neat colour reference. Say the word now and it might call to mind the ruddy colour of leaves in autumn, or the hair of a Pre-Raphaelite muse, but this was not the case even as recently as 1930. In A. Maerz and M. R. Paul's influential *Dictionary of Colour* it is a more orange- than reddishbrown, and has pronounced ashy grey undertones.¹

Part of the reason for this is that, like scarlet [page 138], the word *russet* used to denote a type of cloth rather than a colour. While scarlet was luxurious to the touch, beloved by the rich and so usually dyed bright red, russet cloth was for the poor. In 1363 – the 37th year of the reign of Edward III, King of England – Parliament introduced a new statute to regulate the diets and apparel of English subjects. After dealing summarily with lords, knights, clergymen and merchants, the gaze of the law passed down to the lowest of the low:

Carters, Ploughmen, Drivers of the Plough, Oxherds, Cowherds, Shephards... and all other Keepers of Beasts, Threshers of Corn, and all Manner of People of the Estate, and all other People, that have not Forty Shillings of Goods... shall not take nor wear no Manner of Cloth, but Blanket, and Russet of Twelve-pence.²

To the medieval mind, the closer a cloth was to the colour of the raw materials, the cheaper and meaner it was. Russet, a very coarse woollen cloth, was usually just dipped into weak solutions of first blue woad [page 198] and then red madder [page 152] left over from dyeing the clothes of those further up the social scale.³ Because the end result depended on the qualities of the dyes used and the colour of the undyed wool, russet cloth could be any colour ranging from dun through to brown or grey.⁴

The skill and honesty of the dyer was another important factor. Surviving records from Blackwell Market in the City of London, where merchants' goods were checked over to ensure they were of acceptable quality, show that there was a good deal of defective material going to market. (Kentish russets were, with 25 entries, second only to whites from Gloucester – 50 entries – and Wiltshire – 41 entries – in their shoddy quality.) On 13 April 1562, William Dowtheman from Tonbridge, and William Watts and Elizabeth Statie, both from Benenden, were all fined for their inferior russets. Watts, apparently, was not a man to learn from his mistakes: he'd been fined for precisely the same reason on 17 November the previous year.⁵

Just as the precise colour of russet has refused to remain stable, shifting significantly over time, so has its symbolism. From being a byword for the poor, after the violent social changes brought about by the Black Death, russet gradually gained a reputation as betokening honesty, humility and manliness. In *Piers Plowman*, William Langland's fourteenth-century allegorical poem about good and evil, charity 'is as gladde of a goune of a graye russet / As of a tunicle of tarse [silk]'. It was no doubt this double meaning that Oliver Cromwell was using when he wrote to his Civil War associates in the autumn of 1643: 'I had rather have a plain russet-coated captain that knows what he fights for, and loves what he knows, than that which you call a gentleman and is nothing else.'

Sepia

If you were to surprise a *Sepia officinalis*, or common cuttlefish – and finding one would be the first challenge, as their camouflage is superb – it would respond in one of two ways. You might find yourself suddenly enveloped in a dense smokescreen of dark liquid, or confronted with a host of decoy cuttlefish – dark blobs formed out of a mixture of the same ink and mucus. The *S. officinalis*, meanwhile, would have made a dash for it, leaving you empty-handed.

Almost all cephalopods – a group that includes octopuses, squid and cuttlefish – can produce ink. This burnt coffee-brown liquid is made up almost entirely of melanin [page 278] and has tremendous tinting strength. Although now squid ink is most often found lending seafood risotto the glossy black lustre of a raven's wing, sepia (the ink of the cuttlefish) has long been used as a pigment for writers and artists. Recipes and methods for separating cephalopods from their ink abound, but a common procedure involved removing the sac, drying and powdering it, and then boiling the extract with a strong alkali to extract the pigment. Once neutralised, it could then be washed, dried, ground up and made into cakes to be sold.²

The Roman writers Cicero and Persius both mention, and probably used, sepia as ink, and it is likely the poet Marcus Valerius Martialis did too.³ Martial was born in the city of Bilbilis, around 150 miles north-east of where Madrid now stands, some time between AD 38 and AD 41.⁴ His epigrams skewer the pretentions of his fellow city dwellers in Rome, and satirise stingy patrons and fellow poets. ("Write shorter epigrams" is your advice. / Yet you write nothing, Velox. How concise!', is one such witticism.⁵) Martial's bravado, though, must have been, at least in part, a ruse to conceal all the usual writer's insecurities

Once, when sending out his latest collection – probably written in sepia ink – he included a sponge in the package, so that his words could be wiped away if they did not please the recipient. Leonardo da Vinci was fond of using the warm-toned sepia in his sketches, many of which still survive. The colourist George Field described it in 1835 as 'a powerful dusky brown colour, of a fine texture' and recommended its use as a watercolour.

Today, although artists still value sepia ink for its foxy red undertones, the word is more likely to be used in the context of photography. Originally images were chemically toned to replace the silver in the silver-based prints with a more stable compound, making them longer lasting and a symphony of warm ochres. Now, of course, technology has rendered this unnecessary, but the tones have taken on the mantle of romance and nostalgia. Digital photography tools mean that, with just a few clicks of a button, photographers can disguise their new, fresh images, making them look a century old.

Umber

On 18 October 1969, under cover of a vicious storm, a group of men broke into the Oratory of San Lorenzo in Palermo and stole a priceless nativity scene by Michelangelo Merisi Caravaggio. Caravaggio was by many accounts a violent, troubled man, but no one who stands before one of his few remaining paintings can doubt his genius. *Nativity with St Francis and St Lawrence*, a huge work in oil created 360 years before its theft, shows the birth of Christ as a grim scene of impoverishment and exhaustion. The surviving photos show a very dark composition, just a few figures, heads bowed and dishevelled, picked out against a muddy ground. Like many of Caravaggio's other works, this painting probably owed its dark drama to his use of umber.¹

Although some believe that umber's name is, like sienna's, geographical in origin – one source is Umbria in Italy – it is more likely that the word comes from the Latin *ombra*, meaning 'shadow'. Like hematite [page 150] and sienna, umber is one of the iron oxide pigments commonly called ochres. But while hematite is red and sienna, when raw or unheated, is a yellow-tinged brown, umber is cooler and darker, perfect as a dark glaze.² It is also, like its fellows, a very stable and reliable pigment, and was considered an essential part of every artist's palette up until the twentieth century. However, it is also profoundly unglamorous. George Field, the nineteenthcentury chemist and author of Chromatography, wrote that 'it is a natural ochre, abounding with oxide of manganese . . . of a brown-citrine colour, semi-opaque, has all the properties of a good ochre, is perfectly durable both in water and oil'.3 One can almost hear the yawn in his words.

Umber is one of the oldest known pigments used by humans. Ochres were used on cave walls at Altamira in

Spain and at Lascaux, a trove of cave art in south-west France, which was rediscovered by a dog called Robot in September 1940. As Robot snuffled around the roots of a fallen tree, he uncovered a small opening underneath. His owner, the 18-year-old Marcel Rabidat, returning with three friends and some lamps, squeezed through a 40-foot-long shaft and into a vast chamber filled with late Stone Age paintings.

The period where umber really came into its own, however, was the dramatic tenebrism of the late Renaissance and baroque artists like Joseph Wright of Derby and Rembrandt van Rijn. These painters, sometimes called *Caravaggisti*, because of their admiration for their predecessor, gloried in the drama of strong contrasts between spots of light and deepest shadow, a technique also known as chiaroscuro, from the Italian words chiaro 'bright' and oscuro 'dark'. Rembrandt, particularly in his impoverished later years after his bankruptcy in 1656, used a startlingly small range of pigments to produce the effect, relying heavily on the cheap, sombre ochres, especially umber.5 It is there in the backgrounds and heavy clothing of his late selfportraits, the ones in which he is so uniquely expressive: sometimes thoughtful, or wounded, or quizzical, but always catching and holding the viewer's gaze, his face strongly lit in the pools of darkness.

In 1996 the fate of Caravaggio's masterpiece painting was revealed in a spectacular trial. Francesco 'Mozzarella' Marino Mannoia, a Sicilian mafia specialist in refining heroin, became a government informer after the death of his brother. Francesco told the court that he had sawn the painting from its frame above the altar and bundled it up to deliver to the man who had commissioned the theft. Tragically, though, he had no experience with valuable

Umber, continued.

works of art and no idea of the care with which they needed to be handled. When the patron saw the condition of the painting after its rough treatment, he wept. '[I]t was not . . . in a usable condition any more,' Marino Mannoia admitted at his trial 30 years later. Many still refuse to believe it has been destroyed, continually appealing for the painting's safe return, ever hopeful that it will, one day, emerge from the shadows.

Mummy

On 30 July 1904, O'Hara and Hoar placed an unusual advertisement in the *Daily Mail*. What they wanted – 'at a suitable price' – was an Egyptian mummy. 'It may appear strange to you,' the notice read, 'but we require our mummy for making colour.' Then, to stave off any pricks of public conscience, they continued: 'Surely a 2,000-year-old mummy of an Egyptian monarch may be used for adorning a noble fresco in Westminster Hall or elsewhere without giving offence to the ghost of the departed gentleman or his descendents.'1

By then such a plea was unusual enough to raise comment, but mummies had been dug up and reused in various ways for centuries without much fuss. Mummification had been common burial practice in Egypt for over 3,000 years. Internal organs were removed before the body was washed and embalmed using a complex mixtures of spices, as well as preservatives. including beeswax, resins, asphalt and sawdust.2 Although mummies - particularly those of the rich and distinguished, whose wrappings were likely to contain gold and trinkets³ - could be valuable in themselves, those who dug them up were more often after something else: bitumen. The Persian word for bitumen was mum or mumiya, which had led to the belief (along with the fact that mummified remains were very dark) that all mummies contained the substance.4 Bitumen – and by extension mummies – had been used as a medicine from the first century AD. Groundup mummy, or 'mummia', was applied topically or mixed into drinks to swallow, and it seemed there was almost nothing it could not cure. Pliny recommended it as toothpaste; Francis Bacon for the 'staunching of blood': Robert Boyle for bruises: and John Hall, Shakespeare's son-in-law, used it on a troubling case of epilepsy. Catherine de Medici was a devotee, as was François I

Mummy, continued.

of France, who carried a little pouch of powdered mummy and rhubarb on him at all times.⁵

Trade was brisk. John Sanderson, an agent for an importer called the Turkey Company, vividly described an expedition to a mummy pit in 1586:

We were let down by ropes, as into a well, with wax candles burning our hands, and so walked upon the bodies of all sorts and sizes... they gave no noisome smell at all... I broke off all of the parts of the bodies to see how the flesh was turned to drugge, and brought home divers heads, hands, armes and feet.

Mr Sanderson actually returned to England with one complete mummy and 600 pounds of sundry parts to refresh the supplies of the London apothecaries. Demand, however, outpaced supply, and there are numerous reports of replacements being hastily made from the bodies of slaves and criminals. While on a visit to Alexandria in 1564, the physician to the King of Navarre interviewed one mummy dealer who showed him 40 he claimed to have manufactured himself in the past four years.

Because apothecaries often dealt in pigments too, it is not so surprising that the rich brown powder also found itself on painters' palettes. Mummy, also known as Egyptian brown and *Caput mortum* ('dead man's head'), was used as paint – usually mixed with a drying oil and amber varnish – from the twelfth until the twentieth centuries. It was well known enough for an artists' shop in Paris to call itself – tongue, presumably, in cheek – *À la Momie*. Eugène Delacroix used it in 1854 when painting the Salone de la Paix at the Hôtel de Ville in Paris; his fellow countryman Martin Drölling favoured it too, as did the British portraitist Sir William Beechey. There was some debate as to which bits of the mummy

to use to get the best and richest browns – recommended for translucent glazing layers for shadows and skin tones. Some suggested using just the muscle and flesh, while others thought that the bones and bandages should also be ground up to get the best out of this 'charming pigment'."

Gradually though, towards the end of the nineteenth century, fresh supplies of mummies, authentic or otherwise. dwindled. Artists were becoming dissatisfied with the pigment's permanency and finish, not to mention more squeamish about its provenance.12 The Pre-Raphaelite painter Edward Burne-Jones hadn't twigged the connection between 'mummy brown' and real mummies until one Sunday lunch in 1881, when a friend related having just seen one ground up at a colourman's warehouse. Burne-Jones was so horrified he rushed to his studio to find his tube of mummy brown, and 'insisted on our giving it a decent burial there and then'. 13 The scene made a great impression on the teenage Rudyard Kipling, Burne-Iones's nephew by marriage, who was also a guest at lunch. '[T]o this day,' he wrote years later, 'I could drive a spade within a foot of where that tube lies.'14

By the beginning of the twentieth century demand was so sluggish that a single mummy might provide a paint manufacturers with pigment for a decade or more. C. Roberson, a London art shop that had first opened its doors in 1810, finally ran out in the 1960s. 'We might have a few odd limbs lying around somewhere,' the managing director told *Time* magazine in October 1964, 'but not enough to make any more paint. We sold our last complete mummy some years ago for, I think, £3. Perhaps we shouldn't have. We certainly can't get any more.' 15

Taupe

Some time in 1932 the British Colour Council (BCC) began working on a special project. The idea was to create a standardised catalogue for colours, complete with dyed silk ribbons to show exactly what colour was meant by each term. It would, they hoped, do for colour 'what the great *Oxford Dictionary* has done for words'. It 'will mark', they wrote, 'the greatest achievement of modern times in assisting British and Empire industries with colour definition', thereby giving Britain trade a competitive edge.

What wasn't mentioned was that Britain was behind the curve. Albert Henry Munsell, an American artist and teacher, had been working on a way of three-dimensionally mapping colour since the 1880s; his system was fully fledged by the first decade of the twentieth century and has been used with minor tweaks ever since.² A. Maerz and M. R. Paul, who built on Munsell's work but also wished to incorporate the common names for colours, published their *Dictionary of Colour* — modelled on Samuel Johnson's idiosyncratic *English Dictionary* — in New York in 1930. It included pages of colour chips, a comprehensive index and snippets of information on many common colours.

They all developed a fine appreciation for the difficulty of the task. Colours were hard to pin down; they could change name over time, or the shade associated with a name might morph alarmingly from one decade or country to the next. Chasing down and collating colour terms and samples had taken the BCC 18 months. Messrs Maerz and Paul had laboured over the task for years.³ One colour that vexed both sets of researchers was taupe. It is actually a French word, meaning 'mole'. However, while the colour of a mole was, by broad consensus, 'a deep grey on the cold side', taupe was all over the place – the only thing consistently agreed upon was that it was generally browner than a mole had a right to be.⁴ The BCC's

assumption was that the confusion was due to ignorant English-speakers not realising that *taupe* and *mole* were different words for the same thing. Maerz and Paul were rather more thorough. They set out on an expedition around the zoological museums of the United States and France to look at foreign specimens from the genus *Talpa*, to determine whether there was a logical reason for using both terms. '[I]ts colour certainly varies,' they concluded, but what was generally understood by the term taupe 'represents a considerable departure from any colour a mole might possess'. The sample they included in their book, therefore, was 'a correct match for the average actual colour of the French mole'.⁵

Despite transatlantic efforts to return this colour to something approximating the hue of its parent mammal, taupe has since continued to run wild. Beloved by the make-up and bridal industries, it is roomy enough to contain a plethora of pastel brown-greys while still managing to sound refined and elegant. If only these intrepid colour cartographers had taken all the lessons of Samuel Johnson's great enterprise to heart, they might have been spared the wild-mole chase. Johnson, even as he set down definitions next to words in his dictionary in 1755, was realistic enough to appreciate the ultimate futility of his task. This rueful reflection from his preface could just as easily apply to colours: 'sounds are too volatile and subtile for legal restraints; to enchain syllables, and to lash the wind, are equally the undertakings of pride.'

Kohl
Payne's grey
Obsidian
Ink
Charcoal
Jet
Melanin
Pitch black

Black

What do you think of when you see the colour black?

Perhaps a better question would be: what *don't* you think of when you see black? Few colours are more expansive and capacious. Like the dark obsidian mirror [page 268] that once belonged to Dr Dee, look into black and you never know what might look back. It is, simultaneously, the colour of fashion and of mourning, and has symbolised everything from fertility to scholarship and piety. With black, things are always complicated.

In 1946 Galerie Maeght, an avant-garde Parisian gallery on rue du Bac on the Left Bank, staged an exhibition called 'Black is a Colour'. It was a statement intended to shock: this was the precise opposite of what was then taught at art schools.1 'Nature knows only colours,' Renoir once declared. 'White and black are not colours.'2 In one sense, this is right. Like white, black is an expression of light, in this case its absence. A true black would reflect no light whatsoever - the opposite of white, which reflects all light wavelengths equally. On an emotional level, this has not affected our experience or use of blacks as colours; on a practical level. it has so far proved impossible to find or create a black that reflects no light at all. Vantablack, a carbon nanotube technology created in Britain in 2014, traps 99.965% of the spectrum, making it the blackest thing in the world. In person it is so dark it fools the eyes and brain, rendering people unable to perceive depth and texture.

A whiff of death has clung to black as far back as records reach, and humans are fascinated and repelled by it. Most of the gods associated with death and the underworld – such as the jackal-headed Egyptian god Anubis, Christianity's devil and the Hindu goddess Kali – are depicted with truly black skin, and the colour has long been associated with both mourning and witchcraft.

However, while black is so often linked with endings, it is present at the start of things too. It reminded the ancient Egyptians of the rich silt that the Nile deposited after the floods each year, making the land fertile. Black's potential for creation is there in the opening passages of Genesis – it is, after all, out of the darkness that God conjures light. Night-time too has a peculiar fecundity, for all the obvious reasons, and because of dreams that blossom only when we close our eyes to shut out the light. A piece of artists' charcoal [page 274] is a perfect emblem for beginnings. The outline – usually black – was invented over 30,000 years ago. It may be the example non plus ultra of artistic artifice, but this has never mattered to artists, and the black line is art's foundation stone. It was to hand when early men and women first began expressing themselves by leaving their marks on the world around them, and it has been used at the inception of nearly all artistic endeavours since.³ Some 12,600 years after Paleolithic fingers and pads of soft leather daubed fine charcoal powder onto the cave walls at Altamira, da Vinci favoured fine sticks of the stuff. It was one of these that he used to sketch out a softly blended sfumato - from fumo, for smoke - version of what would become his simultaneously mysterious and expressive painting The Virgin and Child with Saint Anne (1503-19), now in the Louvre.

It was during da Vinci's lifetime, too, that black reached its zenith as the colour of fashion. His near contemporary, Baldassare Castiglione, wrote in his *Book of the Courtier* that 'black is more pleasing in clothing than any other colour,' and the Western world agreed.⁴ Its rise as the most fashionable of colours had three causes. The first was practical: sometime around 1360, new methods were found for dyeing fabrics true black, rather than dirty brown-greys, which made them more luxurious.

A second reason was the psychological impact of the Black Death, which decimated the population of Europe, and led to a desire for greater austerity and collective penitence and mourning.5 Philip the Good (1396-1467), who famously was rarely seen out of black clothing, favoured it to honour the memory of his father, John the Fearless, who had been assassinated in 1419.6 The third reason was the wave of laws that sought to codify social strata through dress: wealthy merchants were forbidden to wear colours reserved for the old money, such as scarlet [page 138], but they could wear black.7 The obsession lasted until the first decades of the eighteenth century. Estate inventories show that in around 1700, 33% of nobles' and 44% of officers' clothing was black; it was popular with domestics too, making up 29% of their wardrobes.8 At times the streets must have resembled Rembrandt's paintings Sampling Officials (1662) or Anatomy Lesson of Dr Nicolaes Tulp (1632): crowds of identikit black-clad folk jostling for space.

Despite the ubiquity, black has retained both its popularity and its fresh, challenging modernity. Kazimir Malevich's *Black Square*, for example, is believed to be the first purely abstract painting. Used as we are to abstract art, the magnitude of this work is difficult to understand. For Malevich, though, *Black Square* (he created four different versions between 1915 and 1930) was a statement of intent. He desperately wanted, as he put it, 'to free art from the dead weight of the real world', and so 'took refuge in the form of the square'. This, for the first time, was art for art's sake, and a revolutionary idea needed a revolutionary colour: black.

Kohl

Lurking in the Egyptology section of the Louvre in Paris is a curious object. It is a squat, sparkling white statuette of a bow-legged creature, whose red tongue lolls from a mouth lined with sharp teeth; it has pendulous, triangular breasts; a fierce blue V for eyebrows; and a long shaft of a tail that dangles rudely between its legs. Made between 1400 and 1300 BC, it depicts the god Bes who, while he may look terrifying, was actually rather sweet: a fearsome fighter, he was popular with ordinary Egyptians because he was a protector, particularly of homes, women and children. What he was protecting in this case, though, was rather different: hidden in the statuette's hollow head is a small container intended for kohl eyeliner.

Bes is one of over 50 such kohl pots in the Louvre's collection. Some, like this one, are decorative and come in the form of servants or cattle or gods; others are more functional, just little jars of alabaster or breccia (a kind of rock).¹ Pots like these turn up in a lot of museum collections, because everyone in ancient Egypt, from pharaohs to peasants, male and female, rimmed their eyes with thick black lines; many were buried with jars of kohl, so that they could continue to do so in the afterlife. Kohl was believed to have magical protective properties, and, as it does today, played the visual trick of making the whites of the eyes stand out, which was then, as now, considered distinctive and attractive.²

The kind of kohl used depended on wealth and social status. The poor might use mixtures of soot and animal fats but, as ever, the wealthy demanded something rather more special. Theirs would predominantly be made of galena, the dark metallic mineral form of lead sulphide. This would be crushed and mixed with powdered pearls, gold, coral or emeralds to give sheen and subtle colour. Frankincense, fennel or saffron might then be added for their scent.

To make the powder useable, it was bound with a little oil or milk so that it could be daubed with feather or finger.³

In 2010, French researchers analysing the traces of powder found in kohl pots discovered that they also contained something even more precious: man-made chemicals, including two kinds of lead chlorides that would have taken around a month to brew. Mystified, they conducted further tests. To their astonishment, these chemicals were found to stimulate the skin around the eye to produce around 240% more nitric oxide than usual, significantly reducing the risk of eye infections. In a time before antibiotics, such simple infections could easily lead to cataracts or blindness. Kohl, like the little pot in the shape of the fearsome Bes, was a very practical form of protection.

Payne's grey

'Stalin,' an early political opponent once wrote, 'gave me the impression . . . of a grey blur which flickered obscurely and left no trace. There is really nothing more to be said about him.'¹ It's a stinging line: in our individualistic age it is almost better not to be remembered at all than to be remembered as dull and insubstantial. Of course the opponent could not have been more wrong: Stalin has left a long and burdensome legacy and humanity is unlikely to forget him in a hurry.

One eighteenth-century gentleman, on the other hand, had faded from memory almost before he died. All that remains is the pigeon-plumage shade of grey to which he lent his name. It is still a firm artists' favourite, even if little is known about the man himself. William Payne was born in Exeter in 1760 and raised in Devon before moving to London. Maybe . . . possibly. A pamphlet on the painter produced in 1922 by one Basil Long spends the first 10 pages alternating between putting forward biographic theories and apologising for a lack of actual evidence.²

We do know that after spending some time as a civil engineer Payne travelled to London and began painting full time. He was a member of the Old Water-Colour Society, where he exhibited in the years from 1809 to 1812, and also showed work at the Royal Academy. Joshua Reynolds is even said to have admired some of his landscapes. Payne, however, was most in demand as a teacher. As his contemporary William Henry Pyne put it: his paintings 'were no sooner seen than admired, and almost every family of fashion were anxious that their sons and daughters should have the benefit of his tuition'. We will never know if it was the strain of dealing with the untalented offspring of London's elite that drove him to find a replacement to true black pigments, but we do know that he was proud enough of this precise mixture

of Prussian blue, yellow ochre and crimson lake to make sure his name stuck to it.

Why is Payne's grey so beloved by artists? It is at least partially because of a phenomenon now known as 'atmospheric perspective'. Think of hills and mountains fading off into the distance, for example: the further away things are, the paler and bluer they appear. This effect is caused by particles of dust, pollution and water droplets scattering the shortest, bluest light wavelengths, and it is exacerbated by fog, rain and mist. It is small wonder that a landscape painter working in Devon was the first to mix the deep blue-black grey so peculiarly suited for capturing this effect.

Obsidian

There are many intriguing objects in the collection of the British Museum in London, but one of the most mysterious has to be a thick, dark and highly polished disc with a small, hooped handle. The Aztecs forged the mirror from obsidian in honour of their god Tezcatlipoca (his name means 'smoking mirror'), and it was brought over to the Old World after Cortés's conquest of the region that is now Mexico, in the mid-sixteenth century.1 Obsidian, also known as volcanic glass, is formed when molten lava. erupting from the earth, comes into contact with ice or snow, and cools very quickly.2 It is very hard, glossy, brittle and either black or a very dark bronze-green, sometimes with a golden or iridescent sheen caused by layers of tiny gas bubbles that become trapped in the magma as it solidifies. Although there is some doubt about this particular mirror's provenance, Sir Horace Walpole, the British antiquarian who acquired it in 1771, was under no doubt about its previous owner and what it had been used for. On the label attached to the object's handle he wrote a curious inscription: 'The Black Stone into which Dr Dee used to call his spirits.'3

Dr John Dee was Elizabethan England's foremost mathematician, astrologer and natural philosopher. He was a Cambridge graduate, and the queen's philosopher and advisor; he also spent many years talking to angels about the natural order and the end of the world. These conversations were held using his collection of 'shewstones' – of which this mirror may have been one – and through several mediums, most famously Edward Kelly. It is not so remarkable that a man of Dee's intelligence believed in the occult – most people did. Indeed, nearly a century later one of the greatest scientific minds in history – belonging to one Isaac Newton – expended the greater part of its energy searching for the Philosopher's Stone.

Black 269

What is remarkable is that anything is known about Dee's mystical investigations at all.

He died in 1608 or 1609, disgraced and in poverty, after having had to sell off the majority of his possessions, including most of his famous library. His papers, too, were scattered or destroyed. In 1586 an angel, speaking through Kelly, ordered Dee to burn all 28 volumes of his painstaking records of their previous conversations, which was convenient timing seeing as envoys from the Papacy were just about to begin questioning the pair about their involvement with witchcraft, a very serious charge indeed. If they had discovered his obsidian mirror, it might well have been enough to land Dee on the rack or the pyre.

The late sixteenth and early seventeenth centuries witnessed the widespread return of the most disturbing, paranoid and pessimistic aspects of Christianity: belief in the potency of the devil on earth, and that his envoys - witches - were busy working to overthrow order and bring him to power. In this context blacks of all shades took on disturbing new meanings. Not only was the devil usually depicted (and described by witnesses at witch trials) as black and hairy, but the idea of the sabbat, which so obsessed Europe and later North America, was filled with darkness. From their venues – often forests at night – to their black-clad participants and the retinue of animals that attended Satan - crows, bats and cats - sabbats were veritable orgies of blackness.5 Obsidian, a dark rock spewed forth from the fiery bowels of the earth, was naturally deeply suspect.

Obsidian crops up in occult company time and time again. In the fiction of George R. R. Martin and Neil Gaiman, blades made from the volcanic glass have magical powers. Historically, Native American tribes have used it in rituals. As recently as the 1990s, women from the

Obsidian, continued.

Santa Clara Pueblo in New Mexico dressed in black and carried long obsidian blades in their right hands and an obsidian spear point, or *tsi wi*, in their left during witch-destruction ceremonies.⁶ Ancient and prehistoric obsidian artefacts – often blades – have been found around the Red Sea, Ethiopia, Sardinia and the Andes. The name of the Aztec patroness of witches, Itzpapalotl, means 'obsidian butterfly'. More damning still for Dee, Tezcatlipoca, the Aztec god for whom his own mirror was made, was the god of warriors, rulers and sorcerers.⁷

Ink

It is one thing for humans to have complex thoughts

and plans; it is quite another to transmit them over long distances. That requires a system of marks that the sender knows the receivers can understand. For most cultures this has meant writing, which in turn has meant creating decent ink.

Inks have tended to be black because they need to be very fluid to write with easily – far more so than paint; most pigments would not be sufficiently legible at such high levels of dilution.

Sometime around 2600 BC in ancient Egypt, Ptahhotep, a Fifth Dynasty vizier, began to think about retirement. His reason was old age and his litany of complaints will be familiar to anyone with elderly relatives: 'Sleep is upon him in discomfort every day. / Eyes are grown small, ears deaf. / Mouth silent, unable to speak.' A few lines on he begins to give touching advice to his son: 'Do not be proud on account of your knowledge, / But discuss with the ignorant as with the wise. / The limits of art cannot be delivered; / There is no artist whose talent is fulfilled.'1 (It must have been good advice: his son later became a vizier himself.) We know about Ptahhotep, his aches and pains, and his son, because he committed his thoughts to papyrus with black ink that remains perfectly legible today.2 It was made using lampblack, a very fine pigment that was easily produced by burning a candle or lamp; to this would be added water and gum Arabic, which helped the particles of lampblack disperse through the water rather than clumping together.3

The Chinese, who ascribed the invention of ink to Tien-Tchen, who lived between 2697 and 2597 BC, also used lampblack for their ink (sometimes also confusingly known as Indian ink). The pigment was produced in huge amounts: row upon row of special, funnel-shaped lamps

Ink, continued.

were tended every half-hour or so by workers who scraped soot off the sides of the lamps using feathers. For special-occasion ink they used the soot of pine logs, ivory, lacquer resin or the deposits of dead yeast left over at the end of wine fermentation, but the end product was essentially the same. With the exception of the initial raw material, the recipe for most ink remained stable until the nineteenth century. Even the invention of the printing press had little impact on it. When the 42-line Bible began spilling off Gutenberg's presses in around 1455, the smell of ink in the air would have been much the same as in countless monastic scriptoriums. The principal tweak to the recipe was the use of linseed oil as the base medium, which made for thicker ink that would adhere more easily to the paper.

Other kinds of dark ink involved extracting the bitter tannins from vegetable material. A particularly famous and long-lasting kind, iron-gall ink, was the product of the acrimonious relationship between a wasp and an oak tree. The *Cynips quercusfolii* lays its eggs in the young buds or leaves of the oak tree, along with a chemical that causes the oak to form a hard, nut-like growth around the larvae. This growth – often called an oak apple – is rich in bitter tannic acid. When combined with iron sulfate, water and gum Arabic, the acid produces a velvety blue-black and very permanent ink.⁷ A variant on this recipe, recorded by Theophilus in the twelfth century, uses the tannic acid in the sap of crushed buckthorn.⁸

For many cultures, however, the practicalities of ink – legibility, permanency and consistency – have gone hand-in-glove with rather more diffuse, emotional, even reverential considerations. The ancient Chinese used inks perfumed with cloves, honey and musk. The scents, it is true, helped cover the odour of the binders used – yak skin and fish intestines were common – but these inks

sometimes also contained powdered rhinoceros horn, pearls or jasper. In medieval Christian monasteries, the act of copying and illuminating libraries of manuscripts, of putting wisdom and prayer to paper, was seen as a spiritual process in itself.

Black ink also had a devotional relationship with Islam: the Arabic word for ink, *midãd*, is closely related to that for divine substance or matter. An early seventeenth-century recipe in a treatise on painters and calligraphers contained 14 ingredients; some, like soot and gallnuts, are obvious enough, but others – saffron, Tibetan musk and hemp oil – are far less so. The author, Qadi Ahmad, was under little doubt of ink's numinous power. 'The ink of the scholar,' he wrote, 'is more holy than the blood of the martyr.' 10

Charcoal

Émile Cartailhac was a man who could admit when he was wrong. This was fortunate, because in 1902 the French prehistorian found himself writing an article for *L'Anthropologie*, in which he did just that. In 'Mea culpa d'un sceptique' he recanted the views he had spent the previous 20 years forcefully and scornfully maintaining: that prehistoric man was incapable of fine artistic expression and that the cave paintings found in Altamira, northern Spain, were forgeries.¹

The Paleolithic paintings at Altamira, which were produced around 14000 BC, were the first examples of prehistoric cave art to be officially discovered. It happened by chance in 1879, when a local landowner and amateur archaeologist was busily brushing away at the floor of the caves, searching for prehistoric tools. His nine-year-old daughter, Maria Sanz de Sautuola - a grave little thing with cropped hair and lace-up booties - was exploring further on when she suddenly looked up, exclaiming, 'Look, Papa, Bison!' She was quite right: a veritable herd. subtly coloured with black charcoal and ochre, ranged over the ceiling.² When her father published the finding in 1880, he was met with ridicule. The experts scoffed at the very idea that prehistoric man - savages really could have produced sophisticated polychrome paintings. The esteemed Monsieur Cartailhac and the majority of his fellow experts, without troubling to go and see the cave for themselves, dismissed the whole thing as a fraud. Maria's father died, a broken and dishonoured man, in 1888, four years before Cartailhac admitted his error.3

After the discovery of many more caves and hundreds of lions, handprints, horses, women, hyenas and bison, the artistic abilities of prehistoric man are no longer in doubt. It is thought that these caves were painted by shamen trying to charm a steady supply of food for their tribes.

Many were painted using the pigment most readily available in the caves at the time: the charred stick remnants of their fires. At its simplest, charcoal is the carbon-rich byproduct of organic matter – usually wood – and fire. It is purest and least ashy when oxygen has been restricted during its heating.

As an energy source, charcoal powered the Industrial Revolution. Such vast quantities were used to smelt iron that whole forests were decimated and smoke filled the air around cities. Charcoal is thus indirectly responsible for one of the classic exemplars of natural selection. The *Biston betularia f. typica*, or peppered moth, is usually a speckled white and black. During the nineteenth century a previously unknown variety with an all-black body and bitter chocolate wings began appearing more frequently around northern towns, while numbers of the white-speckled kind declined sharply. By 1895 a study around Manchester found that 95% of the peppered moths were dark.⁵ Against the bark of the sooty trees, the dark moths were harder for predators to see – hiding, like the Altamira bison, in plain sight.

Jet

In its original sense, the word *jet* may be on the cusp of disappearing. Plug the word into a search engine and squadrons of stumpy aeroplanes appear. And while people still say 'jet black', it is beginning to acquire the worn-thin feeling of something too often repeated.

Actually, the black kind of jet is anything but insubstantial. Also known as lignite, it is a kind of coal formed over millennia from highly pressurised wood; when fine enough, it is so hard it can be carved and polished to an almost glass-like sheen.¹ The most highly prized jet comes from Whitby, a small town on the north-east coast of England.

The Romans were the first to exploit Whitby's jet. It was, until the nineteenth century, so abundant that great lumps could be gathered from the beaches. From there it was probably taken to Eboracum (York), the Roman provincial capital, to be carved and then exported to the rest of the empire. One figurine, found at the beginning of the twentieth century in Westmoreland dates from around AD 330, just as the Roman grip on Britain was beginning to slip. The statuette shows a woman leaning on what appears to be a barrel. She wears a mantle that is hitched over her left shoulder, and seems to be wiping away tears with her left hand. If it is, as has been supposed, a depiction of a Roman goddess to be given as an offering when grieving, then it could be the first example of jet's involvement in what became something of a Victorian obsession.2

Ancient Greeks and Romans may have started the tradition of wearing special, drab clothes when a friend, relative or ruler died, but, for the Victorians, rules and conventions governed every colour of every stitch of clothing a person could wear from the time their loved one died until the niceties of grief were exhausted, up to

two years later. Because glossy pieces of black jet jewellery – no matter how elaborate the design – could be worn throughout the mourning period, they became immensely popular. As with mauve [page 169], Queen Victoria was at least partially responsible for the trend. Within a week of Prince Albert's sudden death from typhoid fever on 14 December 1861 the crown jewellers had been commissioned to produce commemorative black jewellery, which the distraught queen continued to press on relatives for years afterwards. She herself remained in mourning for the rest of her life.³ (A photograph of the dead prince was integrated into all royal portraits until 1903.)

In the 1870s, at the height of the cult of mourning, Whitby's jet industry employed over 1,400 men and boys at between £3 and £4 a week. Their wares were bought by the conspicuously bereaved the world over; Altman's department store in New York proudly advertised their stock of 'Whitby jet earrings' in the 1879–80 catalogue.⁴

By the 1880s much of the best jet in Whitby had been consumed – artisans had needed to mine for it from as early as the 1840s - and the jet carvers were beginning to resort to the softer, more brittle kind that was inclined to break. Hardier and cheaper alternatives – like black cut glass, fancifully known as 'French jet' - were used instead. In 1884 the Whitby jet industry could only support 300 jobs on the paltry weekly wage of 25 shillings. Simultaneously, the public performance of grief was increasingly seen as vulgar, rather than refined. Bertram Puckle, in his 1926 book on the history of funerary customs, wrote of 'the hideous lumps of crudely manufactured jet which it is still considered by some classes of society to be necessary to wear when "in mourning". 5 In 1936 only five jet workers remained in business. The First World War had all but extinguished the West's taste for sartorial grieving.6

Melanin

In folklore it is rare for someone or something to get the better of a black animal, but in one of Aesop's fables, a fox manages it. Seeing a crow in a tree clasping a hunk of cheese in its beak, the fox lavishly compliments the bird's glossy black plumage. Flattered, the crow preens its feathers and, when the fox asks to hear her sing, she immediately opens her beak, dropping the cheese down to the waiting fox.

Perhaps one should not judge the vain crow too harshly: her colouring is rather special. Unlike plants, the animal kingdom possesses a pigment, melanin, that allows for a true black. There are two types, eumelanin and pheomelanin, which, deployed in varying concentrations, account for a vast spectrum of skin, fur and feathers from roan to tawny and, in the highest concentrations, sable.

In humans, varying levels of eumelanin and pheomelanin determine skin colour. Our earliest ancestors in Africa evolved to have dark skin with high concentrations of melanin in order to help protect them from the harmful ultraviolet wavelengths in the sun's rays. Descendents of the groups who left Africa some 120,000 years ago gradually developed paler skin as they travelled northwards, because it was a genetic advantage in regions with less light.²

The black animal par excellence, though, is the raven. Not only are they visually striking, they have long been known for their intelligence. Because of this they have always had cultural prominence: ravens, for example, have attended the Greek god Apollo, the Celtic god Lugus and the Norse god Odin. Odin's ravens were particularly esteemed. Named Huginn (thought) and Muninn (memory), they travelled the world on his behalf, gathering information for him and making him all but omniscient.³ Early Germanic warriors wore the symbol of the crow on

their clothes, and apparently drank the bird's blood before battles. So entrenched was this custom that in AD 751 Boniface, the archbishop of Mainz, wrote to Pope Zachary listing the animals eaten by pagan Germans – including storks, wild horses and hares – and asking which ones he should try to ban first. The pope's reply, when it came, was clear: crows and ravens were at the very top of the list. Zachary was possibly thinking of Leviticus, where it says the raven is the bird 'which ye shall have in abomination among the fowls; they shall not be eaten, they are an abomination'.4

Metaphorical black animals have also plagued humanity. In a letter dated 28 June 1783, Samuel Johnson talked of his depression as a black dog;

When I rise my breakfast is solitary, the black dog waits to share it, from breakfast to dinner he continues barking... Night comes at last, and some hours of restlessness and confusion bring me again to a day of solitude. What shall exclude the black dog from a habitation like this? 5

A century later John Ruskin's horrifying description of the onset of a psychotic break begins: 'A large black cat sprang forth from behind the mirror.' Another man famously dogged by the spectre of depression was Winston Churchill. He wrote to his wife in July 1911 telling her of a German doctor who had cured a friend's depression. 'I think this many might be useful to me – if my black dog returns,' writes Churchill. 'He seems quite away from me now – it is such a relief. All the colours come back into the picture. Brightest of all your dear face.'

Pitch black

'In the beginning', the Bible begins, 'the earth was without form and void: darkness was upon the face of the deep.' Then God said, "Let there be light," and there was light.' Believer or not, the power of this image – God bringing light to the deep darkness – is undeniable.

Pitch black is the most fearsome kind of darkness. For humans, fear of it, perhaps lingering from the days before we could reliably make fire, is universal and ancient. In the dark we become acutely aware of our limitations as a species: our senses of smell and hearing are too blunt to be of much use in navigating the world, our bodies are soft, and we cannot outpace predators. Without sight, we are vulnerable. Our terror is so visceral we are wont to see night-time as pitch black, even when it isn't. Thanks to the Moon, the stars and, more recently, fire and electricity, nights so dark that we cannot see anything are rare, and we know that, sooner or later, the Sun will rise again. 'Pitch' is an appropriate epithet: just as the resinous wood-tar residue might stick to a careless hand, darkness can seem to cling and weigh us down. Perhaps this is why we experience night, figuratively at least, as more than just an absence of light. It is unyielding: a daily helping of death.

Traces of our aversion to night and blackness can be found across cultures and eras. Nyx, the ancient Greek goddess of night, is the daughter of Chaos; her own children include sleep, but also, more ominously, anguish, discord and death.¹ Nott, a night goddess from Germanic and Scandinavian traditions, wears black, rides in a chariot drawn by a dark horse, pulling darkness across the sky like a drape.² Through fear, pitch black has also laid symbolic claim to death, which is, in the most desolate view, a night without end. Both Yama, the Hindu god of death, and Anubis, his ancient Egyptian counterpart, have black skin.

Kali, the fearsome Hindu warrior goddess of both creation and destruction, whose name means 'She who is black' in Sanskrit, is usually depicted with dark skin, wearing a necklace of skulls, and brandishing swords and a severed head.³

Many cultures have worn black in mourning for the dead. In Plutarch's telling of the legend of the Minotaur, the young tributes that were sacrificed each year to the creature were sent off in a ship with black sails, 'since they were heading to certain destruction'. Fear of the deepest dark has also left its mark on language: the Latin word for the darkest matte black is *ater* (there is another word, *niger*, reserved for the glossy, benign variety of black), which led to Latin words for ugly, sad and dirty, and is also the etymological root for the English word *atrocious*. S

The most eloquent expression of humanity's fear of pitch black is also one of the oldest. It comes from the Book of the Dead, the Egyptian funerary text used for about 1,500 years until around 50 BC. Finding himself in the underworld, Osiris, the scribe Ani, describes it thus:

What manner [of land] is this into which I have come? It hath not water, it hath not air; it is deep, unfathomable, it is black as the blackest night, and men wander helplessly therein.6

Glossary of other interesting colours

Α

- Amethyst Violet or purple, from the precious stone
- Apricot Soft peach
- Aquamarine Blue-green, the colour of the sea; also a colour of beryl
- Asparagus Toned-down spring green
- Azure Bright, sky blue, used in heraldry

В

- Bastard Warm gold of the light-gels used in stage lighting to suggest sunshine on stage
- Beryl A translucent mineral; usually pale green, blue or yellow
- Bistre Brownish pigment made from burnt wood
- Blackcurrant Deep purple, from the berry
- Blood Intense, saturated red, usually with subtle
 blue undertones
- Blush Pinky beige, like flushed cheeks
- Bordeaux Deep cherry, from the French wine
- Bronze The colour of the metal; darker and a bit duller than gold
- Burgundy A deep purple-brown, from the French wine

С

- Cadet blue Grey-greenish blue, from military uniforms
- Café au lait Pale brown, the colour of coffee mixed with milk
- Capri blue Sapphire; taken from the colour of the water in the Grotta Azzurra on the island of Capri
- Carmine Mid-crimson red; a pigment made using cochineal
- Carnation Originally from Latin carneus, 'flesh-coloured' (used in French heraldry as the colour of flesh); now creamy mid-pink
- Chartreuse A pale yellow-green; from the liqueur made by the Carthusian monks at La Grande Chartreuse monastery in France
- Cherry Deep red with a little pink
- Chestnut Red-brown, like the seed of the chestnut tree
- Chocolate Rich brown
- Cinnabar A bright red mineral; a source of vermilion
- Citrine Originally lemon-coloured (though the semi-precious stone is warmer); it is often used now as the tertiary colour between orange and green
- Copper Reddish, rosy gold, like the metal; used to describe hair, it denotes a more intense fiery orange
- Cocquelicot Bright red with a hint of orange;
 French for Papaver rhoeas, the wild poppy
- Coral Soft pinky orange like faded, salt-encrusted reefs (traditionally the most desired shade of coral has been red)
- Cornflower A bright blue with a little violet; from the flower
 - Cream Pale yellow; rich off-white
- Crimson Deep red inclined to purple; historically from kermes dye
- Cyan Bright blue with a little green

D

- Delft blue An inky shade; from the pottery made in the Dutch city of Delft in the eighteenth century
- Denim The blue of indigo-dyed jeansDove grey Soft, cool-toned mid grey
- Duck egg Blue-green with a little grey
- Dun A grey-brown; often used to describe livestock

E

- Eau de Nil A pale green thought to resemble the colour of the River Nile
- Ebony Very dark brown; from the tropical hardwood, usually from the genus Diospyrus
- Ecru Pale off-white, the colour of unbleached cloth; from crudus, Latin for raw

F

- Forest Used by Walter Scott to refer to Lincoln green; now slightly blue mid-green
- French grey Very pale grey-green
- Fulvous Dull orange; like tawny, often used to describe animal colours, usually birds' plumage

G

- Gaudy green Like Lincoln green; cloth dyed with indigo and weld
- Glaucous Pale grey blue-green
- Goldenrod Strong yellow; after the flower
- Grape A violet shade; much brighter than real grapes
- Grenadine Originally a peachy orange; now red like the liqueur
- Gules Red; from heraldry
- Gunmetal Mid-blue-grey

Н

- Heather Pre-twentieth century a synonym for mottled; now pinky purple
- Hooker's green Bright green; Prussian blue mixed with gamboge; named after British illustrator William Hooker (1779–1832)

1

Incarnadine A fierce, saturated pinkish red

J

Jasper Soft green; for the colour of the most revered chalcedony

L

- Lavender Pale bluish purple; usually a tint much paler than the blooms themselves
- Lemon yellow; the colour of the fruit
 - Lily white Very pale cream with a bit of warmth

 Lime Very bright green; originally after the fruit,
- but now usually much more luminous, even neon
- Lincoln green Colour of cloth traditionally make in Lincoln, an English city. Worn by Robin Hood and his merry men
- Livid From lividus, Latin meaning 'dull', leaden colour; also used to describe the colour of bruised flesh

M

- Magnolia Pale pink-beige
- Mahogany Red brown, after the hardwood
- Malachite Glassy bright green; the colour of the mineral
- Mallow A pinky lilac colour; from the flower
- Mandarin True orange; from the fruit
- Maroon Originally nut brown marron means chestnut in French – now brownish dark red
- Midnight Dark blue of the night sky
 Milk white Pale greyish cream
 - Moonlight Very pale peach
- Morocco Brick red; originally a colour of painted leather
- Moss Yellowed green; the colour of moss
- Mouse A grey dun brown, similar to fallow
- Mustard Strong yellow, like the condiment

Ν

- Navy Dark blue with a little grey
- Nymphea Mid-pinkish purple

early British car racing

Rose Delicate pink or pale crimson
 Ruby Rich wine shade of red

Raspberry Rich pinky red; the colour of the berry 🌑 Wheat Pale gold

S 0 Sable Black; from heraldry. Resembles the Ochre Pale yellowish brown; from the earth pigment containing ferric oxide fur from the small, weasel-like animal of the Old rose Dusty pink with blue undertones same name Salmon A warm pinky orange Olive drab Green with plenty of grey and brown; Sapphire Dense blue; the colour of the precious stone Onyx Black; from the chalcedony mineral Shell Pale pink Oxblood A dark rust-red Shrimp The colour of boiled prawn shells Sienna A yellow-brown; from the ochre mined from the Italian town of the same name. Redder when heated: burnt sienna Slate Mid-azure grey; from the rock Peacock A saturated blue-green Smalt Glassy blue; from the artists'pigment Pea green Fresh springy green Smoke A soft bluish grey Pearl Very pale lilac-grey Snow White with a grey yellow tinge Peridot Sharp green; from the mineral, a kind of olivine Strawberry Yellow-toned red; the colour Periwinkle Lilac-blue, after the flower of the fruit Sugar Sweetie pink; the colour of candyfloss Phthalo green Piney blue-green, after a synthetic pigment; also comes in deep blue sometimes known as Monastral Т Pistachio A waxy green; the colour of the nut kernel and ice cream Tangerine Yellowy orange; from the skin Plum Reddish purple; after the fruit of the fruit Pomegranate The cranberry-pink colour Tawny Tan-coloured; orange-brown of the fruit Pompadour Warm pale blue; after the Teal Strong green with a dash of blue; after the band on the duck's wing eighteenth-century Marquise, mistress of Tea rose A beige pink King Louis XV Terra-cotta Brown-red; from the Italian for Pompeian red A dark brick red; from colour of the houses discovered by archaeologists 'baked earth' Topaz The gemstone comes in many in Pompeii Poppy A clear brilliant red; from the flower different colours, but the term usually refers to a tawny deep yellow Primrose Pale yellow with a little green; Turquoise Greenish blue, like a tropical sea from the flower Puke Dark brown; named after a woollen fabric V Q Vanilla Pale yellow; the colour of custard Quimper Soft cornflower blue; the colour of dusk Wiridian Dusky leek green W R Racing green Dark evergreen; associated with Walnut Dark brown tone

Watchet Pale blue-grey

Endnotes

Introduction

- ¹Incidentally, his rather arbitrary slicing-up of the rainbow into seven colour segments was because he wanted it to echo his theories on music.
- ² Other animals have different numbers of cone cells. Dogs, for example, have one fewer, and see the same range of colours as someone we would call colour-blind, but many insects, like butterflies, have more. The preying mantis shrimp, a small, iridescent crustacean with eyes like golf-balls on stalks, has 16 different types of cone cells, double the number of any other living creature that we know of. This allows them, theoretically, to see the world in colours we can not even imagine, let alone name.
- ³ P. Ball, *Bright Earth: The Invention of Colour* (London: Vintage, 2008), p. 163.
- ⁴J. Gage, Colour and Culture: Practice and Meaning from Antiquity to Abstraction (London: Thames & Hudson, 1995), p. 129.
- ⁵ K. Stamper, 'Seeing Cerise: Defining Colours in Webster's Third', in Harmless Drudgery: Life from Inside the Dictionary. Available at: https:// korystamper.wordpress.com/2012/08/07/ seeing-cerise-defining-colors/
- ⁶ Quoted in D. Batchelor, *Chromophobia* (London: Reaktion Books, 2000), p. 16.
- ⁷Le Corbusier and A. Ozenfant, 'Purism', in R. L. Herbert (ed.), *Modern Artists on Art* (New York: Dover Publications, 2000), p. 63.
- ⁸ Quoted in G. Deutscher, Through the Language Glass: Why the World Looks Different in Other Languages (London: Arrow, 2010), p. 42.
- 9 Ibid., p. 84.

White

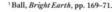

² Ibid., p. 382.

³ Batchelor, Chromophobia, p. 10.

⁴B. Klinkhammer, 'After Purism: Le Corbusier and Colour', in *Preservation Education* ℰ *Research*, Vol. 4 (2011), p. 22.

⁵ Quoted in Gage, Colour and Culture, pp. 246-7.

⁶L. Kahney, *Jony Ive: The Genius Behind Apple's Greatest Products* (London: Penguin, 2013), p. 285.

⁷C. Humphries, 'Have We Hit Peak Whiteness?', in *Nautilus* (July 2015).

⁸ Quoted in V. Finlay, *The Brilliant History of Colour in Art* (Los Angeles, CA: Getty Publications, 2014), p. 21.

Lead white

¹P. Ah-Rim, 'Colours in Mural Paintings in Goguryeo Kingdom Tombs', in M. Dusenbury (ed.), Colour in Ancient and Medieval East Asia (New Haven, CT: Yale University Press, 2015), pp. 62, 65.

² Ball, Bright Earth, pp. 34, 70.

³ Ibid., p. 137.

⁴Vernatti, P., ⁴A Relation of the Making of Ceruss', in *Philosophical Transactions*, No. 137. Royal Society (Jan./Feb. 1678), pp. 935–6.

⁵C. Warren, Brush with Death: A Social History of Lead Poisoning (Baltimore, MD: Johns Hopkins University Press, 2001), p. 20.

6T. Nakashima et al., 'Severe Lead Contamination Among Children of Samurai Families in Edo Period Japan', in *Journal of Archaeological Science*, Vol. 32, Issue 1 (2011), pp. 23–8.

- ⁷G. Lomazzo, A Tracte Containing the Artes of Curious Paintinge, Carvinge & Buildinge, trans. R. Haydock (Oxford, 1598), p. 130.
- 8 Warren, Brush with Death, p. 21.

Ivory

- ¹D. Loeb McClain, 'Reopening History of Storied Norse Chessmen', in *New York Times* (8 Sept. 2010).
- ² K. Johnson, 'Medieval Foes with Whimsy', in *New York Times* (17 Nov. 2011).
- ³C. Russo, 'Can Elephants Survive a Legal Ivory Trade? Debate is Shifting Against It', in *National Geographic* (30 Aug. 2014).
- ⁴E. Larson, 'The History of the Ivory Trade', in National Geographic (25 Feb. 2013). Available at: http://education.nationalgeographic.org/ media/history-ivory-trade/ (accessed 12 Apr. 2017).

Silver

- ¹F. M. McNeill, *The Silver Bough: Volume One, Scottish Folk-Lore and Folk-Belief*, 2nd edition (Edinburgh: Canongate Classics, 2001), p. 106.
- ²Konstantinos, Werewolves: The Occult Truth (Woodbury: Llewellyn Worldwide, 2010), p. 79.
- ³ S. Bucklow, The Alchemy of Paint: Art, Science and Secrets from the Middle Ages (London: Marion Boyars, 2012), p. 124.
- ⁴A. Lucas and J. R. Harris, *Ancient Egyptian Materials and Industries* 4th edition (Mineola, NY: Dover Publications, 1999), p. 246.
- ⁵ Ibid., p. 247.

Whitewash

- ¹E. G. Pryor, 'The Great Plague of Hong Kong', in *Journal of the Royal Asiatic Society Hong Kong Branch*, Vol. 15 (1975), pp. 61–2.
- ²Wilm, 'A Report on the Epidemic of Bubonic Plague at Hongkong in the Year 1896', quoted ibid.

- ³ Shropshire Regimental Museum, "The Hong Kong Plague, 1894–95', Available at: www. shropshireregimentalmuseum.co.uk/ regimental-history/shropshire-light-infantry/ the-hong-kong-plague-1894-95/(accessed 26 Aug. 2015).
- 4'Minutes of Evidence taken Before the Metropolitan Sanitary Commissioners', in Parliamentary Papers, House of Commons, Vol. 32 (London: William Clowes & Sons, 1848).
- ⁵ M. Twain, *The Adventures of Tom Sawyer* (New York: Plain Label Books, 2008), p. 16.

Isabelline

- ¹M. S. Sánchez, 'Sword and Wimple: Isabel Clara Eugenia and Power', in A. J. Cruz and M. Suzuki (eds.), *The Rule of Women in Early Modern Europe* (Champaign, IL: University of Illinois Press, 2009), pp. 64–5.
- ² Quoted in D. Salisbury, Elephant's Breath and London Smoke (Neustadt: Five Rivers, 2009), p. 109.
- ³ Ibid., p. 108.
- ⁴H. Norris, *Tudor Costume and Fashion*, reprinted edition (Mineola, NY: Dover Publications, 1997), p. 611.
- ⁵W. C. Oosthuizen and P. J. N. de Bruyn, 'Isabelline King Penguin Aptenodytes Patagonicus at Marion Island', in *Marine Ornithology*, Vol. 37, Issue 3 (2010), pp. 275–6.

Chalk

- ¹R. J. Gettens, E. West Fitzhugh and R. L. Feller, 'Calcium Carbonate Whites', in *Studies in Conservation*, Vol. 19, No. 3 (Aug. 1974), pp. 157, 159–60.
- ² Ibid., p. 160.
- ³ G. Field, Chromatography: Or a Treatise on Colours and Pigments and of their Powers in Painting, &c. (London: Forgotten Books, 2012), p. 71.
- ⁴A. Houbraken, 'The Great Theatre of Dutch Painters', quoted in R. Cumming, Art Explained: The World's Greatest Paintings Explored and Explained (London: Dorling Kindersley, 2007), p. 49.

- 5 Ball, Bright Earth, p. 163.
- 6H. Glanville, 'Varnish, Grounds, Viewing Distance, and Lighting: Some Notes on Seventeenth-Century Italian Painting Technique', in C. Lightweaver (ed.), Historical Painting Techniques, Materials, and Studio Practice (New York: Getty Conservation Institute, 1995), p. 15; Ball, Bright Earth, p. 100.
- ⁷ C. Cennini, *The Craftsman's Handbook*, Vol. 2, trans. D.V. Thompson (Mineola, NY: Dover Publications, 1954), p. 71.
- ⁸P. Schwyzer, "The Scouring of the White Horse: Archaeology, Identity, and "Heritage", in *Representations*, No. 65 (Winter 1999), p. 56.
- 9 Ibid., p. 56.
- 10 Ibid., p. 42.

Beige

- ¹Anonymous, 'London Society' (Oct. 1889), quoted in Salisbury, *Elephant's Breath and London Smoke*, p. 19.
- ²L. Eiseman and K. Recker, *Pantone: The 20th Century in Colour* (San Francisco, CA: Chronicle Books, 2011), pp. 45–7, 188–9, 110–11, 144–5.
- ³ K. Glazebrook and I. Baldry, 'The Cosmic Spectrum and the Colour of the Universe', Johns Hopkins Physics and Astronomy blog. Available at: www.pha.jhu.edu/~kgb/cosspec/ (accessed 10 Oct. 2015).
- ⁴S. V. Phillips, The Seductive Power of Home Staging: A Seven-Step System for a Fast and Profitable Sale (Indianapolis, IN: Dog Ear Publishing, 2009), p. 52.

Yellow

- S. Doran, The Culture of Yellow, Or: The Visual Politics of Late Modernity (New York: Bloomsbury, 2013), p. 2.
- ² C. Burdett, 'Aestheticism and Decadence', British Library Online. Available at: www.bl.uk/romantics-and-victorians/ articles/aestheticism-and-decadence (accessed 23 Nov. 2015).

- ³ Quoted in D. B. Sachsman and D. W. Bulla (eds.), Sensationalism: Murder, Mayhem, Mudslinging, Scandals and Disasters in 19th-Century Reporting (New Brunswick, NJ: Transaction Publishers, 2013), p. 5.
- ⁴Doran, Culture of Yellow, p. 52.
- ⁵R. D. Harley, *Artists' Pigments* c. 1600–1835 (London: Butterworth, 1970), p. 101.
- ⁶Doran, Culture of Yellow, pp. 10-11.
- ⁷Z. Feng and L. Bo, 'Imperial Yellow in the Sixth Century', in Dusenbury (ed.), Colour in Ancient and Medieval East Asia, p. 103; J. Chang, Empress Dowager Cixi: The Concubine who Launched Modern China (London: Vintage, 2013), p. 5.
- ⁸B. N. Goswamy, 'The Colour Yellow', in *Tribune India* (7 Sept. 2014).
- 9 Ball, Bright Earth, p. 85.
- Why do Indians Love Gold?', in *The Economist* (20 Nov. 2013). Available at: www.economist.com/blogs/economist-explains/2013/11/economist-explains-11 (accessed 24 Nov. 2015).

Blonde

- ¹V. Sherrow, Encyclopedia of Hair: A Cultural History (Westport, CN: Greenwood Press, 2006), p. 149.
- ²Sherrow, Encyclopaedia of Hair, p. 154.
- ³ Ibid., p. 148.
- 4'Going Down', in *The Economist* (11 Aug. 2014). Available at: www.economist.com/blogs/graphicdetail/2014/08/daily-chart-5 (accessed 25 Oct. 2015).
- ⁵ A. Loos, Gentlemen Prefer Blondes: The Illuminating Diary of a Professional Lady (New York: Liveright, 1998), p. 37.
- 6 'The Case Against Tipping', in *The Economist* (26 Oct. 2015). Available at: www.economist.com/blogs/gulliver/2015/10/service-compris (accessed 26 Oct. 2015).
- ⁷A. G. Walton, 'DNA Study Shatters the "Dumb Blonde" Stereotype', in *Forbes* (2 June 2014). Available at: www.forbes.com/sites/ alicegwalton/2014/06/02/science-shatters-theblondes-are-dumb-stereotype.

Lead-tin vellow

¹H. Kühn, 'Lead-Tin Yellow', in *Studies in Conservation*, Vol. 13, No. 1 (Feb. 1968), p. 20.

²G. W. R. Ward (ed.), The Grove Encyclopedia of Materials and Techniques in Art (Oxford University Press, 2008), p. 512; N. Eastaugh et al., Pigment Compendium: A Dictionary and Optical Microscopy of Historical Pigments (Oxford: Butterworth-Heinemann, 2008), p. 238.

³ Kühn, 'Lead-Tin Yellow', pp. 8-11.

⁴Eastaugh et al., Pigment Compendium, p. 238.

⁵ Ward (ed.), Grove Encyclopedia of Materials and Techniques in Art, p. 512.

6 Kühn, 'Lead-Tin Yellow', p. 8.

⁷This is the method for producing lead-tin yellow type I, which is the more common kind. A second, rarer variety includes silica and is heated to higher temperatures, between 900 and 950 °C.

⁸ Ball, Bright Earth, p. 137; Kühn, 'Lead-Tin Yellow', p. 11.

Indian vellow

¹B. N. Goswamy, art historian and author; personal correspondence.

² Handbook of Young Artists and Amateurs in Oil Painting, 1849, quoted in Salisbury, Elephant's Breath and London Smoke, p. 106.

³ Ball, Bright Earth, p. 155.

⁴ Quoted in Salisbury, Elephant's Breath and London Smoke, p. 106.

5 Harley, Artists' Pigments, p. 105.

⁶Field, Chromatography, p. 83.

⁷ 'Indian Yellow', in *Bulletin of Miscellaneous Information* (Royal Botanic Gardens, Kew), Vol. 1890, No. 39 (1890), pp. 45–7.

⁸T. N. Mukharji, 'Piuri or Indian Yellow', in Journal of the Society for Arts, Vol. 32, No. 1618 (Nov. 1883), p. 16.

9 Ibid., pp. 16-17.

10 Finlay, Colour, pp. 230, 237.

11 Ibid., pp. 233-40.

¹² C. McKeich, 'Botanical Fortunes: T. N. Mukharji, International Exhibitions, and Trade Between India and Australia', in *Journal of the National Museum of Australia*, Vol. 3, No. 1 (Mar. 2008), pp. 3–2.

Acid vellow

¹ See: www.unicode.org/review/pri294/ pri294-emoji-image-background.html

²J. Savage, 'A Design for Life', in the *Guardian* (21 Feb. 2009). Available at: www.theguardian.com/artanddesign/2009/feb/21/smiley-face-design-history (accessed 4 Mar. 2016).

³ Quoted in J. Doll, 'The Evolution of the Emoticon', in the Wire (19 Sept. 2012). Available at: www.thewire.com/ entertainment/2012/09/evolutionemoticon/57029/ (accessed 6 Mar. 2016).

Naples yellow

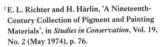

²It is so garbled that a translation from German is difficult, but Neapel means Naples and Gelb means yellow. Richter and Härlin, 'A Nineteenth-Century Collection of Pigment and Painting Materials', p. 77.

³In the nineteenth and twentieth centuries, though, the term Naples yellow was erroneously applied to other yellows too, particularly lead-tin oxides [page 69]. The distinction was not properly cleared up until the 1940s.

⁴Eastaugh et al., Pigment Compendium, p. 279.

⁵ Field, Chromatography, p. 78.

⁶ Ball, Bright Earth, p. 58, and Lucas and Harris, Ancient Egyptian Materials and Industries, p. 190.

⁷ Quoted in Gage, Colour and Culture, p. 224.

Endnotes

Chrome yellow

²V. van Gogh, letters to Emile Bernard [letter 665]; Theo van Gogh [letter 666]; and Willemien van Gogh [letter 667]. Available at: http://vangoghletters.org/vg/

3 Harley, Artists' Pigments, p. 92.

⁴ Ball, Bright Earth, p. 175; Harley, Artists' Pigments, p. 93.

⁵ N. L. Vauquelin quoted in Ball, *Bright Earth*, p. 176.

61. Sample, 'Van Gogh Doomed his Sunflowers by Adding White Pigments to Yellow Paint', in the Guardian (14 Feb. 2011); M. Gunther, 'Van Gogh's Sunflowers may be Wilting in the Sun', in Chemistry World (28 Oct. 2015). Available at: www.rsc.org/chemistryworld /2015/10/van-gogh-sunflowers-pigmentdarkening

Gamboge

¹R. Christison, 'On the Sources and Composition of Gamboge', in W. J. Hooker (ed.), *Companion to the Botanical Magazine*, Vol. 2 (London: Samuel Curtis, 1836), p. 239.

² Harley, Artists' Pigments, p. 103.

³ Field, Chromatography, p. 82.

⁴Ball, Bright Earth, p. 156.

⁵Finlay, Colour, p. 243.

6 Ball, Bright Earth, p. 157.

⁷J. H. Townsend, 'The Materials of J. M. W. Turner: Pigments', in *Studies in Conservation*, Vol. 38, No. 4 (Nov. 1993), p. 232.

8 Field, Chromatography, p. 82.

⁹Christison, 'On the Sources and Composition of Gamboge', in Hooker (ed.), *Companion to the Botanical Magazine*, p. 238.

¹⁰ The way in which the movement of large particles in fluid is affected by the jostling of atoms and molecules.

¹¹G. Hoeppe, Why the Sky is Blue: Discovering the Colour of Life, trans. J. Stewart (Princeton University Press, 2007), pp. 203-4.

Orpiment

¹Cennini, Craftsman's Handbook, Vol. 2, p. 28.

²Eastaugh et al., Pigment Compendium, p. 285.

³E. H. Schafer, 'Orpiment and Realgar in Chinese Technology and Tradition', in *Journal* of the American Oriental Society, Vol. 75, No. 2 (Apr.-June 1955), p. 74.

⁴Cennini, Craftsman's Handbook, Vol. 2, pp. 28-9.

⁵ Schafer, 'Orpiment and Realgar in Chinese Technology and Tradition', pp. 75–6.

⁶ Quoted in Finlay, Colour, p. 242.

⁷Ball, Bright Earth, p. 300.

⁸Cennini, Craftsman's Handbook, Vol. 2, p. 29.

Imperial yellow

¹K. A. Carl, With the Empress Dowager of China (New York: Routledge, 1905), pp. 6–8.

²Chang, Empress Dowager Cixi, p. 5.

³ Carl, With the Empress Dowager of China, pp. 8-11.

⁴Feng and Bo, ⁴Imperial Yellow in the Sixth Century', in Dusenbury (ed.) *Colour in Ancient* and Medieval East Asia, p. 104-5.

⁵ Ibid., pp. 104-5.

Gold

¹One gold mine was found in Carmarthenshire in Wales and was exploited by the Romans from the middle of the first century AD. Another is at Kremnica in what is now Slovakia, which was extensively worked from the beginning of the fourteenth century, leading to a drop in price all over Europe. ² Bucklow, Alchemy of Paint, p. 176.

³ Ibid., p. 177.

⁴See: www.britannica.com/biography/ Musa-I-of-Mali; Bucklow, *Alchemy of Paint*, p. 179.

⁵ Ball, Bright Earth, p. 35.

6 Cennini, Craftsman's Handbook, pp. 81, 84.

Making gold paint was no less finicky and expensive than gilding sheets. The metal is so malleable that if one attempts to grind it the pieces will only begin welding together. Instead, it was mixed with fluid mercury to form a paste which, when the excess mercury was squeezed out, became brittle enough to pound to powder in a pestle and mortar. Finally, the mercury could be extracted by gently heating the mixture. This was work for alchemists, who for millennia had been trying to create gold and were well equipped to handle the real thing.

8 Quoted in Bucklow, Alchemy of Paint, p. 184.

Orange

² Salisbury, *Elephant's Breath and London Smoke*, p. 148.

³ Quoted in Ball, Bright Earth, p. 23.

⁴J. Colliss Harvey, Red: A Natural History of the Redhead (London: Allen & Unwin, 2015), p. 2.

⁵ Eckstut and Eckstut, Secret Language of Color, p. 82.

⁶Rijksmuseum, 'William of Orange (1533–1584), Father of the Nation'. Available at: https:// www.rijksmuseum.nl/en/explore-thecollection/historical-figures/william-of-orange (accessed 1 Dec. 2015); Eckstut and Eckstut, Secret Language of Color, p. 75.

⁷Black, battleship and warm grey were also considered; warm grey was named the second choice. The CMYK code for GGB International orange is C: 0%; M: 69%;

Y: 100%; K: 6%.

⁸L. Eiseman and E. P. Cutter, *Pantone on Fashion: A Century of Colour in Design* (San Francisco, CA: Chronicle Books, 2014), p. 16.

9 Ibid., p. 15.

10 Quoted in Ball, Bright Earth, p. 23.

¹¹ Quoted in Salisbury, Elephant's Breath and London Smoke, p. 149.

Dutch orange

¹Eckstut and Eckstut, Secret Language of Color, p. 76.

²Rijksmuseum, 'William of Orange, Father of the Nation'.

³S. R. Friedland (ed.), Vegetables: Proceedings of the Oxford Symposium on Food and Cooking 2008 (Totnes: Prospect, 2009), pp. 64–5.

⁴ Eckstut and Eckstut, Secret Language of Color, p. 75.

⁵E. G. Burrows and M. Wallace, *Gotham:*A History of New York City to 1898 (Oxford University Press, 1999), pp. 82–3.

Saffron

¹ Eckstut and Eckstut, Secret Language of Color, p. 82; D. C. Watts, Dictionary of Plant Lore, (Burlington, VT: Elsevier, 2007), p. 335.

²Saffron is integral to many Spanish dishes, not least paella, but home-grown saffron is not nearly enough to satisfy demand: today Spain is a vast net importer of Iranian saffron.

³ Finlay, Colour, pp. 252-3.

⁴Ibid., pp. 253, 260.

⁵ Eckstut and Eckstut, Secret Language of Color, p. 79.

⁶ William Harrison, quoted in Sir G. Prance and M. Nesbitt (eds.), Cultural History of Plants (London: Routledge, 2005), p. 309.

7 Ibid., p. 308.

8 Watts, Dictionary of Plant Lore, p. 335.

⁹ Prance and Nesbitt (eds.), *Cultural History of Plants*, p. 308.

- 10 Eckstut and Eckstut, Secret Language of Colour, pp. 80, 82.
- 11 Finlay, Brilliant History of Colour in Art, p. 110.
- 12 Quoted in Harley, Artists' Pigments, p. 96.
- 13 Bureau of Indian Standards, 'Flag Code of India'. Available at: www.mahapolice.gov.in/ mahapolice/jsp/temp/html/flag_code_ of_india.pdf (accessed 28 Nov. 2015).

Amber

- 1 J. Blumberg, 'A Brief History of the Amber Room', Smithsonian.com (31 July 2007) Available at: www.smithsonianmag.com/ history/a-brief-history-of-the-amberroom-160940121/ (accessed 17 Nov. 2015).
- ² Ibid.
- 3 M. R. Collings, Gemlore: An Introduction to Precious and Semi-Precious Stones, 2nd edition (Rockville, MD: Borgo Press, 2009), p. 19.
- 4M. Gannon, '100-Million-Year-Old Spider Attack Found in Amber', in LiveScience (8 Oct. 2012). Available at: www.livescience. com/23796-spider-attack-found-in-amber.html (accessed 21 Nov. 2015); C. Q. Choi, '230-Million-Year-Old Mite Found in Amber'. LiveScience (27 Aug. 2012). Available at: www.livescience.com/22725-ancient-mitetrapped-amber.html (accessed 21 Nov. 2015).
- 5 T. Follett, 'Amber in Goldworking', in Archaeology, Vol. 32, No. 2 (Mar./Apr. 1985), p. 64.
- 6G. V. Stanivukovic (ed.), Ovid and the Renaissance Body (University of Toronto Press, 2001), p. 87.

Ginger

- ² Quoted in Norris, Tudor Costume and Fashion, p. 162.
- 3 C. Zimmer, 'Bones Give Peek into the Lives of Neanderthals', in New York Times (20 Dec. 2010). Available at: www.nytimes.com /2010 /12/21/science/21neanderthal.html

4 Ibid.

Minium

- ¹T. F. Mathews and A. Taylor, The Armenian Gospels of Gladzor: The Life of Christ Illuminated (Los Angeles, CA: Getty Publications, 2001), pp. 14-13.
- ² Ibid., p. 19. We know at least three artists helped complete the work because each had a preferred method of painting the faces. One began with primrose yellow, before adding details with tiny strokes of green and white. Another favoured a base of dull olive, over which he added white and pale pink; a third began with a green ground, and used brown, white and red to add in the features.
- ³D. V. Thompson, The Materials and Techniques of Medieval Painting. Reprinted from the first edition (New York: Dover Publications, 1956), p. 102.
- M. Clarke, 'Anglo Saxon Manuscript Pigments', in Studies in Conservation, Vol. 49, No. 4 (2004), p. 239.
- ⁵ Quoted in F. Delamare and B. Guineau, Colour: Making and Using Dyes and Pigments (London: Thames & Hudson, 2000), p. 140.
- ⁶ Thompson, Materials and Techniques of Medieval Painting, p. 101.
- 7C. Warren, Brush with Death, p. 20; Schafer, 'The Early History of Lead Pigments and Cosmetics in China', in T'oung Pao, Vol. 44, No. 4 (1956), p. 426.
- 8 Field, Chromatography, p. 95.

Nude

- 1 H. Alexander, 'Michelle Obama: The "Nude" Debate', in the Telegraph (19 May 2010).
- ²D. Stewart, 'Why a "Nude" Dress Should Really be "Champagne" or "Peach", in Jezebel (17 May 2010).
- ³ Eiseman and Cutler, Pantone on Fashion, p. 20.
- 4See: http://humanae.tumblr.com/
- ⁵Crayola, incidentally, was impressively ahead of its time on this issue: their 'Flesh' crayon was renamed 'Peach' in 1962, the same year President Kennedy to protect James Meredith, the first African American student admitted to the segregated University of Mississippi.

Pink

¹ 'Finery for Infants', in *New York Times* (23 July 1893).

² Quoted in J. Maglaty, 'When Did Girls Start Wearing Pink?', Smithsonian.com (7 Apr. 2011). Available at: www.smithsonianmag. com/arts-culture/when-did-girls-startwearing-pink-1370097/ (accessed 28 Oct. 2015).

3 Ball, Bright Earth, p. 157.

'In the 1957 film Funny Face, a character based on Vreeland performs a five-minute song-and-dance routine called 'Think Pink!' Vreeland, after watching a screening, is said to have turned to a junior colleague and muttered: 'Never to be discussed.'

⁵M. Ryzik, 'The Guerrilla Girls, After 3 Decades, Still Rattling Art World Cages', in *New York Times* (5 Aug. 2015).

⁶ Quoted in 'The Pink Tax', in New York Times (14 Nov. 2014).

Baker-Miller pink

¹A. G. Schauss, 'Tranquilising Effect of Colour Reduces Aggressive Behaviour and Potential Violence', in *Orthomolecular Psychiatry*, Vol. 8, No. 4 (1979), p. 218.

²J. E. Gilliam and D. Unruh, 'The Effects of Baker-Miller Pink on Biological, Physical and Cognitive Behaviour', in *Journal of Orthomolecular Medicine*, Vol. 3, No. 4 (1988), p. 202.

3 Schauss, 'Tranquilising Effect of Colour', p. 219.

⁴Quoted in Ibid., parenthesis his.

⁵A. L. Alter, *Drunk Tank Pink, and other Unexpected Forces that Shape how we Think, Feel and Behave* (London: Oneworld, 2013), p. 3.

See, for example, Gilliam and Unruh, 'Effects of Baker-Miller Pink'; for further examples see T. Cassidy, Environmental Psychology: Behaviour and Experience in Context (Hove: Routledge Psychology Press, 1997), p. 84.

⁷Cassidy, Environmental Psychology, p. 84.

Mountbatten pink

¹Lord Zuckerman, 'Earl Mountbatten of Burma, 25 June 1900–27 August 1979', *Biographical Memoirs of Fellows of the Royal Society*, Vol. 27 (Nov. 1981), p. 358.

²A. Raven, 'The Development of Naval Camouflage 1914–1945', Part III. Available at: www.shipcamouflage.com/3_2.htm (accessed 26 Oct. 2015).

Puce

¹H. Jackson, 'Colour Determination in the Fashion Trades', in *Journal of the Royal Society* of the Arts, Vol. 78, No. 4034 (Mar. 1930), p. 501.

²C. Weber, *Queen of Fashion: What Marie*Antoinette Wore to the Revolution (New York: Picador, 2006), p. 117.

³ Domestic Anecdotes of a French Nation, 1800, quoted in Salisbury, Elephant's Breath and London Smoke, p. 169.

⁴Quoted in Weber, Queen of Fashion, p. 117.

⁵ Quoted in Earl of Bessborough (ed.), Georgiana: Extracts from the Correspondence of Georgiana, Duchess of Devonshire (London: John Murray, 1955), p. 27.

6 Weber, Queen of Fashion, p. 256.

Fuchsia

Others include: amaranth; mauve; magnolia; cornflower; goldenrod; heliotrope; lavender; and violet, to name a few. In most languages with the exception of English the word for pink is derived from that for the rose.

²I. Paterson, A Dictionary of Colour: A Lexicon of the Language of Colour (London: Thorogood, 2004), p. 170.

³G. Niles, 'Origin of Plant Names', in *The Plant World*, Vol. 5, No. 8 (Aug. 1902), p. 143.

⁴ Quoted in M. Allaby, *Plants: Food Medicine and Green Earth* (New York: Facts on File, 2010), p. 39.

⁵ Ibid., pp. 38-41.

Shocking pink

¹M. Soames (ed.), Winston and Clementine: The Personal Letters of the Churchills (Boston, MA: Houghton Mifflin, 1998), p. 276.

²M. Owens, 'Jewellery that Gleams with Wicked Memories', in *New York Times* (13 Apr. 1997).

³ Eiseman and Cutler, Pantone on Fashion, p. 31.

⁴E. Schiaparelli, Shocking Life (London: V&A Museum, 2007), p. 114.

⁵Two years later the Tête de Bélier was stolen from Fellowes's home near Paris as part of a haul worth £36,000. It has not been seen since.

S. Menkes, 'Celebrating Elsa Schiaparelli', in New York Times (18 Nov. 2013). Although it is with this pink that Schiaparelli was most associated, her collections were awash with many colours. After 'Shocking', each of her perfumes was twinned with its own signature shade: 'Zut' with green, 'Sleeping' with blue and 'Le Roy Soleil' with gold.

⁷ Eiseman and Cutler, Pantone on Fashion, p. 31.

Fluorescent pink

¹H. Greenbaum and D. Rubinstein, 'The Hand-Held Highlighter', in *New York Times* Magazine (20 Jan. 2012).

²Schwan Stabilo press release, 2015; Greenbaum and Rubinstein, 'Hand-Held Highlighter'.

Amaranth

¹V. S. Vernon Jones (trans.), *Aesop's Fables* (Mineola, NY: Dover Publications, 2009), p. 188.

²G. Nagy, *The Ancient Greek Hero in 24 Hours* (Cambridge, MA Belknap, 2013), p. 408.

³J. E. Brody, 'Ancient, Forgotten Plant now "Grain of the Future", in *New York Times* (16 Oct. 1984).

⁴Brachfeld and Choate, Eat Your Food!, p. 199.

⁵Brody, 'Ancient, Forgotten Plant Now "Grain of the Future".

6 Ibid.

⁷Kiple and Ornelas (eds.), *Cambridge World History of Food*, p. 75.

⁸ Quoted in Salisbury, Elephant's Breath and London Smoke, p. 7.

Red

¹N. Guéguen and C. Jacob, 'Clothing Colour and Tipping: Gentlemen Patrons Give More Tips to Waitresses with Red Clothes', in Journal of Hospitality & Tourism Research, quoted by Sage Publications/Science Daily. Available at: www.sciencedaily.com/ releases/2012/08/120802111454.htm (accessed 20 Sept. 2015).

²A. J. Elliot and M. A. Maier, 'Colour and Psychological Functioning', in *Journal of Experimental Psychology*, Vol. 136, No. 1 (2007), pp. 251–2.

³R. Hill, 'Red Advantage in Sport'. Available at: https://community.dur.ac.uk/r.a.hill/ red_advantage.htm (accessed 20 Sept. 2015).

4 Ibid.

⁵M. Pastoureau, *Blue: The History of a Colour*, trans. M. I. Cruse (Princeton University Press, 2000), p. 15.

⁶E. Phipps, 'Cochineal Red: The Art History of a Colour', in *Metropolitan Museum of Art Bulletin*, Vol. 67, No. 3 (Winter 2010), p. 5.

⁷ M. Dusenbury, 'Introduction', in *Colour in Ancient and Medieval East Asia*, pp. 12–13.

8 Phipps, 'Cochineal Red', p. 22.

9 Ibid., pp. 14, 23-4.

10 Pastoureau, Blue, p. 94.

¹¹ P. Gootenberg, Andean Cocaine: The Making of a Global Drug (Chapel Hill, NC: University of North Carolina Press, 2008), p. 198.

Scarlet

¹Cloth dyed with kermes was often said to be dyed 'scarlet in grain'; this is where we get the word 'ingrain', which means to firmly fix or establish.

- ²A. B. Greenfield, A Perfect Red: Empire, Espionage and the Quest for the Colour of Desire (London: Black Swan, 2006), p. 42.
- ³ Gage, Colour and Meaning, p. 111.
- 4 Greenfield, Perfect Red, p. 108.
- ⁵Phipps, 'Cochineal Red', p. 26.
- ⁶G. Summer and R. D'Amato, Arms and Armour of the Imperial Roman Soldier (Barnsley: Frontline Books, 2009), p. 218.
- 7 Greenfield, Perfect Red, p. 183.
- 8 Ibid., p. 181.
- 9 E. Bemiss, Dyers Companion, p 186.
- 10 Field, Chromatography, p. 89.
- ¹¹ Quoted in Salisbury, Elephant's Breath and London Smoke, p. 191.

Cochineal

- Finlay, Colour, p. 153.
- ²Phipps, 'Cochineal Red', p. 10.
- ³R. L. Lee 'Cochineal Production and Trade in New Spain to 1600', in *The Americas*, Vol. 4, No. 4 (Apr. 1948), p. 451.
- ⁴Phipps, 'Cochineal Red', p. 12.
- ⁵ Quoted ibid., pp. 24-6.
- 6 Ibid., p. 27.
- ⁷ Finlay, Colour, p. 169.
- 8 Phipps, 'Cochineal Red', pp. 27-40.
- 9 Ibid., p. 37.
- 10 Finlay, *Colour*, pp. 165-76.

Vermilion

¹ Bucklow, Alchemy of Paint, p. 87; R. J. Gettens et al., 'Vermilion and Cinnabar', in Studies in Conservation, Vol. 17, No. 2 (May 1972), pp. 45–7.

- ²Thompson, Materials and Techniques of Medieval Painting, p. 106. Conversion rates for Roman currency are notoriously difficult; estimates for comparable rates for 1 sesterces range from \$0.50 to \$50. Working with a relatively conservative conversion rate of \$10 for each sesterces, a pound of cinnabar in Pliny's time cost \$70.
- ³ Ball, Bright Earth, p. 86.
- ⁴Bucklow, Alchemy of Paint, p. 77.
- ⁵ Thompson, Materials and Techniques of Medieval Painting, p. 106.
- 6 Ibid., pp. 60-61, 108.
- ⁷Gettens et al., 'Vermilion and Cinnabar', p. 49.
- ⁸ Thompson, Materials and Techniques of Medieval Painting, p. 30.
- One hold-out was Renoir, who was famously conservative when it came to his materials. Sometime around 1904 Matisse began trying to persuade him to swap vermilion for cadmium red, but Renoir refused to try even the free sample Matisse gave him.
- 10 Quoted in Ball, Bright Earth, p. 23.

Rosso corsa

Quoted in L. Barzini, Pekin to Paris:
An Account of Prince Borghese's Journey Across
Two Continents in a Motor-Car, trans. L. P.
de Castelvecchio (London: E. Grant Richards,
1907), p. 11.

- ² Ibid., p. 26.
- ³ Ibid., p. 40.
- ⁴Ibid., pp. 58, 396, 569.
- ⁵Borghese's car is still on display in the Museo dell'Auto in Turin. However, those expecting to see a dashing red machine will be disappointed: the car is now a dull grey colour because it was accidentally dropped into a Genoese dock after being displayed at an American motor show. To prevent it rusting it was quickly repainted; the only paint they could find were some tins of battleship grey.

Endnotes

Hematite

- ¹Phipps, 'Cochineal Red', p. 5.
- ²E. Photos-Jones et al., 'Kean Miltos: The Well-Known Iron Oxides of Antiquity', in *Annual of the British School of Athens*, Vol. 92 (1997), p. 360.
- ³E. E. Wreschner, 'Red Ochre and Human Evolution: A Case for Discussion', in *Current* Anthropology, Vol. 21, No. 5 (Oct. 1980), p. 631.
- 4 Ibid.
- ⁵ Phipps, 'Cochineal Red', p. 5; G. Lai, 'Colours and Colour Symbolism in Early Chinese Ritual Art', in Dusenbury (ed.), Colour in Ancient and Medieval East Asia, p. 27.
- ⁶ Dusenbury, 'Introduction', in *Colour in Ancient* and *Medieval East Asia*, p. 12.
- ⁷ Photos-Jones et al., 'Kean Miltos', p. 359.

Madder

- ¹W. H. Perkin, 'The History of Alizarin and Allied Colouring Matters, and their Production from Coal Tar, from a Lecture Delivered May 8th', in *Journal for the Society for Arts*, Vol. 27, No. 1384 (May 1879), p. 573.
- ²G. C. H. Derksen and T. A. Van Beek, 'Rubia Tinctorum L.', in *Studies in Natural Products Chemistry*, Vol. 26 (2002), p. 632.
- ³J. Wouters et al., The Identification of Haematite as a Red Colourant on an Egyptian Textile from the Second Millennium BC', in *Studies in Conservation*, Vol. 35, No. 2 (May 1990), p. 89.
- ⁴Delamare and Guineau, Colour, pp. 24, 44.
- ⁵ Field, Chromatography, pp. 97-8.
- ⁶Finlay, Colour, p. 207.
- ⁷Perkin, 'History of Alizarin and Allied Colouring Matters', p. 573.
- 8 Finlay, Colour, pp. 208-9.

Dragon's blood

¹ Bucklow, Alchemy of Paint, p. 155; W.Winstanley, The Flying Serpent, or: Strange News out of Essex (London, 1669). Available at: www.henham. org/FlyingSerpent (accessed 19 Sept. 2015).

- ² Ball, Bright Earth, p. 76.
- ³ Bucklow, Alchemy of Paint, pp. 142, 161.
- ⁴Ball, Bright Earth, p. 77.
- ⁵ Field, Chromatography, p. 97.

Purple

- ¹Ball, Bright Earth, p. 223.
- ²Gage, Colour and Culture, pp. 16, 25.
- ³ Quoted in Gage, Colour and Culture, p. 25.
- ⁴Quoted in Eckstut and Eckstut, Secret Language of Colour, p. 224.
- ⁵J. M. Stanlaw, 'Japanese Colour Terms, from 400 CE to the Present', in R. E. MacLaury, G. Paramei and D. Dedrick (eds.), *Anthropology of Colour* (New York: John Benjamins, 2007), p. 311.
- ⁶Finlay, Colour, p. 422.
- ⁷ S. Garfield, Mauve: How One Man Invented a Colour that Changed the World (London: Faber & Faber, 2000), p. 52.

Tyrian purple

- ¹Finlay, Colour, p. 402.
- ²Ball, Bright Earth, p. 225.
- ³ Eckstut and Eckstut, Secret Language of Colour, p. 223.
- ⁴Gage, Colour and Culture, p. 16.
- ⁵ Ball, Bright Earth, p. 255.
- ⁶ Finlay, Colour, p. 403.
- ⁷ Gage, Colour and Culture, p. 25.
- 8 Ibid.
- 9 Finlay, Colour, p. 404.
- 10 Ball, Bright Earth, p. 226.

Orchil

- ¹E. Bolton, *Lichens for Vegetable Dyeing* (McMinnville, OR: Robin & Russ, 1991), p. 12.
- ² Ibid., p. 9; J. Pereina, *The Elements of Materia*, *Medica and Therapeutics*, Vol. 2 (Philadelphia, PA: Blanchard & Lea, 1854), p. 74.
- ³ Pereina, *Elements of Materia*, *Medica and Therapeutics*, p. 72.
- ⁴J. Edmonds, *Medieval Textile Dyeing*, (Lulu.com, 2012), p. 39.
- 5 Ibid.
- 6 And, sometimes, from less far-flung ones: in 1758 production began on an orchil-type dye made from a slightly different lichen that had been discovered in Scotland by Dr Cuthbert Gordon. He called it 'cudbear', a corruption of his first name.
- ⁷ Quoted in Edmonds, *Medieval Textile Dyeing*, pp. 40–41.
- ⁸ Bolton, Lichens for Vegetable Dyeing, p. 28.

Magenta

- ¹Ball, Bright Earth, p. 241.
- ²Garfield, Mauve, pp. 79, 81.
- 3 Ibid., p. 78.

Mauve

- ¹Garfield, Mauve, pp. 30-31.
- ² Ibid., p. 32.
- ³ Ball, Bright Earth, p. 238.
- ⁴Finlay, Colour, p. 391.
- 5 Garfield, Mauve, p. 58.
- 6 Quoted ibid., p. 61.
- ⁷Ball, Bright Earth, pp. 240-41.

Heliotrope

- ¹N. Groom, *The Perfume Handbook* (Edmunds: Springer-Science, 1992), p. 103.
- ²C. Willet-Cunnington, *English Women's Clothing in the Nineteenth Century* (London: Dover, 1937), p. 314.
- ³ Ibid., p. 377.
- ⁴Of a childhood enemy, she says: 'She has just reminded me that we were at school together. I remember it perfectly now. She always got the good conduct prize.' Later, saying to the lady herself: 'You dislike me, I am quite aware of that, and I have always detested you.' And on the vexing issue of higher education for women: 'The higher education of men is what I should like to see. Men need it so sadly.'

Violet

- ¹ Quoted in O. Reutersvärd, "The "Violettomania" of the Impressionists', in *Journal of Aesthetics and Art Criticism*, Vol. 9, No. 2 (Dec. 1950), p. 107.
- ² Quoted ibid., pp. 107-8.
- ³ Quoted in Ball, Bright Earth, p. 207.

Blue

- ¹R. Blau, 'The Light Therapeutic', in *Intelligent* Life (May/June 2014).
- ² 2015 National Sleep Foundation poll, see: https://sleepfoundation.org/media-center/ press-release/2015-sleep-america-poll; Blau, 'Light Therapeutic'.
- ³ Pastoureau, Blue, p. 27.
- ⁴White clocks in at 32%; red, 28%; black, 14%; gold, 10%; purple, 6%; green, 5%. M. Pastoureau, *Green: The History of a Colour*, trans. J. Gladding (Princeton University Press, 2014), p. 39.
- ⁵M. Pastoureau, Blue, p. 50.
- ⁶Heraldry has its own set of colour names, or 'tinctures'. The basics are or (gold/yellow); argent (silver/white); gules (red); azure (blue); purpure (purple); sable (black); and vert (green).

- ⁷Pastoureau, *Blue*, p. 60. Although it is slightly more popular with men, women chose blue more than any other colour; *pink* [page 114], incidentally, was no more popular with women than red, purple or green.
- 8 2015 YouGov Survey [https://yougov.co.uk/ news/2015/05/12/blue-worlds-favouritecolour/].

Ultramarine

- ¹K. Clarke, 'Reporters see Wrecked Buddhas', BBC News (26 March 2001) Available at: http://news.bbc.co.uk/1/hi/world/south_ asia/1242856.stm (accessed on 10 Jan. 2016).
- ²Cennini, Craftsman's Handbook, Vol. 2, p. 36
- ³ Quoted in Ball, Bright Earth, p. 267
- ⁴Cennini, Craftsman's Handbook, p. 38.
- ⁵M. C. Gaetani et al., 'The Use of Egyptian Blue and Lapis Lazuli in the Middle Ages: The Wall Paintings of the San Saba Church in Rome', in *Studies in Conservation*, Vol. 49, No. 1 (2004), p.14.
- ⁶ Gage, Colour and Culture, p. 271.
- ⁷Ibid., p. 131.
- 8 This was particularly the case in southern Europe. In northern Europe, particularly the Netherlands, where ultramarine was scarcer, and where scarlet dye remained the preeminent mark of wealth and distinction, Mary was often clothed in red.
- 9 Gage, Colour and Culture, pp. 129-30.
- ¹⁰ A similar competition, only with a much smaller prize on offer, had been made by the Royal College of Arts in 1817, with no successful applicants.
- 11 Ball, Bright Earth, pp. 276-7.

Cobalt

¹E. Morris, 'Bamboozling Ourselves (Part 1)', in New York Times (May-June 2009). Available at: http://morris.blogs.nytimes.com/category/ bamboozling-ourselves/ (accessed 1 Jan. 2016).

- ²T. Rousseau, 'The Stylistic Detection of Forgeries', in *Metropolitan Museum of Art Bulletin*, Vol. 27, No. 6, pp. 277, 252.
- ³ Finlay, Brilliant History of Colour in Art, p. 57.
- ⁴Ball, Bright Earth, p. 178.
- 5 Harley, Artists' Pigments, pp. 53-4.
- ⁶ Field, Chromatography, pp. 110-11
- ⁷E. Morris, 'Bamboozling Ourselves (Part 3)'.

Indigo

- ¹Educated guesses as to why plants produce indigo differ. Some suggest it could be a natural insecticide; others have wondered if its bitter taste helps to protect it against the ravages of marauding herbivores.
- ²The pods apparently did not find favour with the early modern herbalist John Parkinson, who described them in 1640 as 'hanging downwards, like unto the wormes . . . which we call arseworms, yet somewhat thick and full of black seed'. Quoted in J. Balfour-Paul, Indigo: Egyptian Mummies to Blue Jeans (London: British Museum Press, 2000), p. 92.
- ³ Some cultures traditionally blamed women for indigo crop failures. In ancient Egypt it was believed anyone menstruating near the field might damage it. In one Chinese province, women with flowers in their hair had to stay away from the fermenting-indigo jars. And on Flores Island, Indonesia, if a woman swears while harvesting the plant, it will offend its soul and ruin the dye completely.
- ⁴Balfour-Paul, Indigo, pp. 99, 64.
- Secause these blocks are so hard, many classical authors, and even some early modern ones, thought it was mineral in origin, possibly a semi-precious stone related to lapis lazuli. Delamare and Guineau, Colour, p. 95.
- ⁶ Balfour-Paul, *Indig*o, p. 5.
- 7 Pastoureau, Blue, p. 125.
- 8 Balfour-Paul, Indigo, pp. 7, 13.
- ⁹ Eckstut and Eckstut, Secret Language of Colour, p. 187.

10 Balfour-Paul, Indigo, p. 23.

11 Ibid., pp. 28, 46.

12 Ibid., pp. 44-45, 63.

13 Delamare and Guineau, Colour, p. 92.

14 Balfour-Paul, Indigo, p. 5.

15 'Jean' is believed to descend from bleu de Gênes, or Genoa blue, a cheap indigo dye popular for sailors uniforms.

¹⁶ Just Style, 'Just-Style Global Market Review of Denim and Jeanswear – Forecasts to 2018' (Nov. 2012). Available at www.just-style.com/ store/samples/Global%20Market%20for%20 Denim%20and%20Jeanswear%2Single_ brochure.pdf (accessed 3 Jan. 2016), p. 1.

Prussian blue

¹Ball, *Bright Earth*, p. 273; Delamare and Guineau, *Colour*, p. 76.

²Ball, Bright Earth, pp. 272-3.

³ Field, Chromatography, p. 112.

'Woodwood received a tip-off from a German man called Caspar Neumann, a debtor to the Royal Society who apparently wanted to reingratiate himself. Neumann sent the method, in Latin, to Woodwood in a letter from Leipzig dated 17 November 1723. The revelation ruined Dippel, who fled to Scandinavia where he became the physician to the Swedish King Frederick I before being expelled from the country and spending some time in a Danish gaol. A. Kraft, 'On Two Letters from Caspar Neumann to John Woodward Revealing the Secret Method for Preparation of Prussian Blue', in Bulletin of the History of Chemistry, Vol. 34, No. 2 (2009), p. 135.

⁵ Quoted in Ball, Bright Earth, p. 275.

⁶ Finlay, Colour, pp. 346-7.

⁷ Eckstut and Eckstut, *Secret Language of Colour*, p. 187.

⁸ Quoted in Ball, Bright Earth, p. 274.

Egyptian blue

¹Lucas and Harris, Ancient Egyptian Materials and Industries, p. 170.

² Delamare and Guineau, Colour, p. 20; Lucas and Harris, Ancient Egyptian materials and Industries, p. 188; V. Daniels et al., 'The Blackening of Paint Containing Egyptian Blue,' in Studies in Conservation, Vol. 49, No. 4 (2004), p. 219.

³ Delamare and Guineau, Colour, p. 20.

⁴Daniels et al., 'Blackening of Paint Containing Egyptian Blue', p. 217.

⁵M. C. Gaetani et al., 'Use of Egyptian Blue and Lapis Lazuli in the Middle Ages', p. 13.

6 Ibid., p. 19.

⁷Although it now looks as if ultramarine and Egyptian blue were used concurrently longer than was thought: the two pigments have been found mixed together in the murals at one eighth-century church in Rome.

Woad

¹J. Edmonds, *The History of Woad and the Medieval Woad Vat.* (Lulu.com, 2006), p. 40.

² Ibid., p. 13; Delamare and Guineau, *Colour*, p. 44.

³ Delamare and Guineau, Colour, p. 44.

⁴Quoted in Balfour-Paul, Indigo, p. 30.

⁵ Pastoureau, Blue, p. 63.

6 Ibid., p. 64.

7 Quoted in Balfour-Paul, Indigo, p. 34.

8 Pastoureau, Blue, p. 125.

⁹ Quoted in Edmonds, History of Woad, pp. 38-9.

¹⁰ Pastoureau, *Blue*, p. 130; Balfour-Paul, *Indigo*, p. 56–7.

Electric blue

- ¹New Scientist interview with Alexander Yuvchenko, 'Cheating Chernobyl' (21 Aug. 2004).
- ²M. Lallanilla, 'Chernobyl: Facts About the Nuclear Disaster', in *LiveScience* (25 Sept. 2013). Available at: www.livescience.com/ 39961-chernobyl.html (accessed 30 Dec. 2015).
- ³ A few hours later, Yuvchenko found himself in the local hospital, paralysed with radiation sickness, watching as one by one his fellow nuclear plant workers died around him. He is one of the few survivors from the plant.
- ⁴New Scientist interview with Alexander Yuvchenko, 'Cheating Chernobyl'.
- ⁵ Quoted in Salisbury, *Elephant's Breath and London Smoke*, p. 75.

Cerulean

- ¹S. Heller, 'Oliver Lincoln Lundquist, Designer, is Dead at 92', in *New York Times* (3 Jan. 2009).
- ²Pantone press release, 1999: www.pantone. com/pages/pantone/pantone. aspx?pg=20194@ca=10.
- ³ Ball, *Bright Earth*, p. 179. The pigment took its name from the word caeruleus, used by later Roman writers to describe the Mediterranean Sea.
- 4 Ibid.
- § Brassaï, Conversations with Picasso, trans. J. M. Todd (University of Chicago Press, 1999), p. 117.

Green

- ¹Finlay, Colour, pp. 285-6.
- ² Pastoureau, Green, pp. 20-24.
- ³ Eckstut and Eckstut, Secret Language of Colour, pp. 146–7.
- ⁴ Pastoureau, Green, p. 65.
- ⁵Ball, Bright Earth, pp. 73-4.
- 6 Ibid., pp. 14-15.

- ⁷ Quoted in Pastoureau, Green, p. 42.
- 8 Quoted ibid., p. 116.
- 9 Quoted in Ball, Bright Earth, p. 158.
- ¹⁰ Pastoureau, Green, p. 159.
- 11 Quoted in ibid., p. 200.

Verdigris

- ¹P. Conrad, 'Girl in a Green Gown: The History and Mystery of the Arnolfini Portrait by Carola Hicks', in the *Guardian* (16 Oct. 2011). The portrait has had an eventful history too. It was owned by Philip II of Spain, the sixteenth-century Habsburg monarch. His descendent, Carlos III hung it in the royal family's loo. It was coveted by Napoleon and, later, Hitler, and spent much of the Second World War with many other National Gallery treasures in a top-secret bunker hidden in the Blaenau Ffestiniog slate quarry in Snowdonia in Wales. (This was just as well: the National Gallery later scored a direct hit by the Luftwaffe during an air raid.)
- ²C. Hicks, Girl in a Green Gown: The History and Mystery of the Arnolfini Portrait (London: Vintage, 2012), pp. 30–32.
- ³ Pastoureau, Green, pp. 112, 117.
- ⁴The glowing green mineral malachite is also formed of copper carbonate.
- ⁵ Eckstut and Eckstut, Secret Language of Colour, p. 152.
- ⁶ Ball, Bright Earth, p. 113.
- ⁷ Delamare and Guineau, Colour, p. 140.
- 8 Cennini, Craftsman's Handbook, p. 33.
- 9 Ball, Bright Earth, p. 299.
- 10 Quoted in Pastoureau, Green, p. 190.
- ¹¹ This mixture is often called copper resinate, really an umbrella term for a wide range of mixtures made with verdigris and resins.

Absinthe

- ¹K. MacLeod, introduction to M. Corelli, Wormwood: A Drama of Paris (New York: Broadview, 2004), p. 44.
- ²P. E. Prestwich, 'Temperance in France: The Curious Case of Absinth [sic]', in *Historical* Reflections, Vol. 6, No. 2 (Winter 1979), p. 302.
- ³ Ibid., pp. 301-2.
- 4'Absinthe', in The Times (4 May 1868).
- ⁵ 'Absinthe and Alcohol', in *Pall Mall Gazette* (1 March 1869).
- ⁶Prestwich, 'Temperance in France', p. 305.
- ⁷F. Swigonsky, 'Why was Absinthe Banned for 100 Years?', Mic.com (22 June 2013). Available at: http://mic.com/articles/50301/ why-was-absinthe-banned-for-100-years-amystery-as-murky-as-the-liquor-itself#. NXpx3nWbh (accessed 8 Jan. 2016).

Emerald

- ¹Avarice green; envy and jealousy yellow; pride and lust – red; anger – black; sloth – blue or white. Pastoureau, *Green*, p. 121.
- ² Ibid., pp. 56, 30.
- ³B. Bornell, 'The Long, Strange Saga of the 180,000-carat Emerald: The Bahia Emerald's twist-filled History', in *Bloomberg Businessweek* (6 March 2015).

Kelly green

- ¹ Kelly, a common Irish surname from which the colour takes its name, has a much disputed etymology. Some believe it originally indicated a warrior; others, a religious person.
- ² For the full text see www.confessio.ie.
- ³A. O'Day, *Reactions to Irish Nationalism* 1865–1914 (London: Hambledon Press, 1987), p. 5.
- ⁴Pastoureau, Green, pp. 174-5.
- ⁵O'Day, Reactions to Irish Nationalism, p. 3.

Scheele's green

- ¹Ball, Bright Earth, p. 173.
- ² Ibid.
- ³P. W. J. Bartrip, 'How Green was my Valence? Environmental Arsenic Poisoning and the Victorian Domestic Ideal', in *The English Historical Review*, Vol. 109, No. 433 (Sept. 1994), p. 895.
- ⁴ 'The Use of Arsenic as a Colour', *The Times* (4 Sept. 1863).
- ⁵ Bartrip, 'How Green was my Valence?', pp. 896, 902.
- ⁶G. O. Rees, Letter to The Times (16 June 1877).
- ⁷ Harley, Artists' Pigments, pp. 75-6.
- 8 Quoted in Pastoureau, Green, p. 184.
- ⁹Bartrip, 'How Green was my Valence?', p. 900.
- ¹⁰ W. J. Broad, 'Hair Analysis Deflates Napoleon Poisoning Theories', in *New York Times* (10 June 2008).

Terre verte

- ¹ Eastaugh et al., Pigment Compendium, p. 180.
- ² Field, Chromatography, p. 129.
- ³ Delamare and Guineau, Colour, pp. 17-18.
- ⁴Cennini, Craftsman's Handbook, p. 67.
- ⁵ Ibid., pp. 93-4.
- 6 Ibid., p. 27.

Avocado

- ¹K. Connolly, 'How US and Europe Differ on Offshore Drilling', BBC (18 May 2010).
- ² Eiseman and Recker, Pantone, pp. 135, 144.
- ³ Pastoureau, Green, p. 24.
- ⁴J. Cartner-Morley, 'The Avocado is Overcado: How #Eatclean Turned it into a Cliché', in the Guardian (5 Oct. 2015).

Celadon

- ² Salisbury, *Elephants Breath and London Smoke*, p. 46.
- ³S. Lee, 'Goryeo Celadon'. Available at http:// www.metmuseum.org/toah/hd/cela/hd_cela. htm (accessed 20 March 2016).

4Ibid.

- ⁵J. Robinson, 'Ice and Green Clouds: Traditions of Chinese Celadon', in *Archaeology*, Vol. 40, No. 1 (Jan.-Feb. 1987) pp. 56-58.
- ⁶ Finlay, Colour, p. 286.
- ⁷Robinson, 'Ice and Green Clouds: Traditions of Chinese Celadon', p. 59; quoted in Finlay, *Colour*, p. 271.
- 8 Finlay, Colour, p. 273.

Brown

- 1 Genesis, 3:19.
- ²Ball, Bright Earth, p. 200.
- ³ Eastaugh et al., Pigment Compendium, p. 55.
- ⁴M. P. Merrifield, *The Art of Fresco Painting in the Middle Ages and Renaissance* (Mineola, NY: Dover Publications, 2003).
- ⁵ Quoted in 'Miracles Square', OpaPisa Website. Available at: www.opapisa.it/en/miracles-square/sinopie-museum/the-recovery-of-the-sinopie.html (accessed 20 Oct. 2015).
- 6 Ball, Bright Earth, p. 152.
- ⁷ Martin Boswell, Imperial War Museum; private correspondence.

Khaki

- ¹This was particularly true of their chemical industry, thanks to technical advances in the manufacture of aniline dyes. Britain had become so reliant on German's dye industry that at times during the war Britain found itself almost unable to dye its own uniforms khaki: it was Germany who produced the colourants.
- ²Richard Slocombe, Imperial War Museum; private correspondence.
- ³ J. Tynan, *British Army Uniform and the First*World War: Men in Khaki (London: Palgrave
 Macmillan, 2013), pp. 1–3.
- ⁴William Hodson, second in command of the Guides, quoted in ibid., p. 2.
- ⁵ Martin Boswell, Imperial War Museum; private correspondence.
- 6]. Tynan, 'Why First World War Soldiers Wore Khaki', in World War I Centenary from the University of Oxford. Available at: http://ww1centenary.oucs.ox.ac.uk/material/why-first-world-war-soldiers-wore-khaki/(accessed 11 Oct. 2015). In 1914, officers were easily distinguishable from regular soldiers by special clothing, such as long leather boots and, as Paul Fussell puts it in The Great War and Modern Memory (Oxford University Press, 2013), 'melodramatically cut riding breeches'. These made them special targets; they soon donned regular khaki uniforms like all the rest.
- ⁷A. Woollacott "Khaki Fever" and its Control: Gender, Class, Age and Sexual Morality on the British Homefront in the First World War', in *Journal of Contemporary History*, Vol. 29, No. 2 (Apr. 1994), pp. 325–6.
- ⁸ Marie Lloyd, known as the queen of the music hall, frequently sang the popular 'Now You've Got Yer Khaki On', when performing in 1915, the gist of which was that wearing khaki could make a man seem more attractive.

Buff

- ¹ Salisbury, Elephant's Breath and London Smoke, p. 36.
- ² Norris, *Tudor Costume and Fashion*, pp. 559, 652.

- ³G. C. Stone, A Glossary of the Construction, Decoration and Use of Arms and Armor in All Countries and in All Times (Mineola, NY: Dover Publications, 1999), p. 152.
- ⁴Quoted in E. G. Lengel (ed.), A Companion to George Washington (London: Wiley-Blackwell, 2012).
- ⁵Up to this point the colonies had relied on Britain for much of their cloth; uniforms were hard to reliably source for the Americans during the war and there was a constant struggle to keep the men clothed. When, on New Year's Day 1778 HMS Symmetry was captured while loaded with supplies including 'Scarlett, Blue & Buff Cloth, sufficient to Cloath all the officers of the Army', there was general rejoicing (followed by intense squabbling over where the cloth would end up).
- ⁶ J. C. Fitzpatrick (ed.), The Writings of George Washington from the Original Manuscript Sources, 1745–1799, Vol. 7 (Washington, DC: Government Printing Office, 1939), pp. 452–3.
- ⁷B. Leaming, *Jack Kennedy: The Education of a Statesman* (New York: W. W. Norton, 2006), p. 360.

Fallow

- ¹P. F. Baum (trans.), Anglo-Saxon Riddles of the Exeter Book (Durham, NC: Duke University Press, 1963), p. v.
- ²Riddle 44: 'Splendidly it hangs by a man's thigh, / under the master's cloak. In front is a hole. / It is stiff and hard...' Answer? A key.
- ³J. I. Young, 'Riddle 15 of the Exeter Book', in Review of English Studies, Vol. 20, No. 80 (Oct. 1944), p. 306.
- ⁴Baum (trans.), Anglo-Saxon Riddles of the Exeter Book, p. 26.
- ⁵ Maerz and Paul, *Dictionary of Colour*, pp. 46-7.
- 6J. Clutton-Brock, Clutton-Brock, J., A Natural History of Domesticated Mammals (Cambridge University Press, 1999), pp. 203–4.
- ⁷ Baum (trans.), Anglo-Saxon Riddles of the Exeter Book, pp. 26–7.
- 8 Young, 'Riddle 15 of the Exeter Book', p. 306.

Russet

- ¹ Maerz and Paul, Dictionary of Colour, pp. 50-51.
- ² Quoted in S. K. Silverman, "The 1363 English Sumptuary Law: A Comparison with Fabric Prices of the Late Fourteenth Century", graduate thesis for Ohio State University (2011), p. 60.
- ³R. H. Britnell, Growth and Decline in Colchester, 1300-1525 (Cambridge University Press, 1986), p. 55.
- Although 'russet' was used in the adjectival sense as a colour from the 1400s, it wasn't until the sixteenth century that it became more of a brown than a grey. The Franciscans, an order of priests very active in Europe during the Middle Ages, gained their nickname, the greyfriars, from their habit of wearing russet cloth, and as late as 1611 'light russet' was given as a translation for the French gris in Cotgrave's dictionary.
- ⁵G. D. Ramsay, 'The Distribution of the Cloth Industry in 1561–1562', in *English Historical Review*, Vol. 57, No. 227 (July 1942), pp. 361–2, 366.
- ⁶ Quoted in Britnell, *Growth and Decline in Colchester*, p. 56.
- ⁷S. C. Lomas (ed.), The Letters and Speeches of Oliver Cromwell, with Elucidations by Thomas Carlyle, Vol. 1 (New York: G.P. Putnam's Sons, 1904), p. 154.

Sepia

- ¹R. T. Hanlon and J. B. Messenger, *Cephalopod Behaviour* (Cambridge University Press, 1996), p. 25.
- ²C. Ainsworth Mitchell, 'Inks, from a Lecture Delivered to the Royal Society', in *Journal of the Royal Society of Arts*, Vol. 70, No. 3637 (Aug. 1922), p. 649.
- 3 Ibid.
- ⁴M. Martial, *Selected Epigrams*, trans. S. McLean (Madison, WI: University of Wisconsin Press, 2014), pp. xv-xvi.
- ⁵ Ibid., p. 11.
- ⁶C. C. Pines, 'The Story of Ink', in *American Journal of Police Science*, Vol. 2, No. 4 (July/Aug. 1931), p. 292.

⁷ Field, Chromatography, pp. 162-3.

Umber

- ¹A. Sooke, 'Caravaggio's Nativity: Hunting a Stolen Masterpiece', BBC.com (23 Dec. 2013). Available at: www.bbc.com/culture/ story/20131219-hunting-a-stolen-masterpiece (accessed 13 Oct. 2015); J. Jones, 'The Masterpiece that May Never be Seen Again', in the Guardian (22 Dec. 2008). Available at: www.theguardian.com/artanddesign/2008/dec/22/caravaggio-art-mafia-italy (accessed 13 Oct. 2015).
- ² Ball, Bright Earth, pp. 151-2.
- ³ Field, Chromatography, p. 143.
- ⁴Finlay, Brilliant History of Colour in Art, pp. 8–9.
- 5 Ball, Bright Earth, pp. 162-3.
- ⁶Jones, 'Masterpiece that may Never be Seen Again'.
- 7 'Nativity' remains on the FBI's list of unsolved art crimes.

Mummy

- ¹S. Woodcock, 'Body Colour: The Misuse of Mummy', in *The Conservator*, Vol. 20, No. 1 (1996), p. 87.
- ²Lucas and Harris, Ancient Egyptian Materials and Industries, p. 303.
- ³ Giovanni d'Athanasi recorded the sad fate of the insufficiently distinguished body of the governor of Thebes in his book published in 1836: 'An English traveller, had just bought the fellow mummy of the governor of Thebes, but having taken it into his head, while on his road to Cairo, that there might be some gold coins in this mummy, he caused it to be opened, and not finding any thing in it of the nature he sought, he threw it into the Nile . . . Such was the fate of the mortal remains of the governor of Thebes' (p. 51).
- ⁴P. McCouat, 'The Life and Death of Mummy Brown', in *Journal of Art in Society* (2013). Available at: www.artinsociety.com/ the-life-and-death-of-mummy-brown.html (accessed 8 Oct. 2015).
- ⁵ Ibid.
- ⁶ Quoted ibid.

- Woodcock, 'Body Colour', p. 89.
- ⁸G. M. Languri and J. J. Boon, 'Between Myth and Reality: Mummy Pigment from the Hafkenscheid Collection', in *Studies in Conservation*, Vol. 50, No. 3 (2005), p. 162; Woodcock, 'Body Colour', p. 90.
- ⁹Languri and Boon, 'Between Myth and Reality', p. 162.
- 10 McCouat, 'Life and Death of Mummy Brown'.
- ¹¹ R. White, 'Brown and Black Organic Glazes, Pigments and Paints', in National Gallery Technical Bulletin, Vol. 10 (1986), p. 59; E. G. Stevens (1904), quoted in Woodcock, 'Body Colour', p. 89.
- ¹² Criticism of the use of mummies' in medicine had begun much earlier. In 1658 the philosopher Sir Thomas Browne had called it 'dismal vampirism': 'The Egyptian mummies, which Cambyses or time hath spared, avarice now consumeth. Mummie is become Merchandise.'
- ¹³ Diary of Georgiana Burne-Jones, quoted in Woodcock, 'Body Colour', p. 91.
- ¹⁴ Quoted in McCouat, 'Life and Death of Mummy Brown'.
- ¹⁵ Quoted in 'Techniques: The Passing of Mummy Brown', Time (2 Oct. 1964). Available at: http://content.time.com/time/ subscriber/article/0,33009,940544,00.html (accessed 9 Oct. 2015).

Taupe

- ¹ 'The British Standard Colour Card', in *Journal* of the Royal Society of Arts, Vol. 82, No. 4232 (Dec. 1933), p. 202.
- ²The history of organising and charting colour in a systematic way has been a long and frustrating one, beginning with the first colour wheel in Newton's Opticks (1704) and continuing to the present day. A detailed account can be found in Ball, Bright Earth, pp. 40–54.
- 3 Maerz and Paul, Dictionary of Colour, p. v.
- 4 'The British Standard Colour Card', p. 201.
- ⁵ Maerz and Paul, Dictionary of Colour, p183.

Black

¹M. Pastoureau, *Black: The History of a Colour*, trans. J. Gladding (Princeton University Press, 2009), p. 12.

² Quoted in Ball, Bright Earth, p. 206.

³ J. Harvey, Story of Black, p. 25.

⁴Quoted in E. Paulicelli, Writing Fashion in Early Modern Italy: From Sprezzatura to Satire (Farnham: Ashgate, 2014), p. 78.

⁵ Pastoureau, Black, pp. 26, 95-6.

6 Ibid., p. 102.

⁷L. R. Poos, A Rural Society after the Black Death: Essex 1350-1525 (Cambridge University Press, 1991), p. 21.

8 Pastoureau, Black, p. 135.

Black has remained popular – with most people at least: Oscar Wilde wrote to the *Daily Telegraph* in 1891 to complain of this 'black uniform . . . a gloomy, drab, and depressing colour'.

¹⁰ Quoted in S. Holtham and F. Moran, 'Five Ways to Look at Malevich's Black Square', Tate Blog, Available at: www.tate. org.uk/context-comment/articles/ five-ways-look-Malevich-Black-Square (accessed 8 Oct. 2015).

Kohl

²R. Kreston, 'Ophthalmology of the Pharaohs: Antimicrobial Kohl Eyeliner in Ancient Egypt', *Discovery Magazine* (Apr. 2012). Available at: http://blogs.discovermagazine.com/ bodyhorrors/2012/04/20/ophthalmology-ofthe-pharaohs/ (accessed 24 Sept. 2015).

3 Ibid.

⁴K. Ravilious, 'Cleopatra's Eye Makeup Warded off Infections?', National Geographic News (15 Jan. 2010). Available at: http://news.nationalgeographic.com/news/2010/01/100114- cleopatra-eye-makeup-ancientegyptians/ (accessed 24 Sept. 2015); Kreston, 'Ophthalmology of the Pharaohs'.

Payne's grey

¹ Quoted in A. Banerji, Writing History in the Soviet Union: Making the Past Work (New Delhi: Esha Béteille, 2008), p. 161.

²B. S. Long, 'William Payne: Water-Colour Painter Working 1776–1830', in *Walker's Quarterly*, No. 6 (Jan. 1922). Available at: https://archive.org/stream/williampaynewate 00longuoft, pp. 3–13.

³ Quoted in ibid., pp. 6-8.

Obsidian

¹ British Museum, 'Dr Dee's Mirror', www.britishmuseum.org/explore/highlights/ highlight_objects/pe_mla/d/dr_dees_mirror. aspx (accessed 6 Oct. 2015).

²J. Harvey, *The Story of Black* (London: Reaktion Books, 2013), p. 19.

³ British Museum, 'Dr Dee's Mirror'.

⁴C. H. Josten, 'An Unknown Chapter in the Life of John Dee', in Journal of the Warburg and Courtauld Institutes, Vol. 28 (1965), p. 249. Dee missed some that had been concealed in a secret drawer. When these were discovered after his death a kitchen maid began using them to line her pie dishes. Miraculously enough, some of the papers did survive the flames and pie crusts, including Dee's pitiable account of this destruction – he calls it a holocaust. A full transcript of this section can be found in ibid., pp. 223–57.

⁵ Pastoureau, Black, pp. 137-9.

6 J. A. Darling, 'Mass Inhumation and the Execution of Witches in the American Southwest', in American Anthropologist, Vol. 100, No. 3 (Sept. 1998), p. 738; See also S. F. Hodgson, 'Obsidian, Sacred Glass from the California Sky', in Piccardi and Masse (eds.), Myth and Geology, pp. 295–314.

⁷R. Gulley, *The Encyclopedia of Demons and Demonology* (New York: Visionary Living, 2009), p. 122; British Museum, 'Dr Dee's Mirror'.

Endnotes

Ink

- ¹Translation from UCL online; see: ucl.ac.uk/ museums-static/digitalegypt/literature/ ptahhotep.html
- ²Delamare and Guineau, Colour, pp. 24-5.
- ³ Ibid., p. 25.
- ⁴C. C Pines, 'The Story of Ink', in The American Journal of Police Science, Vol. 2, No. 4 (July/Aug. 1931), p. 291.
- ⁵Finlay, Colour, p. 99.
- ⁶Pastoureau, Black, p. 117.
- ⁷Rijksdienst voor het Cultureel Erfgoed, The Iron Gall Ink Website. Available at: http:// irongallink.org/igi_indexc752.html (accessed 29 Sept. 2015), p. 102.
- ⁸ Delamare and Guineau, Colour, p. 141.
- 9 Finlay, Colour, p. 102.
- 10 Bucklow, Alchemy of Paint, pp. 40-41.

Charcoal

- 1 P. G. Bahn and J. Vertut, Journey Through the Ice Age (Berkley, CA: University of California Press, 1997), p. 22.
- 2 M. Rose, "Look, Daddy, Oxen!": The Cave Art of Altamira', in Archaeology, Vol. 53, No. 3 (May/June 2000), pp. 68-9.
- ³ H. Honour and J. Flemming, A World History of Art (London: Laurence King, 2005), p. 27; Bahn and Vertut, Journey through the Ice Age, p. 17.
- ⁴Honour and Flemming, a World History of Art, pp. 27-8.
- 5 A. Bhatia, 'Why Moths Lost their Spots, and Cats don't like Milk: Tales of Evolution in our Time', in Wired (May 2011).

let

- A. L. Luthi, Sentimental Jewellery: Antique Jewels of Love and Sorrow (Gosport: Ashford Colour Press, 2007), p. 19.
- ²J. Munby, 'A Figure of Jet from Westmorland', in Britannia, Vol. 6 (1975), p. 217.

- ³ Luthi, Sentimental Jewellery, p. 17.
- ⁴L. Taylor, Mourning Dress: A Costume and Social History (London: Routledge Revivals, 2010),
- ⁵ Quoted ibid., p. 130.

Melanin

- 1 It has been estimated that incidences of skin cancer among white people double for every 10-degree decrease in latitude.
- ²R. Kittles, 'Nature, Origin, and Variation of Human Pigmentation', in Journal of Black Studies, Vol. 26, No. 1 (Sept. 1995), p. 40.
- 3 Harvey, Story of Black, pp. 20-21.
- ⁴Pastoureau, Black, pp. 37-8.
- ⁵ Quoted in Knowles (ed.), The Oxford Dictionary of Quotations, p. 417.
- 6 Quoted in Harvey, Story of Black, p. 23.
- 7 Quoted in M. Gilbert, Churchill: A Life. (London: Pimlico, 2000), p. 230.

Pitch black

- Ancient Greeks referred to the 'black Nyx', and she could also be described as 'black-winged' or 'sable-vestured'. Over a millennium later, Shakespeare drew on startlingly similar imagery: he called it 'sable Night' and referred to its 'black mantle'.
- ²Pastoureau, Black, pp. 21, 36.
- 3 Harvey, Story of Black, pp. 29, 32. Defying her frightening appearance, if Kali's devotees feel she has failed them, they can visit her temples in order to fling, in place of garlands and incense, curses and shit.
- 4Quoted ibid., p. 41.
- ⁵ Pastoureau, Black, p. 28.
- 6 Quoted in Harvey, Story of Black, p. 29.

p. 129.

6 Ibid., p. 129.

Bibliography and suggested further reading

Those interested in learning more about the science of colour and the heady rush of the aniline revolution should read Philip Ball's *Bright Earth* and Simon Garfield's *Mauve*. For those who want to be taken to find extraordinary colours across the world in eloquent company look no further than *Colour* by Victoria Finlay. And those with a particular interest in the dark side could do no better than reading Michel Pastoureau's illuminating monograph *Black* – my favourite of his single-colour books – and John Harvey's *The Story of Black*.

Α

- Ainsworth, C. M., 'Inks, from a Lecture Delivered to the Royal Society', in *Journal of the Royal Society of Arts*, Vol. 70, No. 3637 (Aug. 1922), pp. 647–60.
- Albers, J., Interaction of Colour. 50th Anniversary Edition (New Haven, CT: Yale University Press, 1963).
- Alexander, H., 'Michelle Obama: The "Nude" Debate', in the *Telegraph* (19 May 2010).
- Allaby, M., Plants: Food Medicine and Green Earth (New York: Facts on File, 2010).
- Allen, N., 'Judge to Decide who Owns £250 Million Bahia Emerald', in the *Telegraph* (24 Sept. 2010).
- **Aristotle,** *Complete Works* (New York: Delphi Classics, 2013).
- Alter, A. L., Drunk Tank Pink, and other Unexpected Forces that Shape How we Think, Feel and Behave (London: Oneworld, 2013).

F

- Bahn, P. G. and J. Vertut, Journey Through the Ice Age (Berkeley, CA: University of California Press, 1997).
- Balfour-Paul, J., Indigo: Egyptian Mummies to Blue Jeans (London: British Museum Press, 2000).
- Balfour-Paul, J., Deeper than Indigo: Tracing Thomas Machell, Forgotten Explorer (Surbiton: Medina, 2015).

- Ball, P. Bright Earth: The Invention of Colour (London: Vintage, 2008).
- Banerji, A., Writing History in the Soviet Union: Making the Past Work (New Delhi: Esha Béteille, 2008)
- Bartrip, P. W. J., 'How Green was my Valence?'
 Environmental Arsenic Poisoning and the
 Victorian Domestic Ideal', in *The English*Historical Review, Vol. 109, No. 433 (Sept. 1994).
- Barzini, L., Pekin to Paris: An Account of Prince Borghese's Journey Across Two Continents in a Motor-Car. Trans. L. P. de Castelvecchio (London: E. Grant Richards, 1907).
- Batchelor D., *Chromophobia* (London: Reaktion Books, 2000).
- Baum, P. F. (trans.), Anglo-Saxon Riddles of the Exeter Book (Durham, NC: Duke University Press, 1963).
- Beck, C. W., 'Amber in Archaeology', in Archaeology, Vol. 23, No. 1 (Jan. 1970), pp. 7–11.
- Bemis, E., *The Dyers Companion*.

 Reprinted from 2nd edition (Mineola, NY: Dover Publications, 1973).
- Berger, K., 'Ingenious: Mazviita Chirimuuta', in *Nautilus* (July 2005).
- Bessborough, Earl of (ed.), Georgiana: Extracts from the Correspondence of Georgiana, Duchess of Devonshire (London: John Murray, 1955).
- Bhatia, A., 'Why Moths Lost their Spots, and Cats don't like Milk: Tales of Evolution in our Time', in Wired (May 2011).

- Billinge, R. and L. Campbell, 'The Infra-Red Reflectograms of Jan van Eyck's Portrait of Giovanni(?) Arnolfini and his Wife Giovanna Cenami(?)', in National Gallery Technical Bulletin, Vol. 16 (1995), pp. 47–60.
- Blau, R., 'The Light Therapeutic', in *Intelligent Life* (May/June 2014), pp. 62–71.
- **Blumberg**, **J.**, 'A Brief History of the Amber Room', Smithsonian.com (31 July 2007).
- Bolton, E., Lichens for Vegetable Dyeing (McMinnville, OR: Robin & Russ, 1991).
- Bornell, B., 'The Long, Strange Saga of the 180,000-carat Emerald: The Bahia Emerald's twist-filled History', in *Bloomberg Businessweek* (6 Mar. 2015).
- Brachfeld, A. and M. Choate, Eat Your Food! Gastronomical Glory from Garden to Glut. (Colorado: Coastalfields, 2007).
- Brassaï, Conversations with Picasso. Trans. J. M. Todd (Chicago: University of Chicago Press, 1999).
- British Museum, 'Dr Dee's Mirror'.
- Britnell, R. H., Growth and Decline in Colchester, 1300–1525 (Cambridge University Press, 1986).
- **Broad, W. J.** 'Hair Analysis Deflates Napoleon Poisoning Theories', in *New York Times* (10 June 2008).
- Brody, J. E., 'Ancient, Forgotten Plant now "Grain of the Future"', in *New York Times* (16 Oct. 1984).
- Brunwald, G., 'Laughter was Life', in *New York Times* (2 Oct. 1966).
- Bucklow, S., The Alchemy of Paint: Art, Science and Secrets from the Middle Ages (London: Marion Boyars, 2012).
- **Burdett**, **C.**, 'Aestheticism and Decadence', British Library Online.
- Bureau of Indian Standards, 'Flag Code of India'. Burrows, E. G. and M. Wallace, Gotham: A History of New York City to 1898 (Oxford University Press, 1999).

C

- Carl, K. A., With the Empress Dowager of China (New York: Routledge, 1905).
- Carl, K. A., 'A Personal Estimate of the Character of the Late Empress Dowager, Tze-'is', in Journal of Race Development, Vol. 4, No. 1 (July 1913), pp. 58–71.
- Cartner-Morley, J., 'The Avocado is Overcado: How #Eatclean Turned it into a Cliché', in the *Guardian* (5 Oct. 2015).

- Carus-Wilson, E. M., "The English Cloth Industry in the Late Twelfth and Early Thirteenth Centuries", in *Economic History Review*, Vol. 14, No. 1 (1944), pp. 32–50.
- Cassidy, T., Environmental Psychology: Behaviour and Experience in Context (Hove: Routledge Psychology Press, 1997).
- Cennini, C., *The Crafisman's Handbook*, Vol. 2,. Trans. D. V. Thompson (Mineola, NY: Dover Publications, 1954).
- Chaker, A. M., 'Breaking Out of Guacamole to Become a Produce Star', in Wall Street Journal (18 Sept. 2012).
- Chang, J., Empress Dowager Cixi: The Concubine who Launched Modern China (London: Vintage, 2013).
- Chirimutta, M., Outside Colour: Perceptual Science and the Pussele of Colour in Philosophy. (Cambridge, MA: MIT Press, 2015).
- Choi, C. Q., '230-Million-Year-Old Mite Found in Amber', in *LiveScience* (27 Aug. 2012).
- Clarke, K., 'Reporters see Wrecked Buddhas', BBC News (26 March 2001).
- Clarke, M., 'Anglo Saxon Manuscript Pigments', in *Studies in Conservation*, Vol. 49, No. 4 (2004), pp. 231–44.
- Clutton-Brock, J., A Natural History of Domesticated Mammals (Cambridge University Press, 1999).
- Collings, M. R., Gemlore: An Introduction to Precious and Semi-Precious Stones, 2nd edition (Rockville, MD: Borgo Press, 2009).
- Colliss Harvey, J., Red: A Natural History of the Redhead (London: Allen & Unwin, 2015).
- Connolly, K., 'How US and Europe Differ on Offshore Drilling', BBC News (18 May 2010).
- Conrad, P., 'Girl in a Green Gown: The History and Mystery of the Arnolfini Portrait by Carola Hicks', in the *Guardian* (16 Oct. 2011).
- Copping, J., 'Beijing to Paris Motor Race Back on Course', in the *Daily Telegraph* (27 May 2007).
- Corelli, M. Wormwood: A Drama of Paris (New York: Broadview, 2004).
- Cowper, M. (ed.), The Words of War: British Forces' Personal Letters and Diaries During the Second World War (London: Mainstream Publishing, 2009).
- Cumming, R., Art Explained: The World's Greatest Paintings Explored and Explained (London: Dorling Kindersley, 2007).

D

Daniels, V., R. Stacey and A. Middleton,

'The Blackening of Paint Containing Egyptian Blue,' in *Studies in Conservation*, Vol. 49, No. 4 (2004), pp. 217–30.

- Darling, J. A., 'Mass Inhumation and the Execution of Witches in the American Southwest', in *American Anthropologist*, Vol. 100, No. 3 (Sept. 1998), pp. 732–52.
- D'Athanasi, G., A Brief Account of the Researches and Discoveries in Upper Egypt, Made Under the Direction of Henry Salt, Esq. (London: John Hearne, 1836).
- Delamare, F., and B. Guineau, Colour: Making and Using Dyes and Pigments (London: Thames & Hudson, 2000).
- Delistraty, C. C., 'Seeing Red', in *The Atlantic* (5 Dec. 2014).
- Derksen, G. C. H. and T. A.Van Beek, 'Rubia Tinctorum L.', in *Studies in Natural Products Chemistry*, Vol. 26 (2002) pp. 629–84.
- Deutscher, G., Through the Language Glass: Why the World Looks Different in Other Languages (London: Arrow, 2010).
- **Doll, J.**, 'The Evolution of the Emoticon', in *The Wire* (19 Sept. 2012).
- Doran, S., The Culture of Yellow, Or: The Visual Politics of Late Modernity (New York: Bloomsbury, 2013).
- Dusenbury, M. (ed.), Colour in Ancient and Medieval East Asia (New Haven, CT: Yale University Press, 2015).

E

Eastaugh, N., V. Walsh, T. Chaplin and

R. Siddall, Pigment Compendium: A Dictionary and Optical Microscopy of Historical Pigments (Oxford: Butterworth-Heinemann, 2008).

- Eckstut, J., and A. Eckstut, The Secret Language of Color (New York: Black Dog & Leventhal, 2013).
- The Economist, 'Bones of Contention' (29 Aug. 2015).
- The Economist, 'Going Down' (11 Aug. 2014). The Economist, 'The Case Against Tipping' (26 Oct. 2015).
- The Economist, 'Why do Indians Love Gold?' (20 Nov. 2013).
- Edmonds, J., The History of Woad and the Medieval Woad Vat (Lulu.com, 2006).
- Edmonds, J., Medieval Textile Dyeing (Lulu.com, 2012).
- Edmonds, J., Tyrian or Imperial Purple Dye, (Lulu.com, 2002).

- Eiseman, L. and E. P. Cutler, Pantone on Fashion: A Century of Colour in Design (San Francisco, CA: Chronicle Books, 2014).
- Eiseman, L., and K. Recker, Pantone: The 20th Century in Colour (San Francisco, CA: Chronicle Books, 2011).
- Eldridge, L., Face Paint: The Story of Makeup (New York: Abrams Image, 2015).
- Elliot, A. J. and M. A. Maier, 'Colour and Psychological Functioning', in *Journal of Experimental Psychology*, Vol. 136, No. 1 (2007), pp. 250–254.

F

- Field, G., Chromatography: Or a Treatise on Colours and Pigments and of their Powers in Painting, &c. (London: Forgotten Books, 2012).
- Finlay, V., Colour: Travels Through the Paintbox (London: Sceptre, 2002).
- Finlay, V., The Brilliant History of Colour in Art (Los Angeles, CA: Getty Publications, 2014).
- Fitzpatrick, J. C. (ed.), The Writings of George Washington from the Original Manuscript Sources, 1745–1799, Vol. 7 (Washington, DC: Government Printing Office, 1939).
- Follett, T., 'Amber in Goldworking', in Archaeology, Vol. 38 No. 2 (Mar./Apr. 1985), pp. 64–5.
- Franklin, R., 'A Life in Good Taste: The Fashions and Follies of Elsie de Wolfe', in *The New Yorker* (27 Sept. 2004), p. 142.
- Fraser, A., Marie Antoinette: The Journey (London: Phoenix, 2001).
- Friedman, J., Paint and Colour in Decoration (London: Cassell Illustrated, 2003).
- Friedland, S. R. (ed.), Vegetables: Proceedings of the Oxford Symposium on Food and Cooking 2008 (Totnes: Prospect, 2009).
- Fussell, P., The Great War and Modern Memory (Oxford University Press, 2013).

G

- Gaetani, M. C., U. Santamaria and C. Seccaroni,
 'The Use of Egyptian Blue and Lapis Lazuli
 in the Middle Ages: The Wall Paintings of the
 San Saba Church in Rome', in Studies in
 Conservation, Vol. 49, No. 1 (2004), pp. 13–22.
- Gage, J., Colour and Culture: Practice and Meaning from Antiquity to Abstraction (London: Thames & Hudson, 1995).
- Gage, J., Colour and Meaning: Art, Science and Symbolism (London: Thames & Hudson, 2000).
- Gage, J., Colour in Art (London: Thames & Hudson, 2006).

- Gannon, M., '100-Million-Year-Old Spider Attack Found in Amber', in *LiveScience* (8 Oct. 2012).
- Garfield, S., Mauve: How One Man Invented a Colour that Changed the World (London: Faber & Faber, 2000).
- Gettens, R. J., R. L. Feller and W. T. Chase, 'Vermilion and Cinnabar', in *Studies in Conservation*, Vol. 17, No. 2 (May 1972), pp. 45–60.
- Gettens, R. J., E. West Fitzhugh and R. L. Feller, 'Calcium Carbonate Whites', in *Studies in Conservation*, Vol. 19, No. 3 (Aug. 1974), pp. 157–84.
- Gilbert, M., Churchill: A Life (London: Pimlico, 2000).
- Gilliam, J. E. and D. Unruh, 'The Effects of Baker-Miller Pink on Biological, Physical and Cognitive Behaviour', in *Journal of Orthomolecular Medicine*, Vol. 3, No. 4 (1988), pp. 202–6.
- Glazebrook, K. and I. Baldry, 'The Cosmic Spectrum and the Colour of the Universe', Johns Hopkins Physics and Astronomy blog.
- Goethe, J. W., *Theory of Colours*. Trans. C. L. Eastlake (London: John Murray, 1840).
- Gootenberg, P., Andean Cocaine: The Making of a Global Drug (Chapel Hill, NC: University of North Carolina Press, 2008).
- Gorton, T., 'Vantablack Might not be the World's Blackest Material', in *Dased* (27 Oct. 2014).
- Goswamy, B. N., 'The Colour Yellow', in *Tribune India* (7 Sept. 2014).
- Goswamy, B. N., The Spirit of Indian Painting: Close Encounters with 101 Great Works 1100–1900 (London: Allen Lane, 2014).
- Govan, F., 'Spanish Saffron Scandal as Industry Accused of Importing Cheaper Foreign Varieties', in the *Telegraph* (31 Jan. 2011).
- Greenbaum, H. and D. Rubinstein, 'The Hand-Held Highlighter', in New York Times Magazine (20 Jan. 2012).
- Greenfield, A. B., A Perfect Red: Empire, Espionage and the Quest for the Colour of Desire (London: Black Swan, 2006).
- Greenwood, K., 100 Years of Colour: Beautiful Images and Inspirational Palettes from a Century of Innovative Art, Illustration and Design (London: Octopus, 2015).
- **Groom, N.**, *The Perfume Handbook* (London: Springer-Science, 1992).
- Guéguen, N. and C. Jacob, 'Clothing Colour and Tipping: Gentlemen Patrons Give More Tips to Waitresses with Red Clothes', in *Journal* of Hospitality & Tourism Research, quoted by Sage Publications/Science Daily (Aug. 2012).

- Guillim, J., A Display of Heraldrie: Manifesting a More Easie Access to the Knowledge Therof Then Hath Hitherto been Published by Any, Through the Benefit of Method. 4th edition. (London: T. R., 1660).
- Gunther, M., 'Van Gogh's Sunflowers may be Wilting in the Sun', in *Chemistry World* (28 Oct. 2015).
- Gulley, R., The Encyclopedia of Demons and Demonology (New York: Visionary Living, 2009).

Н

- Hallock, J., Preferences: Favorite Color.
- Hanlon, R. T. and J. B. Messenger, Cephalopod Behaviour (Cambridge University Press, 1996).
- Harkness, D. E., John Dee's Conversations with Angels: Cabala, Alchemy, and the End of Nature (Cambridge University Press, 1999).
- Harley, R. D., Artists' Pigments c. 1600–1835 (London: Butterworths 1970).
- Harvard University Library Open Collections Program, 'California Gold Rush'.
- Harvey, J., The Story of Black (London: Reaktion Books, 2013).
- Heather, P. J., 'Colour Symbolism: Part I', in *Folklore*, Vol. 59, No. 4 (Dec. 1948), pp. 165–83.
- Heather, P. J., 'Colour Symbolism: Part IV', in *Folklore*, Vol. 60, No. 3 (Sept. 1949), pp. 316–31.
- Heller, S., 'Oliver Lincoln Lundquist, Designer, is Dead at 92', in *New York Times* (3 Jan. 2009).
- Herbert, Reverend W., A History of the Species of Crocus (London: William Clower & Sons, 1847).
- Hicks, C., Girl in a Green Gown: The History and Mystery of the Arnolfini Portrait (London: Vintage, 2012).
- Hodgson, S. F., 'Obsidian, Sacred Glass from the California Sky', in L. Piccardi and W. B. Masse (eds.), Myth and Geology (London: Geographical Society, 2007), pp. 295–314.
- Hoeppe, G., Why the Sky is Blue: Discovering the Colour of Life. Trans. J. Stewart (Princeton University Press, 2007).
- Holtham, S. and F. Moran, 'Five Ways to Look at Malevich's Black Square', Tate Blog.
- Honour, H. and J. Flemming, A World History of Art (London: Laurence King, 2005).
- Hooker, W. J. (ed.), Companion to the Botanical Magazine, Vol. 2 (London: Samuel Curtis, 1836).
- **Humphries**, C., 'Have We Hit Peak Whiteness?', in *Nautilus* (July 2015).

1

Iron Gall Ink Website.

J

- Jackson, H., 'Colour Determination in the Fashion Trades', in *Journal of the Royal Society* of the Arts, Vol. 78, No. 4034 (Mar. 1930), pp. 492–513.
- Johnson, K., 'Medieval Foes with Whimsy', in *New York Times* (17 Nov. 2011), p. 23.
- Jones, J., 'The Masterpiece that May Never be Seen Again', in the *Guardian* (22 Dec. 2008).
- Josten, C. H., 'An Unknown Chapter in the Life of John Dee', in *Journal of the Warburg and Courtauld Institutes*, Vol. 28 (1965), pp. 223-57.
- Journal of the Royal Society of Arts, 'The British Standard Colour Card', Vol. 82, No. 4232 (Dec. 1933) pp. 200–202.
- Just Style, 'Just-Style Global Market Review of Denim and Jeanswear – Forecasts to 2018' (Nov. 2012).

K

- Kahney, L, Jony Ive: The Genius Behind Apple's Greatest Products (London: Penguin, 2013).
- **Kapoor, A.**, Interview with *Artforum* (3 April 2015).
- Kiple, K. F. and K. C. Ornelas (eds.), The Cambridge World History of Food, Vol. 1 (Cambridge University Press, 2000).
- Kipling, R., Something of Myself and Other Autobiographical Writings. Ed. T. Pinney (Cambridge University Press, 1991).
- Kittles, R., 'Nature, Origin, and Variation of Human Pigmentation', in *Journal of Black Studies*, Vol. 26, No. 1 (Sept. 1995), pp. 36–61.
- Klinkhammer, B., 'After Purism: Le Corbusier and Colour', in *Preservation Education* ℰ *Research*, Vol. 4 (2011), pp. 19–38.
- Konstantinos, Werewolves: The Occult Truth (Woodbury: Llewellyn Worldwide, 2010).
- Kowalski, M. J., 'When Gold isn't Worth the Price', in *New York Times* (6 Nov. 2015), p. 23.
- Kraft, A., 'On Two Letters from Caspar Neumann to John Woodward Revealing the Secret Method for Preparation of Prussian Blue', in *Bulletin of the History of Chemistry*, Vol. 34, No. 2 (2009), pp. 134–40.
- Kreston, R., 'Ophthalmology of the Pharaohs: Antimicrobial Kohl Eyeliner in Ancient Egypt', Discovery Magasine (Apr. 2012).
- Kühn, H., 'Lead-Tin Yellow', in Studies in Conservation, Vol. 13, No. 1 (Feb. 1968), pp. 7–33.

L

- Lallanilla, M., 'Chernobyl: Facts About the Nuclear Disaster', in *LiveScience* (25 Sept. 2013).
- Languri, G. M. and J. J. Boon, 'Between Myth and Reality: Mummy Pigment from the Hafkenscheid Collection', in *Studies in Conservation*, Vol. 50, No. 3 (2005), pp. 161–78.
- Larson, E., 'The History of the Ivory Trade', in *National Geographic* (25 Feb. 2013).
- Leaming, B., Jack Kennedy: The Education of a Statesman (New York: W. W. Norton, 2006).
- Lee, R. L., 'Cochineal Production and Trade in New Spain to 1600', in *The Americas*, Vol. 4, No. 4 (Apr. 1948), pp. 449–73.
- Le Corbusier and A. Ozenfant, 'Purism', in R. L. Herbert (ed.), *Modern Artists on Art* (Mineola, NY: Dover Publications, 2000) pp. 63-64.
- Le Gallienne, R., 'The Boom in Yellow', in *Prose Fancies* (London: John Lane, 1896).
- Lengel, E. G. (ed.), A Companion to George
 Washington (London: Wiley-Blackwell, 2012).
- Lightweaver, C. (ed.), Historical Painting Techniques, Materials, and Studio Practice (New York: Getty Conservation Institute, 1995).
- Litzenberger, C., The English Reformation and the Laity: Gloucestershire, 1540–1589 (Cambridge University Press, 1997).
- Loeb McClain, D., 'Reopening History of Storied Norse Chessmen', in *New York Times* (8 Sept. 2010), p.2.
- Lomas, S. C. (ed.), The Letters and Speeches of Oliver Cromwell, with Elucidations by Thomas Carlyle, Vol. I (New York: G. P. Putnam's Sons, 1904).
- Lomazzo, G., A Tracte Containing the Artes of Curious Paintinge, Caruinge ♥ Buildinge. Trans. R. Haydock (Oxford, 1598).
- Long, B. S., 'William Payne: Water-Colour Painter Working 1776–1830', in *Walker's Quarterly*, No. 6 (Jan. 1922), pp. 3–39.
- Loos, A., Gentlemen Prefer Blondes: The Illuminating Diary of a Professional Lady (New York: Liveright, 1998).
- Lucas, A. and J. R. Harris, Ancient Egyptian Materials and Industries, 4th edition (Mineola, NY: Dover Publications, 1999).
- Luthi, A. L., Sentimental Jewellery: Antique Jewels of Love and Sorrow (Gosport: Ashford Colour Press, 2007).

M

- Madeley, G., 'So is Kate Expecting a Ginger Heir?', *Daily Mail* (20 Dec. 2012).
- Maerz, A. and M. R. Paul, A Dictionary of Colour (New York: McGraw-Hill, 1930).

- Maglaty, J., 'When Did Girls Start Wearing Pink?', Smithsonian.com (7 Apr. 2011).
- Martial, M., Selected Epigrams. Trans. S. McLean (Madison, WI: University of Wisconsin Press, 2014).
- Mathews, T. F. and A. Taylor, The Armenian Gospels of Gladzor: The Life of Christ Illuminated (Los Angeles, CA: Getty Publications, 2001).
- McCouat, P. 'The Life and Death of Mummy Brown', in *Journal of Art in Society* (2013).
- McKeich, C., 'Botanical Fortunes: T. N. Mukharji, International Exhibitions, and Trade Between India and Australia', in *Journal of the National Museum of Australia*, Vol. 3, No. 1 (Mar. 2008), pp. 1–12.
- McKie, R. and V. Thorpe, 'Top Security Protects Vault of Priceless Gems', in the *Guardian* (11 Nov. 2007).
- McNeill, F. M., The Silver Bough: Volume One, Scottish Folk-Lore and Folk-Belief, 2nd edition (Edinburgh: Canongate Classics, 2001).
- McWhorter, J., The Language Hoax: Why the World Looks the Same in Any Language (Oxford University Press, 2014).
- Menkes, S., 'Celebrating Elsa Schiaparelli', in *New York Times* (18 Nov. 2013), p. 12.
- Merrifield, M. P., The Art of Fresco Painting in the Middle Ages and Renaissance (Mineola, NY: Dover Publications, 2003).
- 'Minutes of Evidence taken Before the Metropolitan Sanitary Commissioners', in Parliamentary Papers, House of Commons, Vol. 32 (London: William Clowes & Sons,
- 'Miracles Square', OpaPisa website.
- Mitchell, L., *The Whig World: 1760–1837* (London: Hambledon Continuum, 2007).
- Morris, E., 'Bamboozling Ourselves (Parts 1-7)', in *New York Times* (May–June 2009).
- Mukharji, T. N., 'Piuri or Indian Yellow', in *Journal of the Society for Arts*, Vol. 32, No. 1618 (Nov. 1883), pp. 16–17.
- Munby, J., 'A Figure of Jet from Westmorland', in *Encyclopaedia Britannia*, Vol. 6 (1975), pp. 216–18.

N

- Nabokov, N., Speak, Memory (London: Penguin Classics, 1998).
- Nakashima, T., K. Matsuno, M. Matsushita and T. Matsushita, 'Severe Lead Contamination
 - Among Children of Samurai Families in Edo Period Japan', in *Journal of Archaeological* Science, Vol. 32, Issue 1 (2011), pp. 23–8.

- Nagy, G., The Ancient Greek Hero in 24 Hours (Cambridge, MA, Belknap, 2013).
- Neimeyer, C. P., *The Revolutionary War* (Westport, CN: Greenwood Press, 2007).
- New York Times, 'Baby's First Wardrobe', (24 Jan. 1897).
- New York Times, 'Finery for Infants', (23 July 1893), p. 11.
- New York Times, 'The Pink Tax', (14 Nov. 2014).
- Newton, I, 'A Letter to the Royal Society Presenting a New Theory of Light and Colours', in *Philosophical Transactions*, No. 7 (Jan. 1672), pp. 4004–5007.
- Niles, G., 'Origin of Plant Names', in *The Plant World*, Vol. 5, No. 8 (Aug. 1902), pp. 141–4.
- Norris, H., Tudor Costume and Fashion Reprinted edition (Mineola, NY: Dover Publications, 1997).

0

- O'Day, A., Reactions to Irish Nationalism 1865–1914 (London: Hambledon Press, 1987).
- Olson, K., 'Cosmetics in Roman Antiquity: Substance, Remedy, Poison', in *The Classical World*, Vol. 102, No. 3 (Spring 2009), pp. 291–310.
- Oosthuizen, W. C. and P. J. N. de Bruyn, 'Isabelline King Penguin Aptenodytes Patagonicus at Marion Island', in *Marine Ornithology*, Vol. 37, Issue 3 (2010), pp. 275–76.
- Owens, M., 'Jewellery that Gleams with Wicked Memories', in *New York Times* (13 Apr. 1997), Arts & Leisure p. 41.

P

- Pall Mall Gazette, 'Absinthe and Alcohol', (1 Mar. 1869).
- Pastoureau, M., Black: The History of a Colour. Trans. J. Gladding (Princeton University Press, 2009).
- Pastoureau, M., Blue: The History of a Colour.
 Trans. M. I. Cruse (Princeton University
 Press, 2000).
- Pastoureau, M., Green: The History of a Colour. Trans. J. Gladding (Princeton University Press. 2014).
- Paterson, I., A Dictionary of Colour: A Lexicon of the Language of Colour (London: Thorogood, 2004).
- Paulicelli, E., Writing Fashion in Early Modern Italy: From Spressatura to Satire (Farnham: Ashgate, 2014).

- Peplow, M., 'The Reinvention of Black', in *Nautilus* (Aug. 2015).
- Pepys, S., Samuel Pepys' Diary.
- Pereina, J., The Elements of Materia, Medica and Therapeutics, Vol. 2 (Philadelphia, PA: Blanchard & Lea, 1854).
- Perkin, W. H., 'The History of Alizarin and Allied Colouring Matters, and their Production from Coal Tar, from a Lecture Delivered May 8th', in *Journal for the Society for Arts*, Vol. 27, No. 1384 (May 1879), pp. 572–608.
- Persaud, R. and A. Furnham, 'Hair Colour and Attraction: Is the Latest Psychological Research Bad News for Redheads?', *Huffington Post* (25 Sept. 2012).
- Phillips, S. V., The Seductive Power of Home Staging: A Seven-Step System for a Fast and Profitable Sale (Indianapolis, IN: Dog Ear Publishing, 2009).
- Phipps, E., 'Cochineal Red: The Art History of a Colour', in Metropolitan Museum of Art Bulletin, Vol. 67, No. 3 (Winter 2010), pp. 4–48.
- Photos-Jones, E., A Cottier, A. J. Hall and L. G. Mendoni, 'Kean Miltos: The Well-Known Iron Oxides of Antiquity', in *Annual of the British School of Athens*, Vol. 92 (1997), pp. 359–71.
- Pines, C. C., "The Story of Ink', in American Journal of Police Science, Vol. 2, No. 4 (Jul./Aug. 1931), pp. 290–301.
- Pitman, J., On Blondes: From Aphrodite to Madonna: Why Blondes have More Fun (London: Bloomsbury, 2004).
- Poos, L. R., A Rural Society After the Black
 Death: Essex 1350–1525 (Cambridge University
 Press. 1991).
- Prance, Sir G. and M. Nesbitt (eds.), *The Cultural History of Plants* (London: Routledge, 2005).
- Prestwich, P. E., 'Temperance in France: The Curious Case of Absinth [sic]', in *Historical Reflections*, Vol. 6, No. 2 (Winter 1979), pp. 301–19.
- Profi, S., B. Perdikatsis and S. E. Filippakis, 'X-Ray Analysis of Greek Bronze Age Pigments from Thea', in *Studies in Conservation*, Vol. 22, No. 3 (Aug. 1977), pp. 107–15.
- Pryor, E. G., 'The Great Plague of Hong Kong', in Journal of the Royal Asiatic Society Hong Kong Branch, Vol. 15 (1975), pp. 61–70.

Q

Quito, A., 'Pantone: How the World Authority on Colour Became a Pop Culture Icon', in *Quarts* (2 Nov. 2015).

R

- Ramsay, G. D., 'The Distribution of the Cloth Industry in 1561–1562', in *English Historical Review*, Vol. 57, No. 227 (July 1942), pp. 361–9.
- Raven, A., 'The Development of Naval Camouflage 1914–1945', Part III.
- Ravilious, K., 'Cleopatra's Eye Makeup Warded off Infections?', National Geographic News, (15 Jan. 2010).
- Rees, G. O., Letter to The Times (16 June 1877).
 Regier, T. and P. Kay, 'Language, Thought, and Colour: Whorf was Half Right', in Trends in Cognitive Sciences, Vol. 13, No. 10 (Oct. 2009), pp. 439–46.
- Reutersvärd, O., 'The "Violettomania" of the Impressionists', in *Journal of Aesthetics and Art* Criticism, Vol. 9, No. 2 (Dec. 1950), pp. 106–10.
- Richter, E. L. and H. Härlin, 'A Nineteenth Century Collection of Pigment and Painting Materials', in *Studies in Conservation*, Vol. 19, No. 2 (May 1974), pp. 76–92.
- **Rijksmuseum**, 'William of Orange (1533–1584), Father of the Nation'.
- Roberson, D., J. Davidoff, I. R. L. Davies and L. R. Shapiro, 'Colour Categories and Category Acquisition in Himba and English', in N. Pitchford and C. P. Bingham (eds.), Progress in Colour Studies: Psychological Aspects (Amsterdam: John Benjamins Publishing, 2006).
- Rose, M., "Look, Daddy, Oxen!": The Cave Art of Altamira', in *Archaeology*, Vol. 53, No. 3 (May/June 2000), pp. 68–9.
- Rousseau, T., 'The Stylistic Detection of Forgeries', in *Metropolitan Museum of Art* Bulletin, Vol. 27, No. 6 (Feb. 1968), pp. 247–52.
- Royal Botanic Gardens, Kew, 'Indian Yellow', in *Bulletin of Miscellaneous Information*, Vol. 1890, No. 39 (1890), pp. 45–50.
- Ruskin, J., The Two Paths: Being Lectures on Art, and its Application to Decoration and Manufacture, Delivered in 1858–9 (New York: John Wiley & Son, 1869).
- Ruskin, J., Selected Writings, ed. D. Birch (ed.) (Oxford University Press, 2009).
- Russo, C., 'Can Elephants Survive a Legal Ivory Trade? Debate is Shifting Against It', in *National Geographic* (30 Aug. 2014).
- Ryzik, M., 'The Guerrilla Girls, After 3 Decades, Still Rattling Art World Cages', in *New York Times* (5 Aug. 2015).

- Sachsman, D. B. and D. W. Bulla (eds.), Sensationalism: Murder, Mayhem, Mudslinging, Scandals and Disasters in 19th-Century Reporting (New Brunswick, NJ: Transaction Publishers, 2013).
- Salisbury, D., Elephant's Breath and London Smoke (Neustadt: Five Rivers, 2009).
- Sample, I., 'Van Gogh Doomed his Sunflowers by Adding White Pigments to Yellow Paint', in the *Guardian* (14 Feb. 2011).
- **Samu, M.**, 'Impressionism: Art and Modernity', Heilbrunn Timeline of Art History (Oct. 2004).
- Sánchez, M. S., 'Sword and Wimple: Isabel Clara Eugenia and Power', in A. J. Cruz and M. Suzuki (eds.), The Rule of Women in Early Modern Europe (Champaign, IL: University of Illinois Press, 2009), pp. 64–79.
- **Savage, J.**, 'A Design for Life', in the *Guardian* (21 Feb. 2009).
- Schafer, E. H., 'Orpiment and Realgar in Chinese Technology and Tradition', in *Journal of the American Oriental Society*, Vol. 75, No. 2 (Apr.–June 1955), pp. 73–80.
- Schafer, E. H., 'The Early History of Lead Pigments and Cosmetics in China', in *T'oung* Pao, Vol. 44, No. 4 (1956), pp. 413–38.
- Schauss, A. G., 'Tranquilising Effect of Colour Reduces Aggressive Behaviour and Potential Violence', in *Orthomolecular Psychiatry*, Vol. 8, No. 4 (1979), pp. 218–21.
- Schiaparelli, E., Shocking Life (London: V&A Museum, 2007).
- Schwyzer, P., 'The Scouring of the White Horse: Archaeology, Identity, and "Heritage", in *Representations*, No. 65 (Winter 1999), pp. 42–62.
- Seldes, A., J. E. Burucúa, G. Siracusano, M. S. Maier and G. E. Abad, 'Green, Yellow and Red Pigments in South American Painting, 1610–1780', in Journal of the American Institute for Conservation, Vol. 41, No. 3 (Autumn/ Winter 2002), pp. 225–42.
- Sherrow, V., Encyclopedia of Hair: A Cultural History (Westport, CN: Greenwood Press, 2006).Shropshire Regimental Museum, 'The Hong
- Kong Plague, 1894–95'.

 Silverman, S. K., 'The 1363 English Sumptuary
- Silverman, S. K., 'The 1363 English Sumptuary Law: A Comparison with Fabric Prices of the Late Fourteenth Century.' Graduate thesis for Ohio State University (2011).
- Slive, S., 'Henry Hexham's "Of Colours": A Note on a Seventeenth-Century List of Colours', in *Burlington Magazine*, Vol. 103, No. 702 (Sept. 1961), pp. 378–80.

- Soames, M. (ed.), Winston and Clementine: The Personal Letters of the Churchills (Boston, MA: Houghton Mifflin, 1998).
- Sooke, A., 'Caravaggio's Nativity: Hunting a Stolen Masterpiece', BBC.com (23 Dec. 2013).
- Stamper, K., 'Seeing Cerise: Defining Colours in Webster's Third', in *Harmless Drudgery:* Life from Inside the Dictionary (Aug. 2012).
- Stanivukovic, G. V. (ed.), Ovid and the Renaissance Body (University of Toronto Press, 2001).
- Stanlaw, J. M., 'Japanese Colour Terms, from 400 CE to the Present', in R. E. MacLaury, G. Paramei and D. Dedrick (eds.), Anthropology of Colour (New York: John Benjamins, 2007), pp. 297–318.
- Stephens, J. (ed.), Gold: Firsthand Accounts from the Rush that Made the West (Helena, MT: Twodot, 2014).
- Stewart, D., 'Why a "Nude" Dress Should Really be "Champagne" or "Peach", in *Jezebel* (17 May 2010).
- Stone, G. C., A Glossary of the Construction, Decoration and Use of Arms and Armor in All Countries and in All Times (Mineola, NY: Dover Publications, 1999).
- Summer, G. and R. D'Amato, Arms and Armour of the Imperial Roman Soldier (Barnsley: Frontline Books, 2009).
- Summers, M., The Werewolf in Lore and Legend (Mineola, NY: Dover Occult, 2012).
- Swigonski, F., 'Why was Absinthe Banned for 100 Years?' (Mic.com, 22 June 2013).

Т

- Tabuchi, H., 'Sweeping Away Gender-Specific Toys and Labels', in *New York Times* (27 Oct. 2015).
- Taylor, L., Mourning Dress: A Costume and Social History (London: Routledge Revivals, 2010).
- The Times, 'Absinthe' (4 May 1868).
- *The Times*, 'The Use of Arsenic as a Colour' (4 Sept. 1863).
- Thompson, D. V., The Materials and Techniques of Medieval Painting. Reprinted from the first edition (Mineola, NY: Dover Publications, 1956).
- *Time*, 'Techniques: The Passing of Mummy Brown' (2 Oct. 1964).
- Townsend, J. H., "The Materials of J. M. W. Turner: Pigments', in *Studies in Conservation*, Vol. 38, No. 4 (Nov. 1993), pp. 231–54.
- Tugend, A., 'If your Appliances are Avocado, they Probably aren't Green', in *New York Times* (10 May 2008).

Twain, M., The Adventures of Tom Sawyer (New York: Plain Label Books, 2008).

Tynan, J., British Army Uniform and the First World War. Men in Khaki (London: Palgrave Macmillan, 2013).
Tynan, J., 'Why First World War Soldiers Wore Khaki', in World War I Centenary from the University of Oxford.

U

UCL, Digital Egypt for Universities, 'Teaching of Ptahhotep'.

ur-Rahman, A. (ed.), Studies in Natural Products Chemistry: Volume 26: Bioactive Natural Products (Part G) (Amsterdam: Elsevier Science, 2002).

٧

Vasari, G., The Lives of the Artists,
J. Conaway Bondanella and P. Bondanella trans.
(Oxford University Press, 1998).

Vernatti, P., 'A Relation of the Making of Ceruss', in the Royal Society, *Philosophical Transactions*, No. 137 (Jan./Feb. 1678), pp. 935-6.

Vernon Jones, V. S. (trans.), Aesop's Fables (Mineola, NY: Dover Publications, 2009).

W

Wald, C., 'Why Red Means Red in Almost Every Language', in *Nautilus* (July 2015).

Walker, J., The Finishing Touch: Cosmetics Through the Ages (London: British Library, 2014).

Walton, A. G., 'DNA Study Shatters the "Dumb Blonde" Stereotype', in *Forbes* (2 June 2014).

Ward, G. W. R. (ed.), The Grove Encyclopedia of Materials and Techniques in Art (Oxford University Press, 2008).

Warren, C., Brush with Death: A Social History of Lead Poisoning (Baltimore, MD: Johns Hopkins University Press, 2001).

Watts, D. C., Dictionary of Plant Lore
(Burlington, VT: Elsevier, 2007).

Weber, C., Queen of Fashion: What Marie

Antoinette Wore to the Revolution (New York: Picador, 2006).

Webster, R., The Encyclopedia of Superstitions (Woodbury: Llewellyn Worldwide, 2012).

White, R., 'Brown and Black Organic Glazes, Pigments and Paints', in *National Gallery Technical Bulletin*, Vol. 10 (1986), pp. 58–71. Whittemore, T., 'The Sawâma Cemetaries', in *Journal of Egyptian Archaeology*, Vol. 1, No. 4 (Oct. 1914), pp. 246–7.

Willett Cunnington, C., English Women's

Clothing in the Nineteenth Century (London:
Dover, 1937).

Winstanley, W., The Flying Serpent, Or: Strange News Out of Essex (London, 1669).

Woodcock, S., 'Body Colour: The Misuse of Mummy', in *The Conservator*, Vol. 20, No. 1 (1996), pp. 87–94.

Woollacott, A., ""Khaki Fever" and its Control: Gender, Class, Age and Sexual Morality on the British Homefront in the First World War', in *Journal of Contemporary History*, Vol. 29, No. 2 (Apr. 1994), pp. 325–47.

Wouters, J., L. Maes and R. Germer,

'The Identification of Haematite as a Red Colourant on an Egyptian Textile from the Second Millennium BC', in *Studies in Conservation*, Vol. 35, No. 2 (May 1990), pp. 89–92.

Wreschner, E. E., 'Red Ochre and Human Evolution: A Case for Discussion', in *Current Anthropology*, Vol. 21, No. 5 (Oct. 1980), pp. 631–44.

Υ

Young, J. I., 'Riddle 15 of the Exeter Book', in Review of English Studies, Vol. 20, No. 80 (Oct. 1944), pp. 304–6.

Young, P., Peking to Paris: The Ultimate Driving Adventure (Dorchester: Veloce Publishing, 2007).

Z

Ziegler, P., Diana Cooper: The Biography of Lady Diana Cooper (London: Faber, 2011).

Zimmer, C., 'Bones Give Peek into the Lives of Neanderthals', in *New York Times* (20 Dec. 2010).

Zuckerman, Lord, 'Earl Mountbatten of Burma, 25 June 1900–27 August 1979', Biographical Memoirs of Fellows of the Royal Society, Vol. 27 (Nov. 1981), pp. 354–64.

Acknowledgements

I am hugely grateful to the many people who took the time to help me with individual colour stories and to point me in the direction of relevant research. Particular thanks go to Cédric Edon, Director of Communication at Schiaparelli; Martin Boswell, curator of uniforms and Richard Slocombe, senior curator of art at the Imperial War Museum. To Professors Raman Siva Kumar and B. N. Goswamy, and to Dr Mark Nesbitt, curator at Royal Botanical Gardens, Kew and the staff at Museum Victoria for helping me delve into the mystery of Indian yellow. And to Henning Rader at the Munich Museum and Sabrina Hamann at Stabilo.

Thank you also to Mrs Herries and to Jenny and Piers Litherland, for the loan of their wonderful home where I spent a very happy six weeks writing, and to Carla Bennedetti for looking after me while I was there. Thank you to my editors at John Murray, Georgina Laycock and Kate Miles, to the talented James Edgar who looked after this book's design, to Amanda Jones and Yassine Belkacemi, and to Imogen Pelham, for all her work getting me from proposal to publication. Special thanks also to Michelle Ogundehin and Amy Bradford at Elle Decoration for taking the pitch for the original column. Thank you also to all the friends who have offered support, advice, research suggestions and glasses of wine when they were required. Special mention must also go to Tim Cross and to my brother Kieren for reading through various drafts; to my dad, for always coming to my rescue; and to Fiammetta Rocco for her unfailing kindness and advice.

Thank you, finally, to Olivier, not only for bringing me coffee each morning, but also for the read-throughs, suggestions, patience when I was sure I was going insane, cheerleading, thoughtful criticism, and boundless encouragement.

Index

Page numbers of main colour entries are indicated in **bold**

Α

absinthe 217-19

acid yellow 74-5 Adams, John 242-3 Aesop 130, 278 alchemy 66, 68, 145, 211 Alexander the Great 100 Altamira 228, 250-1, 262, 274 amaranth 130-1 amber 101-3 Ando, Tadao 41 aniline dyes 161, 167 Apple 41-2 Argentina 50 Armani, Giorio 192 Armenia 107 Arnolfini portrait 210, 214 arsenic 82, 168, 212-13, 224-6

> black 262-3 brown 237, 238-9 chalk 56-7 green 211-12 lead white 44

artists 21-4, 30

mummy 254–5 Prussian blue 194 Scheele's green 224 terre verte 227–9

ultramarine 184–5 umber 251

verdigris 214, 215–16 yellow 64 see also cave art; illuminated

manuscripts; Impressionists; Pre-Raphaelites Avicenna 124

avocado 27, 230-1 Aztecs 130-1, 136, 141-2, 268, 270 azurite 82, 196

В

Baever, Adolf von 192 Bahia emerald 220-1 Baker, Gene 118 Baker-Miller pink 117, 118-19 Bali 82 Bamiyan statues 182 Barzini, Luigi 148-9 Batchelor, David 40-1 Baum, L. Frank 220 Beardsley, Aubrey 64 Beechey, Sir William 254 beige 58-9, 110, 246 Berenson, Marisa 127 Berlin, Brent 34 Berny, Pierre de 200 birds 278-9 Biston betularia f. typica 275 bitumen 253 black 17, 19, 228, 261-81 Bloch-Bauer, Adele 86, 89

blonde 65, 67–8
blue 13, 115, 179–205, 228
blueprints 195
Boccumini, Paul 118
Boistard, Pascale 117

Borghese, Prince 148–9 Botticelli 88 Boucher, François 116

Boudicca 104 boys 115 Brant, Isabella 69

Boogert, A. 26

Brassaï 205 British Colour Council (BCC) 256-7

brown 21, 228, 237–57 Buddhism 100, 209 buff 239, 242–3

Burgess, Anthony 95 Burne-Jones, Edward 185, 255 Burton, Sarah 47–8

С

Caesar, Julius 162 Cambodia 80 Cambridge, Duchess of 48 camouflage 120-1, 239, 241 caracol 160 Caravaggio, Michaelangelo Merisi 238, 250, 251-2 Carl, Katharine Augusta 84 carrots 97 Cartailhac, Émile 274 Carthaginians 86 Casagemas, Carlos 204 Castiglione, Baldassare 262 Catholics 96, 131, 138, 139, 140, 142, 223 cave art 21, 228, 237, 250-1, 262, 274-5

262, 274−5 celadon 232−3 Celts 181, 199 Cennini, Cennino 57, 82, 83, 88, 182, 183, 215, 228−9

88, 182, 183, 215, 228–9

Cerro Rico de Potosì 49, 51

cerulean 204–5

Céganno Poul 77, 174

Cézanne, Paul 77, 174 chalk 56-7 charcoal 21, 262, 274-5 Charlemagne 139

Chaucer, Geoffrey 140 Chernobyl 201-2 China 30 blue 192 celadon 232-3

celadon 232-3 cosmetics 45, 109 ink 271-3 ivory 48

red 136, 142–3, 146–7, 150–1 white 41 yellow 65, 80, 82, 84–5

Christianity 33 black 261, 262, 269, 279, 280 blue 180

Eve 68 gold 87 illuminated manuscripts 23, 107–8, 146, 273

scarlet 140 Virgin Mary 68, 87, 115, 180, 181, 184–5

see also Catholics; Protestants Christison, Dr Robert 81 chrome yellow 76, 78–9, 94 Churchill, Winston 126, 279 Cixi, Empress Dowager 84 Cleopatra 99–100, 162

cobalt 180, 187-8, 204-5 Coca Cola 137 coccolithophores 56

cochineal 136, 138, 140, 141–3, 152–3, 193

Codex Exoniensis 244
Colliss-Harvey, Jacky 104
colour: artists 21–4
and culture 29–31
and language 33–5
mapping 26–7, 256–7
mixing 17–19

and vision 13–15 Constable, John 194 cosmetics 45–6, 109, 264–5 cosmic latte 58

Courèges, André 49 Crayola 128

crocoite 78-9 Crocus sativus 98-9 Cromwell, Oliver 140, 247 Crowley, Aleister 140 cuttlefish 248

Cynips quercusfolii 272

D

da Vinci, Leonardo 146, 249, 262–3

Dactylopius coccus 141

Dali, Salvador 77, 126

Dass, Angélica 111

de Wolfe, Elsie 58

death 172–3, 180, 261–2, 276–7, 280–1

Dee, Dr John 261, 268–9

deer 244–5

Defoe, Daniel 57

Delacroix, Eugène 254 Democritus 210 Desmoulins, Camille 223 devil 213, 269 Dewhurst, Richard 71 Dickens, Charles 224 Diesbach, Johann Jacob 193 Dio Cassius 104 Diocletian 163–4 Dippel, Johann Konrad

dragon's blood 154-5
 Drebbel, Cornelius 140
 Drölling, Martin 254
 Dryden, Helen 94

193, 194

Dürer, Albrecht 184 d'Urfé, Honoré 232 Dutch orange 93–4, 96–7, 223 Duthé, Rosalie 67

Egypt: amber 102

Ε

black 261, 262, 280-1 blue 190, 196-7 brown 238 emeralds 220 green 209 hematite 135-6, 150, 151 ink 271 kohl 264-5 madder 152 mummies 135-6, 150, 253-5 silver 50

yellow 77, 82 Egyptian blue 21, 180, 183–4, 196–7

electric blue 201-3 Elizabeth I 54, 105, 139 Elizabeth II 171 Elizabeth of York 93

emerald 212-13, 220-1 emojis 74-5 Estienne, Henri 211 Etruscans 102 Eugénie, Empress 170 Eve 68

F

Fahlman, Scott E. 75 fallow 244–5 Federigo 165-6 Fellowes, Daisy 116, 126 Ferrari, Enzo 149 Field, George: chalk 56 cobalt 188 dragon's blood 155 gamboge 80 Indian yellow 71 madder 153 minium 109 Naples yellow 76-7 Prussian blue 194 sepia 249 terre verte 227-8 umber 250 Finderlers, Jobst 100 Fini, Leonor 126 Finlay, Victoria 72-3

fluorescent pink 128-9

Ford, Henry 29 Fragonard, Jean-Honoré 116 France: absinthe 217-18, 219 blue 181, 192, 204 green 211, 223 madder 153 puce 122-3 yellow 63 François I 87, 253-4 Fuchs, Leonard 124-5 fuchsia 124-5

G

gamboge 64, 71, 80–1, 194
Garcinia trees 80
Gauguin, Paul 78, 95, 217
Geiger, Lazarus 33–4
gender 115–17
Gentlemen Prefer Blondes
68, 127
Gérard, Balthasar 96
Germany: blue 200

ravens 278-9
ginger 104-6, 137
Giotto 69, 87
girls 115
Gladstone, William Ewart 33
Gladzor Gospels 107-8, 109
Gmelin, Christian 185
Godlove, Isaac H. 27
Goethe, Johann Wolfgang 28
Goguryeo 43

gold 50, 86-9, 130, 142, 145,

146, 237 Golden Gate Bridge 94 Goswamy, B. N. 65 Greeks 21, 30, 33, 35, 42, 276 amber 102–3 blonde 67 brown 238 cosmetics 45, 109 green 210 hematite 151 night 280 saffron 98

saffron 98

green 13, 19, 209–33, 228
Greifswald 49–50
Grimes, William Francis 57
Guerrilla Girls 117
Guimet, Jean-Baptiste 185–6
Guyton de Morveau,
Louis-Bernard 40

Н

Hawthorne, Nathaniel 136-7 heliotrope 172-3 Hellot, Jean 195 hematite 88, 136, 150-1, 228, 250 Henry VIII 87, 105 Hermès 94 Herschel, John 194-5 highlighter pens 128-9 Hinduism 204, 261, 280-1 Hippocrates 124 Hispaniola 125 Hogarth, William 194 Hooker, Sir Joseph 71-3 Hooker, William 81 Horace 160 Houbraken, Arnold 56 Hubbard, L. Ron 204

hair 65, 67-8, 104-6

١

illness 64 illuminated manuscripts 23, 107–8, 146 imperial yellow 65, **84–5** Impressionists 20, 78, 94–5, 174–5, 237 Inca 136, 141, 142 India: gamboge 80 gold 66

saffron 100 yellow 65, 71–3 Indian yellow 64, 71–3

madder 152

pink 116

indigo 167, 180–1, 189–92, 193, 198, 200

ink 271–3 Innocent III 210

> Iran 98 Iraq 98

Ireland 94, 222-3 Isabella, Archduchess 54-5

isabelline 54–5

Isatis tinctoria 198–9

Islam 33, 209, 213, 273

Ive, Jonathan 41

ivory 47-8

J

Japan 30
blue 192, 194
gamboge 80
lead white 45
purple 160
white 41
Java 82
jeans 192
jet 276-7
Jews 65
Jobs, Steve 41-2
Johnson, Samuel 256, 257, 279

Jackson, Holbrook 64

Jacobi, Richard 70

Jurassic Park 102

Κ

Kandinsky, Wassily 93, 94, 147, 213
Kapoor, Anish 137, 194
Kay, Paul 34
Keeler, Clyde 179
kelly green 222–3
Kentucky 52
Key, Adriaen Thomasz 96
khaki 239, 240–1
Khan, Naeem 110
Kipling, Rudyard 255
Klein, Calvin 41
Klein, Yves 186
Klimt, Gustav 86, 89
kohl 264–5

L

Langland, William 247 language 33-5, 116 lapis lazuli 182-4 Lascaux 228, 251 Le Corbusier 29-30, 41 Le Gallienne, Richard 63, 66 lead white 39-40, 43-6, 70, 108, 193, 215, 227 lead-tin yellow 44, 69-70 Levy, Adrian 103 Lewis Chessmen 47 lichens 161, 165-6 light: and black 261 **blue** 179 colour mixing 17-19 visible spectrum 13, 14-15, 128 and vision 13-15, 39

Lacaze-Duthiers, Henri de 164

Lacroix, Christian 127

lampblack 271-2

Lippi, Filippino 184 London, Jack 65 Loos, Anita 68 Louboutin, Christian 111 Louis XVI 122–3 Lundquist, Oliver 204

M

Macmillan, Harold 243 madder 152–3, 192, 199–200, 246 Maerz, A. 246, 256–7 magenta 26, 135, 167–8 Magnan, Valentine 218

Magnan, Valentine 218
make-up 45–6, 109, 264–5
Malevich, Kazimir 41, 263
Manet, Édouard 175
maraschino cherries 131
Maria Theresa, Empress 122
Marie Antoinette 122–3
Marino Mannoia, Francesco
'Mozzarella' 251–2

Martial 248–9 Mary, Queen of Scots 138, 139 Mary, Virgin 68, 87, 115, 180, 181, 184–5

mauve 21, 152, 159, 161, 164, 167, 169–71, 172, 277 melanin 248, 278–9

Melville, Herman 29, 39

Mérimée, Jean François Léonor 71 Mexico 130-1 Midas 88 Millais, Sir John Everett 105 Miller, Ron 118 Milton, John 68, 130

Miró, Joan 179 Mirzapur 72–3 Modigliani, Amedeo 105 moles 256–7 Monet, Claude 94,174,175,194 Monroe, Marilyn 68, 116, 127 Morris, William 185, 198

minium 94, 107-9

Mountbatten, Lord 120–1

Mountbatten pink 120–1

mourning 172–3, 180, 276–7, 281

Mukharji, Trailokyanath 72–3

Morrow, Irving 94

mummy 253–5 Munch, Edvard 30, 95 Munsell, Albert Henry 256 Murex brandaris 162, 163, 164, 165 Murray, Thomas 96

Musa 86-7

N

Naples yellow 64, 70, 76-7 Napoleon 224, 226 Nazis 67, 89, 101 Neri di Bicci 44 Nero 163, 220 Netherlands 93, 96-7 New York 97 Newton, Sir Isaac 16, 17, 19, 30, 268 Nicander 45 night 280 mude 110-11

oak tree 272 Ohama Michelle 110

obsidian 261, 268-70 ochre 82, 94 Odin 278 Oenanthe isabellina 54 orange 13, 14, 19, 93–111, 223 purple 19, 159–75 orchil 161, 165-6

Oberkirch, Baronne d' 123

Ordinaire, Pierre 217 orpiment 64, 82-3, 194, 227 Osiris 136, 150, 281 Owens, Mitchell 126

Palladio, Andrea 42

Pantone 26, 204, 209

P

Pastoureau, Michel 25 Patrick, St 222-3 Paul II, Pope 139 Paul, M. Rea 246, 256-7 Payne, William 266-7 Payne's grey 266-7 Peking to Paris race 148-9 penguins 55 peppered moths 275 Perkin, William 21, 152, 153, 161, 169-70 Perrin, Jean 81 Peru 137 Phaeton 103 Philip II 142 Philip the Good 263 Picasso, Pablo 194, 204, 205 pink 115-31 Pissarro, Camille 174, 237 pitch black 280-1 plague 52

Plato 210

Pliny the Elder 21, 124

bitumen 253

blue 180 cochineal 136, 138 dragon's blood 154-5 gold 88-9 lead white 39, 43 madder 152 minium 109 orpiment 82 Tyrian purple 159, 160, 162 mrusset 31, 239, 246-7 vermilion 145 Plumier, Père Charles 125 Poe, Edgar Allan 63, 217 Pompadour, Madame de 116 Pompeii 144, 152 Pozzo, Andrea 76 Pre-Raphaelites 105, 137 prisons 118-19

prostitutes 67, 136

purgatives 81, 82

puce 122-3

punk 128

Protestants 29, 94, 96-7, 223

Prussian blue 81, 193-5, 239

Rabbane, Paco 49 Radhakrishnan, Dr. S. 100 Raphael 215 rave culture 74-5 ravens 278-9 red 13, 14, 135-55, 228 redheads 104-6, 137 Rehmannia glutinosa 85 Reid, Jamie 128 Rembrandt 69, 81, 238, 251, 263 Revnolds, Sir Joshua 81, 266 Richard II 139 Roccella tinctoria 161, 165 Rodin, Auguste 42 Roger, Neil Munro 171 Romans 30, 42 amber 102 blonde 67 blue 179-80 brown 238 Egyptian blue 196-7 emerald 220 indigo 191 jet 276 orpiment 82 purple 160, 162-4 red 135, 136, 140

sepia 248-9

vermilion 144-5

Rossetti, Dante Gabriel 105, 185 rosso corsa 148-9 Rothko, Mark 137 Rubens, Peter Paul 69, 147 Rumphius, George Everhard 82-3 Ruskin, John 32, 279

S saffron 78, 98-100 Sano di Pietro 185 Santa Barbara 230 Sarto, Andrea del 185 Sassoferrato, Giovanni Battista Salvi 185 scarlet 31, 138-40, 199, 239, 246, 263 Scarlet Letter, The (Hawthorne) 136-7 Schauss, Alexander G. 118-19 Scheele, Carl Wilhelm 211-12, 224, 225-6 scheele's green 211-12, 224-6 Schiaparelli, Elsa 116, 126-7 Schlüter, Andreas 101 Schulz, Gottfried 146 Scientology 204 Scott-Clark, Cathy 103 sepia 248-9 Seurat, Georges 212 Sex Pistols 128 sexuality 136-7 Shakespeare, William 139, 140, 220, 244 shellfish 160, 162-3, 164, 248 Renoir, Pierre-Auguste 20, 261 shocking pink 116, 126-7 Siddal, Elizabeth 105 El Sidrón cave 106 Signac, Paul 205 m silver 49-51, 142 smileys 74-5

South Africa 93-4

indigo 192

scarlet 139

silver 50-1

Stabiae 228

Spencer, Lady 123

Stalin, Joseph 266

Suger, Abbot 180

Stewart, Dodai 110, 111

Switzerland: absinthe 218-19

Starbucks 143

Spain: amaranth 130-1

spectrum 13, 14-15, 30, 128

cochineal 142-3

т

taupe 256-7 terre verte 211, 212, 227-9 Thénard, Louis-Jacques 188 Theophilus 145-6, 272 Theophrastus 124 Thias haemastoma 162, 163 Thierry de Menonville, Nicolas-Joseph 143 Tintoretto 69, 215 Titian 69, 105, 184 Töllner, Hans 214 Toulouse-Lautrec, Henri de 95 Travilla, William 127 Tsarskove Selo 101 Tuareg 191 Turkey Red 153 Turner, J. M. W. 12, 81, 224 Tutankhamun 82, 152, 190 Twain, Mark 52-3

Tyrian purple 139, 159-60,

Uffington White Horse 57

162-4, 192

Ulpian 159

U

ultramarine 23, 146, 180-1, 182-6, 188, 193, 197, 227, 237 umber 238, 250-2 uniforms 139-40, 167, 181, 192, 239, 240-1, 242-3 Union-Castle 120-1 United Nations 204 United States: amaranth 131 avocados 231 buff 242-3 environmental protection 230 ivory 48 New York 97 St Patrick's Day 222 Unverdorben, Otto 167 urine 71-3, 162, 166

V

Van Dyck, Anthony 239 Van Evck, Ian 210, 214 Van Gogh, Vincent 30, 63, 78, 79, 95, 194, 205, 217 Van Hoogstraten, Samuel 211 Van Meegeren, Han 187-8 Vantablack 261 Vauquelin, Nicolas Louis 79 verdigris 44, 210, 212, 214-16, 227 Verguin, François-Emmanuel 167, 168 Vermeer, Johannes 187-8 vermilion 108, 109, 144-7 Vernatti, Sir Philiberto 44-5 Veronese, Paolo 83, 212, 215-16 Victoria, Queen 47, 170, 277 Victorians: electric blue 202 heliotrope 172, 173 mourning 172-3, 276-7 violet 174-5, 202 Virgin 137 Virgin Mary 68, 87, 115, 180, 181, 185 vision 13-15 Vitruvius 144

W

Vogue 95

Wah 150

Vreeland, Diana 116

Walker, Alice 159

werewolves 49-50

Walpole, Sir Horace 169, 268

Washington, George 242-3

wedding dresses 41, 47-8

Whitby 276, 277
white 17, 21, 39–59, 228, 261
whitewash 41, 52–3
Wilde, Oscar 63, 64, 170,
173, 217
William I, Prince of Orange
96–7
Winsor & Newton 40, 80, 81
witchcraft 262, 268–70
woad 189, 198–200, 211, 246
Wolfram, Gottfried 101
Wolsey, Cardinal 100
Woodwood, John 194
Wreschner, Ernst E. 150
Wright, Joseph 251

X

X-Ray Spex 128 Xenophon 45 Xu Yin 233

Υ

yellow 13, 14, 63–89, 228 Yoon, JeongMee 115 Yuvchenko, Alexander 201

Z

Zachary, Pope 279 Zingiber officinale 104 Zoroastrianism 100 Zosimus of Panopolis 145